Time

Colour

Introduction

Jan Brand and Anne van der Zwaag 5
Preface

André Platteel 6
The colour of attentiveness

Lidewij Edelkoort 14
Osmosis. The grey-card of life

Personal

Barbara Vinken 40
Your blue eyes:
colour as promise

Anneke Smelik 52
Skin-deep and hair-raising.
The meaning of skin and
hair colour

Anne van der Zwaag 58
M·A·C Pro Store, New York.
Mirror, mirror on the wall...

Edo Dijksterhuis 60
Viviane Sassen: Shadow play

Melissa Ho 62
Byron Kim

Ann Temkin 64
Carrie Mae Weems

Minke Vos 68
Colour difference.
The advertising campaigns
of Oliviero Toscani for
United Colors of Benetton

Valerie Steele 70
She's Like a Rainbow
Colors in Fashion

Claude Lévi-Strauss 76
The two faces of red

Kyoto Costume Institute 78
Viktor & Rolf: Self-portrait

Catelijne de Muijnck 84
Issey Miyake: Colour Hunting
in the Amazon

JeongMee Yoon 88
The Pink & Blue Project

Marije Vogelzang 92
Colour in food and design

Victoria Finlay 94
Religions and colour

Marjan Unger 102
Colour in design

Domestic

Gert Staal 116
Colour and interior. In search
of a lost sensibility

Louise Schouwenberg 132
One colour is no colour

Stefano Marzano 136
Who's afraid of colour?

Peter van Kester 140
The Forbo Colour Space

Malaika Brengman 142
How does colour affect the shop
interior? Colour in interior store
design and its impact on the
consumer. A silent seducer...

**Paula Eklund and
Susanne Piët** 148
IKEA the enabler. Colour
the unique 'you' in comfort

Barbara Bloemink 150
The new century of colour

Walter Benjamin 154
Colours

Public

Aaron Betsky 156
Beneath the pavers, the beach?
The colours of public space

Daniel Birnbaum 172
White

David Batchelor 174
A bit of nothing.
On monochromes

James Woudhuysen 180
Colour, brands and identity

Caroline Bos 184
UNStudio studies colour

Luis Barragán 190
The colours of Mexico

Anne van der Zwaag 194
Temporary architecture:
colour as tour de force

Susanne Komossa 196
Historic colour on public
buildings: more than local
identity Palau de la Música
Catalana and Mercat de Santa
Caterina in Barcelona

Anne van Grevenstein 202
'Moving on with Cuypers'

Tracy Metz 204
An interview with Jan Dibbets
on his church windows

**Kees Rouw and
Lisette Kappers** 206
An architecture of joy

Michael van Gessel 208
No colour, thank you

Mobile

Bart Lootsma 212
Towards the kaleidoscope

Paul Overy 226
Colour in the work
of Norman Foster

Paul Mijksenaar 230
Colour in transit

Jonathan Bell 234
Colour and cars

Ann Temkin 240
Alighiero Boetti

Theo Hauben 246
Slow colours

Anne van der Zwaag 248
Colour and screen:
the rise of the mobile internet

Ghislain Kieft 250
Living grey

Virtual

Max Bruinsma 254
24-hour colour:
all colour is virtual

Ewan Lentjes 262
More than black and white!
Graphic design and colour

Arjen Mulder 272
The perception of analogue
and digital colour

Jan van den Brink 276
Colour in film, a compendium

Jenny He 290
The colourful Tim Burton

Anne van der Zwaag 292
Robert Wilson: light is to
the set as paint is to a canvas

**Rainer Crone and
Alexandra von Stosch** 294
Anish Kapoor: the use
of colour as a metaphor

Ursula Sinnreich 296
James Turrell: the encounter
of inner and outer

Lilian Tone 300
Transient Rainbow. Explosions
and implosions of time

Rem Koolhaas 302
The future of colours
is looking bright

Rogier van der Heide 304
Coloured light:
a world of illusion

Minke Vos 306
Interactive colour: Angela
Bulloch's *Pixel Boxes and
Pedestrian Pixel System*

Anne van der Zwaag 308
Gaming: the battle of colour

Nalden 310
<title>#FFFFFF</title>

Index 315
Colophon 318

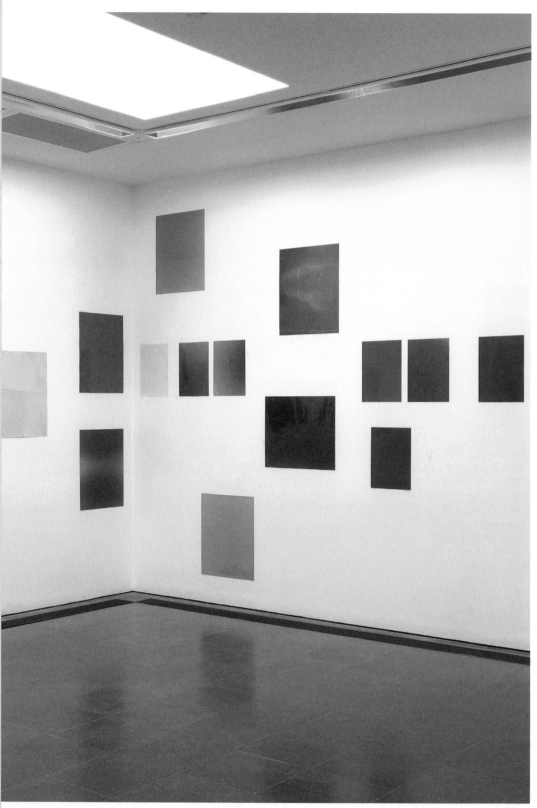

Wolfgang Tillmans, Installation Serpentine Gallery, London, 2010

Preface

Colour is a fixed part of our daily lives. We use it in countless ways and in practically all our activities. Colour is one of the most important visual tools in our contemporary culture, and it plays an essential role in the way people function.

The phenomenon of colour has been explored in books, catalogues and magazines and from many different angles. Theoretical treatises have been written about it, and purely visual surveys have been compiled. In this publication, theory and practice are interconnected.

By taking an interdisciplinary approach, *Colour in Time* demonstrates that colour is involved in a great many aspects of society. The role and meaning of colour in our daily lives change from one domain to the next. On the basis of current developments and applications, this book shows which creative and commercial disciplines are apparent in these domains, and it pinpoints any striking or influential examples of colour use. By placing colour in a social and theoretical context, we can provide insight into the underlying layers of meaning and encourage their discussion. Working from this perspective, we have put together a distinctive handbook that looks back on the history of colour from a contemporary vision.

Colour in Time is also a special period document in its own right. The book's design and colour are based on the personal vision of Irma Boom, making the book itself a visual statement about colour. *Colour in Time* opens with a series of images selected by Lidewij Edelkoort that form a visualisation of this overall theme. A textual introduction interweaves the central idea with the main themes of the book: the personal, the domestic, the public, the mobile and the virtual. Manifesting themselves within these five domains are creative and commercial disciplines that are treated by means of key texts, interviews and case studies. Each domain is introduced by a main article.

By publishing books, ArtEZ Press encourages research and theory development within the various art disciplines. These publications are a way of demonstrating current knowledge and skills in art, culture and education. The books may be the result of a production, a research project or collaboration with other institutions. This publication could not have come about without the support of the Sikkens Foundation, an independent organisation aimed at stimulating those social, cultural and scientific developments in society in which colour plays a specific role.

In issuing this publication, we hope to arouse curiosity for the application and significance of colour in design, architecture, art, film and photography as well as in advertising, fashion, food culture and religion, and to promote its use in these areas.

Jan Brand
Anne van der Zwaag

André Platteel
The colour of attentiveness

Six minutes: that's how long it takes for the sun to come up in the opening scene of Carlos Reygadas's *Stellet Licht* (*Silent Light*, 2007), in which a dark landscape comes to life. First there's a glow, then the image changes from orange to red to blue. It's not only landscapes that come to life under the influence of light, as the film clearly shows later on. A dead woman is resurrected in brilliant whiteness and is visible only to her child, for whom the concept 'death' is not yet commonplace, and to her husband's lover, a compassionate woman who had broken the woman's heart and caused her death. The woman who has been aroused from death is lying in an open coffin; the walls of the room seem to vibrate and become transparent and the white fabric in the coffin blanches in the bright white light. When the woman opens her eyes, no one in the room is taken aback. In Reygadas's film, death is a return to the light. Matter, our bodies, is a coagulation of light that acquires colour by experience. It is preceded and followed by the radiant light that will never be extinguished, not even by death.

Without light we see nothing. When light is broken and when it reflects, colours emerge. Whatever rebounds into our eyes is what we observe. But not everything we observe is equally clear.
 The artist Olafur Eliasson (1967) also plays with light. His *Your Sun Machine* (1997) is a hole that he sawed in the roof of a gallery in Los Angeles, through which the sun projects a circle of light on the floor. When you, the visitor, enter the room, you see a white circle on the floor and you ascribe to it material attributes. Once you realise that there's nothing at all on the floor, but

that what you see is an interpreted observation, it sets a very interesting game in motion. You look up and see that something is missing: a piece of the roof is gone. It's that absence that causes something to be created, something that isn't what you thought it was at first glance. You become aware that it wasn't the sun that projected the image you had observed, but you yourself. Then, as you watch the sunlight, you notice a shift taking place; the circle of light moves through the gallery with the shifting of the sun. The position from which you are observing is shifting constantly; you revolve around the light, with the earth as the vehicle.
 In 2003, an extraordinary exhibition was held at the Tate Modern in London. Visitors would lie down in the entrance hall and gaze upward at *The Weather Project* by Eliasson, an imitation of the sun made with hundreds of lamps that gave off an intense yellow light. A mirror had also been suspended there, and every now and then mist would be sprayed by a fog machine. Lying beneath the work, visitors could stare not only at the work but also at themselves. The mirror made them part of the work, blurring the division between object and subject, just as the division between inside and outside had been blurred: the sun placed the museum in the open air. And that's what Eliasson seems to be getting at: things are not distinct from each other and cannot be separated.

Our ability to observe, by which distinctions are made with the help of colour, is an interaction between the play of light (and sunlight) and the light that we impose as observers. And because refractions and perspectives keep changing, our observations are always different. The world changes colour from one moment to the next. Those moments cannot be singled out; they run

together. Everything is blended.
 The colour intensity of our observation is connected with our ability to be attentive. If we live in the moment, if we are deliberately present, then we experience colour more deeply. Perhaps 'more fully' is better: if we are totally in the moment, our lives will be a fuller experience of colour.
 The *nouvelle vague* filmmaker Jean-Luc Godard (1930) illustrates this in the film *Le mépris* (1963) when he has his muse, Brigitte Bardot, who is lying naked on a bed, ask her lover if he loves every part of her body. In this question-and-answer game, the lovers become submerged in each other, and after every affirmative answer the colour of the image becomes deeper, more intense.
 And in his debut film *A Single Man* (2009), director Tom Ford (1961) spends a day following a professor of literature at an American university sometime in the 1960s. This professor, George, is wrestling with the sudden death of his partner and is determined that very day to join his friend in death. All the details of the day pass before the viewer's eyes: showering, deciding what to wear, eating breakfast, taking the car to work, crossing streets and squares, meeting with other people, having lunch, going back home, dressing for a dinner appointment, entering a café, getting ready for bed. And in the case of George: preparing for his suicide.
 Tom Ford has styled each one of these actions and events down to the smallest detail. The colours of the interior with which George surrounds himself are earth tones; nothing is ostentatious. In the morning, the professor chooses his clothing with care: white shirt, black suit, dark tie and shoes. Many of the film images are quite grainy and largely devoid of colour. Everything looks washed out, even the colourful interior of the home of George's closest woman

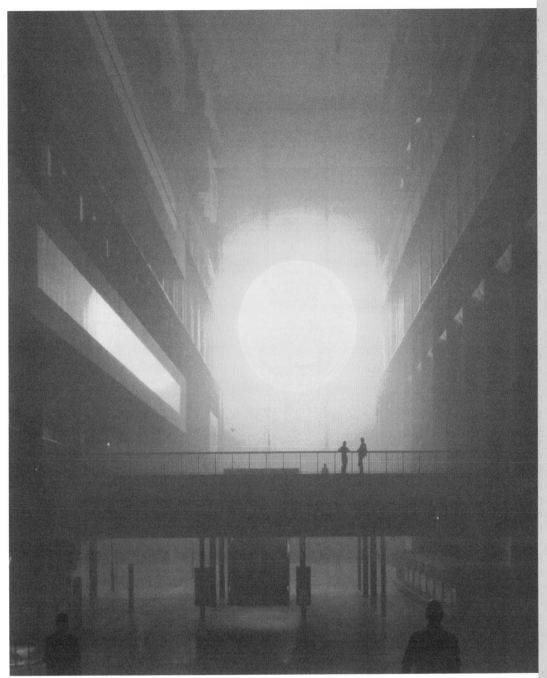

Olafur Eliasson, *The Weather Project*, 2003,
Tate Modern, London

friend. The death of his partner had robbed George of any reason for living. Every image looks like an old moving picture: the professor himself is already starting to fade away.

Only when George comes in contact with people who affect him, or when he runs into situations that remind him of his partner, does the colour return, literally. The addition of red, for example, causes the blood to flow again in the professor's pale skin. Just then the image slows down. George seems to have entered a state of timelessness when he stares into the light-green eyes of his secretary. The camera zooms in on the green and pauses there, and you begin to suspect that this green will give you a glimpse into the woman's soul. A little while later, George is overcome by the white, upwardly spiralling cigarette smoke being exhaled by one of his students, who bears a striking resemblance to the young Bardot in *Le mépris*. This white is not burned nicotine; the colour of the smoke is highly nuanced and intangible, just like the young lady with the cigarette clamped between her fingers. And later that evening he falls for another student who comes to visit him at home: the image slows down and the white sweater of the young man becomes prominent. That white communicates something different than the professor's trim shirt or the white of the cigarette smoke. The sweater is made of wool, which makes it neither remote nor mysterious but inviting to the touch. The professor tells the student that an experience is not something that happens to you but something that is formed by how you handle events.

If you do something with attention and love, your life acquires more colour. But intense colours do not always stand for attentive living. Take the work of photographer Rineke Dijkstra (1959), with their strange combination of saturated colours and poses. Girls in bright orange, green and yellow bathing suits stand on the beach looking bewildered against patches of deep-blue sky. Their heads seem to be filled with ideas of model-like perfection: they want to be models more than anything else, and they're imitating the poses of models they've known from the media. But Dijkstra snaps the shutter just when a bit of insecurity has crept into their behaviour. The brightly-coloured bathing suits pale in comparison with the not-very-successful poses and take on an endearing quality. The bright colours make the girls look pathetic: they want so much to be models and they can't quite bring it off. And brightly-coloured bathing suits can't do anything about it.

Artist Folkert de Jong (1972) makes large figures in cotton candy colours. His images are like gigantic confectionaries. But nibble his cotton candy and you're nibbling on barbed wire. The suggestive childlike innocence of the colours is suffocated by subjects that are coarse and violent: men split in half with wooden staves, beheaded figures and scenes of war.

You can read cultural criticism in the work of Dijkstra and De Jong if you're of a mind to do so: the colours in today's society are all polished up, so that looming at the end of the horizon is a utopia in all the bright colours of the rainbow. Because that utopia is unattainable, you always have the feeling that you're falling short: you become exhausted and pale. The bright rainbow colours also serve as a rug under which everything that we'd rather not see – death, war, betrayal – is swept. Does that make us naïve children who are easily mollified with candies?

Back in the 1950s, the American artist Morris Louis (1912–1962) made his colourful paintings using Magna brand acrylic paint, which was developed just for him. The work *Beta Upsilon* (1960) contains two parts of a rainbow. Although it is painted in vivid colours, the work shows that each rainbow is coming to an end. There's something wrong. Why is one rainbow not good enough? Why do we see only half of each rainbow, and why are they pressed against the far ends of the canvas? True, they're colourful, but the two rainbows seem to lack the energy they need to fill in white canvas in its entirety. In this work, Louis is presenting a foretaste of the downfall of the American Dream and the awakening of a society at a time in which great social dichotomies could no longer be swept under the colourful rug.

Todd Haynes (1961) uses the same theme in *Far from Heaven* (2002). The director shows how oppressive deep, scintillating colours can be. In *Far from Heaven*, Haynes portrays the carefree life of the American Whitaker family, prosperous and with high social standing. The family lives in a beautiful Connecticut suburb. The trees in the garden of the Whitaker family look as if they're made of gold. The dresses worn by wife and mother Cathy are in deep silky tints, the crystal sparkles, the windows have been washed, the furniture is polished and the vegetables being served are all bursting with health.

Everything seems wonderful on the surface. But soon rifts appear in this contrived beauty. Cathy's life falls apart when she discovers that her husband is a homosexual. And when she herself falls in love with the black gardener, she becomes even more confused. Repressed feelings and social disapproval make her life far from heavenly. The safe world illustrated by deep, cheerful colours proves to be a sociological and psychological straitjacket.

The director has his characters, dressed in brightly-coloured

Morris Louis, *Beta Upsilon*, 1960

clothing, disappear into an equally brightly coloured background. In doing so he seems to be saying that people themselves do not create their own identity. They are compelled to take a place in the social construct of their environment. They cannot be freed from their environment, which in fact colours them and holds them down.

Every moment of the day we make numerous choices, just like the professor in *A Single Man*: clothing, accessories, interior, vegetables and fruit, TV channels. Each moment of the day we are surrounded by various objects: buildings, modes of transportation, street lights, store fronts. Everything has colour: from toilet paper, a toothbrush, the entrance hall of a government building to graffiti. Most of the time we observe these colours unconsciously. Many of the things we do are automatic. And the objects that we do consciously choose on the basis of colour, such as our clothing, often refer to a particular period of time, a particular style or a particular culture code by which we reproduce existing values. This holds us down and keeps us from being candid.

Colours evoke images and create worlds. Certain shades of red immediately remind us of

hamburger chains or a brand of cigarettes. A certain yellow and blue call to mind a particular Swedish furniture manufacturer. In this way colour is very deliberately employed to seduce you.

In our culture, too, there are countless associations stored away. If a girl in a novel is lying under a hawthorn tree and reading a book, and if she's wearing a dress that is spotted red from crushed berries, those red spots evoke lust and desire. Pastel tints like light pink and light blue stand for childishness and naïveté. When the pastel tins are intensified, you get associations with digital landscapes and neon. If neon pops up at night in films, you know for certain that calamity is just around the corner. Deep red meat suggests freshness, even though we know very well that the red is created by additives, thereby sabotaging the original meaning of the red in meat: that it is unspoiled.

Every colour seems to awaken unconscious associations.

In the last minutes of *A Single Man*, George speaks in a voice-over and says that life becomes worth living the minute you make contact with what exists now. But his grief makes it impossible for George to live in the present; it keeps dragging him back to the past. The moments in which

he does succeed in living in the present seem too rare to avert his approaching fate. This lack of ability to concentrate, to experience what exists now, is passed on to the viewer as well. Tom Ford's style of filming is so dominant, the references to the sixties so pointed, that you feel as if you've been plunged into an advertising folder from the period and have no trouble at all falling in step with the suffering professor.

In order to live attentively and to experience every moment free of prior values, you've got to be willing to sacrifice prior colour associations. The disorientation this generates interrupts the automatic assignment of meaning: you've got to be attentive because your expectations will never be realised.

In his *Hidden Objects* (2006), photographer Maurice Scheltens (1972) places objects on a record player and lets them spin around so fast that the identity of the objects disappears and all that remains is the colour. As a viewer you're left with associations that change each time you see the work, since you have no fixed point of reference.

In the film *The Point of Departure* (2002) by Jeroen de Rijke (1970–2006) and Willem de Rooij (1969), the camera zooms in from

Introduction

all sides on a richly coloured Oriental rug. It crawls into the rug and zooms back out, giving you an impression of the vast range of colours and the richness of the patterns. You imagine how the rug was made, who used it and what meaning it had for them. The colours and shapes give rise to countless associations. Zooming in on orange can easily trigger a chain of national ideological associations (if you're Dutch), but they have nothing to do with the rug itself. When seen from another angle, entirely new meanings arise. No matter how close the camera comes to the wool, something keeps eluding the attempt to record it. You become aware of something that will not let itself be represented. Then the rug begins to float, turns on its axis and disappears into a black void.

Over the past century, many artists have enlisted the help of colour to arrive at an attentive state. Yves Klein (1928–1962) developed his 'own' colour blue that was nothing but a colour, stripped of any of the associations that all the other blues had. Not long afterward, that new blue became 'Yves Klein blue', which meant it was no longer free of definite meanings. Later, Klein decided to paint his gallery totally white and to exhibit absolutely nothing (*L'exposition du vide*, 1958) – no abstract or colour field paintings, either – because, he said, they were still an attempt to mediate a certain meaning and they stood in the way of the detached experience.

For the last years of his life, the British film director Derek Jarman (1942–1994) was almost blind: all he could see was blue, and it was based on this experience that he made his last film, *Blue* (1993). For fifty minutes you sit staring at a blue screen. As time goes by you begin to see other colours even though the blue has not changed. A voice-over tells fragments of stories, but your thoughts constantly drift away.

In the absence of any image you begin to think up all sorts of things yourself, but nothing sticks since there's no image to serve as a point of reference against which you can verify your associations.

After having produced figurative paintings for a while, Piet Mondrian (1872–1994) decided that putting a tree or a bit of sky on canvas was no longer interesting. He wanted to capture the moment that precedes matter. The primary colours in his work look just like pixels, as if he had zoomed into nature and kept bumping into primary colours again and again. The red, blue and yellow have something honest about them. The presumption of being able to imitate nature disappears. The coloured stripes and fields invite you to objectify what you're seeing: you can give your own associations free rein. It's not what is presented that is important, but the relationship that the viewer has with the work and the meanings that issue from this relationship.

Mondrian's longing to bypass matter resonates with that of Mark Rothko (1903–1970). The colours in Rothko's paintings are not unambiguous; they reflect an emptiness. It's as if the layers of red, yellow and blue were being pushed slowly to the background, where they dissolve in an everlasting void. According to the artist, our observations are conditioned by concepts, but prior to these concepts there are light and colour which can be seen as unborn reality. This unremitting search for the unborn brought Rothko to the abyss of earthly existence. He ended with black paintings and finally committed suicide.

These attempts by Klein, Jarman, Mondrian and Rothko have something romantic about them, as if the artists were searching for something that is more authentic, and therefore better, than everyday reality.

For fashion designer Martin Margiela (1957), on the other hand, everyday reality is interesting, although you wouldn't think so at first. Margiela is wild about garments from the fifties and sixties. Romance is there, ready to pounce. What he does to these pieces, however, is to add a lick of white paint, thereby erasing every association with colour. History and points of reference disappear. What remains is the 'pure' form. In 1997 the Museum Boijmans Van Beuningen in Rotterdam held a retrospective of the work of Margiela. The designer treated his designs with live mould, which consumed the fabric. Suddenly the white clothing was no longer the end but the start of something new. The uncontrolled growth created discolouration, by which Margiela was saying that nothing can be preserved and that everyday reality brings constant change. Contact with the outside world alters us. As a viewer, you become aware that the exhibited works will continue to absorb the surrounding environment and to age, even when they're no longer objects of public attention. Implicitly, Margiela was reacting to the transience of fashion as a whole.

Klein, Mondrian and Rothko are also doing something that isn't romantic but in fact is very modern. They're zooming in on the DNA of matter and arriving at geometric colour fields, which demonstrate an affinity with the pixels that appear when you blow up digital images. In a work by Rothko, for example, you see that the colours are not sharply divided but flow into and influence each other, and that there's white between the colours which acts as a kind of cement, also similar to what you see in zoomed-in digital images.

Stanley Kubrick (1928–1999) also anticipates the pixel in his film *2001: A Space Odyssey* (1968). At the beginning of the film, which takes place millions

André Platteel

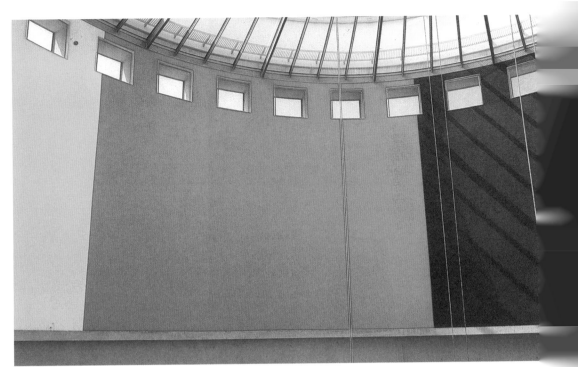

Günther Förg, mural, *Rotunde Schirn*,
Frankfurt, 1986

Anne Weber wearing a dress designed
by Ellsworth Kelly, Sanary, France, 1952

of years ago, a monolith falls to earth. Its geometric black surface brings with it a sense of unrest. A group of monkeys becomes agitated by the monolith, and some are even terrified. Others discover how they can use the heavy black matter to enrich their lives. The film suggests that this thing that has fallen to earth has ushered in the obsession with matter. Its shape reminds us of one single pixel. And there, perhaps, lies the film's prophetic warning: the coming digitisation of society will ultimately reduce everything to pixels, and we will lose contact with the physical. The computer that later seizes command from the humans elaborates on this idea: pixels getting the better of flesh and blood.

Artist Roxy Paine (1966) gives little thought to the possible warning that can be read in Kubrick's work, and instead searches for symbiosis with the digital. Paine makes paintings with computerised programs. The machines pick up a painter's canvas, dip it into a vat of monochrome colour and keep repeating the dipping in different variations, ending up with unique 'landscapes' of drips. Paine doesn't buy the idea that modern technology destroys art: it just produces a different art form.

Nor is Paine bothered by the metaphysical longings that can be detected in the work of Klein, Mondrian and Rothko. Paine doesn't want to avoid matter; he loves matter. He gives familiar things a different colour or makes them from a different material altogether. A tree made of steel, for instance. Not only do you become aware of the original colour and physicality of the tree, but Paine's work also makes you aware that everything you see is fabricated, even nature. The gleaming metal reflects the earthy green and brown and eliminates the longing for authentic colours and forms. Everything is authentic, as long as you expe-

rience it attentively. But you can't shut out previous experiences. The metal tree is not interesting if there's no memory of a 'normal' tree. It's when we hold the work up against a memory that the opening is created once more, enabling us to take a fresh look at nature.

Memories are necessary for orienting yourself. If you want to be attentive, you need to have a handle on previous experiences. With a little intuition, the previous experiences don't have to be-come hobbyhorses that cause your life to solidify.

The Argentinean film artist Ernesto Baca (1969) appeals to intuition in his work *Samoa* (2005). The film shows a quick succession of body parts, nature, abstract surfaces and architec-ture, images that follow each other associatively so that forms and meanings disappear and what remains is mainly colour. The film seems old, damaged. The spots in the image are not jarring; they contribute to the accumulation of colours. Baca draws on your own associations and varies them so rapidly that all you can do is let yourself be carried along by the endless stream of colourful patterns. In this way *Samoa* makes you think of the effect of some video clips and games: images and stories that force themselves on you in a quick succession of rhythms, depriving you of the chance to take critical distance. The only possible meaning you can impose is by way of intuition, in which you respond from a natural affinity. It's not that your memory is switched off; your memory has become a space where all possible actions reveal themselves and where the dif-ference between past, present and future doesn't exist. An eternal now arises. The Bud-dhists have a word for it, *sunya*, which means emptiness. That emptiness is not nothing; it's full – it contains all manifestations.

All colours are represented in it.

Artist Anish Kapoor (1954) appeals to intuition in another way. He makes monochrome works of pure pigments that seems to have a vanishing point. The objects first seem to be an obstruction in the space in which you find yourself, but as you look at them longer they assume a hallucinatory effect and seem to contain an opening to another dimension. You become absorbed into the work. The shape and colour of the works don't refer to anything; they throw you back on your intuition, as if you had to learn to navigate all over again in the other dimension.

For more than thirty years, James Turrell (1943) has been working on the Roden Crater Project in Arizona. There he transformed a crater into a gigantic observatory, which can be reached by way of two tunnels. The project won't be open to the public until 2011, but you can learn something about it from films on the internet and the many interviews that have been done with Turrell. Turrell's aim in the Roden Crater Project is to make it possible to experience light from outside our planetary system, light that is billions of years old. The Roden Crater Project has rooms where at certain points in time you can experience the winter solstice or other cosmic events.

To reach those rooms, you first must walk through a dark corri-dor so your pupils become enlarged. You end up in a room where the sky is a dome. Your open pupils gave you the feeling that you can touch the sky, that you're part of the stars and planets. The cosmos is no longer 'out there' but has become a part of you. An endless painting emerges of ever-changing cloud formations against constantly changing celestial colours. Your thinking grows silent. Associat-ions stop. You let yourself be carried along in the movement of the cosmos. The light from the

André Platteel

cosmos penetrates you. Space and time implode, reflections disappear. You are confronted with your own limits, the physicality of your body, whose borders gradually fade. You are lifted by the light. You float. You no longer observe the cosmos. You are one with it. You are light.

Nicola de Maria, mural and objects in Galeria Mario Diacono, Rome, 1982

Ann Veronica Janssens, *16 views of 'Blue, Red and Yellow'*, 2001

Introduction

Lidewij Edelkoort
Osmosis
The grey-card of life

To measure the strength of light, a photographer uses a grey-card to determine the value between dark and light, just as we need an instrument to measure our current mood and appreciation of society. Are we indulging in serenity with light grey flooding in, or are we burning bridges, bringing the darker shades of ashes? Are our greys pretty and picture-perfect like the lustrous shining tones of pearls, or urban and invisible like concrete poetry? Is grey basic and boring or exotic and avant-garde? How grey are you? How grey are we?

Grey was going to be the dominant colour of the twenty-first century until mutual global aggression made us regress to black and white – the 'you are with us or against us' rhetoric of the Bush administration.

With a strong feeling of political, economic, ecological and humanistic failure, a growing need to go back to grey, to consensus, osmosis, blending and cross-fertilisation has started to invade the political arena, financial markets, social issues and our own families and households. A true need for consensus is felt. Or should I say an urge for consensus?

Therefore, I have been determined to make a colour portfolio out of grey only. To show how beautiful the world can be between black and white, how rich in tone and how strong in statement. And how many variations of these greys exist, made by clouds and shadows and all other blended, fused and hybrid materials. Grey from beginning to end and from morning to evening. Grey as the symbolic colour of networking, sharing and open-ended enterprising. Announcing a society of onthological equality and animistic instincts. Grey as the icon of compassion with all other colours, warm or cool, tender pastel or powerful pigment.

Grey silhouettes will move through life like shadows and clouds in a more anonymous way, signalling the end of our fascination with the people press and reality TV. Modesty, anonymity and privacy are the new ideas for the time to come. Co-ordinating, balancing, negotiating, exchanging, permuting and moderating are the new terms which will be used to describe newer ways of democracy and a more contemporary form of business, where growth will be defined not only by shareholders' greed but by their ethical and ecological principles.

With this tendency towards fused and muted hybrids, jerseys will be heathered, matter will be layered, textiles will be colour woven and dye processes will provide lively surfaces, patterns are blurred and prints are sketched. Pencil drawing is making a remarkable comeback.

Never before have I felt such a need to express a trend as holistic and dominant.

Yet since 'every cloud has a silver lining', we will alternate bad and good news, male and female gender, urban and rural aspects and therefore also matte and shine. Coming to terms with reality.

A variation on a forecasting text first published in 2006 for spring 2008. Some people may think that these neutrals are ideal for dressing in a light-hearted neutral way, whereas others will feel a sense of loss and even impending danger. It may be clear that some of these trends forecast severe and natural disasters like draughts, floods, winds and quakes. We can only hope that we will be spared from the manmade one.

The light grey of dawn

The mouse grey of youth

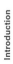

The chaotic grey of combat

The stiller grey of life

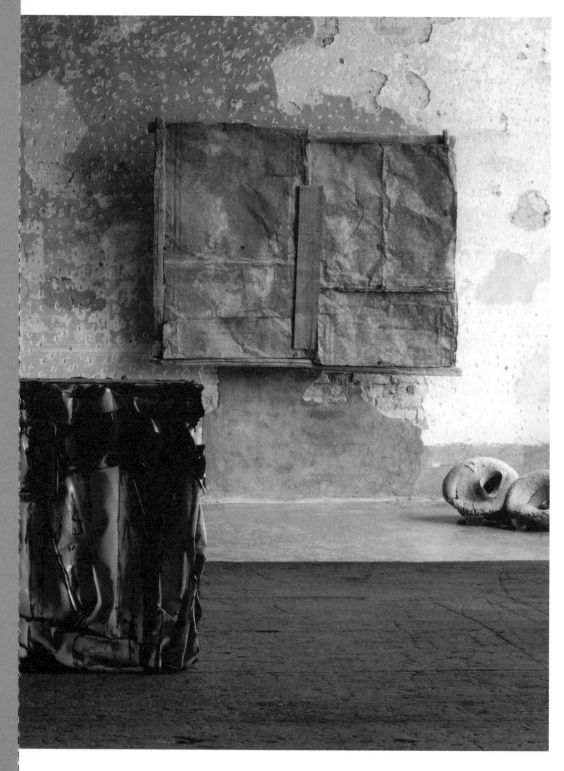

The mental grey of metal

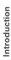

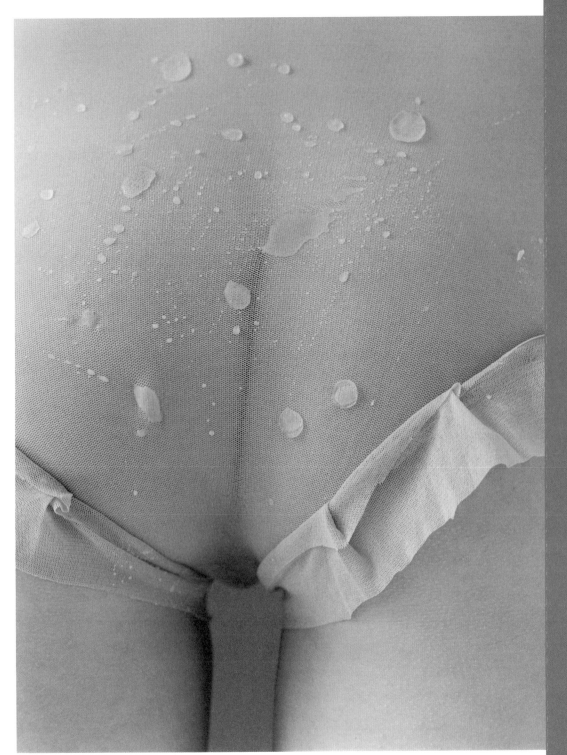

The feathered grey of pleasure

The warmer grey of harvest*

*Yellow will be the new pink

The naked grey of construction

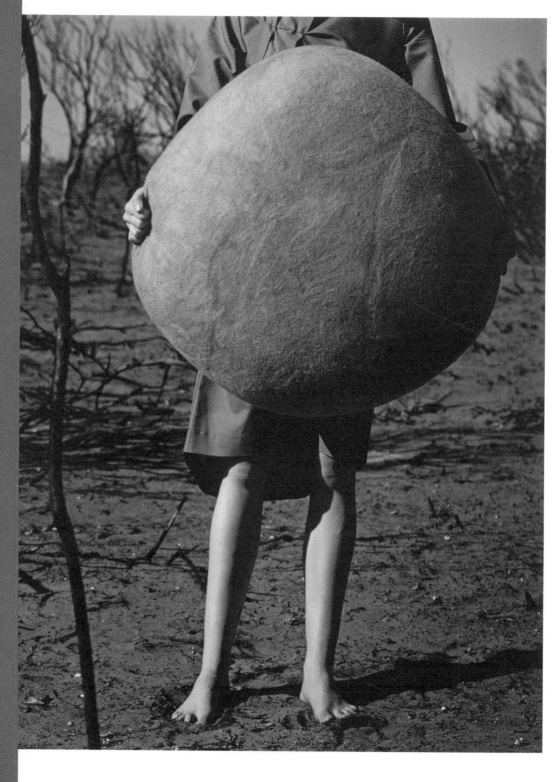

The creative grey of craft

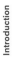

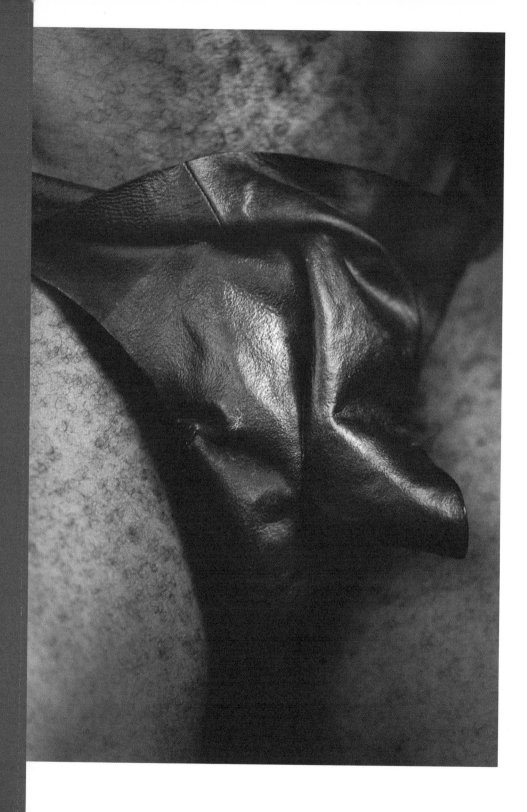

The savage grey of animism

The nesting grey of wisdom

The final grey of existence

Personal

Barbara Vinken
**Your blues eyes:
colour as promise**

Colours are just as natural to us as the air we breathe. When we open our eyes in the morning we see the salmon-coloured wallpaper in the bedroom, the white of the curtains, the yellow wall of the house across the street, the red roof tiles, the green of the trees and – with a bit of luck – the blue of the sky. Perhaps there are reddish gold cherubs romping on the navy blue sheets. As we make our way to the bathroom, we walk on oriental rugs decorated with softly-tinted Edens, on kilims in multicoloured patterns or on designer carpets as green as mossy stones.

The walls of the bathroom feature colourful tiles or exposed stones. Everything has colour: the toothbrush, the hand towels, the lavender-coloured soap and even the hair we see in the mirror – ordinary chestnut brown or streaked with purple or green. And no doubt some of us stop to admire the blue tattoo on our upper arm or hip. When a woman gets dressed today, she's more than likely to choose a sweater or blouse from the rich purple palette, colours named after fruits or flowers: violet, lilac, pink, eggplant, plum, raspberry, lavender or orchid. Men go for dark purple shirts that they wear with dark gray suits. In a couple of months we'll dismiss these colours as hopelessly old-fashioned; their chance won't come again for another few years. But perhaps both of them will opt for black. Black doesn't go out of fashion so quickly. When we leave the house, we get on a black bicycle or a mint green Vespa (shades of the fifties), climb into a yellow bus or a blue tram, while people with frightfully bad taste step into a white Mercedes coupé with a red leather interior.

Some people, mostly women, take a minute to check the colour of their nails before they go out the door, wondering if they'd rather not go for a blood red from Shiseido rather than Chanel's legendary rouge noir, and they follow this with a suitable shade of facial make-up. Nude tints underscore the natural beauty without being too conspicuous. Other women go heavy on the paint: red lips, black eyeliner, black lashes. Even the colours we use in making ourselves up are dictated by fashion and evoke a particular era. Light pink lips with silver glitter, blue eye shadow and blue accented eyelids, blue lashes and a very light sun-kissed gold face powder that blends into a barely visible beige rouge are unmistakably seventies. Dark red, mat lips against white skin with black-lined eyelids, dark eye shadow and black lashes: that's existentialism all over.

Colour isn't just a human product but a natural product as well. The rivalry between natural and manmade colours is expressed in a poem by Paul Gerhardt which praises the beauty of nature, something that even the most refined cultures cannot surpass: 'Daffodil and tulip, they dress themselves more beautifully than King Solomon himself in his splendid silken robes.'[1] Colours in nature are fairly constant. Some of them can be changed through lengthy breeding processes. Carnations can be bred to be black, bright blue or fluorescent green; ornamental cabbage can even be bred to be purple or orange. The only way we can see *la vie en rose* is by wearing eyeglasses that alter the natural colours. Artificial colours are an important element in the way we style our environment and ourselves: in furnishing our homes and in choosing clothing and make-up. The Surrealists were so extreme when it came to artificially styling their environment through the

use of colour that they added food colouring to their meals: they served blue rice, purple cauliflower and green chicken breast. Nothing can escape colour, even if our life is deadly dull. Colourlessness in the literal sense is impossible as long as we keep our eyes open.

Human beings have always used colour to change and decorate their environment – their homes, their clothes and even their faces. But our love of colour is more than a question of psychology or personal taste. Colours promise insight; they are a path to truth. According to Plato's epistemology, observing the earthly is a gradual process that leads from the immanent to the transcendent. We find an important trace of this sensory-supersensory function of colour in the idolisation of blue eyes.

'Deine blauen Augen machen mich so sentimental, Wenn du mich so anschaust, wird mir alles andere egal,
Deine blauen Augen sind phänomenal…'[2]

sang the Berlin rock band Ideal in the nineties.

'Plus bleu que le bleu
de tes yeux,
je ne vois rien de mieux
même le bleu des cieux.
Plus blond que tes cheveux
dorés
ne peut s'imaginer,
même le blond des blés.'

Singing in the sixties, Charles Aznavour endorsed the cliché that the Italian Renaissance poet Petrarch had made world famous with his blond Laura. The golden hair and blue eyes of the beloved in Aznavour's song surpass even the blue of the sky and the golden yellow of grain – and entirely without irony. 'Blue eyes, blue eyes,' sobbed Elton John, filled with longing, in his imaginative depiction of sublime cosmic harmony. Eyes as blue

as the deep-blue sea, as clear and radiant as the endless sky: a distant reflection of heavenly, cosmic beauty. After the National Socialist cult of racial purity, with its blue eyes and blond hair, it was hard for people in Germany to imagine blue eyes and golden hair without some critical reservations.

Attaining the ideal has always required giving nature a helping hand; some sort of hair colouring was always available but in our days, even the colour of the eyes can be manipulated. The demand for coloured contact lenses, which can never be blue enough – bluer than the deepest sea – is steaming ahead. Other colours come only at a great distance.

Just when Petrarch was being charmed by the gold of Laura's fluttering tresses in the church of St. Clare, the beauties of northern Italy were dyeing their hair with chamomile. An optimal effect was achieved by letting wet hair dry in the sun. This practice jeopardised the radiant white of the skin, of course, a problem that the ladies solved by simply cutting out the crown of their gigantic straw hats. Bleaching the hair blond is easier today thanks to hydrogen peroxide, though it's no less harmful to the skin. Hair bleaching is very popular among the dark-haired women of southern Europe, while few blond women in the north opt to darken theirs. Even the blondest blond isn't blond enough for some. In order to pass for a real blond, Marilyn Monroe even bleached her pubic hair; the total removal of pubic hair, Brazilian style, had not yet come into fashion.

The great admiration for blond hair has little to do with the fact that it's so rare in relation to the other hair colours of the world. If that were true, red hair (which is really in danger of extinction) would be the most desirable. If blond women find it easier to climb the social ladder through marriage, as statistics show, it's

owing to a trace of Platonism remaining in our culture: enclosed in blue and gold is a promise that surpasses sensual beauty. This is revealed in the radiance connected with blond beauty; a blond person carries with her the quality of light. The Italian word for blue, 'azzuro', in which we hear the word 'azure', expresses that most clearly. The name 'sky blue', which has been degraded today into an opaque kitsch colour par excellence for babies, still contains a heavenly promise. No wonder the Parisian women in Émile Zola's novel *Au bonheur des dames* thought life wasn't worth living without a dress of sky blue silk, silk that bore the name *ciel de Paris*. The emporium *Au bonheur des dames* owed its wealth to the heavenly appetites of the women of Paris.

Still audible in the words and images associated with Zola's novel is the reverberation of a cosmic epistemology whose most influential proponent in the West was Pseudo-Dionysius the Areopagite. The teaching he formulated tied into the Neoplatonic tradition. In this tradition, the veneration of blue is the last echo of a mystical colour doctrine, especially when it appears in the translucent iris or seems to transform into pure light effect in the shimmering blue of silk. For Pseudo-Dionysius, submission to blue – such as the blue that radiates and gleams in precious stones by means of refraction – was the precondition for the gradual ascent to the beatific vision, beholding divine beauty and truth. The colour theory of Pseudo-Dionysius would later be materialised in the miraculous radiance of gothic stained-glass windows. Even today, no one standing in the cathedral of Chartres on a sunny day can escape the beauty of the blue light pouring in.

The manifestation of supernatural truth and beauty in the light that breaks down into colours, thereby revealing the harmony of the cosmos, is what enables the gradual ascent to the divine. But that's only one side of the coin. The other side is the suspicion that this is just a purely sensual form of overwhelming awe, the accusation that it's all about fascination with something of human design – in short, the problem of idolatry and fetishism, which is closely related to the sensory fascination with colour. The golden calf, the very symbol of idolatry around which everyone dances, isn't the only thing that radiates a golden lustre. The statues of classical antiquity were anything but white and pure as chaste marble. They were painted in bright colours. The classicistic ideal articulated by Johann Joachim Winckelmann of a noble simplicity and silent splendour[3] had very little to do with historic reality. The fascination that these divine images originally evoked, and the damnation that early Christianity called down upon them, were essentially induced by their magnificent display of colour, which conferred on them an extreme vividness. The faces in particular were irresistibly seductive: the cheeks and lips were coloured red, the eyes were lined with black and the eyelids were accented with blue or green. The colours were not a manifestation of divine truth, but later on, from the Christian perspective, they were seen as the source of dazzling enticement that led to idolatry.

Also multicoloured, as colourful as possible – and certainly not as sombre as the nineteenth-century restorations would have us believe – were the Romanesque churches. The ambivalent role played by a magnificent colour display may have resulted in a very detailed colour iconography. The whole point was not to get

Barbara Vinken

stuck in pure admiration for the beauty but to become filled with the meaning that rose above the sensory: emerald green is associated with Mary because sin bounces off the virgin Mother of God the way raindrops bounce off the feathers of the Amazon parrot. Both the parrot and Mary are protected by emerald green.

So in our culture there has always been a fierce ambivalence to-wards colour. On the one hand colours can serve as sensory vehicles that open the door to the metaphysical. Things made by human hands can show us the way to higher understanding, like the windows of Gothic cathedrals that allow Creation to shine in all its subtlety. On the other hand, colours are a means of seduction that can entangle us in worldly pleasures. Lurking in colour is the danger of being overcome by the power of the sensual.

Perhaps the best way to demonstrate this is, once again, by means of the history of the made-up eye. Make-up already existed in ancient Egypt: galena powder produced a radiant complexion, cheeks and lips were coloured with vermillion and the hair was made a gleaming blue by dusting it with lapis lazuli. But the make-up for the eyes – green and black – had a unique status and was prepared especially by priests. The eyes were regarded as the symbol of the god Râ, and they allowed the person to glimpse the divine by means of their beauty, which was emphasised by make-up. In later European tradition, too, the eyes were seen as the windows of the soul, windows in which the soul – the part of the person that is closest to God – shines in all its radiance. In the glance of the eyes, one soul can lovingly pour into the other. In the work of the French writer Gustave Flaubert, this transcending of the sensory, perceptible world founders on

the gaze of the eyes. Nowhere was Flaubert able to express more strikingly the fetishistic materialisation of the modern world, in which transcendence is superseded by fascination, than in his masterful description of the dark blue, almost black eyes of the heroine of his great novel of infidelity, *Madame Bovary*.

The eyes of Emma Bovary gleam as if they had been covered by several layers of enamel: their reflective effect is the result of a profane technique. The application of multiple sheer layers of enamel creates an opaque glimmer that seals off the surface. The soul can no longer speak through the glance of such gleaming, sealed eyes. He who looks into them can do no more than become fascinated by the recognition of his own image.

Royal purple: the power of colour

The difference between colours in modern times and those from the nineteenth century and earlier is their price. Until well into the nineteenth century, dyes were as rare as they were costly and were extremely difficult to obtain. That's why, until modern times, the history of colour has also been the history of deception. Creating the paints used for painting was a difficult, labour-intensive process. Blue, for example, was made by grinding ultramarine or lapis lazuli into a powder. Black came from burnt plants, vermilions from ore, green from verdigris. Until the Renaissance, the enormous material value of paintings was just as important as the reputation of the painter: gold leaf and azure were more expensive than black. If someone had paid for ultramarine, he wouldn't want to be cheated with a surrogate.

The dyeing of fabrics by means of vegetable or animal secretions was also a laborious

and expensive process that was subjected to unrelentingly strict controls for any signs of fraud throughout Europe during the Middle Ages. The symbolic power of colour was often based on hard cash. For us today, the clearest example of the representative power of colour is royal purple. Eight thousand spiny dye-murexes, small sea snails, are needed to produce one drop of royal purple dye: a scandalously expensive colour, the very height of luxury! Like almost every other Western form of luxury, royal purple came from the Orient. The name Phoenicia (modern Lebanon and Syria) means land of purple.

Even in ancient Rome royal purple was a sign of power and purple-dyed fabrics were the supreme status symbol, so the wearing of purple garments by senators and their families was strictly regulated. Unlike the emperor, they were not allowed to cover themselves from head to foot in such extravagant splendour; they had to make do with a narrow purple band. In 1468 the role of royal purple shifted from the colour worn by the emperor to that worn by the princes of the church. The Roman Catholic Church designated this colour for its cardinals.

During the Middle Ages, exact regulations were also formulated for the use of indigo blue, golden yellow and scarlet. Colour's close association with money and power made it extremely desirable. This is particularly evident in the use of heraldic colours. Because it cost a great deal of money to produce the pigments required to make them, these colours practically constituted the logo of the ruling noble houses. At tournaments, noblemen wore the colours of the women for whom they were competing, and in time of war, soldiers carried the colours of the house for which they were fighting. Heraldic fashion made

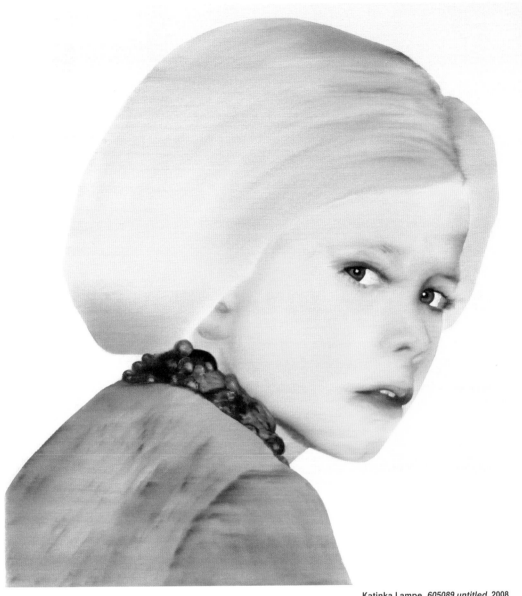

Katinka Lampe, *605089 untitled*, 2008

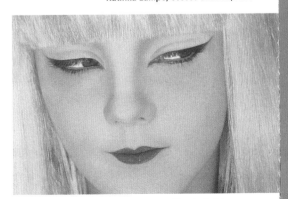

page 40
**Krijn de Koning,
temporary site-specific work for
'De Nieuwe Kerk' (The New Church),
Amsterdam 2010**

page 43
**Gerhard Richter,
1025 Farben (Colours), 1974**

Pierre et Gilles, *Blonde Geisha.
Tracy Leigh*, 1979

the body a bearer of family colours and turned it into a living family shield.

Colour in the political culture of modern states has acquired an even more unambiguous symbolic meaning than in medieval iconography. The fascists in Italy wore black shirts, the National Socialists in Germany wore brown, and in modern times red is no longer the colour of the warm love of caritas, visible in the colours of the *enfants rouges*, the orphans, but the colour of the revolution of the poor and the left-wing parliamentarians who come to their aid. The meaning of colour was never really meant to last.

A typical example of this is the dispute over the colours of the French *tricolore*, which is ambiguous enough to offer each political current its own possible interpretation. Even today, no one can agree on what the symbolism of the flag actually is. Revolutionaries and supporters of the constitutional monarchy both thought that the royal white in the flag was enclosed and kept in check by the red and blue of the Paris city arms – that is, by the colours of the people. The royalists, however, saw the blue as the colour of the royal robe, and the red as the colour of Saint Denis, the nation's patron saint; in this interpretation, the holy alliance of throne and altar has no common people to disturb it.

The uncontested revolution in terms of paint and colour occurred with the accidental discovery of the first synthetic textile dye, mauveine, also known as aniline purple, in the year 1856. From then on, the expensive and time-consuming making of dyes was something for enthusiasts. Those almost alchemical processes, in which green pigment was created by dissolving verdigris in arsenic, or vermillion was produced by

boiling a mixture of mercury and sulphur, disappeared from sight. A radical change took place. Colour lost its representative power and assumed a prominent role in the world of fashion, and when it did – and this is almost too good to be true – it was purple once again that led the way. From the symbol of power, purple had become the quintessential fashion colour.

In London, a young chemistry student accidentally conjured up a purple-red soup from an aniline compound. Fortunately he didn't throw the stuff away but dipped a piece of raw silk into it, which took on the colour mauve. The student, William Henry Perkin, later called the colour mauveine. It was the first dye made by a chemical process. Soon aniline dyes would replace natural dyes based on vegetable and animal materials. The new purple, which differed from vegetable dyes in that it was both brilliant and colour-fast, was immediately declared *dernier cri*. Queen Victoria appeared at her daughter's birthday in mauve silk in 1862, and the French empress Eugénie enthusiastically swathed herself in purple from head to toe at the next ball in the Palais des Tuileries.

For these monarchs, however, the colour of their garments was not an expression of power but a statement of fashion, pure and simple. Ironically enough, the transition from a symbol of imperial power to a fashion colour took place in the courts of Europe. In a popular song that exposed the depravity of the big city, the lifestyle in which the hunt for sexual gratification pushed even parental duties aside – 'children in the coal cellar eating briquettes' – there was still a distant echo of lilac or purple as the prime example of a frivolous colour: 'Lila ist Mode, Lackschuh modern, seidene Strümpfe tragen die Herrn.'[4] In the end it was purple, the colour of colours, that would change

the value of colour forever. Purple had become a pure fashion phenomenon whose only ability to recall the earlier power symbol was as an ironic quote.

Today, colours are produced chemically, simply and economically, in every possible shade and in unlimited amounts, in colours that are permanent, brilliant and colour-fast. You might say that only now has the world really become multicoloured, bright and gaudy. And for almost nothing. This revolution was continued into the twentieth century by colour photography, colour films and colour television. 'Ich kann mich doch gar nicht entscheiden, / Ist alles so schön bunt hier!'[5] sang Nina Hagen.

The euphoric aftershocks of this revolution can be found in the rainbow edition put out by the Suhrkamp publishing house as well as in the fashion label that created such a furore in the seventies: 'United Colors of Benetton' even incorporated the word 'colour' in its name. Now everyone can afford to wear a royal purple jacket – indeed, every possible shade of purple, all at the same time, day and night (fashion permitting, of course). The relationship between colour, money, prestige and power has been severed for good.

After this loss of meaning, colour was no longer suitable as a status symbol. All that remained was the mood impact: blue induces creativity, red makes you active, green calms you down. Endless rows of books have been written about the effect of colour on the individual psyche. Psychologists have recently discovered that if a woman wears a blue sweater she is much less likely to attract the attention of men than if she appears in fire-engine red. Whether this intense form of male interest has to do with a behaviouristic pattern or with the

Barbara Vinken

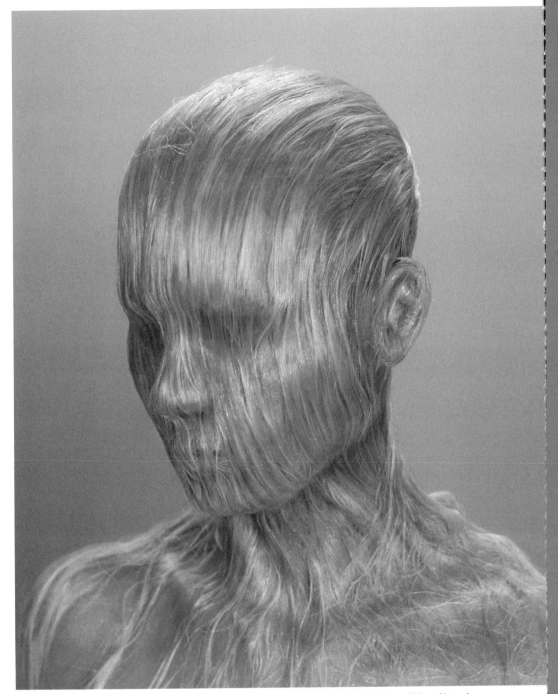

Levi van Veluw, *Natural
Transfer II*, 2009

information stored in language through the centuries – that fire-engine red is the colour of burning love and smouldering passion – we need not decide here. At any rate, films and hit songs are wild about the 'woman in red'.

Colour, which changes at speeds that would have been unthinkable before the chemical revolution and has the ability to attach itself to virtually anything, is an overpowering fact in interior architecture as well as in fashion. Colour marks the change of seasons. Every season has its own colour that plays a definitive role, right down to choice of make-up. Fashions that feature everything in different tones of the same colour alternate with fashion in which pink and orange, blue and green clash with each other in glaring contrast. It's not the colour that serves as a sign of prosperity today but the luxury of being able to afford a change of colour every season, both in the interior of one's home and in one's clothing. In a typical lifestyle shop you can buy everything in every shade of purple, from nightgowns to bedroom slippers, from tablecloth to tableware, from side table to cutlery and corkscrew, and then buy all the same products in green in the next season.

This cheerful new multicoloured world is not one in which all the possibilities are realised, however. In modern times and up to today, colour is one of the essential factors that separate men's fashion from women's. Up to about the time of the French Revolution, men's and women's attire was equally colourful, but that was soon to change. The modern bourgeois today dresses himself in subdued colours, mostly shades of gray and blue as well as beige and dark green – and in black on solemn occasions. At conservative soirees such

as opera performances, women stand out like colourful hummingbirds against the black-suited men. A female real estate agent can show up at work in Valentino red without raising any eyebrows, and she can wear violet or pink, too, but her male colleague would make a strange impression in a suit of bright red, pink or violet, despite the spectacular development of the 'metrosexual' phenomenon. In men's clothing, colours like this can serve as accents at the very most. In the early twentieth century, too much colour in the wrong place was the mark of a homosexual. In Proust's *A la recherche du temps perdu*, Baron de Charlus betrays his effeminacy by wearing a tie with a red spot and carrying a handkerchief with a green border. If men wear colours, they would have to refer back to the privileges of nobility. Even today, the leisure clothing worn by men in conservative cities bears a certain resemblance to heraldic colours and thereby refers to the privileges of the nobility: golden beige, silky wine red, dark hunter green. With the advent of the colourful shirt and the equally colourful tie, clearly contrasting with a proper background, men's clothing has retained the memory of wearing noble colours.

In modern times, architecture, interior architecture, lifestyle and fashion have always positioned themselves with regard to the possibility of total colour. They've identified with bright colours in the form of Pop Art – just think of the Centre Pompidou or the brash colours in the sculptures of Niki de Saint Phalle. The meaning of the contrast between brightly coloured and black, or colourful and natural, has turned upside down since the colour revolution. In modern times, what used to be regarded as the height of luxury – multicoloured splendour – is now considered cheap. In modern times, natural and

simple are seen as the opposite of chemical and artificial, light as the opposite of colour, black – the absolute colour value – as the opposite of colourful. The desire to be anything but multicoloured is seen as a mark of good taste. Glass and steel, which dominate the facades of tall buildings, represent the qualities of pure radiance and light. The colours of natural stone such as white, beige or gray, as well as the colours of wood, are not perceived as colour values.

In earlier times there was also opposition to colour in fashion, of course, but that was mainly a protest against an ostentatious, costly demonstration of power and wealth. Humility and modesty were expressed by the wearing of undyed linen and wool, for example, in place of the dyed wool or silk with expensive ornamentation that identified the clothing of the rich and powerful. Those who had turned their backs on the world, had chosen a life of strict sobriety and abstained from every form of splendour, expressed this choice by wearing black. Catholic clergymen and nuns, who had died to the world, also wore black in their day-to-day lives; Protestant clergy even wore black during religious services.

The members of the Spanish court shrouded themselves mainly in black according to strictly held norms, in conscious opposition to the ostentatious, colourful frivolity of the French. Black is the colour of mourning, and it was only a few generations ago that women of a certain age stopped wearing colour altogether in order to demonstrate that everything worldly had become alien to them. The Sicilian widow has become proverbial in that respect. The dandies, the black princes of elegance, wore black as a demonstrative statement. Walter Benjamin described black as the colour in which modern

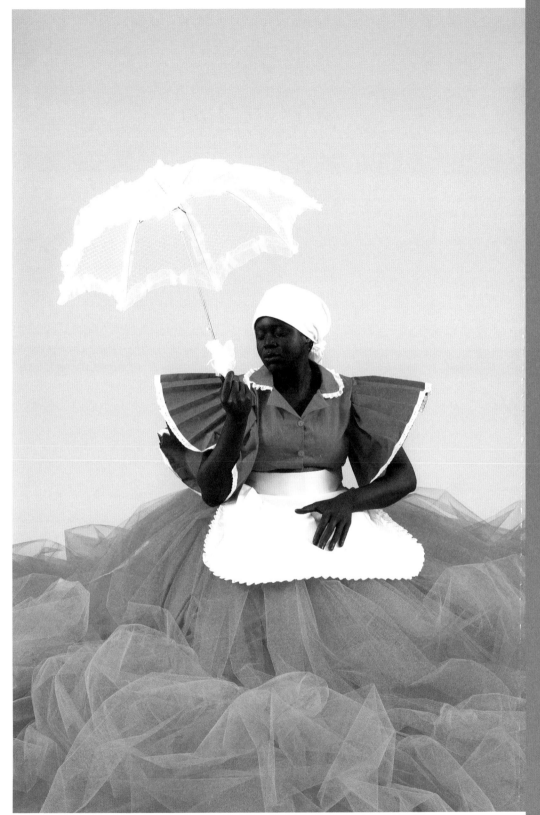

Mary Sibande, *I'm a lady*, 2009

times grieves for the reification of the world.

Black today, even after the age of existentialism, is the colour of intellectuals. There's so much black at the Venice Biennale that it looks like the colour of a guild or a caste. The triumph of black in the circles of intellectuals – and especially in circles that are closely tied to the visual arts – demonstrates the legacy of all connotations that have ever been associated with black, while adding a whole new element to it. The protest against everything colourful, against the vile pattern of ubiquitous consumerism, imparts a modern twist to the new black, which has propelled itself to the level of un-colour, anti-colour. Multicolour is the world of the popular, of disco and pop culture. Black is what the elite, stylised fringe groups wear, from punk to grunge and from romantic to gothic.

Multicoloured magnificence originally came from the Orient – vermilion for lips and cheeks and lapis lazuli for the blue-powdered hair of Egypt, purple from Carthage and indigo from India – and the new black (which puts every other colour in the shade) also comes from the East, namely Japan. In the face of this overwhelming black, which took Europe by storm with the fashion of Comme des Garçons and Yamamoto, all other colours vanish in comparison.

The only thing that can stand up to this, perhaps, is the decidedly cheap, cheerful dispersion paint of Andy Warhol. He stopped painting his canvases and instead covered them with a layer of ordinary house paint as a satirical comment on the material value of colour. In times past, when the material value of the paint was an important issue, Warhol wouldn't have earned a cent with these paintings. All his paint wants to be is paint, and nothing more. But this simple, immanent meaning could only be pursued by painting like a house painter, by painting out the metaphysical promise. The pure immanence of the colour can only be reached by painting over the transcendence, by painting it away...

In the light sculptures of a Dan Flavin, an Olafur Eliasson or a James Turrell perhaps one can still perceive a glimmer of the blue world of the cathedrals; in all their overwhelming, sensory perceptibility they hold the promise of the supernatural.

Notes

1. Paul Gerhardt (1607–1676): 'Narcissus und die Tulipan, die ziehen sich viel schöner an als Salomonis Seide.'
2. 'Your blue eyes make me so sentimental, / when you look at me that way, everything else pales in comparison, / your blue eyes are phenomenal...'
3. Literally, 'edle Einfalt und stille Größe'.
4. 'Lilac is in fashion, patent leather shoes are modern, and the men wear silk stockings.'
5. 'I can't make up my mind, / It's all so marvelously colourful here!'

Dan Flavin, *Untitled*, 1997

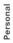

Anneke Smelik
**Skin-deep and hair-raising.
The meaning of skin and
hair colour**

The colour of your skin and hair is inextricably bound up with your body, as biological data that are allotted to you by nature at birth. The colour of your hair changes throughout your lifetime. When you are young your hair is usually lighter in colour; in puberty it gets darker; and as you age it turns grey. The colour of your skin on the contrary does not change, although the nuance of the skin colour can fluctuate. This is especially true of white skin because it is subject to the influence of various factors like climate, health and emotions. For example, you can turn scarlet from the sun, white from the cold or from nausea, yellow from a malfunctioning liver, red from anger or embarrassment, or green from envy. The skin thus always expresses something – often involuntarily and sometimes despite our efforts to suppress it. As such, it becomes our emotional and physical barometer.

The body belongs not only to nature but to culture as well. The colours of the skin and hair are therefore more than just physical data. They also play an important role in social relationships and cultural values. To give an example: for the upper class at the beginning of the twentieth century white skin had to be as white as possible because only the lower classes were exposed to the sun, like the farmer who labours in the field or the sailor who stands on deck in all kinds of weather. This ideal was turned around in modern times with the introduction of leisure time and travel opportunities for the upper class, who came home with a tanned skin from holidays in distant places, while pale-faced labourers slogged away long hours in factories.

Sociologically, the colour of skin and hair is tied in with the complicated concept of 'race'. This is a controversial notion from a biological point of view that nevertheless has made deep inroads in social relationships. In the last centuries, a hierarchy emerged under the influence of Western colonialism focusing on the Aryan ideal of white skin, blonde hair and blue eyes and giving it a higher status than darker skin, black hair and brown eyes. The word 'white' received connotations of purity and beauty, as in the expression 'lily-white skin'. Hollywood has even developed a specific system of lighting to give the white female star a halo of radiance.[1] Yet the significance of white is not only positive, as the stereotype of the dumb blonde clearly shows.

During the 1960s, the black civil rights movement in America used the slogan 'black is beautiful' in order to reverse this humiliating hierarchy. The fight against racial prejudice can also be seen in the changing use of the words 'black' and 'white'. Americans of African origin were first called 'negroes' (which literally means 'black'), then 'coloureds' or 'blacks' and now 'African-Americans' in order to avoid the association with biological 'race'.

Hair and skin colours cannot be changed permanently, but you can decorate or dye them temporarily. Because so much social meaning is attached to skin colour, people from every age and culture have embellished their skin by dyeing it or decorating it with tattoos, piercings and scars. Up until recently, Western culture regarded such body decorations as primitive, but in modern times the body has increasingly become a fashion object by which people can express their identity.[2] In recent years, we have thus seen that the 'lower class' cultural expressions of tattooing and piercing have become widespread and are now more or less acceptable. Yet, excessive painting of the skin is still rare; children may like to paint their skin at parties, but adults usually limit skin-painting to exceptional situations like Carnival celebrations or football matches.

Actors use grease paint on stage or in films to enhance their expressiveness. Such make-up can run from natural to excessive, depending on the genre. In fantasy like science fiction or horror films, more make-up is used than in realistic drama, and in comedy the make-up is applied more heavily than in romantic sitcoms. In Hollywood films, it is important to use make-up in the best possible way to turn actors into glamorous examples of flawless beauty. Actors or actresses who play roles that require 'ugly' make-up are therefore greatly admired. Even people who appear on realistic programmes like politicians on television talk shows are made up because the bright lighting makes the skin looks dead without grease paint. Paradoxically enough, dead people are made up for their funerals for the same reason.

In contemporary culture body decoration is called 'cosmetics'. Make-up is applied almost exclusively to the face and is chiefly used by women, hardly ever by men. It looks funny when male politicians appear on television with too much make-up on, because the norm for men is no make-up at all and anything put on the face should therefore remain as invisible as possible. In the case of the female face, colour is applied by means of foundation, blusher, eye shadow, eyebrow pencil, mascara and lipstick. It seems there is a biological reason behind this: the blush on the cheeks, the colour on the lips and the larger-looking eyes are subtle ways of imitating the effects of sexual arousal. In daily life, make-up is usually a close approximation of the natural skin colour, but sometimes it takes on fantastic or

Thierry Mugler, Chimère evening-
ensemble, autumn/winter 1997–1998

page 54/55
Louise te Poele, *VVVSOP*, 2009,
from the *Farmers series*

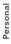

excessive forms, such as at glamour parties, in subcultures like punk or gothic, or in the extreme fashion shows of John Galliano or Alexander McQueen. This exuberant body decoration can be understood as a grotesque exception, a colourful way of letting off steam in the drab, grey reality of the daily routine.

Like body decoration, the practice of hair dyeing is not a modern invention but has been around since time immemorial.[3] Thanks to developments in chemistry it is now of course possible to dye the hair all the colours of the rainbow. Most people, however, stick relatively close to their own natural colour, the exception being the aforementioned subcultures – punk (pink, green or blue hair) and gothic (pitch-black hair).

Hair dyeing has a number of striking aspects. First, as with cosmetics, there are major differences between men and women. Almost all women dye their hair, a step that men are much less likely to take. Here cultural roles play a role: in northern European countries, hair dyeing is far less common among men than in southern countries. Second, it is interesting that women often keep on dyeing their hair long after it turns grey. Middle-aged men are almost all grey, while women in that age bracket still have blonde, brown, red or black hair. In a culture in which youth is the ideal, grey hair is not attractive as it betrays old(er) age. In contemporary culture grey hair is not a sign of wisdom that commands respect; rather, it suggests a loss of strength, beauty and attractiveness. For many women, it is a pivotal decision to let one's hair go grey and to stop dyeing it.

A third salient aspect is the advancing spread of blonde hair throughout the world. Ever since the Second World War, the beauty ideal has been dominated by blonde hair and blue eyes. In this context it is interesting to know that blonde hair in adults is actually a myth, since only five percent of them continue to have naturally light-coloured hair after puberty.[4] This means that almost every adult blonde woman is an unnatural blonde who dyes her hair. The most iconic blonde movie and pop stars are actually brunettes: women like Marilyn Monroe, Brigitte Bardot and Madonna. In the Netherlands, Princess Máxima, a striking blonde, is really a dyed brunette.

The blonde norm has now become so dominant that it can be found in countries where dark hair is much more common. It is striking to see how many female TV announcers or TV stars on Italian, Spanish, Greek or Turkish television are (unnatural) blondes. The desire for blonde hair can even be found among women from ethnic groups with naturally black hair. Almost all Bollywood stars have dark eyes and black hair, but the Indian film star of the moment, Aishwarya Rai, has green eyes and light-brown dyed hair. African-American female pop stars like Beyoncé Knowles, Mariah Carey, Mary J. Blige and Tina Turner or models like Oman and Tyra Banks, tend to strip their kinky hair of its racial characteristics: their hair is not only straightened or relaxed, but is often dyed a much lighter colour as well, sometimes even blonde. In performances or photo shoots the women actually often wear wigs. There are fashion photos of Naomi Campbell with straight blonde or curly red hair instead of her own kinky black hair. In other photos she has green or blue eyes, achieved by a combination of contact lenses and photoshopping. The prevailing blonde beauty ideal is apparently so prescriptive that it is considered cool and trendy to dye black hair blonde. The opposite is unthinkable: a blonde model like Doutzen Kroes or Claudia Schiffer would never wear brown contact lenses or dye her hair a darker shade.

We see here once again how skin and hair colour acquire social meaning. The colour of skin and hair are among those physical aspects that are never without significance but have far-reaching consequences in society, as we can see from the striking differences between women and men, and black and white people. Perhaps the colourful worlds of advertising and fashion helps us prepare for a greater diversity of colours on the skin or in the hair, whether from nature or out of a bottle. A 'rainbow coalition' may introduce a more colourful world for women and men, and for black and white people alike.

Notes
1. Richard Dyer, *White*, London: Routledge, 1997.
2. Joanne Entwistle, *The Fashioned Body*, Cambridge: Polity Press, 2000.
3. Jennifer Craik, *The Face of Fashion: Cultural Studies in Fashion*, London: Routledge, 1994.
4. Joanna Pitman, *On Blondees*, London: Bloomsbury, 2003.

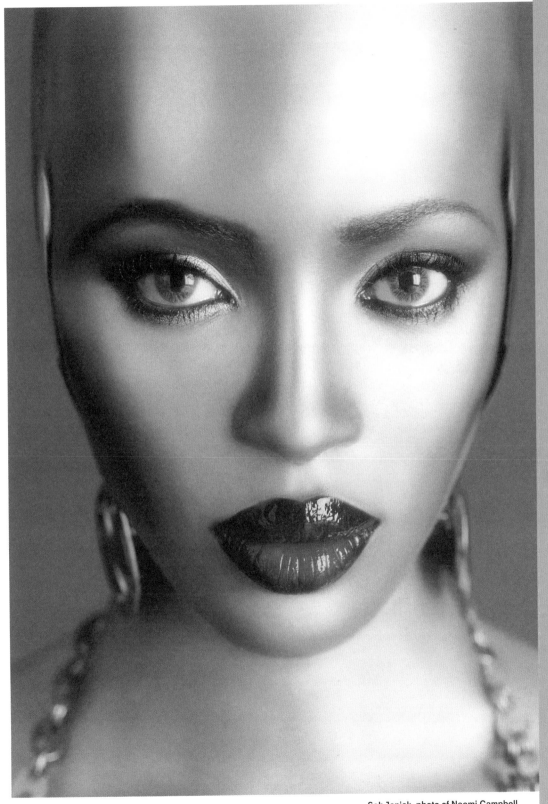

**Seb Janiak, photo of Naomi Campbell
for the French ELLE**

Anne van der Zwaag
**M·A·C Pro Store, New York.
Mirror, mirror on the wall...**

Women's definition of ideal beauty is entirely different than men's. The enticing advertisements and glamorous commercials of major cosmetic brands such as Chanel and Lancôme call for red-painted lips and long black eyelashes, or a natural look that's anything but natural. Although most men say they prefer a woman without make-up, only twenty percent of all women wear no cosmetics and more than half never leave home without it.

So it's not surprising that according to recent research, the average British woman spends about ten thousand euros on make-up over the course of a lifetime. In addition, any given woman owns an average of five lipsticks, and more than a tenth of the women questioned have between ten and twenty lipsticks at home. The reason for these numbers is that women want to experiment as much as possible and are always on the lookout for the ideal lipstick, mascara, eyeliner or rouge. It has nothing to do with impulse buying. Women just feel prettier and more self-assured with make-up.

The M·A·C Pro Store at 7 West 22nd Street in New York is a veritable Walhalla for women. In the enormous space it comprises, dozens of colours are presented in minimalistic displays. The message is clear: the product sells itself. In this concept, the store functions more as a laboratory than as a shop. The almost 560-square-metre space is primarily oriented towards visagists and professionals in the beauty trade. There's a mixing machine, there are samples: everything necessary for experimentation. The results can be captured immediately in the photo studio, and training sessions and workshops are given in a separate room. The library is furnished as a study area and is filled with books, magazines and other reference material. M·A·C Pro Membership is meant for make-up artists, cosmetologists, stylists, fashion designers, models and photographers, and gives the professional access to what the company calls the M·A·C World, for 'Beyond a brand, M·A·C is a culture.'

Professionalism, craftsmanship and quality are priorities at M·A·C, as the collaboration with top designers like Emanuel Ungaro, the late Alexander McQueen and Manish Arora clearly shows. The designs of the Indian fashion guru are characterised by bright, exuberant colours, and so is his make-up collection. After its establishment in Toronto in 1984, Make-up Art Cosmetics soon became known in the fashion industry and in the film world. Founders Frank Toskan and Frank Angelo focused primarily on the professional market, visagists and make-up artists. The standard cosmetic products were far from ideal, and under the influence of bright lights and high temperatures the colours quickly faded. M·A·C created cosmetic formulas and colours specifically for these conditions. The flourishing company was taken over by Estée Lauder Companies in 1998 and now includes 750 shops in fifty countries.

At the present time, M·A·C is the only Estée Lauder brand with a structural increase in sales. With carefully planned marketing campaigns in which all attention is focused on colours and shop design, and product packaging and publicity are relatively simple, M·A·C has positioned itself within ten years as a colour authority in the field of cosmetics in both the professional and the consumer markets. Make-up use in the consumer market is really on the rise, not despite but because of the recession. Women today use *more* cosmetics, announced the *Daily Mail* in 2009. British women spend approximately 1.1 billion pounds (1.27 billion euros) on make-up per month. According to the study reported in the *Daily Mail*, the economic malaise is responsible for an increase in make-up use. This explains why M·A·C is besieging the consumer market with assertive slogans like 'Be creative. Be adventurous. Be inspired'. Women, especially those between the ages of 24 and 35, use make-up to feel better and to stimulate their self-confidence – the so-called 'lipstick effect'.

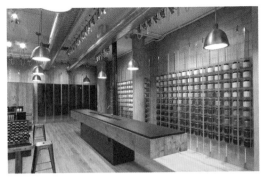

Interior M·A·C Pro Store, New York City

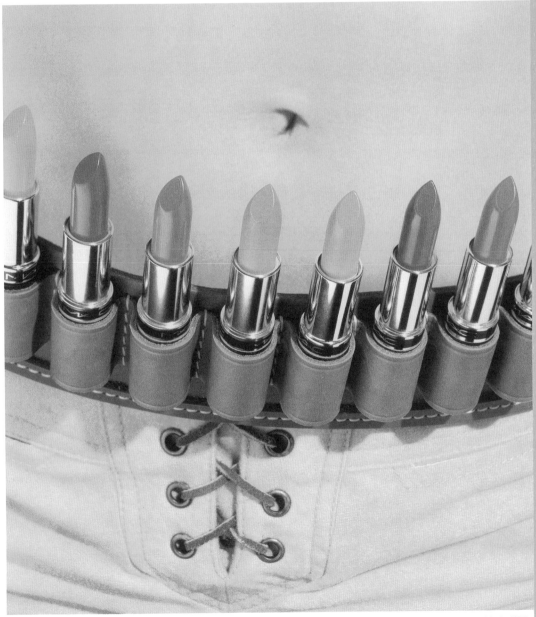

James Wojcik, *Lipstick belt*, 1997

Edo Dijksterhuis
**Viviane Sassen:
Shadow play**

Viviane Sassen would rather have been black. It's a more pleasing skin colour, less naked. It's not her opinion, but a fact she observes. Those who are aware that Sassen lived in Kenya between the ages of two and five will understand what she means. Her earliest memories are connected to the polio clinic where her father worked and where she played with the patients.

Viviane Sassen is in every way the opposite of the crippled African. She is tall (even by Dutch standards), has blond hair and a lily-white skin. Even as an infant she knew she was different, that there was an unbridgeable disparity between herself and her friends.

An additional barrier has been added in the form of a camera. She has been portraying Africans since 2001. It all started fairly documentarily in the South African townships, and gradually a plan for a book evolved. The work that Sassen made in Ghana for the Prix de Rome is also part of the ongoing Africa project with which, in her own words, she 'attempts to recreate the images of my youth'.

Her working method is intuitive. Sassen lets herself be taken by the appearance or behaviour of the people she encounters. Conversations follow and she endeavours to win the people's confidence by drawing. The camera comes into play at the very last. The final images – some staged, some spontaneous – are realised in collaboration with 'the model', who always receives a print of the image afterwards.

The accountability Sassen feels towards her subject is not a feature of her commercial work. The photographer, who flunked out of fashion design school, has

had assignments for fashion names such as Diesel, So and Miu Miu. In the advertising setting, she is the executer, working to clear parameters. Or, as she puts it, 'It's putting the pieces together, entirely practical.' Nevertheless, even her commercial work bears a distinctive Sassen signature. The photos look stylised but the models are not standard beauties. Moreover, their faces or even the clothes they advertise are only partially in shot. It is fashion photography with a twist, which is more about mood, feeling and mentality than clothes and make-up.

In her autonomous work, this aspect of Sassen's approach is magnified. The photographs of African street kids and people from the ghettoes are infused with an almost fashion-like aesthetic, which distinguishes them from usual images of Africa. These are no coarsely grained mirrors of misery, no sun-baked National Geographic pictures, no exotic icons of noble savages along the lines of Leni Riefenstahl's Nuba. They do not fit in the standard imagery idiom, which sets the viewer thinking. What is my image of Africa, and why? Why do we always see the same images? How did paternalism and exoticism creep into the Western eye and become embedded there?

Sassen is also affected by the political and moral dilemmas. Who gives her the right to photograph African street kids? Isn't there a fundamental imbalance of power at work? Where does interest end and exploitation begin? Is Sassen projecting her own fantasies and if so, is that permissible?

These questions are deeply rooted in Sassen's choice of subject, composition and 'the story' that she tells with a complete series. But there is one element in her photos that goes straight to the heart of the matter: her play with shadow and contrast. Photographing Africans in

the shadow is taboo. It renders them almost faceless. Associations with 'the dark continent' – dangerous, unknown, wild – surface. Even in Jungians psychology, the archetype of the shadow – the collection of a person's unconscious qualities – bodes ill.

But Sassen turns everything on its head. The shadow strikes back at the viewer, who wonders where all those prejudices come from. And at the photographer, who tries to leap over her own shadow.

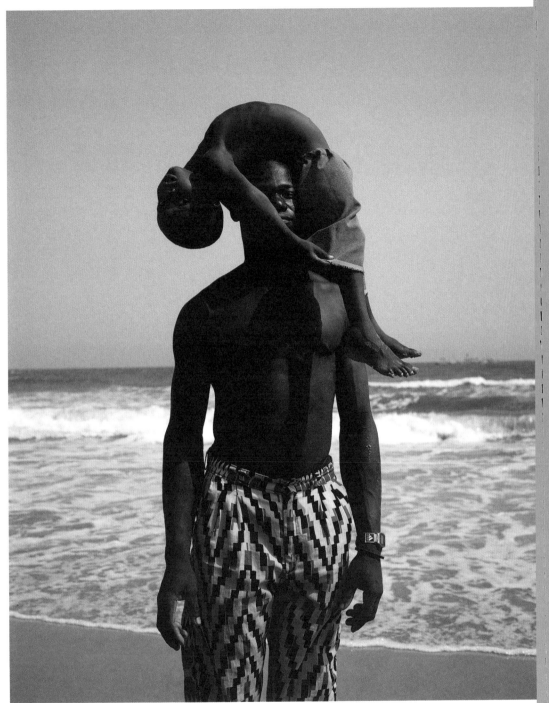

Viviane Sassen, *DNA*, 2007

Melissa Ho
Byron Kim

*'Why are you making abstract
paintings?' The 'you' meaning
Asian-American artist, artist-
of-colour, artist-with-something-
to-say.*
Byron Kim, 1992[1]

When Byron Kim began the
paintings that would eventually
constitute *Synecdoche* in 1991,
his aim was both to bury the
monochrome and to praise it. An
admirer of no less an absolutist
than Ad Reinhardt, Kim nonethe-
less knew that for artists of his
own generation, 'purity in ab-
straction is an anachronism'.[2]
So he set out to make a new kind
of Colour Field painting. Rather
than reaching for the sublime,
Kim grounded his project in the
concrete: each oil-and-wax panel
was painted from life, based on
the skin tone of an individual.
He was not after the chromatic
nuances or anatomical details
of human flesh. Instead he aimed
to capture a single colour as
representative of one person's
skin. As a young 'artist of colour',
Kim had felt inhibited by the
sense that abstract painting was
an exclusive club of white male
practitioners. By taking on skin
colour as his subject matter,
Kim's questioning of his position
in the tradition of abstraction
became part of the work itself.

Kim first painted family mem-
bers and friends but soon began
approaching strangers in the
park or at the library, spending
perhaps twenty minutes with
each to match paint to skin tone.
He also accepted commissions,
making 'portraits', for example,
of family groups and of artists he
respects, including Brice Marden
and Vija Celmins. Such subsets
of paintings are subsumed by the
larger group, which is exhibited
with its elements in alphabetical
order by sitter's first name, a
complete list of which is also
displayed. At its first major

showing in 1992, *Synecdoche*
comprised approximately two
hundred parts, and it now con-
sists of nearly four hundred. The
artist has yet to declare the work
complete and continues to make
additions.

A chart of skin tones bears
implicit reference to the range of
nineteenth-century imagery that
attempted to gradate classifica-
tions of race. Yet *Synecdoche* is
made in the spirit of inclusive-
ness rather than categorisation,
and its turf is aesthetic, not
taxonomical. It no more lays
claim to any ranking of human
beings than commercial colour
charts assert hierarchies of
colour. Kim's vast polychromatic
grid looks as random as a
Gerhard Richter colour chart of
the 1970s, suggesting a hetero-
geneous society in which friend
and stranger, passerby and
luminary, mingle on equal
footing.

The 10-by-8-inch dimensions
of *Synecdoche*'s panels delib-
erately mimic the format of a
photographic headshot, but –
flattening individual identity as it
does to a series of colour chips
– the work functions as por-
traiture only ostensibly, a fact
announced by its title. A synec-
doche is a figure of speech in
which a part signifies the whole
– saying 'hands' to mean
'workers', for example. But so
little do the brown and pink
rectangles tell us about the
individuals who supplied each
shade that *Synecdoche* serves
instead as a *reductio ad absur-
dum* of the notion that skin
colour can stand proxy for a
person. With this elegant rebuke
of essentialist conceptions of
race, Kim was perfectly in tune
with the cultural concerns of the
late 1980s and early '90s.
Synecdoche's inclusion in the
1993 Whitney Biennial (famous
as the 'multicultural' Biennial)
earned the young artist critical
attention and ensured that the
work's political implications
received special emphasis.

Less often noted is the work's
personal content. Like On Kawara's
Today paintings, *Synecdoche*
has an air of programmatic
detachment that disguises its
subjectivity. With its chartlike
structure, it presents colour as
truth, but – as Kim is well aware
– observed colour is anything
but straightforwardly factual.
The painter's concept of intrinsic
local colour notwithstanding, a
colour cannot be isolated either
from its immediate context or
from its perceiver. Kim wrestled
with the inherent instability of
colour each time he faced a new
sitter, 'staring at [his or her] arm
while trying to see its local colour
while wondering whether local
colour was what I was after, after
all . . . What is the right colour?
Is there any meaning in it?'[3]
Eschewing the lofty ambitions
of monochrome painters before
him, Kim had chosen a project
with a seemingly well-defined
procedure – yet this led him back
to the central metaphysical chal-
lenge of painting. Kim was still,
as Barnett Newman had said,
'trying to paint the impossible'.[4]
His struggle to capture skin
colour suggests larger questions:
What are the limits of represen-
tation? How can we hold onto
felt experience? Each of Kim's
monochromes is a kind of diary
entry, with colour standing in for
what cannot be described.

Notes
1. Byron Kim, 'An Attempt at Dogma',
 Godzilla 2, no. 1 (1992), p. 3, 8.
2. Kim, 'Ad and Me', *Flash Art*
 (International Edition), no. 172 (1993),
 p. 122.
3. Kim, 'The Local Colour of Shadow',
 in: Eugenie Tsai, *Threshold: Byron
 Kim, 1990–2004*, Berkeley: University
 of California, Berkeley Art Museum &
 Pacific Film Archive, 2004, p. 41.
4. Barnett Newman, 'A Conversation:
 Barnett Newman and Thomas B.
 Hess', 1966, in: John P. O'Neill (ed.),
 *Barnett Newman: Selected Writings
 and Interviews*, New York: Alfred
 A. Knopf, 1990, p. 279.

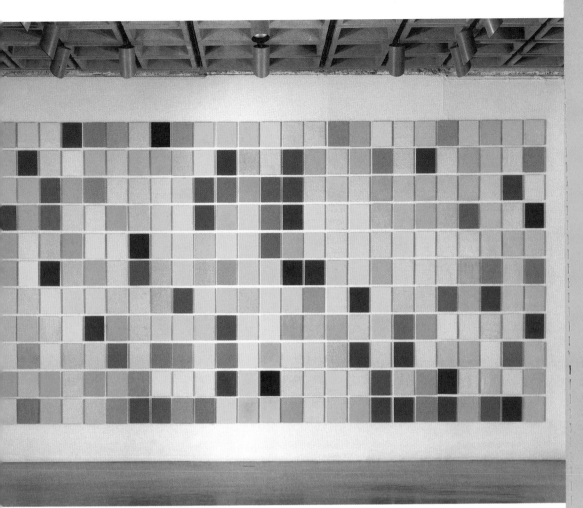

Byron Kim, *Synecdoche*, 1991

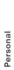

Ann Temkin
Carrie Mae Weems

Deep Black, Ashy Black, Pale Black, Jet Black, Pitch Black, Dead Black, Blue Black, Purple Black, Chocolate-Brown, Coffee, Sealskin-Brown, Deep Brown, Honey Brown, Red Brown, Deep Yella Brown, Chocolate, High-Brown, Low-Brown, Velvet Brown, Bronze, Gingerbread, Light Brown, Tan, Olive, Copper, Pink, Banana, Cream, Orange, High Yella, Lemon. Oh, and yeah Caramel.
Carrie Mae Weems, 1990[1]

In her *Coloured People* series (1987–1990) Carrie Mae Weems literalises a verbal expression by chromatically tinting black-and-white photographs of single individuals through a hand-dyeing process. Her subjects, primarily children, all would be considered black in contemporary American society, and the obvious fabrication of the photograph – the overlay of magenta, burnt orange, or blue – parodies the simplistic construct of applying a colour term to any human being, no one of whom is actually white or black. She photographed her models at an age 'when issues of race really begin to affect you, at the point of an innocence beginning to be disrupted'.[2]

The term 'coloured people' goes back at least to the early nineteenth century. Like 'Negroes', it fell out of favour around 1960 and was variously replaced with such alternatives as 'blacks', 'African Americans', and 'people of colour'. Henry Louis Gates Jr. has wryly noted the cycles of preferred terminology, writing, 'I don't mind any of the names myself. But I have to confess that I like "coloured" best, maybe because when I hear the word, I hear it in my mother's voice and in the sepia tones of my childhood'.[3] Gates's remark brings up a crucial issue in Weems's work: the powerful role of personal memory. Both the hand-dyed tints and the prevalence of children as subjects situate these photographs in a hypothetical past tense, full of the complicated emotions that accompany it.

The musicality of the works' three-word titles, one word placed under each image, particularly when read in combination with one another, plays an important part in their effect. The viewer's instinctive enunciation of the titles emphasises the silence of the images above them – the sitters' customary role as the subjects of the gaze and the labels of others. Weems's work, highly conscious of photography's documentary tradition, raises important questions about the history of artistic point of view. During the making of this series, she wrote: 'I'm feeling extremely coloured nowadays, and I'm happy about my "conditions".' For much too long, I've placed great emphasis on being European and Western. Often at the expense of overlooking the value of Afro-American culture, I've used European aesthetics and standards as a starting point for creating my own work. So this notion of "feeling coloured" has to do with drawing upon Afro-American culture as a foundation for creating art.'[4]

The works invite multiple interpretations. Do they celebrate the polychromatic beauty of African American skin tones, particularly of children? And/or do they critique, as many writers have argued, African Americans' own biases on the subject of skin colour and the manner in which they have adopted a white perspective by regarding lighter skin tones more highly?[5] Weems's art cannot be reduced to a straightforward political point. It is much more about personal – and universal – sensations of memory and desire, the workings of which are tangled up in one's self-identification and one's identification by others. Weems's gumdrop colours – standardised hues that she applies to her black-and-white photographs – seduce viewers into what she calls 'the complicated discussion I want to have with the audience and myself'.[6]

The mix of text and image characteristic of all Weems's work rejects the Modernist orthodoxy that prized purity in visual art. In so doing, Weems also dismisses a whole set of Modernist taboos, such as that of dealing in one's art with issues that are historically and culturally specific rather than supposedly timeless and universal. There is an implicit parallel between exploding the monolithic character of art and expanding our notion about who can make and view it.

The three identical images in each of these works are varied only by the staccato tap of the single word applied in adhesive capital letters beneath it. This repetition makes an obvious nod to the Minimal and Conceptual traditions of the 1960s and '70s, which were largely the province of artists who were both white and male. Weems does not isolate her practice from those traditions but rather complicates it with the inclusion of issues they have ignored, such as race, class and gender – issues that fall outside an art-about-art discourse or a discourse that did not recognise itself as one conducted by a specific subset of the population. Weems considers it her mandate as an artist to show that in American society the idea of what colour charts is far more complex than a range of hues along a spectrum.

Carrie Mae Weems, *Blue Black Boy*,
1987–1988, detail

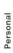

Notes

1. Carrie Mae Weems, *Then What? Photographs and Folklore,* Buffalo: CEPA Gallery, 1990.
2. Weems, telephone conversation with Ann Temkin, 13 October 2007.
3. Henry Louis Gates, *Coloured People: A Memoir,* New York: Alfred A. Knopf, 1994, p. xvi. It's a phrase that invites punning, and, in fact, other artists such as Adrian Piper have also explored its possibilities. See Adrian Piper and Houston Conwill, *Coloured People: A Collaborative Book Project,* London: Book Works, 1991.
4. Weems, in Deborah Willis-Thomas, 'Weems, Carrie Mae', in: *An Illustrated Bio-Bibliography of Black Photographers, 1940–1988,* New York: Garland, 1989, p. 148.
5. See, for example, Andrea Kirsh, 'Carrie Mae Weems: Issues in Black, White and Colour', in: Kirsh and Susan Fisher Sterling, (eds.), *Carrie Mae Weems,* Washington, D.C.: The National Museum of Women in the Arts, 1993, p. 16.
6. Weems, conversation with Temkin, 13 October 2007.

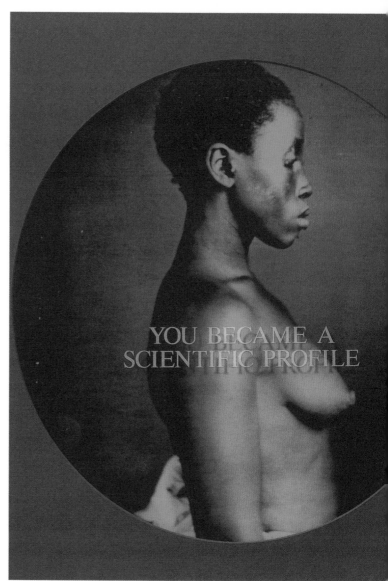

Carrie Mae Weems, *From here I saw what happened and I cried*, 1994–1995, two images from a series of twelve

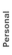

Minke Vos
Colour difference
The advertising campaigns
of Oliviero Toscani for
United Colors of Benetton

In the summer of 1989, something happened that had never occurred before in the history of advertising: the Italian clothing label Benetton adopted its advertising slogan, 'United Colors of Benetton', as its official brand name. The name change was the result of the careful buildup of the brand's image, which focused on the use of the visual. The first advertising image featuring the logo with the new brand name was a photo of a bare-breasted black woman nursing a white baby. There was no additional text. 'United Colors of Benetton' said it all.

Right from the beginning, colour has been important for Benetton products. Brother and sister Luciano and Giuliana Benetton started a home-based textile factory for knitted children's clothing in the mid-fifties. Compared with the prevailing styles of children's clothing, Benetton was innovative because it made use of bright colours. By developing its own method of dyeing the entire garment instead of the unwoven threads, Benetton was able to meet the demand for clothing in fashionable colours, from the sixties on. This bit of history is the background for the important role that colour has played in the formation of the Benetton image.

The demand for Benetton clothing is growing worldwide. To take advantage of this development, Benetton began working on advertising campaigns in the eighties that were internationally oriented and featured large groups of happy children with a wide range of skin colours. The slogan 'Tutti i colori del mondo' ('All the colours of the world', 1984) is a metaphor for every colour of human skin as well as for Benetton's wonderfully colourful clothing. The man responsible for the development of these advertising campaigns is the Italian photographer Oliviero Toscani (born in 1942).

When Toscani was asked to take the job in 1982, he was already known for his eye-catching advertising work. Until 2000 he designed the advertising campaigns for the Benetton label as a whole, i.e. not for the separate collections. In carrying out this task he used striking photographs of artistic quality, thereby imparting the same quality to the advertising visuals. This strengthened the brand's image.

In 1986 Toscani launched the first campaign with the slogan 'United Colors of Benetton'. The accompanying photos consisted of pairs of people with different skin colours and of different sexes. Many of these images referred to social themes and conflicts that were current at the time, such as the campaign featuring a Jewish boy and a young Palestinian. By bringing such contrasts together visually, Benetton hoped to promote respect for human diversity. The company went one step further a few years later by turning the advertising slogan into a brand name.

From that moment on, Benetton clothing itself disappeared from the advertising campaigns. The images Toscani used for the campaigns were increasingly radical in content, such as the photo of the kissing priest and nun (1991). The photos were of a high artistic quality, unlike those of the children in the campaigns from the early eighties. The power of the photos lies not only in their content but also in the simplicity of the composition. Toscani reinforced this by zooming in on the composition's few elements or by cutting bits off. He also used contrasting colours like black and white to make the images more striking.

In the early nineties, Toscani also began selecting existing documentary photos for the advertising campaigns. He took these photos from newspapers and news archives and super-imposed on them the logo of United Colors of Benetton. He chose these photos for their visual quality, which had to match the quality of those he used in his own work. The man dying of AIDS in one of the photos, for example, has a Christ-like appearance that alludes to the depiction of the dying Jesus in old paintings.

The aim of the photos is to promote the union of 'human colours' by showing situations that can be recognised and shared all over the world, such as the campaign picture of a baby still attached to the umbilical cord. Although some people find these images shocking, Toscani uses them deliberately to emphasise the norms and values that the brand wants to reflect and to provoke social discussions. The collaboration between Toscani and Benetton for the 'unification of colours' shows that a brand can create its own image by consistently opting for artistic quality in its advertising campaigns.

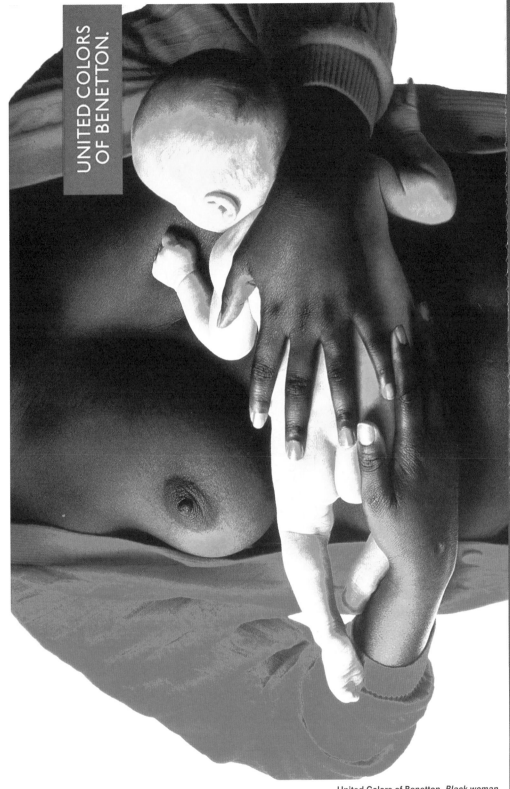

UNITED COLORS
OF BENETTON.

United Colors of Benetton, *Black woman breastfeeding white baby*, advertising campaign, July 1989

Valerie Steele
**She's Like a Rainbow:
Colors in Fashion**

She's Like a Rainbow: Colors in Fashion, the third rotation at the Fashion and Textile History Gallery of The Museum at FIT, explores the history, symbolism, science and psychology of colour in fashion. Why is red the colour of passion and revolution? Why is blue such a popular colour, whereas yellow has so many negative associations? Why is black today's most fashionable colour?

But first: What is colour? Are black and white colours? Obviously black and white things exist – lumps of coal, snow – and colour has traditionally been perceived as an intrinsic attribute (or at least an apparent characteristic) of objects in the world. The sky is blue, or at least it looks blue. Yet colours are not simply natural phenomena; they are also complex cultural constructs. Colours have a history, and people have not always perceived colours in the same way.

When Isaac Newton identified the spectrum of colours in the rainbow, he saw seven colours – red, orange, yellow, green, blue, indigo and violet – partly because seven was regarded as a magic number. The modern spectrum omits indigo. Once colour was interpreted as a property of light, black and white were disqualified as colours. Instead black became defined as the absence of light, and white was the reflection of sunlight in its entirety. But light waves do not really come in colours. Indeed, colours, as such, do not exist.

Colours are a figment of your imagination. Or, if that sounds too much like *The Matrix*, then think of it this way: colour is the product of light and vision. Just as flowers and their insect pollinators evolved together, so did colours and the eye. It is only when electromagnetic light waves of particular lengths interact with the cone cells in the retina that your brain 'sees' colours. Many animals only see in black-and-white, while some can see ultraviolet, which is beyond human visual ability.

Furthermore, there are few, if any, universal truths related to colours. The popular belief that certain colours are intrinsically flattering to different 'types' of people has no objective validity. Our responses to colour, including its taxonomy and symbolism, are highly subjective. At various times, theorists have identified colours as primary (red, blue, yellow), secondary (green, orange, purple), so-called achromatic (black, white, grey), as well as tertiary (olive), neutrals (beige) and pastels (pink).

Colour symbolism not only varies greatly across cultures, but it also changes over time. Moreover, it can be highly ambiguous, as when a particular colour may express two contradictory ideas, such as life and death. Obsolete beliefs about colour, even those from the distant past, continue to have an afterlife. As Michel Pastoureau, the world's greatest historian of colour, puts it: 'In the domain of symbols, nothing ever truly disappears.'

Red

Red was the paramount colour in classical antiquity, along with black (darkness) and white (light). Today, it plays something of the same role in fashion. Highly visible in nature, red functions there either as a symbol of danger, as with coral snakes, or a means of sexual attraction, as with the male robin's red breast. Within the sphere of culture, red brings with it a similarly dualistic symbolism, because the red of blood can symbolise both life and death. Ever since antiquity, red has been the colour of war, because war involves bloodshed. Red became the colour of revolution by combining Christian imagery (the blood of martyrs) with military symbolism. In the French Revolution, red symbolised the blood of the people spilled in the cause of liberty. Later revolutions would shift the emphasis to the idea of class warfare.

Red also symbolises sacred and profane love. Blood is associated with the life force and, by extension, with fertility and desire – the Russian word *krasnoï* means both 'red' and 'beautiful'. An auspicious colour for Asian brides, red was also a popular choice for European brides until the nineteenth century, when the white wedding dress came into fashion. Yet red is also associated with prostitution and sin – from the 'scarlet woman' of the Bible to today's red light districts.

'Red has an expression of dignity, magnificence and pomp,' wrote one nineteenth-century author in *The New York Times* (17 December 1876). 'In the uniform of soldiers [and] in the dress of women, it is suggestive of pride, bravery and license. It asserts a strong will [and] provokes observation.' By contrast, 'green can only awaken amiable and gentle thoughts [and] blue is an expression of purity.' Today, in fashion as in nature, red's assertiveness and sexual allure have become its greatest strengths.

Blue

Blue was a second-rate colour in antiquity compared with red, white and black. It was possible to import indigo from India, but this was much more expensive than dyeing fabric red with madder. The Romans associated blue with the Celts and Germans, northern 'barbarians' who made blue dye from woad. From a barbarous colour, blue was redefined as a celestial or divine colour in the Middle Ages. Blue began to compete with red as the colour of royalty. The Virgin

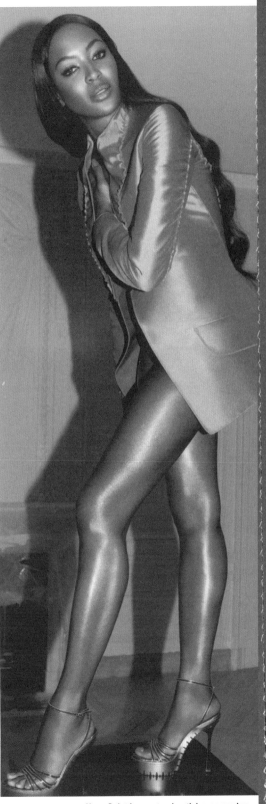

**Maison Martin Margiela, spring/
summer collection 2009**

**Yves Saint Laurent, advertising campaign,
2008**

Mary was also frequently depicted wearing blue. For many centuries thereafter, blue was regarded as an especially appropriate colour for women because it signified purity. Although women also wore red, its vividness and martial associations made it seem relatively masculine.

Blue would gradually be redefined as a masculine colour. Scholars believe that this shift occurred because Protestant reformers of the sixteenth century favoured serious, 'moral' colours such as black, grey and blue. Since women were regarded as more frivolous and sexual, they inherited bright colours, such as red and its pastel cousin, pink. As Michel Pastoureau says: 'Red versus blue meant the festive versus the moral, the material versus the spiritual, [and] the masculine versus the feminine.'

By the eighteenth century, however, blue was rapidly becoming the most popular colour in the Western world, associated not only with the 'blue bloods' in the ruling class but also with 'blue collar' workers and the blue uniforms of the modern state. Moreover, the various shades of blue carried different connotations: light blue was thought suitable 'for the dress of an innocent maiden', while very dark blue approached black and was called the *bleu d'Enfer* (the blue of Hell). Today, blue is the favourite colour of most Americans, and the colour most likely to be worn – in everything from blazers to blue jeans.

Yellow

Yellow has a bad reputation, being commonly associated with treason and cowardice. Yet throughout world history, many people, especially in Asia, have regarded yellow as a highly auspicious colour. In Imperial China, yellow was the colour of power, and yellow clothing was reserved for the emperor. However, in Europe during the Middle Ages, all of the good symbolism associated with yellow – the sun, light, warmth, life, etc. – was transferred to gold. The bad symbolism – autumn, decline, sickness – was relegated to yellow. Negative associations were then extended to include treason, falsehood, cowardice and heresy. In medieval Europe, Jews, heretics and sorcerers were forced to wear the yellow star.

It was only in the eighteenth century that yellow began to become fashionable in Europe, in part because of the era's fascination with chinoiserie. 'Yellow is the eldest daughter of light, and we must not be astonished if such a nation of colourists as the Chinese look upon it as the most beautiful of colours,' declared Charles Blanc in his influential book *Art and Ornament in Dress* (1877). Yellow contrasted with black, however, is evocative of dangerous animals such as tigers and stinging insects. 'This contrast of black and yellow is much fancied in countries where the passions are hot and violent.'

In the 1930s, the Russian-American designer Valentina refused to make yellow dresses, saying, 'Yellow is for flowers.' But with the rise of multiculturalism in contemporary society, yellow (and also orange) have become increasingly popular, reflecting the influence of non-Western colour preferences. Meanwhile, gold continues to symbolise wealth and luxury.

Black

Black has long been associated with night and death, evil and sin. This is not simply the product of Western racism, since traditional African symbolism makes some of the same connections. After all, night is black, just as blood is red. Yet black also has many positive connotations. 'There is a good black and a bad black,' writes Michel Pastoureau. This distinction is often related to whether black is shiny or matte.

Within Western society, black clothing was always far more than a symbol of mourning. Black clothing could be pious or sexy, austere or elegant. The association of black with formal evening dress derives from the princely black of the late Renaissance. The rise of Spanish black in the sixteenth century was a pivotal moment in the history of fashion. Soon even the enemies of Catholic Spain, such as Martin Luther and the Puritans, had adopted austere, respectable black clothing.

Black has long been a sign of power for men. In Quentin Tarantino's film, *Reservoir Dogs*, Mr. Pink asks, 'Why can't we pick out our own colour?' Joe replies, 'I tried that once. It don't work. You get four guys fighting over who gets to be Mr. Black.' But black has been equally important in women's fashion. Long before Coco Chanel became famous for her little black dress, black was widely regarded as elegant, flattering and much too sexy for young, unmarried women. Black dominated the fashions of the 1950s, when Balenciaga was famous for 'Spanish black, almost velvety, a night without stars'. Black was equally iconic for rebels of the fifties, although it fell out of fashion during the colourful sixties. Subcultural styles, such as punk, gave black an outlaw glamour. Japanese avant-garde designers launched the wave of all-black clothing that has dominated much of the fashion world from the eighties to the present. Meanwhile, other fashion designers have focused on the erotic allure of black. No longer associated with mourning, black is the colour of chic and luxury.

Purple

Purple – mauve to be exact – was fashion's first artificial colour. It was introduced in 1856, made possible by English chemist William Henry Perkin's invention of aniline dye, which

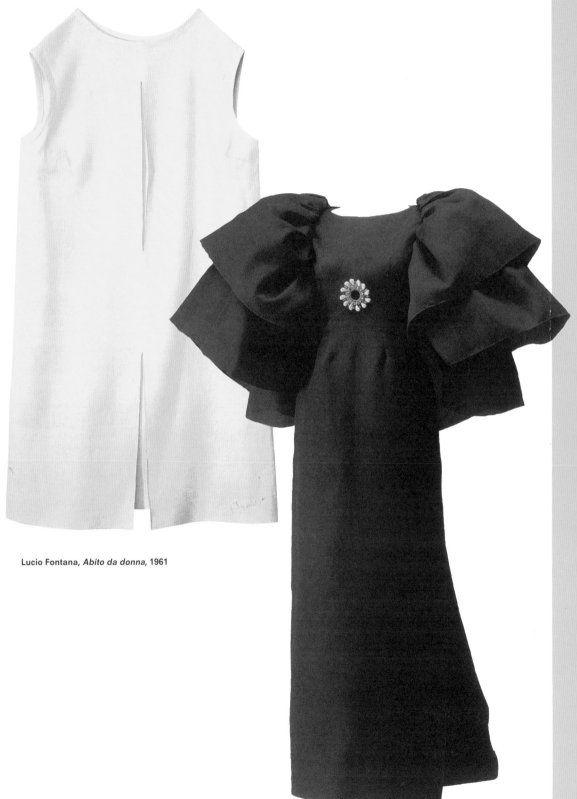

Lucio Fontana, *Abito da donna*, 1961

Cristobal Balenciaga, evening gown, 1964

transformed the history of colour in clothes. Following mauve were many other extraordinarily bright colours, including aniline black, fuchsia, magenta and methyl blue. These startling new colours were both popular and affordable, resulting in a democratisation of colourful clothes. In reaction, aesthetes denounced artificial colours as gaudy and vulgar, preferring natural, faded-looking colours.

The fashion pendulum swung back again in the early twentieth century, when fashion designer Paul Poiret denounced the fashion for 'nuances of nymph's thigh, lilacs, swooning mauves, tender blue hortensias [...] all that was soft, washed-out and insipid.' He boasted, 'I threw into this sheepcote a few rough wolves: reds, greens, violets, royal blues, orange and lemon. [...] The morbid mauves were hunted out of existence.' (Notice how the word 'mauve' had changed in meaning, from an extremely vivid purple to a pale lavender.)

But fashions in colour continued to change, and soon Poiret's 'barbaric' colours were *démodé*. 'Scherazade is easy,' said Chanel. 'A little black dress is difficult.' The neutrals of the twenties – beige, black, navy, grey and champagne – gave way in the thirties to a renewed interest in vivid colours, such as Schiaparelli's famous 'shocking pink'. Colour cycles have become more rapid and complicated in recent decades, as different colour trends can co-exist at the same time.

Inez van Lamsweerde and Vinoodh Matadin, *Yamamoto. Maggie's box*, 1997

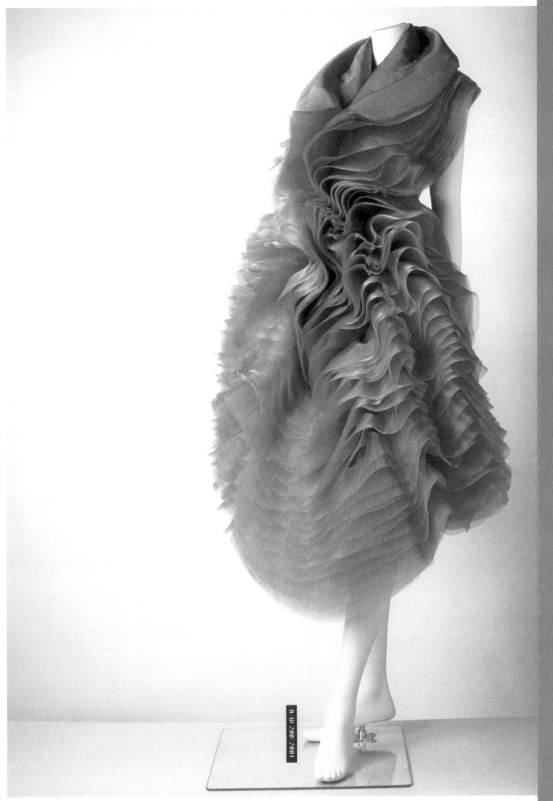

Junya Watanabe,
autumn/winter collection 2000–2001

Claude Lévi-Strauss
The two faces of red

If a language had only three words for colours, they would be red, white (light) and black (dark). This elementary triangle, an almost universal foundation of the category of colour, unites its two essential contrasts: the presence and absence of luminosity, and the presence and absence of tone. Of this last dimension, red, because it is the most chromatic and most saturated, is the preeminent colour.

Red's recognised superiority is such that, in numerous languages, the words describing its richest shades – *cramoisy* (crimson) or *écarlate* (scarlet) in French, for example – lend sumptuousness to any object. Red endows a sense of the brilliant, dazzling, magnificent, or, simply, beautiful. It is in this sense that the name of Moscow's Red Square should be understood. Until the seventeenth century, to say that someone was this or that *en cramoisi* ('in crimson') in old French meant that he or she possessed a character flaw, exaggerated to the nth degree, which nothing could efface.

A flaw, and not a quality, because red's eminent position in the system of colours does not always and everywhere give it a positive meaning. Many indigenous societies in Australia, Africa and America associate red at times with fertility and life, at other times with sterility and death – extreme states in both cases, but diametrically opposed.

Specialists of the European Middle Ages point out that knights in *vermeil* ('vermilion') – that is to say, red – equipment and armour, who often figured in medieval epics, were diabolical figures who came from another world to fight and kill the hero. At the same time, red's negative connotations as the colour of executioners and prostitutes ('scarlet women' in England,

'red lights' at the doors of brothels in France), did nothing to deter the Catholic Church from assigning shades of red, purple and violet to mark the highest degrees of its hierarchy.

In his *Treatise on Colour*, Goethe correctly insisted on the ambivalence of red – the most elevated colour of all, in his estimation, but which, as a pigment, could assume a more elevated or degraded connotation: 'Thus the dignity of age and the gentleness of youth can wear the same colour.' The history of the red flag illustrates this ambivalence in another manner. It appears at the beginning of the French Revolution, announcing the intervention of public forces to disperse seditious crowds. A few years later, it took on the opposite meaning.

More recently, towards the middle of the nineteenth century, the romantic Parisian poets, upon visiting the southwest of France near the Spanish border, were shocked by traditional Basque houses, whose red shutters, timbers and beams gave them a 'bloody' and 'barbaric' look. On the other hand, as I can personally testify, contemporary visitors to Japan have been surprised and charmed by the red humpback bridges in its parks and gardens. As with the obi, whose colours contrast with those of the kimono it encircles, this audacious contrast with the surrounding greenery – gay, seductive and uncommon for us – has widened our aesthetic sensibilities. I have no doubt that among our architects and designers, this experience inspired the use, inconceivable only fifty years ago, of a range of vivid colours for the decoration of the interiors of our public spaces and modes of transportation. As proof, France's newest trains were significantly named *Corail* (coral), a shade of red. Among many other such debts, this may be the latest we owe to Japanese taste.

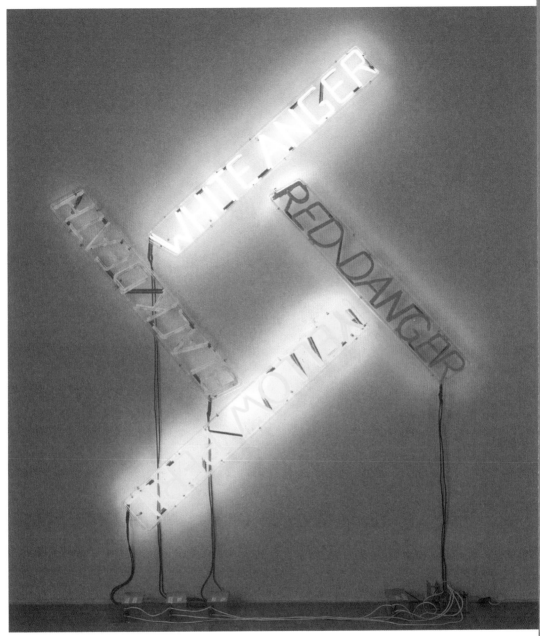

Bruce Nauman, *White Anger, Red Danger, Yellow Peril, Black Death*, 1985

Colour and Viktor & Rolf
In the ten years since your debut, and since autumn/winter 2001–2002, your presentation has shifted from being form-oriented to focusing on the theme of 'colours'. Would you tell us the process behind your realisation of ideas and how you embody your chosen image into the work?
First of all we don't feel that we went from form to colour. Both are equally important in the Viktor & Rolf language. We always need a reason to create something. In the past we have noticed that using colour can be problematic in the sense that it did not seem to be a conceptually justifiable element to design with. That is why we used a lot of grey in our early work. In the black collection, the colour black was meant to emphasise the shapes of the clothes, funnily enough (amongst other things), and to make them seem two-dimensional. We wanted to create extreme silhouettes.

You have selected colours as your theme since autumn/winter 2001–2002. What triggered this decision? Please explain your intentions and the meanings or symbolism behind the colours you have chosen in past seasons.
At a certain point we felt very negative and depressed, and we felt the only way to deal with it was to use that feeling creatively and to turn the negative into the positive. Since it felt so black inside us, we felt we had to drip the whole show in black paint, including the models. Like a black hole in the universe that sucks up all energy.
The white collection that came afterwards was a reaction to this heavy darkness. The white and the reference to Holy Communion was intended to symbolise our desire to enter into the fashion community and accept its rules, regardless. The blue collection that followed was based on the principle of the colour chroma-key blue. This is used in the film industry as a blank canvas that can be replaced with any desired image by means of a computer programme. For instance, the weather girl stands in front of a chroma-key blue backdrop and the computer replaces the blue with the map with the weather. By showing a collection in this colour, and by replacing the blue with moving images, we wanted to express our desire to go beyond clothes and to celebrate the immaterial. We wanted to make clothes that are more than just a product but that catch a dream. This ties in with our belief that fashion is more than just clothes, that it provides an aura and an escape from reality, a fantasy, a dream.

We utilise clothing like 'second skins' to make our bodies take on an ideal shape, yet at the same time we make the personal decision to wear various colours. In your opinion, what is the relationship between colours, clothes and ourselves? And what is the role of colour in contemporary fashion?
That is such a general question. Fashion is about possibilities, like life, and when all is possible, all colours and shapes are possible. What colours are in fashion at a specific period in time depends on the meaning of those specific colours, what they represent and how that fits into our times.

Presentation
You have put together experimental Paris Haute Couture collections since autumn/winter 1998–1999, which have expanded in range of fashion, as well as Paris Prêt-à-Porter collections since autumn/winter 2002–2003 in which you have presented explicit and novel concepts. Each presentation you undertake brings with it new surprises with its originality. What meaning underlies your activities at your fashion shows in Paris?
You have just used the one word that indeed is the most important thing in the Viktor & Rolf world: ORIGINALITY. For us a thing only means something when it's original, when it's a unique vision, a vision that is inimitable. It is what we want to give to the world plus it is what we find most valuable in other people's work.

Where did you find the inspiration for such a unique presentation?
Inspiration we find in ourselves. Our shows are self-portraits.

It is also very interesting to see the roles that each of you plays in your activities. You were even models for your first men's collection in spring/summer 2003. As creators playing many roles and not only producing works, what are the various roles you think a designer should have in the current fashion world?
We can only speak for ourselves, not for designers in general. Since our work is autobiographical we find it necessary to use ourselves in our work. It makes the work uniquely ours.

What was the motive behind becoming a duo? Does each of you have specific allotted tasks? What they are?
We do everything together from the first sketch to every business decision. When we work together it is like 1+1=3. Something extra is added that we cannot explain, or maybe we can call it magic. But for us the most important thing about being a duo is that it keeps us sane. We can always put everything in perspective.

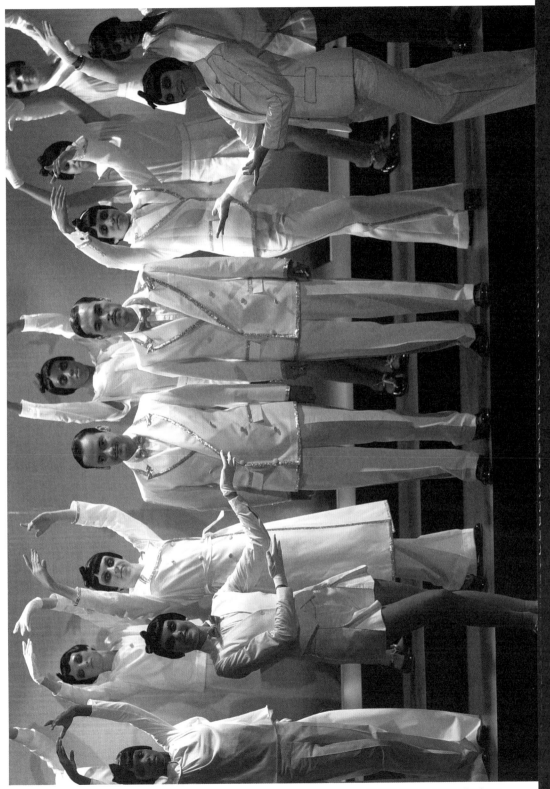

Viktor & Rolf, *There's no Business like Show Business*, spring/summer collection 2001

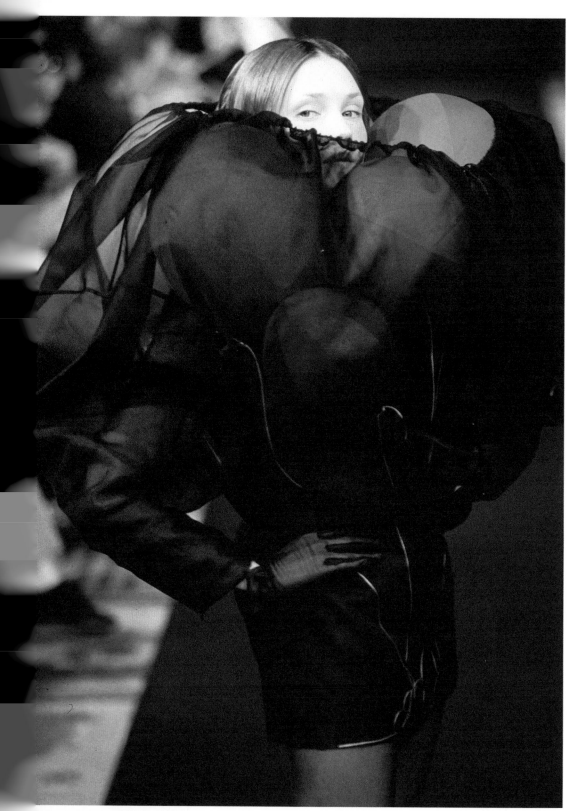

Viktor & Rolf, *Atomic Bomb*, autumn/
winter collection 1998–1999

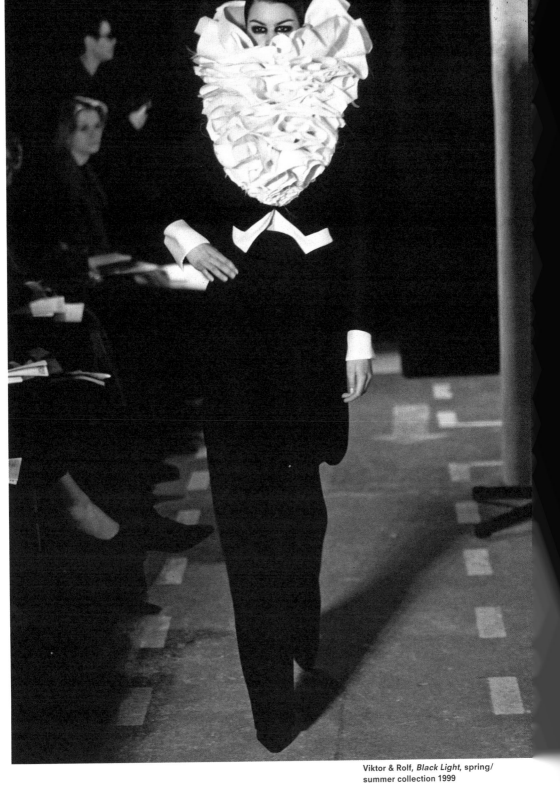

Viktor & Rolf, *Black Light*, spring/
summer collection 1999

Art and fashion

You have participated in a number of art exhibitions including the installation *Winter of Love* at the Musée de l'Art Moderne in Paris, PS. 1 in New York in 1994 and *Designer's Dream* at the Torch Gallery, Amsterdam in 1996, and the work was very well received by the contemporary art world. In those days there was some disagreement as to whether your works should be labelled fashion or art. What do you think is the relationship between 'fashion' and 'art?' We understand that you both studied at art school. What kind of education did you actually receive? What was the position of fashion in your education?

We studied in the fashion department of an art academy in Arnhem, Holland. Its main focus was on fashion design. Business was not at all a part of the curriculum, neither was art. We have always seen ourselves as fashion designers, even when we showed our work in museums and galleries. On those occasions, our work was about fashion.

In the Netherlands, the Groninger Museum in Groningen and the Centraal Museum in Utrecht own your works. In addition to those, which other art museums in the Netherlands or in other countries house your works?

Musée de la Mode et du Costume (Palais Galliera) in Paris. KCI in Japan. FNAC (Fonds National d'Art Contemporain) in France.

Fashion in colours

Please tell us about the image you had in mind for each of the colours presented at the sections in this exhibition: *Black, Multicolour, Blue, Red & Yellow* and *White*.

Our own shows. The black show for the *Black* room. The white show for the *White* room. The atomic bomb show for the *Multicolour* room. The red shoes for the *Red & Yellow* room.

What was it about this exhibition that made you decide to accept the role of guest curator?

The prestigious name of KCI and their incredible collection, and the interesting concept of the exhibit that we found suitable to our work.

In this exhibition, which is your favourite piece? Are there any designers or artists, now or in the past, that you associate with any of those colours?

Not any one piece, but probably the projection of the black show. We are still surprised about the power of those images. When we had the idea we had no clue as to how strong visually it would come out.

It is no exaggeration to say that today we have obtained freedom in the use of colour, and our environment is overflowing with colour. How do you think our sensibilities concerning colour will change in the twenty-first century? And what will cause the change, if any?

We are not fortune tellers, but the abundance of images that penetrate everyday life, and that cause a feeling of indigestion, will certainly provoke a different attitude.

Prospect

After having participated in the Paris Haute Couture Collection, the Paris Prêt-a-Porter Collection, and the Men's Collection, you intend to unveil your own perfume as shown in your work of miniature dolls (*Le Parfum*; 1996). What is your ultimate goal as designers?

To create a Viktor & Rolf world in real life. To visualise our dreams.

What course can we expect the future fashion world to take? Or what do you think we will require as far as clothing is concerned?

Again we are not fortune tellers, except that we know fashion does not have the same impact any more as it used to have. This has to do with the scope of fashion, which has become dramatically bigger over the past twenty years. Real fashion (i.e. that which is worn and – more importantly – seen by many) is dictated more and more by sophisticated (= quick) production and distribution facilities. Designer fashion will continue to exist, but it can only be truly meaningful if it manages to take an appropriate stand in this changing context. Maybe this is the reason why we find it important to let our work communicate with people outside the sometimes claustrophobic fashion world as well.

And lastly, what is your favorite colour?

Black.

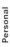

Viktor & Rolf, *Black Hole*, autumn/
winter collection 2001–2002

Catelijne de Muijnck
Issey Miyake: *Colour Hunting in the Amazon*

Colours do not need to be made. They are already there, as gifts from heaven. When one looks over the earth, it is in nature that true colours are found, not manmade, not constructed with logic.
Issey Miyake Creative Team

For years, the Japanese label Issey Miyake has set itself apart with an extraordinary combination of fashion, skill and technological innovation. At the end of the nineties, Dai Fujiwara, designer for Miyake, developed A-POC (A Piece of Cloth), a revolutionary process by which computer-driven machines produce rolls of fabric on which the design of the garment is already printed and the seams are already finished, so all the customer has to do is cut the garment out and tailor it to her needs. Since being appointed creative director in 2006, Fujiwara has been on the lookout for companies and persons with exceptional technological knowledge who might serve as sources of inspiration or collaborative partners. For the so-called *Wind* collection, for example (spring/summer 2008), he worked with the Dyson vacuum cleaner company, and for the ready-to-wear collection for autumn 2010 he sought inspiration in the geometric models of the universe developed by mathematician William Thurston.

Notwithstanding his vast knowledge and fondness for technology, Fujiwara also regards nature as an important source of inspiration. In the film *Colour Hunting in the Amazon* (2008), we see Dai Fujiwara and members of his creative team in the Amazon rain forest, searching for a colour palette for the spring/summer 2009 collection. The team described the adventure as follows: 'Unlike hunting animals, capturing insects, or gathering plants and flowers, we simply collected colours.'[1] They began their investigation from a work station located at the foot of an enormous rubber tree deep in the rain forest. They selected trees in the surrounding area and collected leaves, fruit and soil samples, to compare them with the three thousand colour samples they had brought along. Then they stretched lines across a narrower tributary of the Amazon that had thickly forested banks and hung from it pieces of fabric in the found colours. By approaching the lines by motorboat and riding beneath them, they tested the extent to which these colours coincided with the environment. They also collected colours from the principal river, which reminded them of skin colours. The results proved to be a large number of quite unpretentious and restrained greens and browns, not the bright, outspoken colours you would expect from the jungle. From these colours they finally selected eight. They then dyed threads to match the colours and used them in random order for the warp of a motorised loom. In combination with the weft (the crosswise threads), a large variety of expressive fabrics were thereby woven for the collection, which for the team reflected the rich harmonies of the colourful planet Earth.

Yet nature wasn't the only source of inspiration for this collection. At the end of the colour hunt, Fujiwara was not entirely satisfied with the results: 'After being in the jungle and feeling nature around me, I found myself wanting to go into the city and see something man-made, so we decided to go to Rio de Janeiro.'[2] Here they visited the architect Oscar Niemeyer, whom Fujiwara greatly admires and whose undulating lines further inspired the spring/summer 2009 collection. They also took photographs in the city's slums, the *favelas*. When the photos were rotated at rapid speed, patterns emerged that became a subtle addition to the collection's colour palette and gave the creative team a new method for arriving at colour patterns.

Notes
1. From a text on the project issued by the Issey Miyake Creative Team, 2010.
2. Kelly Wetherill, 'Dai Fujiwara, Fashion's man of the future', in: *One Eighty*, vol. 2, no. 1 (color + art), Academy of Art University, San Francisco, spring 2009, p. 91.

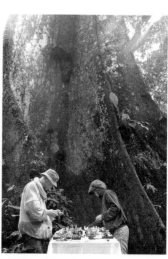

Dai Fujiwara for Issey Miyake,
Colour Hunting in the Amazon, 2008

Catelijne de Muijnck

Dai Fujiwara for Issey Miyake,
Colour Hunting in the Amazon, 2008

Issey Miyake, spring/summer collection
2009 based on *Colour Hunting in the
Amazon*

JeongMee Yoon
The Pink & Blue Project

My work *The Pink and Blue Project* explores the trends in cultural preferences and the differences in the tastes of children (and their parents) from diverse cultures, ethnic groups as well as gender socialisation and identity.[1] The work also raises other issues, such as the relationship between gender and consumerism,[2] urbanisation, the globalisation of consumerism and the new capitalism. The saccharine, confectionary pink objects that fill my images of little girls and their accessories reveal a pervasive and culturally manipulated expression of 'femininity' and a desire to be seen.

The Pink and Blue Project was initiated by my daughter, who loves the colour pink so much that she wanted to wear only pink clothes and play with only pink toys and objects. I discovered that my daughter's case was not unusual. In the United States, South Korea and elsewhere, most young girls love pink clothing, accessories and toys. This phenomenon is widespread among children of various ethnic groups regardless of their cultural backgrounds. Perhaps it is the influence of pervasive commercial advertisements aimed at little girls and their parents, such as the universally popular Barbie and Hello Kitty merchandise that has developed into a modern trend.[3] Girls train subconsciously and unconsciously to wear the colour pink in order to look feminine.

Pink was once a colour associated with masculinity, considered to be a watered down red and held the power associated with that colour. In 1914, *The Sunday Sentinel*, an American newspaper, advised mothers to use pink for the boy and blue for the girl, if you are a follower of convention.[4] The change to pink for girls and blue for boys happened in

America and elsewhere only after World War II.[5] As modern society entered twentieth-century political correctness, the concept of gender equality emerged and, as a result, reversed the perspective on the colours associated with each gender as well as the superficial connections that attached to them.[6] Today, with the effects of advertising on consumer preferences, these colour customs are a worldwide standard.

When I began producing the pink images, I became aware of the fact that many boys have a lot of blue possessions. Customers are directed to buy blue items for boys and pink for girls. The clothes and toy sections for children are already divided into pinks for girls and blues for boys. Their accessories and toys follow suit. The differences between girls' objects and boys' objects are also divided and affect their thinking and behavioural patterns. Many toys and books for girls are pink, purple, or red, and are related to make-up, dress-up, cooking and domestic affairs. However, most toys and books for boys are made from the different shades of blue and are related to robots, industry, science, dinosaurs, etc.[7] These kinds of divided guidelines for the two genders deeply affect children's gender group identification and social learning.[8]

As girls grow older, their taste for pink changes. Until about second grade, they are very obsessed with the colour pink, but around third or fourth grade, they do not obsess with pink as much anymore. Usually, their tastes change to purple. Later, there is another shift. However, the original association with the colour-code often remains.

To make these images, I arrange and display the cotton-candy coloured belongings of several children in their rooms. When I first started taking these pictures, the objects were arranged without an order, but I soon

realised that the photographs in which small possessions are well-organised and displayed in the front of the scene make the images appear to be more crowded. This method shows that my organisation of subjects is similar to the way museums categorise their inventories and display their collections.

Notes
1. Marjorie Garber, *Vested Interests: Cross-dressing & Cultural Anxiety*, London: Routedge, 1992, p. 2. Note that it is the connotations of the colours, and not the perception of the genders, that has changed.
2. Media Awareness Network, *Special issues for young children – Young consumers as collectors* (see www.media-awareness.ca/english/parents/marketing/issues_kids_marketing.cfm). Marketers have discovered something about children that parents have long known: they love to collect things. Kids' collections used to consist of marbles, stamps or coins. But now, thanks to our consumer culture, kids amass huge collections of store-bought items such as Beanie Babies, Barbies or Pokemon cards and figures. The marketing strategy behind the Pokemon was simple and lucrative – create 150 Pokemon characters, then launch a marketing campaign called 'Gotta Catch 'Em All', to encourage children to collect all 150 of the cheaply made, over-priced figures.
3. 'Ads and kids: How young is too young?' Media Channel.org – *Issue Guides – Marketing to Kids*. A child wakes up in her Disney character pajamas, rolls out of her Barney sheets, her toothbrush, toothpaste and perhaps even her soap covered in cute licensed characters. Gathering up her Pokemon cards and strapping on her Rugrats Backpack, she heads off to school.
4. *The Sunday Sentinal*, 9 March 1914.
5. Garber, *Vested Interests* (note 1): p. 1. Baby clothes, which since at least the 1940s have been routinely divided along gender and colour lines – pink for girls, blue for boys – were once just the other way around, according to the *London Times*. In the early years of the twentieth century, before World War I, boys wore pink, 'a stronger, more decided colour', according to the promotional literature of the time, while girls wore blue (understood to be 'delicate' and 'dainty'). Only after World War II, the *Times* reported, did the present alignment of the two genders with pink and blue come into being.

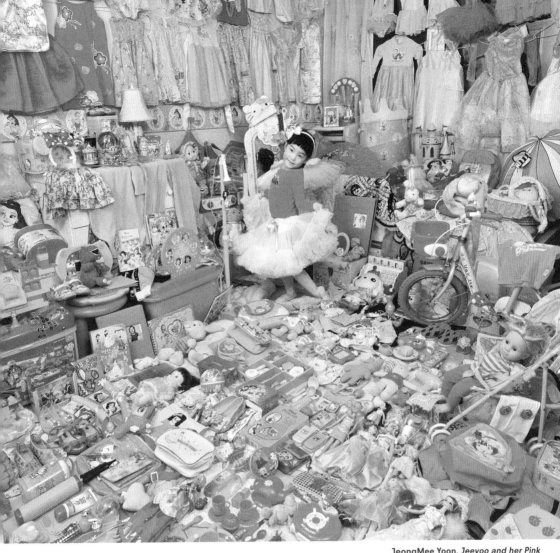

JeongMee Yoon, *Jeeyoo and her Pink
Things*, 2008, from *The Pink & Blue Project*

6. Elliot Bledsoe, *Pretty in Pink*,
 www.vibewire.net (September 2003).
 Traditionally, babies in most societies
 were gender-neutral, as if they were
 'it' rather than 'he' or 'she'.
7. Merris Griffiths, 'Blue worlds and pink
 worlds: A portrait of intimate polarity',
 in: David Buckingham (ed.), *Small
 Screens*, Leicester: Leicester
 University Press 2002. The social
 worlds of boys and girls may in fact
 be much less polarised than the
 famously constructed worlds of
 Barbie and Action Man. Numerous
 studies suggest that children's play is
 a reflection of gender stereotyped
 socialisation patterns and that toys
 are important in their ideological
 formation.
8. Gerianne M. Alexander, 'An evolu-
 tionary perspective of sex-typed toy
 preferences: pink, blue, and the
 brain', *Archives of sexual behavior*,
 32 (February 2003), p. 7–14. Contem-
 porary conceptual categories of
 'masculine' or 'feminine' toys are also
 influenced by evolved perceptual
 categories of male-preferred and
 female-preferred objects.

JeongMee Yoon, *Jeonghoon and his Blue Things*, 2008, from: *The Pink & Blue Project*

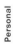

Marije Vogelzang
Colour in food and design

It all began with a seemingly simple assignment – 'design something using the colour white' – which I was given as a third-year student at the Design Academy in Eindhoven. When you're doing a course in design, you experiment with a variety of materials in different workplaces. My kitchen was my workplace, and the kitchen cabinets were full of materials and tools. I had done a bit of research and had learned that in non-Western cultures, funerals and food often go hand-in-hand and that the colour of death is not black but white.

Although I was no more competent than the average student when it came to cooking, I ended up making a white funeral meal. Everything was white: the food, the tableware, the furnishings – even the clothing of the guests. The design as a whole evoked an atmosphere of serenity, and I learned that as a designer you can also create non-tangible things, like rituals.

Whenever you work with food, you make contact with the essence of human existence. Designers always focus their attention on the human individual: they design cars, houses, clothing and cookers, but they usually bypass the things that people really need. Designers who work with food are called 'food designers' as a rule, as if their main interest were limited to the design, the aesthetic of food. But isn't most food already perfectly designed by nature itself? What interests me is the verb 'to eat', the origin and the preparation of food, the etiquette that goes with it and the history and culture behind it.

Food is much more than just a substance or a number of calories; food touches on religion, culture, biology and politics. I once conducted research on

colour and food for a children's clinic in New York that was aimed at overweight children and their eating habits. The basic idea was that a person's perception of food takes place to a great extent in their head and not in their stomach or mouth. When coloured snacks are coded to trigger positive associations by means of package design and an accompanying booklet, children learn to look at food in a new way. Red snacks stimulate self-confidence, yellow ones encourage children to make friends and black snacks promote discipline. This momentarily frees food from the negative associations these children usually have towards it. Many overweight children know it's not good to eat fast food, but they enjoy eating it all the same. After they've eaten their fill, they often feel badly because they themselves also see the connection between the food they eat and the humiliation of their obesity.

I've translated my philosophy into eight sources of inspiration, all of which help explain the possibilities offered by working with food and can be directly related to colour.

1. Senses
What makes us think that red soft drinks are sweeter than yellow ones, even though they contain the same flavourings, and why do we take white wine for red when it's served at room temperature and dyed with red colouring agents?

2. Culture
Why do we only eat coloured eggs at Easter, and why do Palestinian food manufacturers in Israel incorporate the colours of the Palestinian flag into their merchandise by using za'atar, a green, typically Arabic herb, along with paprika and sesame?

3. Biology
Why are orange carrots a relatively recent phenomenon,

and why were the older varieties only white and purple? How much can we control the colour of an egg yolk by changing the feed given to the chicken?

4. Science
Why do purple vegetables and fruits contain more flavonoids than those of other colours? How many people are allergic to E120 (carmine, a red food dye)? And who made the discovery that this pigment can be extracted from female scale insects?

5. Context
Imagine what it would be like to eat black food in a black room with black dishes, and to do this with black people.

6. Technology
How do you make grey ice cream (and why would you want to)? How is it that purple beans turn green during cooking?

7. Psychology
Why don't we like blue tomatoes? Why do people eat more sweets when they're all the same flavour but different colours, rather than all the same colour?

8. Society
Is it healthy to eat cultivated salmon that are given food containing astaxanthine, a dye that makes fish pink? If we make oranges orange by using artificial dyes, why don't we declare them works of art?

The role that colour plays in our eating culture is an important one, and it goes much further than aesthetic considerations alone. It's my job to look at the backgrounds and context of food; design is a means by which you tell the story.

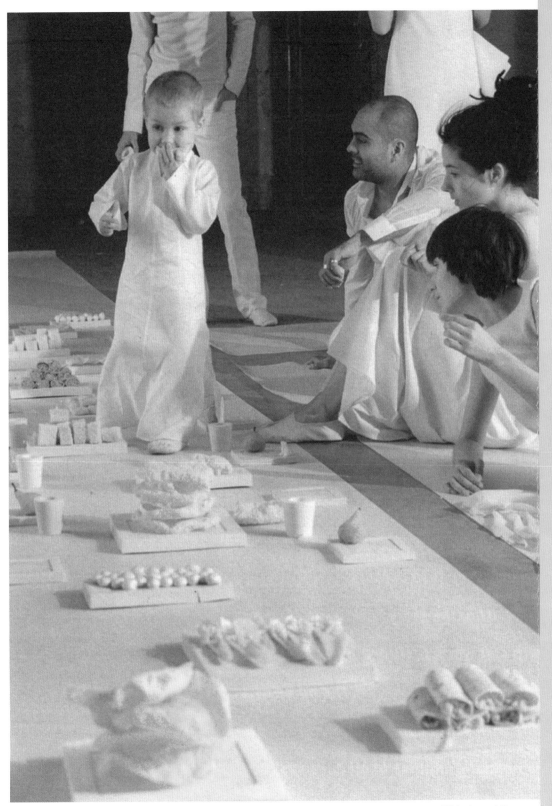

Marije Vogelzang, *White funeral dinner,*
1999

Victoria Finlay
Religions and colour

There are thousands of places in Australia where red ochre paint can be mined, and anybody with a mind to it can go to visit them. But over that entire huge continent there are just three or four places where the ochre is different: it is believed to be sacred.

In ancient times, and until the late nineteenth century, aboriginal people used to go on regular trading expeditions over hundreds of miles, carrying narcotic *pituri* leaves, boomerangs and grinding stones to barter for their greatest prize: this rare, and very sacred, red colour from Wilga Mia in Western Australia, or Parachilna towards the south. And even today, although they are marked on maps, their entrances decorated by tourist signboards, those places are still secret in a way, their most significant stories unknown to all but a few aboriginal men who have gone through the right initiations. These men have learned the ancestral secrets of this first colour paint: not only learning how to collect and use it, but – it is rumoured still – understanding what it really means.

In the summer of 1933 anthropologist Theodor Strehlow, who had grown up with the Aranda people of Central Australia among whom his father was a missionary, was invited by four elders of the Loritja tribe to see a rain ceremony. He described[1] how they cut their arms with glass and used the jets from their veins to cover their ritual spears in so much blood that he had to watch through the lens of his camera lest he faint. Most Loritja ritual spears were habitually painted in red ochre, which he guessed might be safe symbolic substitutes for that blood. Certainly one thing that distinguishes sacred ochre from ordinary ochre is that it is shiny – like blood and light. So perhaps ochre did not just symbolise something otherworldly in aboriginal culture: perhaps it actually embodied it.

Signifier or embodiment: these are the two main roles of colours in all kinds of religions. And although colours are most obvious in religions at the points where they symbolise aspects of the divine, and our relationship with it, they are most powerful when they are believed to go one step further – and actually embody the divine.

For example, the Virgin Mary's blue robe. First it is a symbol, not only of the colour of heaven but also of a preciousness that relies on the viewer's understanding of the price of paint. In medieval and Renaissance times there were just two artists' pigments that most artists couldn't afford: gold leaf and ultramarine blue. So gold was used sparingly for haloes, and 'ultramarine' paint – so called because it came from 'beyond the seas' and indeed from just one mountain in Afghanistan's remote Badakshan region – was frequently used to show the robe of the most precious Mary, with the paint provided by patrons.

These two forms of signifying symbolism – simple and sumptuary – can be extended to most of the other colours that have clad the Virgin during her iconographic lifetime. In the seventh century, Byzantine artists often showed her in purple, which was – when thrice-dyed from the bodies of rare Mediterranean sea snails – a colour reserved for emperors and the super-rich, so it was an inspired choice for the Queen of Heaven. And in the sixteenth century, with cochineal red dyestuffs from the New World achieving staggering prices in the textile markets of Europe, Dutch artists would often use cinnabar to paint the Virgin in red. This was partly to symbolise her blood sacrifice, losing her beloved son. But mostly it was to show how valued this holy mother was, clad in the most fashionably shaded dress possible.[2] It was rather like the effect 400 years ago of showing her in ermine, or today of dressing her in the most fashionable and recognisable designer garments.

These are good stories, but those three colours – ultramarine blue, cinnabar, Tyrian purple – are also remarkable for something more than just symbolism: the 'embodiment' side of their relationship with religious thinking. Ultramarine paint comes from the precious blue stone lapis lazuli whose finest quality is known in Afghanistan as *rang-i-surpar*, meaning the colour of the flame, and at its best it is the almost violet colour of heat itself – an embodiment of elemental forces. Cinnabar, meanwhile, is made of mercury (II)-sulphide, and if you concentrate on it, you can sense its mercurial, shining quality.

And purple, too, that other colour of Mary, and also the colour of Bacchus and of Roman Emperors, is about something much more than fabulous decoration – not just in its symbolism but in its very being. In his book *Color and Culture*, John Gage has an intriguing theory[3] about the sacred importance of purple in the classical world. The Greek word for purple had a double connotation of movement and of change, he argued. And these two qualities are the conditions of lustre, or lustrousness itself.

There are other aspects of colours in faith which strengthen either the signifier or the embodiment. Sometimes, for example, colours play a role in identifying the faithful. So the Sikh babas, or holy men, dress almost exclusively in either white or orange. This is partly to symbolise purity and wisdom respectively, but also, pragmatically, orange is a colour that hadn't been 'taken' by the other major faiths in India in 1699 when Guru Gobind Singh initiated the *khalsa* or body of Sikhs. It was visually distinctive from the white of the Hindus and

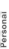

Raghubir Singh, Sri Lanka, 1979

the green of the Muslims. At an event that my own charity organised in November 2009 at Windsor Castle with representatives of nine major world faiths, it was the Sikhs who were photographed most: in their orange they were quite unmistakeable.

In Tibetan Buddhism there are four main sects, and three are known by the colour of their hats – so there are the 'black hats' or Kagyupa, the 'red hats' or Nyingmapa, and the 'yellow hats' or Gelukpa, of which the Dalai Lama is the head. Even Sakyapa, the fourth sect, refers to a colour – sa meaning 'pale', or 'white' and kya meaning 'earth', and the Sakyapa are also called the multicoloured sect because their monastery buildings sport red, white and black stripes, reminding their followers of the respective qualities of knowledge, compassion and self-control.

Sometimes the colours in religions are simply calendrical: you know where you are in the ritual year, just by seeing what the priest is wearing. In Catholicism, for example, there are five prescribed colours: white is used at Christmas and Easter, while red (representing fire and blood) is used on the feasts of the apostles and the martyrs, Good Friday and Palm Sunday. Pentecost is red too, representing the fire of the Holy Spirit. Green, the natural colour, is for the in-between times, being about normal life that hasn't gone crazy, that is the opposite of feasts and fasts, while purple (representing penance, the last colour before infinity) is for the fasting times, and black is used almost exclusively for the offices of the dead.

In ancient times, students aspiring to be Sufi seers joined so-called 'Schools of Colour' in which they concentrated, sometimes for several years, on the truths that are embodied within a given colour.[4] So for example they might choose to concentrate on yellow, to better understand the majesty of the

sun and of their own mind. Or green, to meditate on immortality and what it is to die or not to die.

One of the aspects of colour and spirituality that the Sufis might well have meditated on was the fact that there is almost no consistency when it comes to colours. Take yellow, for example. In China it was the colour of emperors, representing wealth and strength and vitality and gold. For the Buddhists coming from India it was the colour of penitents and priests, representing poverty and humbleness, quietness and lack of interest in gold. And in Judaism it is a shameful colour because it is the colour that Jews were forced to wear in many places where they were persecuted.

Blue has a similar inconsistency. It is mostly the colour of heaven or mercy – the Buddhist deity Guanyin often wears it to indicate her compassion, King David of the Jews was clad in royal blue, and the ancient Egyptians thought it represented truth. But like yellow it has another side to it. The Hindu deity Shiva is also known as Nilakantha, the blue-necked one, because of a story that he once drank a pot of poison in order to save Creation, so the blue is a reminder to humans that evil exists, but that it can be contained through courage and right actions.

Or take the wide diversification of mourning colours used by people of different faith traditions.[5] In Asia grieving families often wear white; in Europe black is de rigueur, except in some families where violet is acceptable, or in Brittany, France, where some widows used to wear yellow. In Armenia people traditionally mourned in sky blue, to express their hope that their loved ones were in heaven, while in Persia they would dress in the pale brown of withered leaves.

Consistency though, is probably not important. What could be far more important is the space that colours give to think,

or literally to realise. In 2009 artist Anish Kapoor gave an interview to BBC Radio Three's arts programme Nightwaves, about his bold use of single colours, like yellows, or particularly blues. 'Colour is stuff, colour is material,' he said.[6] 'Colour is a physical thing: it's not just a surface […] and it's that sort of interplay between the "stuffness" of colour and its illusory, somewhat evasive, "other" qualities that much of the work is about.'

You could say something very similar about the way colours work in religions. At the surface, colours give pleasure as well as serving as useful signals and spiritual metaphors. But also perhaps, if we are lucky, for a fractional moment they remind us of that underlying thing we keep forgetting – and whose job it is arguably for religions to remind us of in their very different ways. Colours, at their best, remind us about the true nature of matter, and the nature of our own human relationship with light, whatever that light may be.

Notes
1. Theodor Strehlow, Songs of Central Australia, Sydney: Angus & Robertson, 1971.
2. So fashionable was that Latin American cochineal that the word 'scarlet' in English, which initially referred to the best quality of cloth, came to refer only to red – for who would dream of dyeing the supremely expensive 'scarlet' fabric in any other colour?
3. John Gage, Color and Culture, Berkeley, California: University of California Press, 1999.
4. Ellen Conroy, The Symbolism of Colour, London: William Rider and Son, Ltd, 1921, p. 25.
5. Victoria Finlay, Treasure, London: Sceptre, 2006, pp. 64–65.
6. Anish Kapoor, in an interview for Radio Three's Nightwaves, Anne McElvoy, 28 September 2009.

Sikh leaders at Windsor Castle at the launching of the EcoSikh movement, November 2009.

Sikhs traditionally wear the colours white and orange.

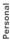

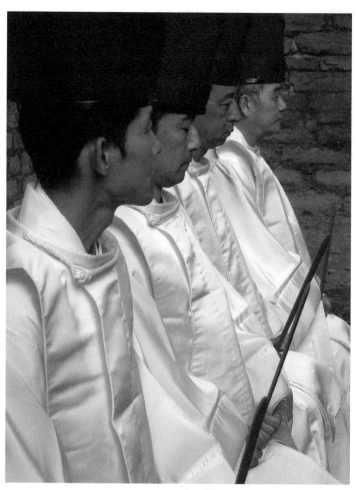

Four Shinto priests from Japan during a ritual at a special ceremony in the ruins of a church in Visby, Sweden. Shinto priests traditionally wear white, symbol of purity.

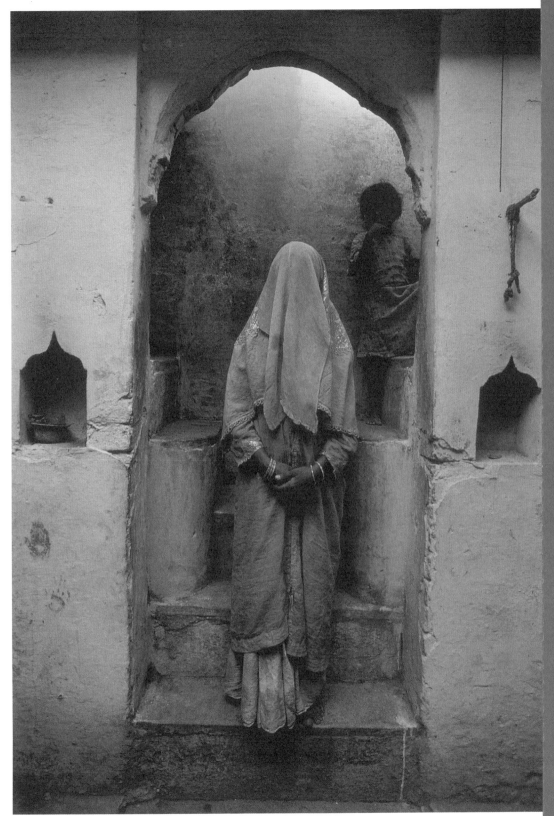

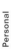

Cary Wolinsky, India, 1983

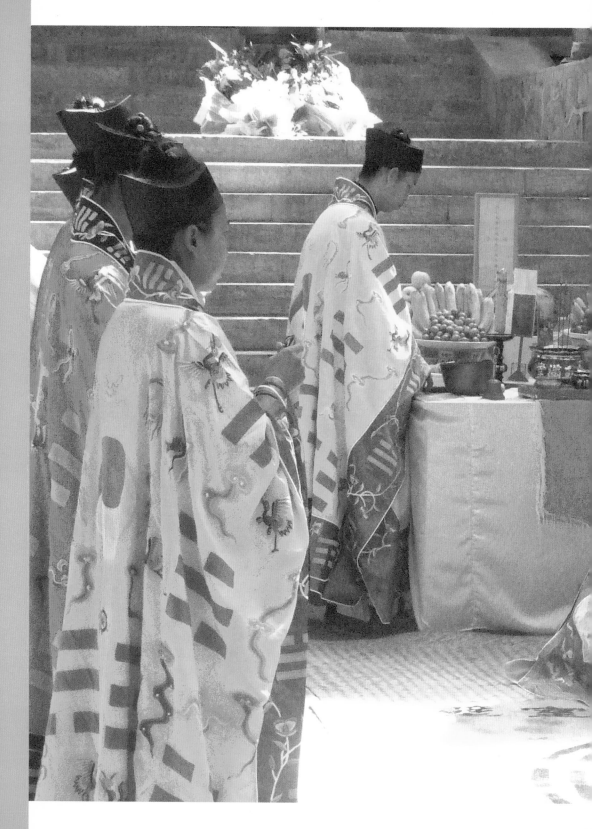

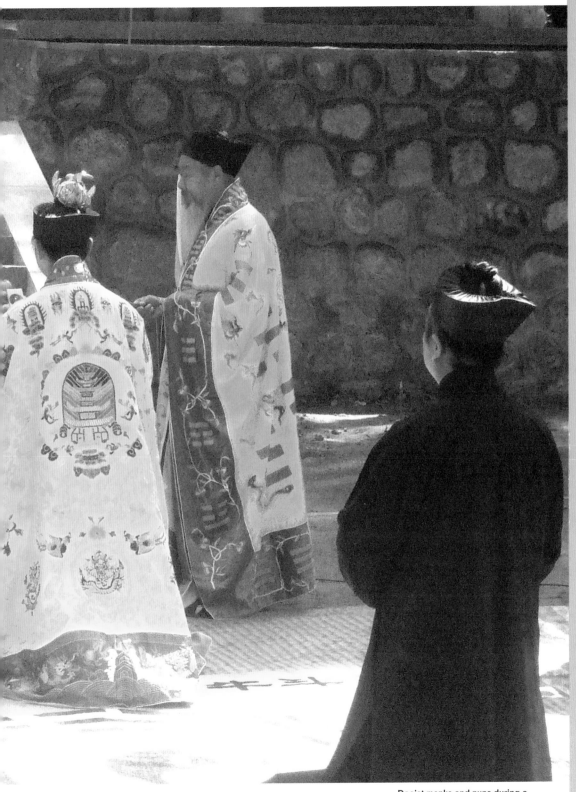

Daoist monks and nuns during a
ceremony at the opening of the first
Daoist Ecology Temple, Tai Bai Shan
(pilgrim mountain) in central China,
4 June 2007

Marjan Unger
Colour in design

Colour is a fascinating pheno-
menon in every respect, and
its importance in the world of
design is beyond dispute.
Many aspects of colour will be
discussed in this article: the
scientific explanation, the history
of colour theories from different
countries, the experience of
colour, colour in the teaching
of design and colour in fashion.
Those who think it's enough just
to pick out 'a nice colour' may
change their minds after reading
this article.

Colour is a decisive factor in
our lives. Colours can be extremely
powerful, yet they're rarely
analysed or used for their own
intrinsic value. In the design world,
colour is usually evaluated on the
basis of symbolism or conven-
tion, on subjective grounds like
ambiance, and in terms of a
whole range of other emotional
values that are ascribed to
colours. This makes colour a
fascinating topic, and for me it's
also a source of pleasure; colour
can be hard and clear-cut but it
can also be emotionally compel-
ling – I can lose myself entirely in
exciting colour combinations.

As a natural phenomenon,
colour can be analysed and
described scientifically, which
suggests that colour theory
should have a definite structure.
But it's not easy to connect such
a phenomenon with logic and
hard facts. To begin with, you as
an observer cannot have a pure
experience of colour; the only
way to determine colour with
precision is by using complex
colour meters. We experience
colour mainly in contrast with
other colours, and that produces
corrupted results because colours
influence each other. A lemon
yellow placed alongside a green
becomes a different colour than
the same lemon yellow seen
beside a deep red or purple.
Even more troublesome, it's

impossible to express colour
satisfactorily in words. When
I talk about lemon yellow, I envi-
sion a sharp light yellow. This
doesn't mean that the words
'lemon yellow' suggest the same
yellow to other people (maybe
they have an old, wrinkled, dark
yellow lemon in their kitchen), let
alone that they see the same
colour at all.

Psychologists and linguists
take for granted that there are
only about eleven basic terms
for colour: black, white, red,
blue, yellow, green, brown,
purple, orange, pink and grey.
This is true for many languages.
The words for additional colours
are created by linking an object
to the colour, like a lemon, or
adjectives like 'clear', 'bright'
or 'soft'.

Just as there are people with
perfect pitch, so there are people
with a perfect eye for colour.
They can start with hundreds of
colours and select just the tint
they need. That comes in very
handy, especially if colour is an
essential aspect of their line of
work, such as that of painter or
textile designer. But it's only the
contrast with all those other
colours that makes this perfect
selection possible. Usually such
people are also able to combine
colours in attractive ways. They
have what is called a 'good
colour sense', which implies a
skill located in the domain of
the emotions that cannot be
approached objectively.

Colour is a subject that un-
avoidably swings back and forth
between scientific objectivity and
relative values. The practical
aspect of colour in design makes
the subject even more compli-
cated. Every design discipline
and every material has its own
technique for applying colour.
Each profession has its own for-
mulas for pigments and its own
painting or dyeing techniques
that are passed down from ge-
neration to generation. Some-
times these formulas are handled
with great secrecy, as in the case

of silk dyers. Ceramists regard
their glaze formulas as part of
their working capital, along with
their equipment.

Over the past thirty or forty
years, colour consultancy –
providing colour advice to
industry and the design world –
has become a profession in its
own right. Stylists, too, keep
their insights under wraps; they
have a tendency to present
certain colour combinations as
their own personal property,
even though human beings have
been experiencing colour for as
long as they've had eyes, and
there isn't a colour combination
that hasn't already been made.

To summarise: colour is diffi-
cult to define and can be regard-
ed from many different perspec-
tives, from hard scientific analysis
to soft ideological concepts. In
some design fields, the more
subtle aspects of working with
colour are often jealously guard-
ed as professional secrets.
Addressing the subject of colour
is a massive undertaking with a
spectrum that runs from scien-
tific to perceptual. For me, the
value of colour as a defining
element of everything around us
lies in the tension between the
intangible and the unavoidable.
Everything we see has colour,
something that every designer
who makes anything has to
acknowledge.

Some facts
It's wonderful that all three modern
European superpowers – England,
Germany and France – have
produced scientists who have
made important contributions to
the analysis of colour and the
development of colour systems.
But the Belgian theologian
Franciscus Aguilon (1567–1617)
of Antwerp and the Dutch scien-
tist Christiaan Huygens (1629–
1695) were also major players in
the study and description of the
properties of colour. After all that
research conducted in the various
language regions, consensus
was finally reached on how light

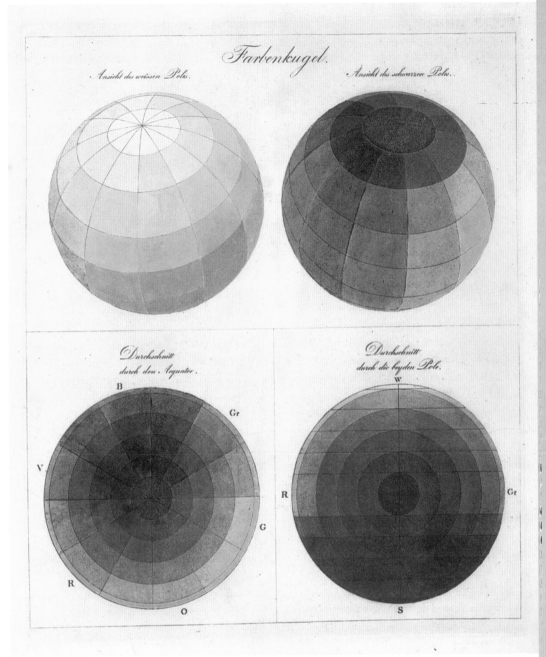

Philipp Otto Runge, *Farbenkugel (Colour circle)*, Hamburg 1810

and colour work. I'm not terribly interested in national prestige, but one positive spinoff of this discovery is that the application of colour in art and design has been regarded as a serious subject in all these countries throughout history, and artists, designers and particularly art teachers have all had recourse to the research published in their own language. Obviously students have benefited as well.

The big prize for the scientific analysis of colour goes to Sir Isaac Newton (1642–1727) – he owed his title to his colour research. In 1704 he published *Opticks*, the first structured study of colour that was not based on human whimsy. Using a prism, Newton broke down sunlight – white light – into the spectral series red, orange, yellow, green, blue, indigo and violet. Up until then, colours had usually been arranged between the poles white and black, in which yellow came closest to white and blue to black.[1]

Newton concluded that white was the sum of all the colours of light, full sunlight, and that black was the absence of light. He identified three primary colours – red, yellow and blue – as well as the secondary colours, which are mixtures of two primaries: orange, green and violet or purple. If you arrange these colours in a circle, you see immediately what complementary colours are: the colours directly opposite each other in the circle.

What Newton did was analyse the wave frequencies that people and animals experience as light. What we see as colour is the reflection of light on the objects around us, from cars and trees to layers of air. What we experience as white is the full reflection of light, while black is the absorption of all the wave frequencies. Newton, who focused his research on the composition of light, did not include black in his colour theory since it was a total absence of light.

There is an important difference between mixing colours in the form of light (optical mixing or addition) and mixing colours in the form of dyes or pigments (physical mixing or subtraction). The rules for optical mixing are quite different from those that apply to physical mixing. In optical mixing – as in the case of theater lights – light is added; when red, yellow and blue are combined, the result is white. In physical mixing – as in the case of paint – light is taken away; when red, yellow and blue are combined, the result is black. This explains why the colours in a computer image appear so different from the printed image. It's because a computer monitor works with light and printing works with pigments.

Objects reflect some wave frequencies and absorb the rest. This has to do with the pigment, the colouring agent that consists of grains and determines how light will be absorbed and re-flected. Living creatures and organic matter such as trees and plants, as well as synthetic materials such as plastics and synthetic fabrics, all contain their own kinds of pigments.

If you really want to analyse colour you have to include the operation of the eye. The German writer and scientist Johann Wolfgang van Goethe (1749–1832) had little interest in the theories of Newton. He based his colour theory on ancient Greek philosophers, and his research mainly had to do with the workings of the eye. He was fascinated by natural phenomena such as the path of the sun across the face of the earth and how the colour of sunlight changes drastically from sunup to sun-down. One of the things Goethe wrote about was how the eyes (and the brain behind them) strive for harmony. If you gaze at a bright red spot and then turn away from it, you see a green spot as a kind of phantom left on your retina. This is called the

'simultaneous effect' of colours. In that same striving for rest and harmony, the eye, in concert with the brain, is capable of making adjacent yet contrasting colours coalesce. It's an effect of colour that many painters have con-sciously exploited, especially the Impressionists and the Pointil-lists.

Goethe worked with a colour circle in which yellow was shown opposite blue, red was opposite green and orange was opposite violet. In the early nineteenth century, his research was promptly converted into a useable colour theory for artists by the artist Philipp Otto Runge (1777–1810), the results of which were evident in his own work and in that of Caspar David Friedrich (1774–1840). But Runge relocated yellow across from purple or violet and blue across from orange, as Aguilon had done. The German philosopher Ludwig Wittgenstein (1889–1951) con-tributed significantly to the understanding of colour, and he further explored its subjectivity. The work of Goethe, Runge and Wittgenstein was of crucial im-portance to the artists working in Germany in the early twentieth century, who would raise colour to an independent visual medium in their work and would convert their ideas into an educational model at the German Bauhaus academy.

French artists, notably the Impressionists, Post-Impres-sionists, Pointillists and Fauvists, relied on the theories of their countryman Michel-Eugène Chevreul (1786–1889). In 1824, Chevreul became the director of France's most prestigious weaving mill, the Gobelins, from which the generic term 'gobelin' (wall tapestry) is derived. When he took charge of the factory the colour situation was completely out of control. The number of colours had risen since the Middle Ages from 40 to 30,000, and his goal was to impose order. He tried to cut back on the unman-

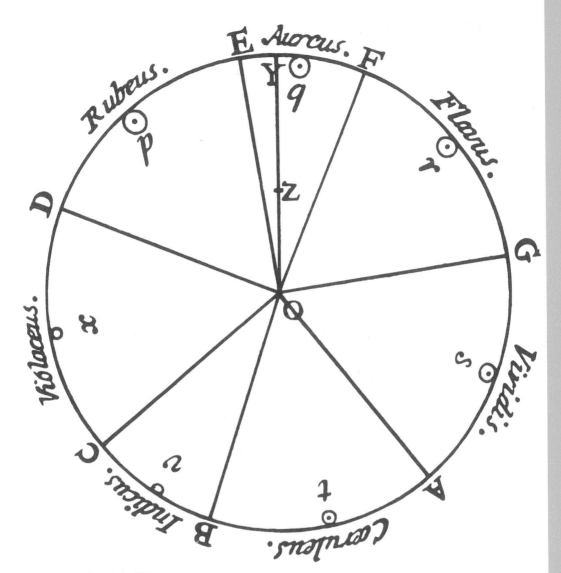

Isaac Newton, colour circle, 1704

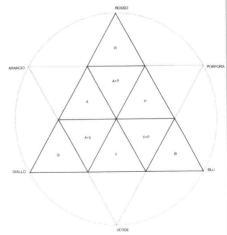

J.W. von Goethe, colour circle, 1810

ageable number of colours by designing a colour circle with equal greyscale equivalences, or the extent to which colours reflect light. By doing this he was able to reduce the number of colours from which his weavers could choose to 1,420.

Contributions to colour research and the systematic structuring of colour have come from unexpected quarters as well. In 1880, the English brewer Joseph Lovibond (1833–1918) began searching for a method to produce consistently coloured beer. Having noticed that stained glass windows in cathedrals kept their colour for centuries, he purchased various shades of brown glass, hoping to use this stable comparative material to develop a standard colour for his beer. He wasn't able to keep this discovery to himself, for the orders poured in and soon he was able to make any desired tint from combinations of colour filters in the three primary colours. Using his 'Lovibond Tintometer', a kind of slide projector, he ended up with nine million combinations and as many colour nuances.

The Dutch contribution to the scientific study of colour was made by Christiaan Huygens (1629–1695), a contemporary of Newton, who used his splendid lenses to prove that light is a wave phenomenon.

Experiencing colour
We must be able to communicate colour, but language has proven to be an inadequate tool for doing so. There are many systems for the standardisation of colour, but all of them have their shortcomings. One good example is the Pantone Matching System (PMS), introduced by the American Pantone company in 1963. The printer is given a number of standard colours of ink from which he can produce countless colour variations. The formulas for these variations are found in the 'Pantone colour fan'. Each number tells the printer how

to mix the corresponding colour. The system works very well for printing supporting colours. One inspiring application can be found in the magazine *View on Colour* by Lidewij Edelkoort, which includes a selection of Pantone samples. It cannot be applied to full-colour printing, however, where the colours are built up of minuscule dots consisting of four colours (CMYK).

The step of transferring a colour from the computer monitor to physical material – very important for designers – can be quite problematic. You can install wonderful programs on your computer to create magnificent colour combinations on screen, but when you have to convert them into a series of transparent plastic waste baskets, patterned pile carpeting or thick yarns for sweaters, vests and scarves, trouble arises. The only way to achieve excellent results is to go back to applying good old colour samples to the material itself.

Our eyes are extremely refined instruments that transmit countless signals to our brain so we can perceive all those millions of colours. The retina has two kinds of light-sensitive cells: cones and rods. The cones allow us to distinguish colour. The rods are more light sensitive and enable us to see in the dark. We cannot perceive colour in dim light, however, because the cones only work when the light is adequate. Most animals see colour just as humans do. Tests have shown that tortoises can distinguish colour well, but dogs much less. Frogs are programmed to jump on something blue when danger threatens and to avoid green. Most deep sea fish are colour blind; this has to do with natural selection, since they don't have to perceive colour and are mainly sensitive to the blue that penetrates the ocean depths.

Some people have faulty colour perception and are generally referred to as colour blind. That's not entirely true, however, since

there's nothing wrong with their vision. They only perceive colour to a limited degree. Colour blindness occurs mostly among men; it has to do with heredity. There are many different forms of aberrant colour perception with quite splendid names. 'Protanopes' confuse red and orange with yellow and green. 'Deuteranopes' have the same problem, but they can't tell blue from purple, either, while 'tritanopes' – who are very rare – confuse green with blue and grey with violet or yellow. Colour discrimination can be tested on the basis of the 'grey value'; different colours with the same grey value are combined in one picture, usually of a human or animal figure in one of the crucial tints.

That grey value is of great importance to designers. Say you want to bring out a product in a series of colours that have a certain coherence. You do that by choosing colours with the same grey value. If you're looking for contrast, then your options lie not only in your choice of reds, yellows or blues, otherwise known as the 'chromatic' contrast. Contrast can also be achieved by using tints that are related but have a very different grey value. The colour theory of Johannes Itten (1888–1967), an early instructor at the Bauhaus academy and quite influential, was based on seven different contrasts: besides chromatic contrast and light-dark contrast he also identified 'warm' and 'cold' colours, complementary contrast, simultaneous contrast, quality contrast and quantity contrast.[2] For our purposes here, the important things are knowledge of the colour circle, with its primary and secondary colours, and a firm grasp of the 'non-colours', white and black. The whole range of greys, also called achromatic colours, is also important, and what really matters in the end is the mutual coherence among

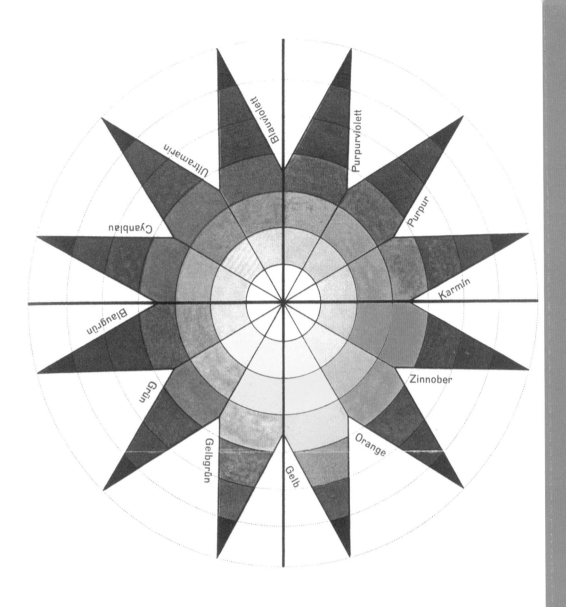

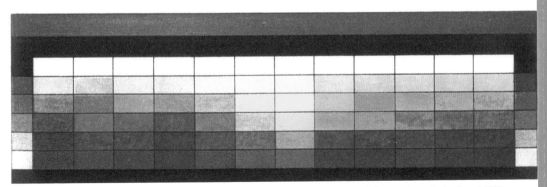

Johannes Itten, *Farbenkugel*, 1921

these elements. But once again it's difficult, if not impossible, to approach the visual qualities of colour combinations objectively.

Colour in art training

In every art program – from the painters' schools in Rome and Florence in the sixteenth and seventeenth centuries and the Paris Academy since the seventeenth century, to institutions such as the Royal Academy in London since the eighteenth century – colour has been the focus of serious attention. Students began by mixing their own paints. If you were a master, you could join with your peers in discussing the way to create a beautiful skin tone in oils. It was the German Bauhaus, however, that tackled the subject of colour theory systematically and made colour an independent part of the art and design curriculum. It was not a consistent approach. Interestingly enough, colour was first presented as factual knowledge and only then as a subjective phenomenon. Wassily Kandinsky (1866–1944) taught his students to study the relationship between colour and form. He arrived at a combination of colours and forms that was raised to the level of universal pattern: over the course of the twentieth century, the yellow triangle, the red square and the blue circle evolved into a logo for the Bauhaus as educational institution. Indeed, yellow is a much sharper colour than blue, and on the greyscale red is somewhere between these other two primaries. Sometimes the colour-form units are incorrectly cited by historians or designers, but a red circle next to a blue square and a yellow triangle also looks good, which proves that there's little absolute when it comes to colour, even from a historical perspective.

The Bauhaus was opened in Weimar in 1919 in a country that had been totally depleted by the First World War. It was a lost war

as far as Germany was concerned, and the reparations that Germany would have to keep paying to the winners would continue to have a serious impact on the country's economy. The first students to come to Weimar were rich in idealism but poor in money, food and clothing. They eagerly soaked up the education that was offered them, and with good results. Bauhaus teachers and students ended up in every corner of the world, and many, as teachers, passed their insights on to the next generation of students. In 1924 the academy moved to Dessau, to a building designed by Walter Gropius (1883–1969), the prominent first director of the Bauhaus. The rise of National Socialism in the early thirties did not auger well for this combination of progressive designers, artists and pedagogues. The end came in 1933, and what remained of the Bauhaus, which by then had settled in Berlin, was shut down.

In 1919 Gropius wasted no time in devising an educational model that required all students to take the so-called 'Vorkurs' (preliminary course). This course put them straight to work on elementary visual concepts like line, point, surface, light, colour, texture and structure. They also became skilled in composition, that being the unifying relationship tying all these elements together. Most of the teachers were artists themselves. Students could continue with more pragmatic courses by choosing a particular material and workshop, such as the wood, metal, textile or ceramics workshop. Those workshops were led by a technical instructor and an artist, each of whom made an equally significant contribution to the program – at least on paper. Finally, those who toughed it out to the end were given the opportunity to take a high-level course with architecture as the all-encompassing discipline, a program worthy of a

visionary architect. After World War II, the Bauhaus model was embraced in the art academies of the Netherlands, especially the preliminary year and disciplinary study.

The two most important pedagogue/artists to devote themselves to colour study at the Bauhaus were Wassily Kandinsky and Johannes Itten. The Russian Kandinsky has already been mentioned. He worked for long periods in Germany and based his ideas about colour on the theories of Goethe. He was a gifted colourist himself, which he had already proven between 1911 and 1914 with his *Compositions*: breathtakingly beautiful paintings (in my estimation at least) that are pure colour and movement. Itten, who was Swiss, developed the pedagogical basis for the *Vorkurs*. He founded his colour theory on the scientifically-grounded colour circle, and after his premature departure from the Bauhaus in 1923 he worked it into a complete model that was also widely used in the Netherlands. Even though his colour theory had a correct scientific basis, Itten's approach to colour was both philosophical and metaphysical. He acted like a guru and valued the intuitive more highly that the rational; emotion was the decisive factor. Yet his students were first required to complete rigorous exercises, such as painting colour circles and working with his seven contrasts.

Mixing colours requires expert skill. And far more importantly: although it's virtually impossible to objectify the quality of colour combinations, even with the colour circle, it is possible to conduct an objective assessment of suitable colour combinations in product manufacturing.

In the Netherlands, colour theory was still being taught in art and design academies in the sixties and seventies, but the balance between the technical study of colour and the percep-

Wassily Kandinsky, *Spannung in Rot*, 1926

tion of colour began shifting to the latter. Gradually the personal approach – 'I like this' – has gained the upper hand. More space was created for the emotional and symbolic value of colour, and a rich vein of meanings was tapped. Even the practice of linking colours with moral values, often based on age-old traditions, is being taken seriously. Blue signifies goodness; red means danger.

In the mainly Christian or atheistic West, blue is a cool colour that suggests rest, passivity, the sky and infinity and therefore stands for the intellect, loyalty and peace. That coolness in debatable in my opinion; I've seen lovely warm deep blues. Red, on the other hand, is associated with warmth and fire; it stands for passion and for the kind of love that goes hand in hand with passion. This results in the use of red as a warning signal for danger. Green is ambivalent and stands for conflicting notions such as life and mortality, for safety and envy or jealousy.

Every culture in the world has its own colour symbolism, which implies an infinite number of possible interpretations. The way colours are seen depends on the observers' regional and philosophical or ideological outlook. The interplay between reason and emotion in the perception of colour becomes even more complex when a contestable element like beauty enters the discussion. The beauty of a perfectly executed and scientifically correct colour circle, with flawless transitions between primary and secondary colours, proves woefully inadequate when the discussion turns to beauty that appeals to the eye and the mind.

Colour in fashion

Nothing illustrates the subjectivity of colour in design better than fashion, with its rapidly changing ideal of beauty. Clothing is worn on the body, so it invites the expression of personal preferences by both designers and customers – those who wear it. Here, too, we're faced with another duality, since colour can be one of the strongest unifying factors in fashion. During a single season or even over a number of years, a particular colour or colour scheme can enjoy incredible acceptance and widespread popularity.

Fashion thrives on longing, on the notion that the present is but a fleeting moment and on the optimistic belief that a new day is coming and you'd better make the best of it – by buying something new for tomorrow, for instance. Colour is a tried and tested way of arousing that longing. It's a primordial process, and even the enemies of fashion, who see it as a system for stimulating consumption, are sensitive to it. When non-colours such as black, grey and white are in fashion, there's an unmistakable increase in the longing for colour. When bright colours are in fashion, there follows a longing for more subdued tints. Fashion needs main colours for entire garments and contrast tints for the details. Colour in fashion is a question of painstaking coordination. It's no wonder that since the sixties, predicating colour developments in the fashion industry has grown into a profession of its own and is now being applied to furniture and other household products. Fashion designers are dependent on the availability of fabrics and other materials for clothing and for all the accessories that are part of any current fashion trend. Textile designers and textile manufacturers lay the foundation for colour in fashion in the products they supply, thereby exercising influence on many other disciplines.

In the fall of 2004, an exhibition on colour in fashion was held at the Mori Art Museum in Tokyo. The exhibition was divided into five galleries with five different colour schemes consisting of beautifully designed garments, five large video presentations of fashion shows and the colour of the environment itself. The first gallery was devoted to black, the deepest non-colour, which compels the observer to turn his attention to each garment's silhouette and texture. The next display, very cleverly executed, was a gallery featuring many colours in cheerful combinations – multicolour, as it's called in the international language of fashion. Not a single colour was left out. Following this was a blue gallery and a gallery with a red-and-yellow combination. The last gallery was devoted to 'mind-expanding' white. Since the Mori Art Museum is located on the 52nd and 53rd floors of an office complex and is eager to make use of the spectacular view, visitors exiting this last gallery passed straight into the white clouds, to magnificent effect.

The quality of the exhibition was determined first of all by the clothing itself, and that's not as logical as it sounds. If there's one discipline in which practitioners are trained to increase the product's value by means of presentation, it's fashion. But the Kyoto Costume Institute, founded in 1978, is the owner of a marvelous clothing collection, and that was the collection from which guest curators Viktor Horsting (1969) and Rolf Snoeren (1969) were able to draw. It was common knowledge in trade circles that the finest pieces in European fashion collections that had come on the market over the last twenty-five years via auctions, antique dealers and luxury second-hand clothing businesses, were quietly being bought up by the Japanese. The Institute also has the best examples of the work of the leading Japanese fashion designers. In 2002, the German publisher Taschen put out a thick book on the history of fashion from the eighteenth to the twentieth century that was based

Herbert Bayer, *Entwurf für die Wand-
gestaltung des Nebentreppenhauses im
Weimarer Bauhaus-Gebäude*, 1923

exclusively on the top items from the collection of the Kyoto Costume Institute.

There was plenty to enjoy at this exhibition: not only the clothing itself but also the powerful application of colour in each gallery and the way the galleries were arranged in sequence. The theme was more accurately 'fashion in colour' than 'colour in fashion'. With this event, based on a knowledge of the natural sciences, the history of technology, psychology, philosophy, cultural anthropology and cultural history, the Kyoto Costume Institute and the Mori Art Museum have upheld their reputation as makers of well-grounded exhibitions. But how do you convey all the associations and connotations of colour to the viewer? The research staff began with five basic themes: black for modernity, multicolour for diversity, blue for universality, red in combination with yellow for commerce, and white for purity. Viktor & Rolf were chosen as the designers for this exhibition because they had demonstrated with their Paris shows that they could comprehend the depths of fashion and play with it, too. Colour has played a leading role in a number of their shows. The deciding factor was the presentation of their 2002 winter collection, which featured chroma-keying, the effect used in television broadcasting when a blue background screen is electronically replaced by a desired colour image. Use of the chroma-key served to dematerialise colour in fashion and to render it autonomous.

Black has been in fashion for a very long time. From 1980 to the early twenty-first century, black was the favorite colour for designers experimenting with cut, material combinations, detailing and finishing, or rather the 'lack' of finishing. The frayed seam and hem became fashionable by means of black. The Japanese avant-garde designers in particular demonstrated a strong preference for black during this period. Black provides a beautiful contrast with many different skin colours, the strongest being with white skin, of course. It intensifies the contrast between the clothed and the unclothed parts of the body. So the 'little black dress', introduced by Chanel in the twenties as the ideal basic party garment, was also prominently represented in the exhibition.

The cultural period of Classicism, which followed the French Revolution of 1789, was a decidedly white period. This had to do with the prevailing sense that a new social model had been launched based on classical antiquity. But it can also be traced to contemporary developments in the bleaching of cotton. For the first time, thin white cotton was available in large quantities.

It was a great relief to see that a neglected theme like the influence of new dyes on colour in fashion was finally being explored in Tokyo. The trade in dyes by land and by sea had traditionally been a decisive factor in the development of taste and fashion. At first it was a small elite who set the tone, since they were the ones who could afford the expensive new dyes. That triggered a demand for particular dyes, a commercial interest that was usually recognised rather quickly. Tints of red, indigo blue and saffron yellow have been in fashion since the days of antiquity, for instance.

The discovery of aniline dyes in 1856 was a side effect of the research being conducted by the English chemist William Henry Perkin (1838–1907), who was searching for a medicine for malaria. It resulted in a tidal wave of sharp and rapidly changing colour contrasts in the second half of the nineteenth century. Various deep purples and violets like magenta and a vivid colour like fuchsia were combined with deep black or light yellow. Until that time, deep colours, which required a great many dyes, were reserved for the nobility. Then in around 1860, practically from one day to the next, they became common property. In the twentieth century, too, colours came into fashion thanks to technical developments, such as the production of new materials and new coatings. Take the shocking pink of plexiglas and synthetic fibers, or the various metallic coatings. As for the twenty-first century, we can still expect to see new colours being launched purely on the basis of new developments in materials and techniques.

Naturally, fashion in colour was also determined by cultural factors. In around 1910, fashion in Paris and other fashion centers became extremely colourful due to the influence of Diaghilev's famous Ballets Russes with its visually magnificent performances. That followed a period in which markedly pale hues dominated the refined clothing of the elite. An interesting complement to this is the rise of the indigo blue used in blue jeans, which was promoted from workers' clothing to leisure wear and finally to high fashion in the decades after the Second World War – perhaps the most widespread fashion trend the world has ever seen.

There are colours and colour combinations that have never been 'out of style', such as dark blue and white. The only problem is that designers and stylists keep having to come up with new terms with which to recommend this colour scheme, even though everyone in the fashion world knows what 'navy blue' means. You find navy blue among couturiers, international designer clothing and clothing without labels. You also find very good colourists there. I may regard Yves Saint Laurent, Paul Smith and Junya Watanabe as some of the top colourists in fashion, but the industry requires

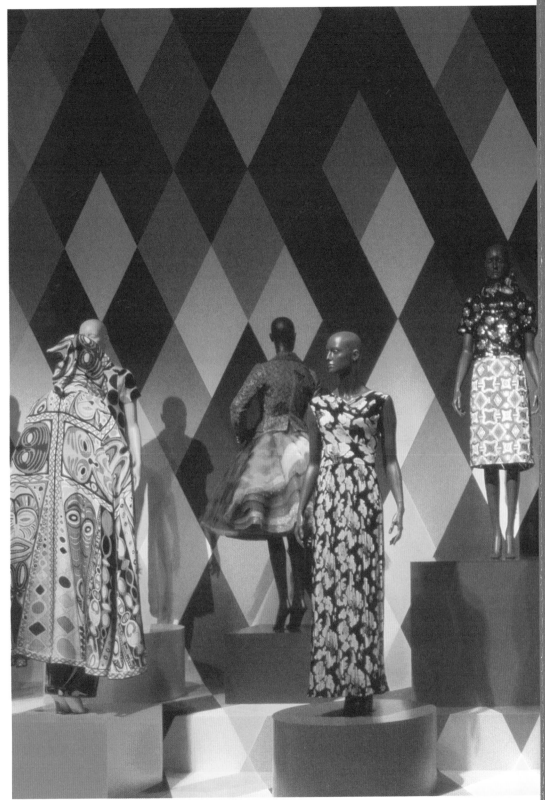

Installation at the exhibition *Fashion in Colors*, Mori Art Museum, Tokyo, 2004

colour-sensitive people at every level.

There's much more to be said about colour in fashion, but for now this conclusion will have to suffice: that colour in fashion and fashion in colour are less subjective than you might think at first glance. External and more objective factors also play a major role, such as trade relations and discoveries in textile bleaching and dyeing techniques, in addition to culturally specific motives that may have their source in the ballet, for example, or developments in the art world.

Looking

One important question is the extent to which colour and colour theory are still an integral part of the curricula in design and art academies in the Netherlands and elsewhere. It may not be very stimulating to spend months making colour tests based on strict chromatic rules, but what's often happening now is that colour is being regarded only in terms of its subjective values, and students are being asked to respond purely in terms of their 'colour sense'. This doesn't result in great clarity or to skilled use of this fantastic medium. At the very least, concepts and principles are being introduced in the classroom that make it possible to exchange ideas about colour. This concerns not only colour theory but also practical things like pigments and techniques. There's a vast arsenal of expert knowledge that designers in many different disciplines can access.

In today's consumer society, colour is a number one selling point. Products are sold because the colour is 'good', whatever that may mean from season to season, and sales are bound to be good if you tempt the consumer to buy something because it matches something he already has, not because he really needs it. The great thing in a country like the Netherlands is that a good, coherent and up-to-date colour palette is within reach of almost everyone: in early 2005 the prestigious Sikkens Prize was awarded to the popular Hema department store for its colour policy.

Any designer who can come up with beautiful colour combinations and interesting series of colours has a formidable point in his favor. Colour is a sensory experience. You can find inspiring colour combinations everywhere, and many of them have come about without a designer's intervention. The key is to keep your eyes open – to look – and looking can be trained. A hundred different shades of grey can be as deeply satisfying as a deep royal blue or a passionate red. It's just not easy to reach agreement when it comes to colour preferences. Designers who are ready to commit themselves to that one colour choice have the option of satisfying their own taste, that of their client or that of the general public. It all depends on the area in which the designer is working. But a good colourist will have to satisfy all three, intuitively, maybe with some kind of colour prognoses in the back of his mind. A less skilful colourist would be wise to make use of all the available aids and tools. Even colourblind designers should be able to provide nicely coloured work to non-colourblind clients as long as they receive the proper advice.

The conclusion of this long story is that colour in design is primarily a matter of imagination and association, and only then a matter of scientifically grounded research. Techniques like the application of pigments play a leading role. My contention is that feelings may come before system, but a good grasp of system and technique is what any designer needs in order to put those feelings to work.

Notes

1. Franciscus Aguilon, professor of theology at the Jesuit college in Antwerp, proved an exception. Long before Newton's research he developed a colour scheme with yellow, red and blue as the three main colours and green, orange and purple placed in between. His theory was confirmed by Newton.
2. Johannes Itten, *Kleurenleer*, De Bilt, 1970 (original title: *Kunst der Farbe* [*Studienausgabe*], 1961).

Literature

50 jaar Bauhaus, Stedelijk Museum Amsterdam, 1968

Cole, Barry L., Jennifer D. Maddocks and Ken Sharpe, 'Visual search and the conspicuity of coloured targets for colour vision normal and colour vision deficient observers', in: *Clinical and Experimental Optometry* 87, no. 4–5, (July 2004), p. 294–304

Cooper, J.C., *Illustriertes Lexicon der traditionellen Symbole*, Leipzig, 1986

Deventer, Mart van, 'Opvattingen: Strijdpunten en misverstanden over kleur', in: *Kunstschrift*, Openbaar Kunstbezit (1987), no. 6, p. 196–203

Fukai, Akiko, Tamami Suoh, Miki Iwagami et al., *Fashion. A History f rom the 18th to the 20th Century. The collection of the Kyoto Costume Institute*, Cologne, 2002

Haan, Hilde de, and Ids Haagsma, *Wim van Hoof: Vakman, polychromeur: Kleur en architectuur*, Stichting Fonds voor beeldende kunsten, vormgeving en bouwkunst, Amsterdam, 2001

Salome, Lotte, 'En toen… wegenwacht', in: *Trouw*, Monday, January 24, 2005, p. 11

Spiering, Hendrik , 'Nol, Wor en Wap', in: *NRC Handelsblad*, Saturday, May 8, 1999

Viktor & Rolf & KCI, *Colors*, exhibition catalogue, The National Museum of Modern Art, Kyoto, 2004

Walraven, J., *Kleur*, Ede, 1981 (original title: *Colour*, London, 1980)

Domestic

Gert Staal
**Colour and interior.
In search of a lost
sensibility**

They still exist, the hypersensitive ones. The ones who cannot tolerate the idea of an interior as a hotchpotch of artefacts that entrench themselves in your physical existence over a succession of life stages. The ones who work fastidiously to bring everything in the world around them into balance – who treat their environment like a composition, orchestrating its unity down to the last note and throwing all the dead weight overboard, starting all over again if necessary until they reach the moment of perfection.

People like the stylist S.M., in whose hands even a relatively colourless upstairs apartment in Amsterdam has acquired the astonishing coherence of an oriental period room in a museum: running water in the hallway, gold leaf ornaments on a chocolate brown wall, economical use of lighting. Or an antique dealer like A.V., who has managed to elevate every room in his Belgian castle to nothing short of theatrical décor: a boudoir with a work by the painter Lucio Fontana almost haphazardly placed on walls of oxblood red, with draperies that bear a deceptively strong resemblance to mailbags but in reality were fashioned from the most expensive silk, and with a couch so oversized that it became a place to sit, a bed and a table all at the same time. Walls brushed with the simplest whitewash serving as a powdery background for a set of porcelain recently salvaged from a sunken ship of the Dutch East India Company.

The French novelist J.-K. Huysmans brought such a person to life in his novel Á rebours (1884).[1] The main character in the book, Jean Floressas des Esseintes, is an aristocrat who, out of

boredom, exchanges his life in the Parisian beau monde for an existence on the outskirts of the city. He moves into a house that he makes over entirely to suit his decadent taste, a place so perfect in its artificiality that Des Esseintes hardly needs to participate in public life any more. His world turns against nature, against the unpredictability of events that evade his central control. In other words: his interior surpasses nature by perfecting it.

In choosing a colour scheme for his rooms, the young aristocrat turns to his favourite literature for inspiration: mainly French and classical Latin texts. Every choice he makes is based on a cultural reference. The interior decoration of the house does not express any general taste or collective ideology, but is merely the expression of the solitary intellect, the personal association.

Á rebours marks a moment in history in which an individual could declare his identity by means of his daily living environment. Origin, social status, profession: all these factors were critical in the interior decoration of palaces and villas, city apartments and country houses. Even back in Huysmans's day, such conventions played an important role in the values that the interior represented. But at the same time the home environment was a reflection of a unique identity: that of the specific occupant. Affected, reserved, historical, functional or theatrical, one's home could be an encyclopaedia or a poem, a random mathematical sum or a meticulously animated work of art.

Exactly twenty years before the appearance of the novel, Owen Jones published his book The Grammar of Ornament in which he formulated his 'General Principles in the Arrangement of Form and Colour in Architecture and the Decorative Arts'. In 1851 it was Jones who was responsible for the colour scheme of the Crystal Palace in London. His

approach to Joseph Paxton's sensational edifice involved the use of mainly primary colours: red, yellow and blue. In writing his book, Jones followed in the footsteps of Gottfried Semper, his source of inspiration, and searched for universal patterns to which the use of colour in architecture was subject.

Jones saw colour as a means of developing and understanding form, which implied that colour was subordinate to form. As long as colours are properly distributed across an object they can help to distinguish light from shadow, and colours can make a noticeable difference in indicating the bottom and the top of an object: primary colours mark the uppermost part, secondary and tertiary colours are meant for the bottom. 'Black grounds suffer when opposed to colours which give a luminous complementary,' Jones wrote.[2]

Apparently the main character in Á rebours was aware of that pitfall. When Des Esseintes first designed his dining room his colour scheme was totally black. The garden paths that were visible from the dining room were done in charcoal black. The pond, wedged between blocks of basalt, was filled with ink. Naked black women served the meals, which consisted of blood sausage, turtle soup, caviar, black bread and Turkish olives on black-edged dishes. An orchestra, invisible to the visitor, played funeral dirges.

Gradually the aristocrat grows tired of so much mischief. The next transformation of his house will have to be less extravagant (at least to the main character's way of thinking), and particularly less aimed at impressing his guests. In the end, the only person meant to derive pleasure from the house in Fontenay-aux-Roses is the inhabitant himself. He creates an interior that has to be comfortable, even though it's decorated in a peculiar style. The rooms provide a restful if unusual

environment, Des Esseintes decides, and are geared to the needs that his future state of solitude will require. He still colours the water, although now it's in his aquarium. But the colours he seeks are constantly changing, just as the colours of a river change at different times or under different weather conditions. Des Esseintes colours the water with green essences, silver or grey, depending on the fluctuations in his state of mind.

In 2005 there was a corner house in the Hoograven suburb of Utrecht that lay empty. The cubical structure was part of a complex that the architect Gerrit Rietveld had planned for this new part of the city fifty years before: a collection of apartments alternating with a few low-rise blocks.

Rietveld's functionalist designs made a direct connection between interior and exterior, the private and the public domains. To supplement the modest and rationally subdivided residences he created a generous open area that had the same spatial transparency as the houses and was expressly designed to serve as a common facility. A well-lit interior – where the family could find rest and peace of mind – opened onto a green open area. This common space was where post-war city-dwellers could meet each other and develop as a healthy community.

In the autumn of 2005, curator Guus Beumer, designer Herman Verkerk and yours truly were able to 'purloin' this building for a short time in anticipation of a renovation. For a few weeks, the house was part of the exhibition *Now & Again*, organised as part of the *Utrecht Manifest* design biennale. It was briefly transformed into a 'black house' within a natural setting that was also made as black as possible. The characteristic transparency of the house was negated by a screen of black strips placed over the facade, like a stiff

curtain between the interior and the exterior. The garden soil was dug up until it looked black. The interior was fully stripped of all its brightness. Floors, walls, ceilings, stairs, the kitchen: everything was painted pitch-black or covered with black fabric. Lamps, vases, chairs, pans and pens: every object in the house was purchased from among the black merchandise being sold by big department stores and trendy shops for household goods. Not much high design, but plenty of baroque furniture and chandeliers taken from high design that were setting the tone in popular magazines at that time.

Unlike the black dining room in Huysmans's novel, this was not about the projection of an individual aesthetic or about the personification of someone's decision to abandon the social order, expressed in one particular interior. In this exhibition, the house represented a collective reorientation, both within the design world and in the perception of a society that had been shocked into an awareness of the threats to the public domain. The Black House can be understood as a three-dimensional book of trends, offering a vision of current reality and the prevailing preference for a historic style with references to the Baroque, Rococo and Biedermeier periods.

The colour black made it possible for the historical design language to align itself with the functionalist interiors of the fifties. The colour became a medium, a floodgate between the past and the present. The reason for this may have had something to do with the abstract quality of black, which tended to neutralise the historical overtones of the various decorative products and enable the interior to function primarily as an image in its own right.

There's more than a century separating the house on the edge of Paris from the one in

Utrecht – Fontenay from Hoograven. During that period, private homes in the West gradually became more transparent entities. As the conflict between outside world and private life dissolved, the interior was able to turn its face outward with less embarrassment, like a display window for self-confident citizenship. Even two world wars were not able to influence that process to any significant degree. Under the influence of mass education, mass communication and mass consumption, which was the result of a distribution of wealth, the fear of the unfamiliar disappeared. The private home no longer had to barricade itself from its own surroundings like a fortress.

With the security crisis of the early twenty-first century, this perspective changed drastically. Suddenly the interior is no longer an invitation to the outside world but a buffer against an unpredictable reality, a place to which the occupant retreats from public life. Those who design such interiors have little to gain from the doctrines that produced the 'doorzonwoning' – a Dutch housing style that was almost universal in the latter part of the twentieth century in which the living room ran the full length of the house, with large windows on both ends to let in plenty of light. Designers today search for reassurance in an idealised and private past in which the world still seemed 'intact'.

For a long time, the basic principle that dominated the discourse on modern interiors was Modernism. The designing of furniture and appliances, and even the development of colour schemes regarded as suitable in these domains, was subject to an almost unassailable law. The 'whitening' of the middle-class interior may have been based on a rather limited interpretation of colour use by the pioneers of twentieth-century architecture,

Steven Aalders, *Color Study (Saenredam)*, 1999

Page 116
Pieter Saenredam, *St. Odulphuskerk in Assendelft, 1649*

as Mark Wigley convincingly demonstrated in his book *White Walls, Designer Dresses*. Nevertheless, white had become standard throughout the second half of the twentieth century. What the prophets of good taste of the fifties and afterwards essentially were doing was endorsing a plea that the painter Theo van Doesburg committed to paper in 1930. Van Doesburg called white 'the spiritual colour of our age'. Pure white, he says in his article 'Vers la peinture blanche', 'is the colour that extends across an entire era; our time, which is one of perfection, purity and certainty'.[3]

'Matt Black', as it was known in the terminology of the British design magazine *Blueprint* at the time, was the single most important distinguishing characteristic of the industrial design products of the eighties. The hinged Tizio lamps of Richard Sapper (small red details), the Braun calculator (orange and yellow keys), the A'dammer cabinet of Aldo van den Nieuwelaar (also available in white, by the way). Black lacquer and powder coatings gave such products a well-marked place in the otherwise light interior, actually emphasising their solitary, objectified status. Because 'timelessness' was seen as an essential quality of design, colour was not required to make any kind of time-specific statement. On the contrary, the outspoken use of colour was left to stylists, and stylists were rarely welcome figures in the domain of the designer.

Despite the nuances added by the Modernists themselves as well as by Post-Modernists and other critical social movements (take the influence of the squatter movement in various European countries, for example), the design world remained extremely loyal to the supposed purity of early Modernism, even when it came to the use of colour and certainly when it came to the use of white.

'Contemporary architecture has typically continued to labour under the yoke of Modernist morality in relation to colour,' comments Mark Pimlott, senior lecturer in Architecture at Delft University of Technology. He points out that the increasing autonomy of art and architecture under Modernism made for a strained relationship. While artists were allowed to embrace colour, colour was shunned by architects. The only place where colour was tolerated was the interior, 'where it could play a relatively traditional role in private domestic scenes'.[4]

J.-K. Huysmans used several pages to describe the colour scheme of the house in Fontenay-aux-Roses. The figure in his novel painstakingly reports his preferences and choices, pondering the influence of candlelight on the intensity of the colours he chooses, for example. At the same time, he explains why other options are more suitable for people who have not had the opportunity to train their eyes through the study of art and literature. For the decadents of the late nineteenth century, knowledge and the experience of beauty were inextricably linked.

Interestingly enough, the mission of the Colour Lab that was recently set up by designer Hella Jongerius in Berlin is based on a comparable notion. After her Polder Sofa (2005) was put into production by the Swiss furniture manufacturer Vitra, a request came to develop new colours for the famous Lounge Chair designed by Charles and Ray Eames, a steady Vitra product. And then she was asked to think about a colour system for the company's current and future products. The colours had to be suitable for such a wide range of materials as foam and hard plastics, leather, lacquered and anodised metal, wood and various kinds of fabrics.

Jongerius has discovered that

there is an essential difference between her approach to interior colour and the conventional approach. In an interview in the magazine *Frame*, she says, 'I don't approach it [colour, GS] as a stylist. I consider all aspects of colour. What you're seeing nowadays in interiors are industrial colours that have emerged from trend-forecasting. The *in* colours are determined for us. You no longer hear anyone asking, What do I like? What suits me? Only series of system colours are available. There's no connoisseurship involved, no artistic hands-on experiments while relying entirely on intuition, no language of colour, no knowledge and little experience. It's all exceedingly flat.'[5]

A hundred years ago, she says in a recent video interview, colour was a valued aspect of our cultural heritage, but nowadays it's dominated by the poverty of the manufactured product. Painters knew that in order to make red darker you had to add green, the complementary colour. That gave the colour depth. But today the industry's method of darkening colour – any colour – is just to add black. There's no research required, and it saves time. In other words, 'a fast-food colour industry' has developed. And the consumer is no longer aware of any other possibilities…

In early 2010, the Musée des Arts décoratifs in Paris presented the study exhibition *Aussi rouge que possible*… A number of objects were assembled from all parts of the collection: furniture and tableware, jewellery and clothing, sketches and vases, posters and toys – from many centuries and several continents – and all of it red, the colour which, according to the museum, is 'suggestive, versatile, off-putting, powerful, majestic, luxurious, erotic, enchanting and devilish'. It's the colour of fire and blood. In another part of the museum there's a series of splendid

Gert Staal

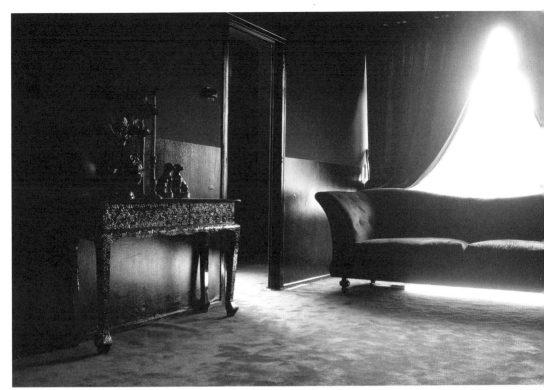

Guus Beumer, Gert Staal, Herman Verkerk,
Het Zwarte Huis (The Black House),
biennale *Utrecht Manifest*, 2005

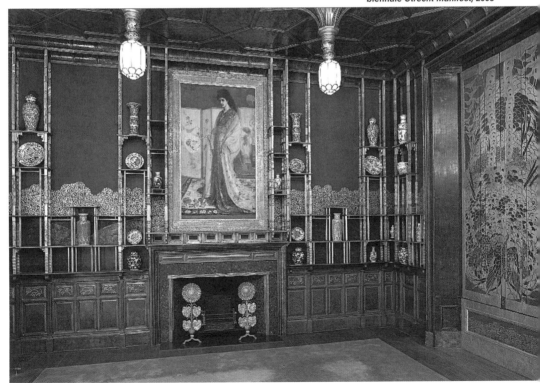

James Abbott McNeill Whistler, *Harmony
in Blue and Gold*, Peacock Room in

the house of Frederick R. Leyland,
London, 1876–1877

drawings showing how the excavated remains of Pompeii inspired architects, especially those from the mid-nineteenth century like Alfred Nicolas Normand, to apply the red ochre found in the villas of Pompeii to the interiors of stately Parisian residences. The depth of colour mentioned by Jongerius, the colour sensibility that's been pushed aside by industrialisation: all those qualities are fully present in the series of sketches made by Normand for a house on the avenue Montaigne, the so-called 'Maison pompéienne du prince Napoléon'.

When you think about the Vermelha Chair designed by Fernando and Humberto Campana, which is also part of *Aussi rouge que possible...*, you see not only how flat the idea of modern furniture design is (a tub in the form of an almost randomly shaped ball of string) but especially how uninteresting – 'flat', as Jongerius calls it – the red of the string actually is.

Jongerius has set a task for herself and her colleagues, and that is to restore the subtlety to design, and with that to the application of colour. It's that subtlety that's crucial to her research. The core of this was already in evidence in the installation *Inside Colours* (2007), which she made for the Vitra Design Museum in Weil am Rhein. She locates her colour study on the borderline between the traditional research conducted by an artist and the systematic methodology of the scientist. 'Through this kind of exploration, I want to develop artistic, high-quality colours that can be applied within both design and architecture. [...] One of my goals is to develop an open language for the profession – a system, but without numbers and colour fans.'[6]

On the one hand she seems to be conducting some kind of archaeological project, levelling and reconstructing history layer by layer, and on the other hand she's making an almost speculative bid for the future. Whereas the architect Normand used antiquity literally as a source and point of perspective for the perfect mid-nineteenth-century interior, the twenty-first-century designer is not interested in actual reconstruction. What must be rediscovered for the sake of the ideal house are the right sensibility and a common language so that colleagues can discuss that sensibility, at least among themselves.

It's a domain that the British writer Oscar Wilde regarded as the essence of the visual arts. In a lecture he gave in 1882 entitled 'The House Beautiful', Wilde referred to the Peacock Room, created in London five years earlier by the painter James Abbott McNeill Whistler. Wilde said that that room, which incorporated all the colours of the peacock's tail, was the best work in terms of colour and decoration that the world had ever seen since Correggio. Painters as well as designers 'must imagine in colour, must think in colour, must see in colour'.[7]

For today's designer that may sound like a familiar lesson, but all too often reality proves the opposite. In their dealings with colour, architects rarely depart from a limited palette of 'safe' colours, particularly when they're working on an interior. Usually the colours in such projects are so completely diffused that they almost never have an autonomous significance of their own. Should an unsafe colour happen to pop up, however, it's mostly just to attract attention: after all, the bar in the new corporate office did need a little something to make it look welcoming.

A simple sketch by Charles and Ray Eames from 1949 – probably mostly the latter's work – ruthlessly reveals how simple it was for these designers to connect the artistic use of colour with their own work. The sketch 'Room Design' seems like a design for an exhibition on contemporary housing.[8] In an almost nonchalant gesture, all the objects in the room – cabinets, table, a rug, a painting – are reduced to one coherent colour composition. Colour is equivalent to form at the very least; colour has almost become function.

Artist-designers like Whistler, Ray Eames and, more recently, Liam Gillick and Tobias Rehberger, explore the space-colour dynamic, thereby imparting additional meaning to the perception and the use of that space. Rehberger did that quite deliberately in his café for the Biennale Pavilion at the 53rd Venice Biennale (2009). He was awarded the Golden Lion for his design as the event's best artist. In the opinion of the jury he had earned this distinction 'for taking us beyond the white cube, where past modes of exhibition are reinvented and the work of art turns into a cafeteria. In this shift social communication becomes aesthetic practice.'[9]

For a long time the exhibition hall has served as a neutralising blank screen between art and daily reality. In fact these spaces are very much like the white tents that are hastily set up to isolate a serious crime from the surrounding environment. In Rehberger's café, the exhibition site once again assumes the features of the salon: the place where art and conversation, drinks and meditation exert their influence. Rehberger's work can also be regarded as restoration in another sense. In taking this step he was following a long visual arts tradition in which the emphasis lay not on the painting as a portable, independent object but on the work of art that was fully integrated into the constructed surroundings and set the tone for that environment.

In the first months of 2010, the first phase of a transformation in

Gert Staal

Ixion-room, House of the Vettii, Pompeii

Rowan and Erwan Bouroullec,
Room screen, 2008

the academic children's hospital in Amsterdam could be seen. The only children who come here are those with especially serious, sometimes life-threatening diseases and chronic illnesses. Up until now, these children were treated in surroundings that were hardly any different from the nearby adult wards. Painted or copied figures from popular children's books gave the corridors the improvisational character of a nursery school.

The interiors of the renovated children's hospital were designed by Opera Amsterdam, chiefly known for decorating exhibition areas in the Victoria & Albert Museum in London, the Museum Volkenkunde in Leiden, the Rijksmuseum in Amsterdam and other such locations. Colour plays a crucial role in the presentation of the new hospital. Not only did Opera develop a colour system that corresponded to the various components of the architectural plan, but it also analysed the way in which the children observe colour in various situations. It was all about striking a balance between an environment that was rich in sensory stimulation and, in the immediate vicinity of a terminally ill child, an environment with a low stimulation level. A child lying in bed never looks for bright colours, for example. A separate colour scheme was created for each part of the children's hospital – from the infants' ward to the ward for young adults – so the colours could also play a role as signposts.

Earlier on, the architect had assigned yellow as the uniform colour for the entire complex. Opera added a second colour for each ward, and all the colours together form their own spectrum. Each ward was also given a so-called 'joker' colour, which occasionally contrasts harshly with the others. The designers derived the second colours from an overall plan in which they approached the

hospital like a city with all its individual features: botanical gardens, a zoo, etc. The colours were a logical extension of that metaphor, reinforcing the design's total concept. It's interesting that because of the metaphor, the colour scheme has never been a topic of discussion with the hospital's end users: they accept the result because they understand the logic.

The designers have seen how important the application of colour is in a project like this. Unlike the design of the average exhibition, here there's a demonstrable connection with the well-being of the individual. Colour is a critical factor in the conditions that the hospital offers the child and its family; colour directly influences the state of mind of everyone concerned.

That's exactly what Hella Jongerius means when she explains why the application of colour can enrich the design discipline: 'Colour can calm you, give you energy, let you disappear by stimulating your imagination and influencing your mood. You can organise a room around colour, and colour can allow objects to merge, to whisper or to shout. Ultimately the need for colour is about well-being. Shoved aside by decoration, well-being means far more than just feeling good. Well-being entails a greater awareness of the world around us, and with that kind of awareness, there's simply no way to ignore colour.'[10]

The pursuit of well-being has emerged as a constant in this modest search for the relationship between the architectural interior and colour use. It may even be the key concept that links the two domains. In both the physical design of the home and the application of colour, the occupant projects a longing for harmony, for protection, for social acceptance or for personal development. And as

Jongerius rightly observes, the concept of well-being as it is used throughout history and in different parts of the culture definitely means more than that the person or group in question simply 'feels good'. Take the well-being of a group of squatters: if there's one thing that the colour spectrum in their temporarily occupied accommodation does *not* express, it's social acceptance. Yet hidden within their non-conformity is a group code that dictates a completely uniform picture: this is the typical squat of a Western metropolis, painted every colour of the rainbow.

In a tradition in which the interior is mainly the reflection of social status, well-being cannot be seen apart from the need to 'fit in' socially. Even in the urban palaces of the Italian renaissance, it was clear to every well-to-do resident that the furnishing of the *sala* (reception room), the *scrittoio* (study) and even the *camera* (bedroom) had to satisfy the requirements of social intercourse in the city. That tradition continued through later centuries. Social standing goes hand-in-hand with interior decoration, even in the Low Countries of the seventeenth century, where material wealth could be displayed as long as it was hidden from the public eye.[11] The houses in which rich merchants dwelled are still being occupied by an elite in the year 2010. And that elite also follows a code, in which well-being and public visibility have become each other's most loyal companions.

If the way colour is being used in design and interior decoration today has anything to tell us about the relationship with the concept of well-being, it's that a fundamental reorientation is in the making. More and more people, especially professionals, are expressing their dissatisfaction with an efficient but inadequate industrial output. In addition, many of the old codes are

Gabriele d'Annunzio and Gian Carlo Maroni,
music room in *Vittoriale degli Italiani*, 1919–1938

BUILDING TOY

ts colored panels make variety
of playhouses, tents or planes

Charles and Ray Eames, *The Toy,* **1951**

One of the most imaginative playthings of the year, called simply The Toy, has reached U.S. stores. Designed by Charles Eames, it especially intrigues young men (5 to 10) who have an engineering or architectural bent and young ladies (same ages) with a homing instinct. Each toy consists of four 30-inch plastic-coated paper squares and four 30-inch triangles in brilliant colors. Five toys were used to make the shapes in which the children (*above*) are lodged. There are also a number of dowels and 36 colored pipe cleaners (*top, center*) to hold the parts together. These parts come compactly rolled in a 30-inch tube. An instruction sheet suggests numerous roomy house shapes for a child to build and play in, and many others may be invented. The Toy costs $3.50 and is easy for a child to assemble since the parts are large and easily connected.

Jürgen Mayer H., *MyHome* exhibition,
Vitra Design Museum, Weil am Rhein,
2007

Zuigelingen Hortus

Intensive Car

Tieners Sport / Spel

Oncologie Fau

Opera Amsterdam, renovation of the Emma Children's Hospital
AMC, 2010, colour palettes for the identification of the wards

128

1) MAIN AREA – INDEX AND DIRECTION PANELS (WALL MOUNTED)

2) ONGOING ROUTE: FLOOR ICONS

H7

Zuigelingen

Staf

Color: Pantone 382 Font: Chevin Bold | 330 pts. | tracking 35 pts.
Color: Pantone Cool Gray 11 U

Color: Pantone 1565 Font: Chevin Bold | 330 pts. | tracking 35 pts.
Color: Pantone Cool Gray 11 U

3) DESTINATION SIGNS

Opera Amsterdam, renovation of the Emma Children's Hospital AMC, 2010,
directional signs for the walls, icons for the floors, destination signs

clearly on their last legs. The terms imposed by Modernism are no longer of any practical significance in a world where trends follow each other at such a murderous pace that even temporary footing has become unreliable. The belief in superior taste, or in a spitefully professed 'bad taste', or the trust in hypersensitives with an absolute sense of colour: it's all on the wane.

Apparently the time has come for another round of self-examination, this time by traditional and empirical means: by experimenting and observing, by placing function above taste and meaning above ideology. In this journey of discovery, the architects seem to have relinquished all control. It's designers like Hella Jongerius, artists like Tobias Rehberger and interior designers like Opera who are prepared to begin again from the bottom up: with processes, with history, with function, with the perception of colour, with a form of well-being that is largely personal and at the same time cannot exist without any demonstrable relevance for the community at large.

Notes

1. J.-K. Huysmans, *À rebours*, 1884. Consulted text: J.-K. Huysmans, *Against Nature*, Sawtry 2008, introduction and translation by Brendan King.
2. Owen Jones, *The Grammar of Ornament*. Original text reproduced in: Susanne Komossa, Kees Rouw and Joost Hillen (eds.), *Colour in contemporary architecture: projects / essays / calendar / manifestoes*, Amsterdam 2009, p. 348.
3. Theo van Doesburg, 'Vers la peinture blanche', *Art Concret* 1 (1930), no. 1. Quoted in: Mark Wigley, *White Walls, Designer Dresses*, Cambridge, MA/London 2001, p. 239.
4. Mark Pimlott, 'Colour in Architecture', in: Komossa et al., *Colour or contemporary architecture: projects / essays / calendar / manifestoes* (see note 2), p. 88.
5. Ibid., p. 89.
6. Femke de Wild, 'Symphony of Shades', *Frame*, no. 70, Sept. / Oct. 2009, p. 188.
7. Ibid., p. 190.
8. Oscar Wilde, 'The House Beautiful' (1882), in: *The Collins Complete Works of Oscar Wilde*, London/New York 2001, p. 916.
9. The sketch 'Room Design' is shown in Alex Coles, *Design Art: On Art's Romance With Design*, London 2005, p. 134.
10. Press release for La Biennale di Venezia 2009: Fare Mondi (Making Worlds).
11. De Wild, 'Symphony of Shades' (see note 6), p. 190.
12. A phenomenon that the British historian Simon Schama appropriately characterised in the title of his study of the culture of the Low Countries during the Golden Age: *The Embarrassment of Riches* (1987).

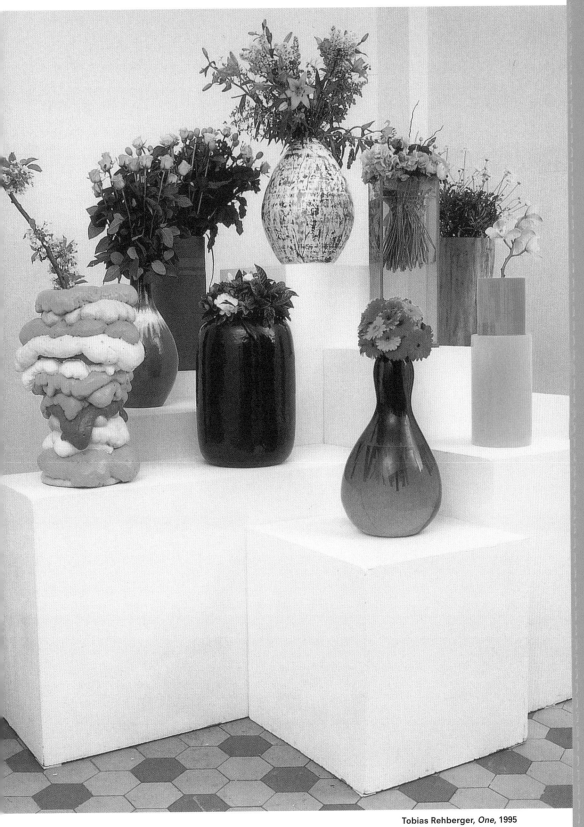

Tobias Rehberger, *One*, 1995

Louise Schouwenberg
One colour is no colour

Passages from 'a conversation that might have taken place', a fictional conversation between Hella Jongerius and Louise Schouwenberg (the final version of the full text appeared in the monograph on Jongerius published by Phaidon Publishers in November 2010).

HJ
Everything around us has colour. As soon as we open our eyes we see a palette of colours through which we can make out people, objects and landscapes. Colour determines how we see things, how we feel. Something like that deserves quality treatment, but I don't find quality in the vast range of colours offered by the paint and coating industry. I do, however, see it in the fine arts. Look at the paintings of Paul Cézanne, Mark Rothko and Barnett Newman. Every tone, every nuance, every colour combination is the result of endless experimentation with pigments, mixing and layering. Newman's monochrome paintings are built up of meticulously applied layers of paint, giving every colour an incredible intensity. It doesn't take long to realise that what we see in industrial colour fans is only a fraction of what is actually possible. Colour development used to be the result of artistic research or consultation with colour specialists – artists – but that hasn't been true for a long time.

LS
Aren't you asking the industry to perform the impossible if you want the same depth of colour that painters achieve in their work?

HJ
I think that at least it's worth the effort to see if there isn't something to be learned from artists'

colour experiments. The industry has defined quality in terms of quantity, not in terms of improving the colours themselves. It's been responsible for a gigantic expansion of the colour palette, and all those colours can be produced relatively cheaply. Nice work, to be sure, and once upon a time that was a relevant achievement, but not anymore.

I challenge the idea that freedom of choice is all about indiscriminately offering *every* possibility, which is what the paint and coating industry is doing right now. Besides, mostly what they're doing is showing us the *illusion* of unlimited choice. When I look in the paint store for the kind of magnificent colour nuances that you see in the work of Johannes Vermeer, for example, I don't find it. I don't want to resign myself to the idea that such quality is simply unobtainable in industrial paints. I'm a designer and I want to be able to apply the highest possible standards to the industrial situation.

In 2006 I was commissioned by Vitra to analyse their colour palette and make whatever changes I saw fit. Vitra has never had its own colour collection; instead it uses the colours that designers themselves propose for their furniture. What the company wanted was to renew its colour palette, which had slowly expanded over time. The spirit of the times is demanding other choices. Many new designers have come to work for Vitra in the meantime, and many production techniques have also changed over the years.
[...]
I analysed the company's existing colour fan and looked to see where I could expand and improve it and where I could re-establish its roots. In the course of that analysis, it struck me that the colours from the Vitra archive are often much more layered than the flat colours that snuck into the

collection later on. The original Eames chairs had marvellous irregularities as well as subtle colour and shadow nuances because they were made of synthetic fibres. In the old models you can see the interweaving of those irregular threads and you can also see a slight relief in the surface, which produces an array of light and shadow effects. At a certain point the production process was improved, which made it possible to supply perfect monocolours and absolutely smooth surfaces. This put an end to the colour nuances of the original designs. What a loss! So in dealing with the textile colours I played with the differences in the thickness of the threads, and I developed a number of duotones in which the old nuances recur but in a new way. The colours combine optically, making the perception of colour literally more layered, more intense. In other places I looked for more depth by searching the line for polychrome colours, colours that are fluid because they seem to consist of several tones and can therefore be interpreted in a number of ways. I also experiment with applying the same colours to a great many materials of different dimensions such as plastics, metal, wood and textile, and I match colours with other colours, which brings out the best of their individual qualities. Small nuances can produce major results. Colour only acquires character in connection with other colours. One colour is no colour.

LS
What about the expectations of the Vitra target group? You're there to serve a company. In each case you have to project yourself onto a specific product and a specific author as well as onto the company's strategic interests.

Hella Jongerius for Vitra,
Vitra Colour Palette, 2009

HJ

That's right. You can't introduce too many different colours or you end up with an expensive stockpile. And be sure to include cautious colours, lots of whites and greys, because the company made its name as a manufacturer of office furniture. The Home division has only existed since 2002. Furniture for offices, restaurants and hotels is purchased by the architect in large lots, and the choices are usually more conservative than when a couple is looking for a couch for their living room. In the eyes of most architects, grey, black and dark-blue colours still emanate a sense of gravity and power. That's why for Vitra's office line I chose a series of greys that contain just a bit more colour than the average grey tints. Not too much craziness. Stretching public taste can only be done with caution. Yes, it is about target groups. I have to be careful with that, and it often requires complex puzzling. I chose more colour nuances for the Home series, including colours that seem to consist of several colours. Truth is not a single entity. There is no green; there are many greens. No red, but many reds. In fact, red can also contain yellow, brown or blue. Grey may contain a trace of green or an afterimage of blue, the remembrance of red.

LS

This colour research has resulted in the interactive Colour Lab in the VitraHaus in Weil am Rhein, which was just opened. There customers can carry out their own experiments with colour tones, with the effect of light and texture, and how colours respond to each other.
[...]
You've also expressed a desire to develop a colour library containing both existing colours and newly developed ones. It's something for the future, I gather, because the plan hasn't yet been realised. Up until now you've chosen colours from existing colour systems and built up a collection around it. Now you want to concoct your own colours?

HJ

I had to limit myself to industrial colours and that was always a tremendous challenge. But my hands are itching. I want to make a colour world of my own, and experiment with raw materials. For me that's a logical development. If I want a lighter or darker tone, for example, I don't want a colour in which titanium white or black have been added. That's what happens in the industry, and it's the easy way out. But the effect is much more nuanced if you work with different reducing whites or contrast colours or with a combination of colours and colour layers.
[...]
Once again, the industry opts for standard solutions based on the benefits of stability, not on ideas about quality. It's time for an intensification and a real improvement of colour. In nature and in art you can see how whole worlds of irregular, fluid colours take shape. I want to achieve the same thing in industrial colours.
[...]
No colour is ever exhausted!

Hella Jongerius for Jongeriuslab,
Porcelain Colour Research, 2006

Stefano Marzano
Who's afraid of colour?

When we consider future qualities of life in the global home, it is important to take as our starting point the emerging values and sensitivities of the people who will live in them. We need to look at what will be important to them. How will they live? What will they want their homes to provide them with and how will their homes look and feel? People differ – and increasingly so, as the trend towards greater individualism, self-expression and personalisation intensifies. We see an increasingly noticeable search on the part of many people for individual expression, experience and sensorial pleasure, a desire for variety and richness, and a need for greater meaning in their lives. By taking into account these shifts in society and by exploring ways in which people might interact, we can imagine a number of preferable futures based on new qualities of life centred on people and their developing mindscape.

Inside the home of tomorrow
For many years, since electronic equipment made its mass entry into our homes, attention was focused far more on the technology inside than on the aesthetics outside. TVs tended to be black boxes, audio equipment had many knobs and buttons, and computers were grey. People were excited by the technological look and were keen for these products to look very different from anything that had gone before. But today, now these technologies are available in almost every home, they are beginning to take other forms. In fact, the home of the future is more likely to look like the home of the past than like the home of today. The technological black boxes – the television, the audio system, the telephone, etc. –

are either merging into the background and disappearing from view, or quite the opposite, are taking on striking, non-technical forms. We want to surround ourselves with objects that are attractive, not so much because they contain high technology but because they have personal meaning for us, are attractive and contribute to a harmonious whole.

Widespread 'intelligisation' is an opportunity to help enrich the living environment with 'colour' and cultural significance, leaving the world of grey and black boxes behind for a world of butterflies and flowers – products and solutions that address our psychological needs. People are becoming increasingly aware of their sensory and emotional needs. We listen more to our senses, we 'read' our environment through them. Pleasure, sensory experience and variety are increasingly seen as ends in themselves, restoring balance and regenerating vitality and creativity. Whether in the form of short, sharp bursts of sensory stimulation, or slower, more diffuse sensations to be savoured over time, they make a significant contribution to the enjoyment of everyday life. This brings a new challenge to designers. Rather than concentrating on the product alone, they must concentrate on the effect it has on us. What does it *do* for us? How does it make us *feel*? Creating environments that can be personalised or that can sense our moods, lift our spirits or soothe us. An environment that enriches us and extends our creativity.

Setting the mood
We are increasingly involved in creating and shaping our own surroundings and are receptive to ways of expressing and even influencing our feelings. The unique qualities of colour and light stimulate subtle, emotional reactions. The challenge for designers is to define and

capture these emotions in new propositions. In recent years, Philips has explored how people perceive atmosphere, how it enhances their moods, and particularly the role that colour and lighting can play. Coloured light has always been present in our lives, in different forms, right from the time we were babies and attracted to the brightest hues. It affects us emotionally, often without us realising it because, as we grow up, we tend to associate certain colours with particular emotions. Blue light calms us down, red light energises and warms. Yellow is thought to remind us of sunshine and so stimulates happiness. Colour at any time of the day or night sets a mood and helps create an atmosphere. Most people like the idea of adapting the atmosphere in personal spaces such as the home or place of work and recognise that finding yourself in an environment tailored to your own moods or feelings can help in the relaxation process. New propositions will allow us to mix and match our styles and interiors as the mood takes us. Just as we are seeing the black boxes in our homes disappear, we are no longer confined to applying colour or décor in the way dictated to us previously. We have freedom to express ourselves, our moods.

Philips LivingColors is a distinctive LED-based light source and now an iconic design that allows people to 'wash' their walls with any colour of their choice. This unique and extremely successful solution is a triumph in straightforward and intuitive design. Its remote control is so simple to use it is almost impossible to pick it up and not work out instantly how to choose a specific colour.

In explorations into ways we could enhance the atmosphere, Philips looked at ways to easily adapt the colour of furnishings in the home. The resulting design concept was Chameleon.

Stefano Marzano

Philips, *LivingColors*, 2006–2007

As simple as pointing to what you want, the lampshade changes to match any colour you 'show it' – your tie, the sleeve of your shirt, a colour pencil. The built-in sensor detects a colour and the fabric of the shade replicates it precisely. Show it black and the shade simply switches itself off.

In a similar design exploration, this time looking at colour and light in the domestic garden, Light Chimes draw on people's affinity with nature and blur the boundaries between the interior and exterior of the home, making the invisible visible through the medium of light and colour. Built-in sensors make the light glow more intensely when a breeze passes through them and their colours change in response to the temperature. When the temperature rises, the colour of the light grows 'cooler'; when it decreases, the light grows 'warmer'.

New order to potential colour chaos

The role of colour and how we apply it in our personal environments can be used as bold statements or subtle nuances. Colour, as one element in non-verbal communication, is more powerful than you might first believe. According to some colour specialists, colour is noticed by the brain before shape or wording – the mind absorbs colour before design. They estimate that even as much as ninety percent of the information we take in about a new brand is related to colour. In today's interconnected world, we live in a mosaic of colliding cultures, diversities, attitudes, interests and beliefs. The world is now really an inter-connected village. We increasingly seek diversity, choice and adaptability as other cultures, their colours and aesthetic patterns and traditions become more transparent and accessible to us.

In this global meltingpot, how will we know how to apply this new content available to us – the patterns, colours, icons of other cultures, traditions and beliefs – in our own surroundings? What will best reflect the atmosphere we would like, and how should it be applied? From the kaleidoscope of patterns, colours and styles, how can we create an atmosphere that reflects the mood we are looking for? Or how can we be sure that the look we try to recreate will stimulate the reaction we would like? This new dilemma brings a new task to designers, colour specialists, etc. With such a vast and often conflicting choice available, it will be their role to help us decide what is appropriate. It means companies will need to re-examine what they offer in terms of the larger benefits for people, taking on the role of advisor, educator and editor: providing people with the best tools to create their own solutions, filtering content to match the audience, but at the same time fitting with their brand. It will be up to them to take the lead so that we can live in harmony in our surroundings, allowing us to maintain our environments in a way that is appropriate to us. Helping us explore how our homes can meet our own psychological and creative needs. Helping bring a new order to potential colour chaos.

Philips, *Chameleon*, 2005

Philips, *Light Chimes*, 2005

Peter van Kester
The Forbo Colour Space

Painters have a special interest in colour and light, and so does artist Peter Struycken. But instead of brushes and canvas, he uses light and computers. In his films, videos, drawings and spatial installations, he explores the way colours change and vary in space and over time. To exploit the advantages of working with algorithms, he works on the computer. Although such systems seem to be limiting, they do create uniformity and produce an abundance of forms, colours and processes that he couldn't have imagined beforehand. They also generate puzzling irregularities that fascinate him. Processes interest Struycken more than once-only, individual works of art.

Peter Struycken came in contact with Forbo Flooring Systems, the producer of the popular 'Marmoleum' brand of linoleum, while conceiving a number of colours for linoleum floors in the Groninger Museum that were taken from the colour palette he had designed for that institution. This acquaintance inspired Josée de Pauw, Design Director, to initiate an intensive collaboration.

Struycken began by putting together a basic palette for Forbo consisting of a few hundred colours. The point of departure was linoleum white, which has a yellowish quality due to the presence of natural linseed oil. He didn't use the computer to come up with this colour palette; he did it exclusively 'by eye'. The human eye is extremely good at seeing and assessing colour differences, up to a few hundred colours. Based on the three characteristics that the eye registers in observing colours – hue, lightness and saturation – Struycken carefully coordinated both the colours and the characteristics. On the basis of previously defined intervals, he arrived at a colour space that

enabled him to organise systematically the gradation of the hues and the lightness and intensity of the colours. This gave Forbo a colour library, the Forbo Colour Space, which designers can apply for years to come in designing new compositions of linoleum colours. 'The colours in this space form a visually coherent whole,' says Struycken. 'They don't guarantee successful, appealing combinations, however, let alone entire collections. That's the designers' job.'

This process requires a great deal of research. How would the chosen colours survive the linoleum production process? After being mixed, would they lose the coherence they had had on the flat surface? While experimenting, Struycken made an interesting discovery. It's difficult to understand what he found without first explaining a bit of colour theory. In practice, colours are created by mixing, and this can be done in two different ways. Paint is mixed by means of 'subtractive mixing'. The basic colours cyan, magenta and yellow, applied in layers, 'absorb', as it were, more and more white from the base (subtractive = absorbent). On a computer or television screen, however, colours are mixed differently: by an 'additive' process. By combining beams of light consisting of red, green and blue pixels, i.e. by projecting them onto the same place, all the colour combinations can be achieved.

In a physical object, colours are usually mixed either by subtraction or addition. The special thing about linoleum is that in the manufacturing process, not only do the original basic colours remain visible, but they mix partly by subtraction and partly by addition. This is because some pigment particles mix like paint while others remain more distinctly individual so they mix by addition, as reflected light. This

results in a nuanced profusion of colour, depending on the distance from the viewer, even when the number of colours is small. The visual pleasure it provides is enormous.

On the basis of this principle new linoleum colours were created that were brought together into a series of six marbled greys and six uni's, making optimum use of this characteristic. 'They were the product of experiments I did with blends of linoleum pigment to see whether a grey colour impression could be produced using the additive method,' explains Struycken, 'and it worked! Up close you see each colour that was used, and as you pull back they all combine and become greyer! Forbo thought the results were surprising and distinctive enough to design a series of linoleums based on them.'

The collection, which was given the name *Marmoleum Colourful Greys*, consists of a balanced palette that changes in hue and lightness at optically equivalent intervals within the same saturation. In this way the relationships between the colours can be articulated and, most importantly, felt. The colour compositions were chosen in such a way that they produce a final 'grey' impression, even though the constituent colours are still quite recognisable. A very stimulating counterbalance! From an architectonic point of view there are a wide range of possibilities for utilising and reinforcing the effect: Marmoleum that appears rather reserved – what we see, after all, is grey – but that on closer observation offers colours in abundance.

Peter Struycken, collection and
points of reference, *Marmoleum
Colourful Greys* for Forbo Flooring
Systems, 2001–2004

Example of the use of *Marmoleum Colourful Greys*
in the Haarlemmermeer Pavilion, Amsterdam

Malaika Brengman
**How does colour affect
the shop interior?**

**Colour in interior shop
design and its impact
on the consumer
A silent seducer…**

The colour of money …

Decisions about how a shop should be lit, what music should be played and what colours should be used may seem trivial at first, but nothing could be further from the truth. According to a recent study from the Point-of-Purchase Advertising Institute, more than two-thirds of all purchasing decisions are made in the shop itself.[1] There the consumer is seduced in any number of ways, and the general atmosphere inside the shop plays a crucial role. Indeed, it exudes a certain image and triggers feelings in the mind of the shopper that ultimately influence his purchasing behaviour. Empirical studies show that the atmosphere in a shop critically determines the number of products that will eventually end up in the shopping carts as well as the total amount of money that will be spent.[2] In this way, research tells us, the shop environment exercises significant influence on the retailer's success.[3]

Taking colour seriously: retail managers beware …

In the commercial world today, 'shop atmospherics', or 'the conscious designing of the shopping environment in order to evoke specific emotional effects in the buyer that enhance his purchase probability',[4] is a marketing instrument not to be ignored among retailers. Retail managers are more conscious than ever of this fact, and they invest enormous amounts of money furnishing their shops. Yet as improbable as it sounds, complex decisions having to do with the design and management of the shop atmosphere are often poorly reasoned and are not based on solid information.[5] Retail managers usually make the mistake of letting themselves be led by their personal taste. Sometimes they follow the recommendations of the architect or the decorator. In other cases, their wife or secretary has the final say. Rarely is any thought given to how this decision will influence the feelings and ultimately the purchasing behaviour of the shopper, let alone the sales…

Colour my day …

It has long been acknowledged that colour not only provides objective information about our environment, but also influences the way we feel.[6] In a shop, emotions can be evoked by colour just as much as by other atmospheric stimuli like music, fragrances and layout, thereby influencing the consumer's purchasing behaviour.[7] The fact that colour has an effect on buying behaviour is not something to be sneezed at, and it has been demonstrated empirically.[8] A remarkable experiment on the purchase of console television sets showed that consumers arrived at a purchasing decision much more frequently in shops painted blue than in those painted red.[9] The red shop evoked an uncomfortable feeling, which triggered avoidance. Not only that, but in the blue shop the most expensive model was chosen significantly more often than in the red shop. This experiment indisputably demonstrates the crucial impact of colour in shop decoration on the shopper's purchasing behaviour.

No eye for colour …

Colour is an element in the shop environment that is highly adaptable at a relatively low cost. Until recently, however, it wasn't clear what colour to go for.[10] Little research had yet been done on the effects of colour in shops. The studies that had been carried out were not systematic and revealed important methodological shortcomings. For instance, the fact that colour has several dimensions was not taken into account; the focus was always restricted to a single aspect of colour – pigment – and other aspects were ignored; or the investigated colours were not exactly specified.

Focus on colour in three dimensions …

Colour is actually our perception of the reflection of light. The dominant wavelength of the reflected light determines the pigment or the nature of the colour (blue, green, red…). Although it is usually assumed that pigment is a nominal variable without any natural order, it has been demonstrated that colours can be arranged as continuous or ratio-scaled variables on the basis of their wavelength, going from short wavelengths (cold colours) to long ones (warm colours). Pigment, however, is just one of the three aspects that determine a colour. A colour can only be precisely defined when three dimensions are taken into account: the pigment, the saturation level and the value of the colour. Saturation (or chroma) refers to the concentration of the reflected light. It determines the intensity, the richness or the purity of the colour. When the concentration is strong (high saturation level) we observe a vivid colour. When the concentration is more diffuse (low saturation) we observe a *fade*, a more greyish colour. Finally there's the value of the colour, which refers to the amount of light being reflected. If a great deal of light is reflected, we observe a light colour; if little light is reflected the colour is dark.

Concrete Architectural Associates,
Lairesse Apotheek, Amsterdam, 2002

Which colour for the shop interior?

For my doctoral dissertation[11] I studied how colour in the shop environment influences the emotions of customers and their subsequent shopping behaviour. This involved examining the specific effects of the three dimensions of colour (pigment, saturation and value). An experiment was set up in which 874 respondents were shown a photograph of a shop created with Computer Aided Design; the colours of the interior were manipulated. A total of 32 colour variants were tested: eight pigments (violet, blue, blue-green, green, yellow-green, yellow, orange and red), each with two saturation levels (vivid or faded) and two value levels (light or dark). Each respondent was shown one photo of the shop in a particular tint. The study was presented as a market research survey for a new Italian shop dealing in design furniture and accessories that would be located in Belgium. The respondents were asked what emotions the shop evoked in them (degree of pleasantness, excitement and tension); they were also asked about their interest in the shop and their purchasing intentions. From the findings of this investigation it can be deduced that the more pleasant the consumer finds the colours in a shop, the longer he will linger there and the more money he will be prepared to spend. A positive feeling of excitement, evoked by the shop colour, also tends to draw the consumer in. A feeling of excitement can revert into tension and stress, however, which go hand in hand with an unpleasant feeling. Such negative stress leads to avoidance.

The results

It was determined that most of the people surveyed experienced the blue shop as pleasant, while the yellow-green and to a lesser extent the red interiors evoked an uncomfortable feeling. The other colours fell somewhere in between without suggesting a clear pattern regarding short or long wavelengths. Thus some warm colours like yellow and orange actually did evoke pleasant sensations. It also appeared that lighter colours were usually experienced more positively than dark ones. The influence of the saturation level on the experienced pleasantness was not significant.

As for the excitement that was induced by the colour in the shop interior, there seemed to be a complex interaction between the pigment, the saturation and the lightness of the colour. This makes it particularly difficult to interpret the results in this area; separate conclusions must be drawn for each specific tint. Yet generally speaking the pigment orange seemed to cause the most positive excitement. Yellow-green and to a lesser extent red tended to induce negative tension. The effect of blue, on the other hand, appeared quite soothing. In general it can be stated that vivid and dark colours evoked an unpleasant feeling of stress.

Conclusions

By and large, vivid or dark interiors are not to be advised. A light interior is recommended because it brings about a pleasant, relaxed feeling, which is conducive to exploration in the shop. Certain pigments such as yellow-green and red can also best be avoided because these colours arouse feelings of stress. Blue, green, yellow or orange interiors are recommended because these colours bring about positive feelings. In all of this we must take into account the fact that in terms of detail these general conclusions do not apply to all the colours in the same way. Some colours may produce different effects due to complex interactions.

It is evident that when colours are chosen for a shop interior, the target group should also be considered. Is the focus on women or men, on a young or an older public? After all, it was demonstrated that the effects were significantly influenced by these demographic factors. In addition, some people actually like the sensation of excitement while others do not, which should also be taken into account.

The extent to which these findings may be generalised to other shop contexts is yet to be verified, but even so, this study does offer food for thought. It seems clear that decisions about the colour of a shop interior should not be taken lightly, since the colour used in shops greatly influences the emotions of the shoppers, and through these emotions their ultimate purchasing behaviour…

Not just theory …

This kind of colour psychology is also being applied in practical situations, as the following anecdotes from the fast food sector indicate. The American hot-dog chain 'Wienerschnitzel' reported a seven percent increase in sales after the addition of a bit of orange in the colour of its restaurants.[12] McDonald's, which uses a colour red in its restaurants because red is supposed to induce people to eat more and faster,[13] has decided to switch from vivid red to a 'less stressful', more pastel-like, lighter red because both consumers and personnel complained that the intense red gave them headaches.[14] It's another indication that the colour used in the decoration of an interior space has an important influence on people who spend time there.

Shop designed with the help
of Computer Aided Design,
blue colour variant

Notes

1. Retail Marketing In-Store Services Limited, *The POPAI Europe Consumer Buying Habits Study*, Watford, 1998.
2. R.J. Donovan and J.R. Rossiter, 'Store Atmosphere: An Environmental Psychology Approach', *Journal of Retailing*, 58 (spring 1982), p. 34–57; L.W. Turley and R.E. Milliman, 'Atmospheric Effects on Shopping Behavior: A Review of the Experimental Evidence', *Journal of Business Research*, 49 (2000), p. 193–211.
3. V. Kumar and K. Karande, 'The Effect of Retail Environment on Retailer Performance', *Journal of Business Research*, 49 (2000), no. 2, p. 167–181.
4. P. Kotler, 'Atmosphere as a Marketing Tool', *Journal of Retailing*, 49 (winter 1973), p. 48–64.
5. J.-C. Chebat and L. Dubé, 'Evolution and Challenges Facing Retail Atmospherics: The Apprentice Sorcerer is Dying', *Journal of Business Research*, 49 (2000), p. 89–90.
6. P. Valdez and J. Mehrabian, 'Effect of Color on Emotions', *Journal of Experimental Psychology: General*, 123 (1994), no. 4, p. 394–409.
7. J.A. Bellizzi and R.E. Hite, 'Environmental Color, Consumer Feelings, and Purchase Likelihood', *Psychology and Marketing*, 9 (1992), p. 347–363.
8. J.A. Bellizzi, A.E. Crowley and R.W. Hasty, 'The Effects of Color in Store Design', *Journal of Retailing*, 59 (1983), no. 1, p. 21–45; A.E. Crowley, 'The Two-Dimensional Impact of Color on Shopping', *Marketing Letters*, 4 (1993), no. 1, p. 59–69.
9. Bellizzi and Hite, 'Environmental Color' (note 7).
10. J. Janssens and B. Mikellides, 'Color Research in Architectural Education: A Cross-Cultural Explorative Study', *Color Research and Application*, 23 (October 1998), no. 5, p. 328–333.
11. M. Brengman, The Impact of Colour in the Store Environment: An Environmental Psychology Approach, doctoral dissertation, University of Ghent (2002) (http://lib.ugent.be/fulltxt/thesis/RUG01-000748140_2010_0001_AC.pdf).
12. R. Lane, 'Does Orange Mean Cheap?', *Forbes*, 23 (December 1991), p. 144–147.
13. J. Argue, 'Color Counts', *The Vancouver Sun*, 10 June 1991, p. B7.
14. J.M. von Bergen, 'What's Your Favorite Color?', *Calgary Herald*, 13 February 1995, p. C1.

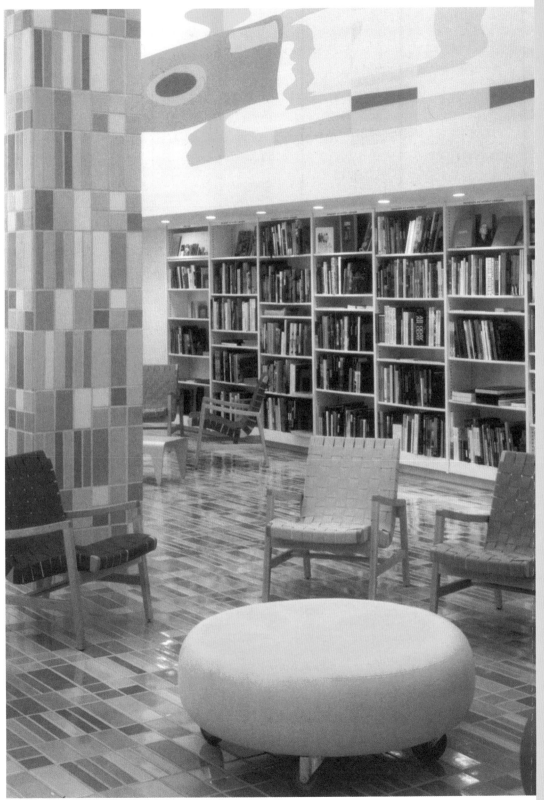

Jorge Pardo, *Dia Bookshop Project*,
New York, 2000

Paula Eklund and Susanne Piët
IKEA the enabler. Colour the unique 'you' in comfort

Marketing

Ask any man on the street to close his eyes and name the colours of IKEA, and nine times out of ten he's certain to give you the right answer: blue and yellow. And what's even more interesting, he won't be thinking of Gamma, a competitor with the same combination of colours. IKEA, as everybody knows, is special. IKEA has laid claim to a special Yves Klein kind of blue, and the contour of its graphics creates a transparent and optimistic impression that is clearly visible from the nation's highways.

Why start with the blue-and-yellow formula? The answer is both simple and revealing: it's the essence of the Swedish flag. This choice of colours forms the very basis of IKEA's marketing: it's 'Swedishness'. The colours of the logo are not reflected in the colour gamma of the IKEA retail concept in any special way. Its idea – its Swedishness – is, though.

What do we mean by Swedishness? Swedishness is a package of values:

- Being close to nature, which is reflected in colours, forms and materials.
- An appreciation of light. A hard climate forces you to focus on light.
- Both simplicity and firmness, key values for design. Form follows function.
- Stability and endurance. IKEA coaches you along the different stages of life.
- Respect for authentic roots and tradition, combined with love for family life.

Retail concept

This package of values is what constitutes the concept's signature: simplicity and nature; light, stability and sustainability;

tradition and family. The last two values – tradition and family – are the ones that dominate at the three biggest festivals of the Swedish year: Midsummer (around June 19-21), the Lobster Festival in August and Santa Lucia Day (December 13). It's during these times that Swedishness simply explodes in exceptionally frivolous accessibility for trends in decoration and homely, traditional, Carl Larsson-like colour combinations of red and green.

As almost everybody knows, the heart of Swedishness is the Smörgåsbord: a basic concept of food, ingredients and nurturing laid out in an attractive, colourful, tasty design of stacked sandwiches that are open to variation according to the tastes of the individual guests. This is IKEA's core retail concept. Secure in the knowledge that everything on offer is basically healthy, you are invited to select your own ingredients to suit your own surroundings.

IKEA provides affordable living for everyone. Over time, Sales evolved into Service. As the emotion market evolved, it developed an experience of optimistic security, a comfort zone of modest taste for the young at heart and the beginning consumer.

Design

Operating from its base, IKEA spreads its design wings according to the trends that appear on the promising horizon of the avant-garde. Designers are invited to signal anything promising they may see on this horizon, focusing on a few select items like lamps, vases, textiles and certain pieces of furniture. The same approach has been followed by offering more daring colours here and there, in a rug or a lamp. These stimuli, embedded in IKEA's familiar, safe concept, are meant to pull consumers out of their comfort zone. Meet the challenge to be outstanding. Be

brave, not beige. You're being lured by colours, which are aptly related to consumer moods (green for restfulness, blue for new, slate grey for purity). Create your own thing. Select your own colours and fabrics for an IKEA sofa, for example, by choosing something from the Benz slipover company. IKEA has become your coach, enabling you to sample your own style and to create your own 'you'. It all has to do with the demands of the Zeitgeist, where you claim your place on society's stage in order to survive.

Right now the emotion market is demanding the expression of individual identity, with lifestyle being a tool for total makeover. The invitation to break out of your shell and express yourself is meant to create a new you, and – comfortingly enough – that's okay.

KLIPPAN, 30 years...

...of personal fashion

IKEA, pictures from 2010 catalogue

Barbara Bloemink
The new century of colour[1]

The widespread use of colour is one of the most visible trends in contemporary design, as evidenced by the new shades and hues appearing on everything from automobiles and appliances to food and fashion. Yet colour is rarely given the consideration with which we reflect on other elements of design, such as form, structure, materials, function and process. This is, in part, because colour is impossible to describe definitively. Depending on to whom one poses the question, colour is defined as a reflection of light, a visual sensation, an objective trait with millions of variations, or a cultural phenomenon.[2]

The relegation of colour as a secondary element of design has existed in Western philosophy from at least the third century BC in the writings of Plato and Aristotle, who argued that colour is dangerous in its imitation of reality. In the eighteenth century, the philosopher Immanuel Kant declared colour to be merely a sensation, and therefore only 'secondary' in our experience of the beautiful. Today, however, colour is considered a primary attribute of what we judge to be appealing and beautiful, and acts as an aesthetic marker that helps characterise and differentiate the marketplace for contemporary design.

Different ages and cultures define colours differently, ascribing to them varying symbols and emotive associations. Until fairly recently, colour was always a luxury due to the preciousness of certain dyes and the available technology for extracting and adhering the colours to different forms and materials. For centuries, the only colours available were those derived from dyes acquired from natural minerals and organic substances, such

as plants, tree saps and certain insects. The difficulty in extracting dyes from their sources added to their value. In the late Middle Ages, for example, red dye extracted from the crushed bodies of cochineal insects began to be imported into Europe where, combined with a salt, it created a bright, deep red on silk and woollen fabrics. European courts from the Middle Ages through the seventeenth century favoured rich, jewel tones such as blue, red and green for court fashions, with purple generally reserved for the reigning monarch. With the beginning of the Rococo style under the reign of Louis XV, the decorative arts, fashion and textiles took on a more feminine pastel palette of pinks, blues and greens.

Nineteenth-century technological innovations led to new synthetic dyes and pigments and advances in colour printing and manufacturing techniques. As colour shades became less expensive and more readily available, cyclical changes in colour usage, particularly in fashion and art, occurred increasingly rapidly.[3] Global trade and intercontinental travel also brought unseen ranges of colours to Europe and America. In 1876, Christopher Dresser, the first Western designer to be invited to Japan, radically influenced manufacturing in England, bringing back not only innovative shapes and techniques, but also an entirely new variety of colours to be used on European ceramics, glazes, wallpapers and metalwork. Meanwhile, his contemporary, the Arts and Crafts proponent William Morris, reacted against the increasing use of manufacturing and synthetic colours by designing fabrics, wallpapers, tiles and furniture using only natural dyes. He often reverted to ancient formulas for extracting the dyes from only organic sources.

In the twentieth century, context influenced colour prefer-

ences. New York's Art Deco style, for example, reflected the metallic colours of industry and commerce, including black, gold and silver; while Florida's characteristic Art Deco architecture featured a palette of sun-washed tropical colours. As times changed, so did many of the traditional associations of colours in areas of design. By the early twentieth century, the use of black in women's clothing, no longer merely associated with mourning, quickly became linked with perceptions of elegance and glamour. The simplicity of Gabrielle 'Coco' Chanel's signature 'little black dress' helped establish black as an appealing colour for women's fashions, as it conferred on urban women a 'uniform' that could easily transition from day to night through the changing of accessories.

Following World War II, the general public gained access to a broad array of colours, synthetic dyes and mass-produced fabrics. As burgeoning post-war families moved to the suburbs, manufacturers reinforced women's domestic roles by offering the illusion of glamour to daily chores, creating appliances in a wide assortment of colours. During the 1950s, washing machines were available in pink, turquoise and yellow, changing in the next decade to earth tones of gold, brown and avocado.[4] Advertising suggested that women decorate their kitchens and washrooms around the colours of their appliances, implying a planned obsolescence based on aesthetics rather than function. By the 1970s, most domestic appliances were again available in only neutral shades of white or beige.

The closest parallel to the current zeal for colour in fashion and consumer products took place during the 'Pop' era of the 1960s. The spread of colour in photography, printing, films, magazines and television

Verner and Marianne Panton in front of
a wall of round lamps

iPod Mini, Apple

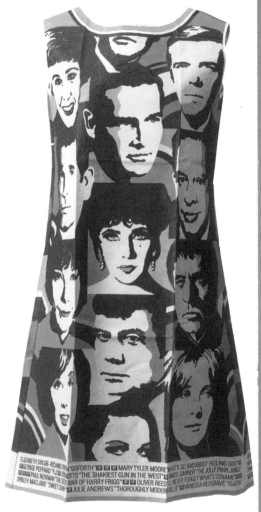

Mini dress, United States, 1968

significantly increased the public's awareness of – and appetite for – colour in everyday life. For the first time, styles and fashions focused on adolescents, and reflected their enthusiasm for space-age metallics, bright acrylic paints and the application of colour to new materials such as polyesters and plastics. The palette of the Pop era reflected the growth of interest in advertising and popular culture.

While fashion reflected these tendencies in the United States, in Europe during the same period the use of colour extended more generally to include interior and product design. In addition to devising his own idiosyncratic colour theories, Danish designer Verner Panton was highly influential in promoting the use of saturated colours in interior design and furniture during the 1960s and 1970s. Panton once observed, 'I am not fond of white, the world would be more beautiful without it. There should be a tax on white paint.'[5] Richly toned rooms with colour-drenched walls, rugs, furniture and lighting were conceived by Panton to 'glow' in a visual bath of singular colour.[6]

During the 1970s and 1980s in the United States, although specific colours reflected the fashion 'trends' of the year, most designed objects were largely available only in neutral colours. This was particularly true of new technological gadgets, from the calculator to the computer. The designers, wanting to emphasise the 'serious' functionality of their inventions, only offered these devices to the public in metallic grey, black, or white. Apple computers, in a brilliant effort to reinforce its signature branding as different from the norm, revolutionised consumer technology in the late 1990s with the original iMac computer, which came in three bright, translucent colours: aqua, tangerine and cranberry. Over a decade later, Apple's all-white iPod set itself apart from its gray metal competitors, then empowered consumers to choose from a selection of fun colours for its iPod Minis.

Through television and magazines, design doyenne Martha Stewart made colour, and the coordination of matching items for the home, accessible to the general public at low prices. In doing so, she not only promoted awareness of design, but also enabled consumers to feel their choices all reflected 'good taste'.

In recent years, however, consumer interest has moved from matching colours to variety and individuality. Although still in concept form, Ford Company's 2004 'Mood Car' suggests that in the future, consumers will be able to change the colour of their car according to their mood or occasion. Suddenly, colours are no longer tied to acceptable behaviour or specific objects. Instead, everything from mixers and washer/dryers to toasters and tea kettles comes with colour choices. In fashion, there are no longer any inappropriate combinations of colour or pattern. Compared with the 1960s, where the Pop fashions featured bold, but consistent, colours, many designers today juxtapose and mix unexpected patterns and colours in a single outfit. Meanwhile, accessory companies have changed the paradigm so that handbags and shoe colours are not limited to seasonal black, white, navy, or brown, but are changed on a whim and replaced to match whatever outfit is being worn.

With the use of the Internet and computers giving users access to millions of colour combinations, companies such as BMW and Nike increasingly promote the individualisation of purchases. On the Mini-Cooper's 'design-your-own' web site, buyers can select the colours of their new car's body, roof and interior. And if you are lucky enough to get an appointment, the Nike Lab provides customisation of your shoes.

At least among young consumers, colours have become divorced from their historic psychological, cultural and emotional associations. Traditional rules of what colours are considered most inherently 'appetising' no longer apply. The colour blue rarely occurs in nature, and almost never in products from edible organic sources. In the past, if your meat or cheese turned blue, it indicated that it was rotting and no longer healthy to eat. Currently, however, tomato catsup comes in bright blue, purple and green as well as red; M&M'S has introduced blue into its traditional candy palette; and electric-blue colouring is regularly found in carbonated and high-energy drinks, ice cream and snacks.

Today, most of us take for granted our immediate access to a myriad of colours, and feel free to use colour to design and define our environments. However, we rarely stop and consider how it influences our choices of what we buy and wear. By presenting three hundred years of Western costumes by colour rather than chronology, *Fashion in Colours* offers us a thoughtful respite from the usual museum installation. Rather than being drawn to a particular gown because of its colour, the viewer's eye is now drenched in colour, making the individual 'materiality' of each gown disappear. Gradually, as the eye adjusts, one notices subtle surface details, and similarities of structure, form and materials across time. The resulting immersive environment encourages viewers to ponder colour's historical and symbolic associations, and, finally, the role our daily colour choices play in how we define ourselves.

Notes

1. Taken from William Segal, 'Color Association of America', foreword to *The Color Compendium* by Margaret Walch and Augustine Hope, New York: Van Nostrand Reinhold Press, 1990.

2. Red has the lowest wavelength on the visible spectrum that humans can perceive; all colours that are invisible to our eye and below red's wavelength are known as 'infra-red'. Similarly, purple sits at the top of humans' observable spectrum, and anything above is called 'ultra-violet'. To see 'infra-red' or 'UV' light, we need instruments that reinterpret the 'colour' and allow us to see its signature as colours within our visible range.

3. In the 1820s, the French chemist Michel-Eugène Chevreul began lecturing on the influence on perception of colours placed adjacent to each other. Chevreul's highly influential *The Principals of Harmony and Contrast of Colours*, published in 1839, presaged Bauhaus teacher Joseph Albers's 1963 book, *On the Interaction of Color*, both of which radically influenced artists and designers throughout the nineteenth and twentieth centuries.

4. Ellen Lupton, 'Sex objects', in: *Mechanical Brides*, exhibition catalogue Cooper-Hewitt, National Design Museum, New York: Princeton Architectural Press, 1993, p. 23.

5. Quoted in *Verner Panton: The Collected Works*, exhibition at AXA Gallery, New York, June–October 2005, originally organised by the Vitra Design Museum, Weil am Rhein, Germany.

6. This concept is recalled in Viktor & Rolf's original design concept for the exhibition of works from the Kyoto Costume Institute, *Fashion in Colors,* which opened at The Museum of Modern Art, Kyoto, before travelling to the Mori Art Museum in Tokyo. Although redesigned for its installation in Cooper-Hewitt, National Design Museum in New York, Viktor & Rolf's notion of organising the fashions by colour rather than chronology remains a constant in each installation of the exhibition.

Walter Benjamin
Colours

In our garden there was an abandoned, ramshackle summerhouse. I loved it for its stained-glass windows. Whenever I wandered about inside it, passing from one coloured pane to the next, I was transformed; I took on the colours of the landscape that lay before me in the window, now flaming and now dusty, now smouldering and now sumptuous. It was like what happened with my watercolours, when things would take me to their bosom as soon as I overcame them in a moist cloud. Something similar occurred with soap bubbles. I travelled in them throughout the room and mingled in the play of colours of the cupola, until it burst. While considering the sky, a piece of jewellery or a book, I would lose myself in colours. Children are their prey at every turn. In those days, one could buy chocolate in pretty little crisscrossed packets, in which every square was wrapped separately in colourful tinfoil. The little edifice, which a coarse gold thread kept secure, shone resplendent in its green and gold, blue and orange, red and silver; nowhere were two identically wrapped pieces to be found touching. From out of this sparkling entanglement the colours one day broke upon me, and I am still sensible to the sweetness of the chocolate, with which the colours were about to melt – more in my heart than on my tongue. For before I could succumb to the enticements of the treat, the higher sense in me had all at once outflanked the lower and carried me away.

Studio Makkink & Bey,
Tokyo Day-tripper, 2002

Public

Aaron Betsky
**Beneath the pavers,
the beach?
The colours of public
space**

White

The ideal public space is white.
It is the shining city on the hill,
the New Jerusalem, or Utopia.
Unlike the real Jerusalem, which
is yellowish and a bit of a mess,
this utopia is perfect. It consists
of an arrangement of buildings
vaguely inspired by the temples
of Greece and Rome, but without
any of the colours or decoration
that once adorned these structures
of veneration. The White City
and its stretches of emptiness
show up in the paintings of John
Marin and Alma Tadema, in the
architectural visions of Le Corbu-
sier and Hugh Ferris, and, most
fully in the United States, in
Daniel Burnham's 1908 Plan
for Chicago.

This White City, which Burnham
built in part for the 1893 *World's
Columbian Exposition*, is a distil-
lation of the teachings of the
Ecole des Beaux-Arts, at least
in its most dogmatic period, at
the beginning of the nineteenth
century. Faced with the emer-
gence of the landscape of
industrialisation with its sooty
cities reaching out in block after
cramped block as far as the eye
could see, with the proliferation
of new building types and new
inhabitants, architects dreamed
of order. The perfect city would
have a place for everyone and
everything, all of it connected
by avenues, boulevards and
underground or ever-overhead
transit systems. Dirt would
disappear into distant factories
and underground into sewers.
At the core of the perfect metro-
polis would be the open square,
a place of monuments where the
city's highest ideals, embodied
by its heroes, would become the
focal point for open spaces
defined by the city hall, the
parliament, the main cathedral,

the palace of the ruler, or
whatever other house of power
the architect might think appro-
priate.

There was no function for this
space, and that was exactly the
point. The smooth functioning
of the rational city, whether
envisioned by Ledoux, Burnham,
Garnier, or Le Corbusier, needed
a lacuna, a place of rest, a halt.
It would be the place from which
and in which citizens could
observe and understand their
new and perfect world. There
they could gather in festival or
in demonstration to celebrate or
denounce the rulers. There the
ruler could appear in his full,
colourful splendour, and there
order would reign. It was the
place from where you could see
the new and the good, and
where the new and the good
could see you.

Why was this place white?
Because it was not the colour
of clans or kings. It was the
absence of individual identifiers
that defined it as part of a new
and abstract space, that of the
citizen (whether still subject to
a king or not). This new space
was also a revival (or so those
who envisioned it thought) of
the spaces of Athens and Rome,
which they, at least until the
middle of the nineteenth century,
assumed had been clad in every
dimension with white marble.
That stone was also the material
of the heroic sculptures of
Michelangelo and Bernini, and
thus its idolising properties be-
came transferred to the buildings
and spaces forming the new,
post-Enlightenment world.

White was also almost not
there. It was the colour of
absence and abstraction, of
things that did not look like
nature, like bodies, like clothes,
or like anything in particular. It
was the colour that came closest
to the pure and divine light of
God or of reason, the disap-
pearance of all physical reality
into the pure nothing of heaven
or of the spirit. The White City

was white because it was heaven
on earth, made by man.

Architects tried to build the
White City, but failed. Burnham
saw his great white square turn-
ed into a highway intersection.
The White City of Tel Aviv
answered the aged tones of
Jerusalem with Zionist fervour,
but descended into decrepitude
and fear. The flats of the post-
War era became billboards for
graffiti and laundry, their coats
of paint and plaster soon fading
into ignominy, their forecourts
and squares filling with weeds
and kiosks. And the white
square, the perfect place of
nothing, the place that made
sense of and place for it all? It
remained a dream, somewhere
under the asphalt of the traffic
square, under the parked cars,
under the layers of soot and
grime, in our imagination, and in
our dreams. 'Beneath the paving
stones, the beach', its white
sand only a promise.

Grey

The reality of public space in the
Western world is not pure white,
but grey. It is the grey of the
granite pavers of Paris, which
was the city that was the model
for all urban schemes. It is the
grey of the asphalt that replaced
the paving stones when they
became too expensive. It is the
grey of reality, the mixture of
colours, the dulling of dreams
into everyday life.

The squares that were built
were places where power dis-
played itself. In concrete terms,
that meant they were forecourts
for palaces, parliaments, or
courthouses or churches. If they
had a function, it was for the
ritual affirmations of power, such
as investitures or parades. It was
no coincidence that the Com-
mune of Paris in 1848 started its
work by digging up the granite
blocks and piling them, together
with whatever else they could
find, into the barricades that
both physically and symbolically
prevented the rulers from

exercising power. Behind the barricades, the city returned to smaller communal units, each with its own character.

Restoration led not to the return of kings but to the victory of middle-class power, and the grey of public space reflected the subdued and recessive stance of this urban power structure. Like the suits of the men newly in charge, the grey of public space, which came from that more efficient asphalt, stood for no particular ideal, but rather was a neutral shade. And it did allow things to happen: the public square did not remain empty, waiting for a great occasion. It became part of the system of movement that was the mainstay of middle-class culture and economy: the free interchange of people, goods and information, unfettered by any barriers or preconceptions.

In a practical sense, this meant that most public spaces became, like Burnham's Chicago centre, intersections. Where there was space left over, they became places to store the elements of movement. They became parking spaces. They also reverted to the previous model of what an open space was for: the market. Before there was public space, which was an eighteenth-century invention, there was either the commons, or non-private space, or there was the marketplace, where goods could be freely traded. In the late nineteenth century, public space became invaded by the impermanent structures of temporary stalls, as well as the more permanent accoutrement of that new place of middle-class meeting, the café.

Here the middle-class citizen with enough money to buy a beer or a coffee could gather to do something indeterminate: to wait, to read a newspaper, to have conversation, to watch others go by. Public space became a place in which one appeared. One saw or was seen, and thus the grey background became a backdrop against which one could identify one's self, through dress, through conversation, and through pose. For the preferred colour remained grey. As Adolf Loos pointed out, the embodiment of perfect style was an English gentleman, standing just so, with each element of his clothing perfectly coordinated, in a public square.

Public space became a grey zone, not just literally but conceptually as well. Who owned public space? The great, grey masses. What was allowed there? Well, that is a grey zone. You can get a permit to put your café tables there, and you are allowed to converse. But what if you talk too loudly, or place too many tables there? What if a mob gathers there, or what if you defy authority? Then the grey-suited cops might come and shoo you away. What if you do something lewd, piss on the pavers or tag the monuments with your identity? Both you and your mark will be removed as quickly as possible. We consider a uniform, tidy greyness, to be the mark of a well-maintained and well-defined public space.

As a result, our grey places have become more and more depopulated. There is not much to do there if you cannot have fun. Moreover, you are exposed to the elements and, when you are not gathering for a purpose, that makes these spaces less attractive. I think of public space as grey asphalt on a grey day with a light drizzle. Better to go indoors, to the shopping mall, which is sort of a public space, in a grey sort of way. Rem Koolhaas: 'All conditioned space is conditional.'

Red
Not all public space is grey. In Northern Europe, much of it is red. Instead of granite pavers, the surface consists of brick (at least where the asphalt has not invaded or has been ripped up in the interest of historic restoration), as do the facades of even many monumental buildings. The brick not only has a warmer colour, but it also has a denser pattern. The architect Berlage once said that the red brick was like the red worker, who banded together with his brothers to create a strong red wall. The brick square seems more pedestrian, more plebeian, more of the people. Its model is of course Red Square in Moscow, though that space was decreed by Tsars and has since become a site of rampant (state) capitalism. Walk through the market square in a Dutch town such as Haarlem, Alkmaar or Gouda, and you will find yourself surrounded by brick underfoot and all around, creating a continuous pattern without clear focal point. Instead, the space is interrupted by functional structures such as weighing halls, which further dissipate any sense of grandeur or display. Everything is measured or measurable.

The red square is one that usually does not have the clear shapes that nineteenth- and twentieth-century architects laid down for purpose-built public space. It is more often than not a remainder or a revival of that earlier space of the market or a slightly larger intersection. There is little logic or reason to it, and it elongates, compresses, and even bleeds off into nooks between adjacent buildings. It is often difficult to say where red public space begins and where it ends. We are all citizens only when we appear in public spaces, but we are all consumers and travellers. We pass through the red square, we buy things there, and we might even gather there, but we do not appear there in the self-conscious manner of the middle-class user of public space.

The red public space – or yellow, or brown, or any other earth tone – is a place of nostalgia these days, as often as not,

a place that tries to resurrect the simpler notion of compact urbanism and community, organic and fitting to the human scale. It exists only in the cores of cities that function today as much as images of what a city should be as they do as vital centres for sprawling metropolitan realities.

At least this is true in the Western world. In Latin America, the King of Spain in 1542 laid down the Law of the Indies, which decreed central, rectangular squares, bordered by a cathedral and a ruler's palace, for each and every city. Most survive to this day. Their model is the Zócalo in Mexico City, and it is a colourful place. Yellow and grey, red and even a little black, it is a layering of many centuries of construction and use. It is a place for the display of power centring not on a statue but on a giant flagpole. This is the people's place, and almost every day one community or another, from religious pilgrims to massed protesters, takes it over.

Recently, architects such as Luis Barragán and his student Ricardo Legorreta, have abstracted this colonial tradition into the deeply-coloured planes of their semi-private spaces. They have erected deep-purple, magenta, and ochre walls that do not enclose but define zones and open possibilities. The landscaping of the University of Mexico, designed by Barragán in 1949, shows the way towards a more fluid public space. It is open and yet defined, filled with strong colour that gives it a character that you cannot quite ascribe to any politics or use. This public space proposes a place where a society might form itself.

As the incessant movement of people, goods, and information knits the world together, public space of this sort is creeping into Western Europe and America. Designers see the liveliness of such spaces, and use the techniques they see there to enliven their sites, but most uses just occur. In Hong Kong, thousands of maids gather in the square in front of the HSBC Building every Sunday, filling it with their language, sounds and appearance. In Los Angeles, squares become places for music and the perpetual motion of the evening stroll. Globalisation adds colour to the notion of the public, and thus to public space. But if it works for public space, it will also work for private enterprise. In the instant city of Dubai, the world's tallest skyscraper and second-largest shopping mall anchor housing developments that are meant to look like souks, arrayed around a vast public space complete with dancing fountains and rambling pathways. It is open to expats, and maintained by thousands of workers from India, Pakistan, and Sri Lanka. The workers remain invisible.

Green

The best public space is not urban. It is nature that has been captured and made to function as the city's lungs, lounge and leisure space. Once the refuge of the rich and the holy in the *hortus conclusus*, then the place of dalliances and displays of power under royalty, the public park first made its appearance along with urban public space at the beginning of the nineteenth century (the first may have been Budapest's City Park, in 1812). Its model was again the commons, the meadow that had been available to all and whose name still survives in such American places as the Boston Commons. This new park, however, was a different thing. It was a self-conscious attempt to create a place of escape within the city itself, open to all (who behaved) and able to offer respite and refuge.

In the medical analogies then fashionable, the park became the city's lungs, a term that still survives today. Certainly, the foliage and its production of oxygen could offer a small respite from the increasingly smog-ridden city. But parks were also lungs in that they would let the public breathe in and out without constraints. Here were places where you did not work, trade, or even appear, but where you just lived. Living meant doing those things that work and appearance did not necessitate – to wit, play. Parks were, first and foremost, playgrounds, from the informal fields for picnics and leisurely strolls, to organised playing fields, to the trysting spots in secluded glades.

The design of parks contradicts everything that made sense in the middle-class city. After some dalliances with the French garden (which persisted as a design in Mediterranean cities through the twentieth century), the dominant model became that of Capability Brown's great English gardens. Everything was designed to create a facsimile of a carefully groomed version of nature, with each clump of trees, each range of bushes, each spreading meadow and each meandering stream composed into a foreground, middle ground and background. The infrastructure that made this work, from drainage pipes to 'ha-has' to carriage paths, was carefully hidden. New York's Central Park became the paradigm of such public green space, its circulation routes separated and hidden in the topography, its grand gestures of green gesticulating against the march of towers along its borders.

Parks have survived much better than any other urban space. They continue to function as their designers envisioned them, despite the immense changes in demographics and the sheer scale of the cities around them. Over time, they begin to deteriorate as their plantings grow old and governments save on their maintenance, but always they seem to somehow revive and become safe and lively places

Aaron Betsky

Daniel Burnham, *Plan of Chicago*,
1908–1909

page 156
Olafur Eliasson,
Your colour memory, 2004

page 159
Ellsworth Kelly,
Ground Zero, 2003

Brassaï, *Nuits parisiennes*, 1935

Place Vendôme, Paris

City square, Saint-Lazare, Paris

Zócalo (Plaza de la Constitución),
Mexico City, view from above

Zócalo (Plaza de la Constitución),
Mexico City

again. Green is the most perva-sive colour of public space in our Western culture.

This is so even as cities sprawl out into the surrounding land-scape, because the very notion of suburbanisation comes from the desire to mix the amenities of urban life with what we perceive as the benefits of nature. The city distends to its furthest reaches, fading out into large and larger plots with more and more lawn, before the suburban develop-ments themselves become apparitions between working fields and un-felled forests. There, once again, we confront the reality of public space in our society, even in its green garb: it is becoming privatised. The green of the suburbs is not just there for the taking or the strolling. It consists of endless repetitions of little lawns, often kept that colour through an immense waste of water and fertiliser. It is not public, nor is it nature. It is a mark of open space imposed on the land and reserved for private enjoyment. When suburbs do build parks, they often restrict their uses and even those who can use them. The most beautiful and largest green spaces are the golf cour-ses, perfect and abstract lanes of green reserved for those who pay and devoted to their own arcane rituals.

It is only beyond the city and the suburb, in the natural pre-serves we have set apart from development, that the green still denotes open nature. Though here it is also hemmed in by borders and often interlaced with infrastructure, these forests and deserts, prairies and playgrounds for wildlife remain the very image of what is natural. In fact, I would argue that it is only through such parks that we truly know nature, experience it for ourselves and can understand something that is other, beyond and perhaps even better than we as humans have made. Green is the colour of Eden, of our origins, and, if

we are going to survive on this planet, of our future.

Blue

There is yet one other public space that has survived and that continues to thrive. It is liminal, and perhaps not worth more than a footnote. It is the beach. Like all public spaces, it is an invention of the middle class and of the industrial revolution, though it appeared later than public squares and parks – the first beach in the United States did not open until 1896, in Revere, Massachusetts. Previ-ously, beaches had been places for fishing or for getting on or off boats, and they were often the edges of poor communities. Beaches were generally useless. Even when romantic poets started wandering along them, they did so to get away from it all, includ-ing the public.

Only in the middle of the nine-teenth century did the notion that ocean air was healthy engender a movement to the shore, where large hotels and spa resorts marked off pieces of the beach for the private enjoyment of their guests. As the number of hotels proliferated and going to the beach became a mass pursuit, that exclusivity became eroded, while larger and larger stretches of empty sand became colonised for free lying, leaping into the waves, or building sandcastles. In the twentieth century, popu-listic governments added infra-structural improvements, most famously at such places as Jones Beach on Long Island, where a system of roads, parking lots, restrooms and changing facilities and public rooms led millions every summer to the edge of the Atlantic Ocean.

These beaches are about as free as public space can be in our society. In some of them, you are not even required to wear anything at all, and most people wear very little. The body, which remains largely hidden in urban public space, comes into play.

The beach draws you back to your corporeal existence, asks you to take care of it, opens up the possibility of coupling with others, and then the water washes away your sins. Michel Foucault once predicted that the very notion of humanity would be wiped away by history as foot-steps on the beach are by the sea. At the beach, you can escape from what you are in the city, which includes being part of the public. The beach is post-public space.

Beaches are actually white, or a kind of yellow (in some cases grey or black), but what really makes them work is the blue: the blue of the water and the sky. They provide some tangible benefits (and dangers): suntans (burns) and opportunities to swim (drown), but, more than anything else, they are emblems of immensity. At the beach, you can see a pure, abstract nothing that, in the city, you can only imagine. Blue is the colour not of ideal human space but of the immensity beyond the human. The beach is not beneath the pavement but beyond it, prom-ising ultimate freedom from being a citizen of the city.

Black

Nowhere are you as free as in the city in the depth of night. It is for that very reason that the first things authorities do in times of crisis is to impose a curfew. They know that in the dark, the dark forces can gather. The prime method of control – being able to see – disappears. In the night, everything is public space. There are no edges, there are no conditions. Only where either the moon or artificial light breaks through the darkness of night can control and public space – cafes and places to linger, to see, and to be seen – re-emerge.

Public space is a victory over darkness. That is why it is white: it stands for the good and the pure, against the evil or at least the unknown and unknowable.

Aaron Betsky

Central Park, New York City, 1857–1873,
overview

Public space made a great leap forward when electric illumination extended its reach in both time and space. Today the white, orange and yellow hues of sodium halide and other cheap forms of illumination give public space a permanent pall in the darkness, making it look institutional and drained of colour. Only where and when the lights fade out does the enveloping darkness reassert itself.

Certain people seek this darkness, not just to do things our society considers illegal or to hide from the law, but to find another kind of connection. At night, public squares and parks become places of assignation for those whose love cannot stand the light of day or public scrutiny. In our culture, that means as often as not gay men. Gay men have long sought the edges where light fades out into darkness, and where control dissolves. There they can make contact with each other, often in situations where they can remain anonymous even to their partners. In other cultures, darkness includes and hides those of different sexes whose love is illegal or who cannot afford a little bit of communal freedom away from their families.

At times of crisis, black public space appears in the middle of the city. When the power fails, people congregate in the dark streets and squares, looking to each other for support. Trapped underground during air raids or in collapsed buildings after earthquakes, people from disparate backgrounds create temporary communities, exchanging ideas, hopes, fears, and food. I do not mean to idealise such occurrences, created as they are by horrible occasions, but I do believe that a strange beauty descends over a city during a black-out, an ominous and yet liberating sense of the disappearance of structures, boundaries and place. Space opens up, in all its terror and possibility.

We also hope that outer space, as in the realm beyond the earth, will be a black public space, an endless realm for exploration. We hope it is not the 'final frontier', as science fiction would have us believe, but something so immense that it is larger than all of us.

That space is not just out there, of course, it is already everywhere around us. We have made deep, black, ungraspable space part of our daily lives by sending signals through it, by connecting through it, by making it into the digisphere that has become our second home. Black is the colour of the public space inside the box on which I write this; black is the colour of the space that connects me to millions of others through the internet. Ironically, for that black space to work it has to allow words and images to emerge, making for the transparent economy and culture we inhabit. There everything can be known and everything can appear. As a result, what appears can be controlled, and we already realise that the pure freedom of the ether is a fiction.

The only free space, the only space that is truly open and public, is that which we cannot see. As soon as we inhabit it, use it, and experience it, it becomes grey. We dream of the white purity of possibilities, we inhabit the dark night of dreams and nightmares, and we wind our way through all the colours of reality.

Public space is the colour of our lives. It is a projection of our hopes and fears, and it contains us in the everyday. What is beneath the pavers, we cannot see.

Aaron Betsky

168

Jones Beach, Long Island,
New York, 1923–1929

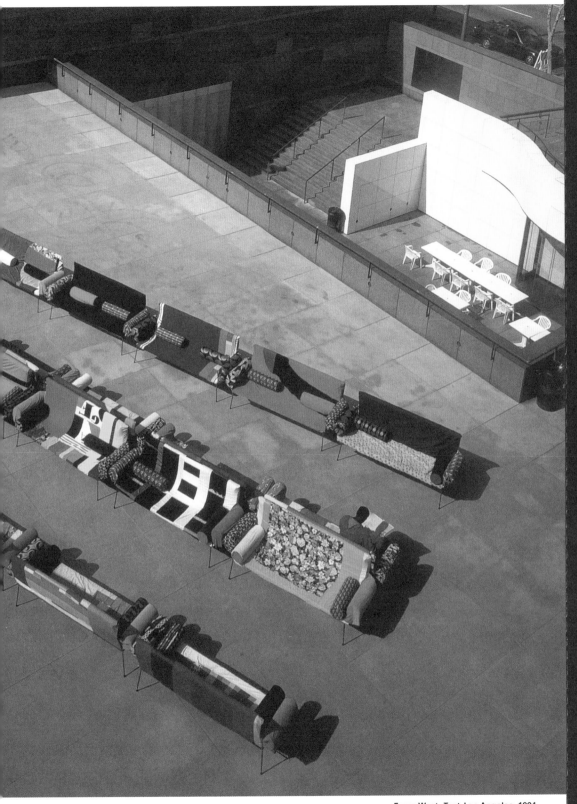

Franz West, *Test*, Los Angeles, 1994

Daniel Birnbaum
White

There is not a philosophical method, though there are indeed methods, like different therapies.
Ludwig Wittgenstein

When we forget that abstractions are intellectual constructs and instead take them to be concrete realities, we easily end up in the realm of metaphysics. An example of such a construction that we tend to misrepresent as a concrete reality is the colour white. This has given rise to an elaborate metaphysics of neutrality that has implications not only for the theoretical realm of aesthetics but also for the much more tangible realms of architecture and interior design. We are familiar with the symptoms. Can we define the disease?

White, one is often inclined to think, is the non-colour, the degree zero of hues, and thus something like a neutral given preceding any specific colouring. A backdrop that in no way restricts or influences whatever is to appear. But what do we mean when we say white? In his *Remarks on Colour*, Wittgenstein quotes Lichtenberg's statement that nobody has ever seen 'pure white'. So are most people using the word in an incorrect way? he inquires critically. Of course not: the idea of 'pure white' is one more example of a construction that produces metaphysical confusions. Wittgenstein suggests that these perplexities can be treated as symptoms. Given the correct treatment, the right therapy, the symptoms will dissolve and disappear. There is not one universal kind of therapy, but the medium in which the cure he suggests takes place is specific enough: ordinary language.

'When philosophers use a word – "knowledge", "being", "object", "I", "proposition", "name" – and try to grasp the essence of the thing, one must always ask oneself: is the word ever actually used in this way in the language game which is its original home?

What we do is to bring words back from their metaphysical to their everyday use.'[1]

So this is what the therapy does: it brings concepts back to their concrete use. The metaphysical symptoms thus disappear. But Wittgenstein was never optimistic or naïve enough to believe that his cure would prove final. The symptoms will always reappear since the illness is chronic. The illness is at home in our language itself since it unceasingly produces abstractions such as 'being', 'object', 'I', 'proposition', and, to add one more example, 'pure white'.

If we are aware that the concept of 'pure white' keeps giving rise to certain pathologies, we may think that we can get rid of all the symptoms through a radical critique of the concept itself. A solution more in tune with Wittgenstein's ideas would stress that the misunderstandings are likely to re-emerge and that the therapy will always be an ongoing and more or less infinite process. The analysis, as Jacques Lacan once stressed, is over the moment the patient understands that it will continue forever.

Olafur Eliasson no doubt knows this as well. The critique of the metaphysics of whiteness is an infinite task, and the 'therapy' of light is a never-ending and ultimately unachievable task. One can only reconstruct the various steps that took us to where we are and revisit the historical moments when crucial decisions were taken. White is not only the colour of hospitals, of scientific laboratories, of fashion stores and art galleries. In fact white is the colour of modern architecture as such. It is, as Mark Wigley has shown, one of the key features that make it recognisable as *modern*. Many decades before the white cube galleries were built in Manhattan and then spread like a strange virus across the globe, decisions had already been taken that made this development – so intensely scrutinised since Brian O'Doherty's 1976 *Inside the White Cube* – possible.

Note
1. Ludwig Wittgenstein, *Philosophical Investigations*, Oxford: Blackwell Publishers, 2001, § 116.

Olafur Eliasson, *The white colour circle*, 2008, part 3 from 'The colour circle series'

David Batchelor
**A bit of nothing.
On monochromes**

My original motives for making monochromes – back in the late 1980s – were vaguely malicious. The subject was interesting because it seemed to be pretty much the dumbest kind of painting that it is possible to make. A single, uninterrupted plane of flat unmodulated colour spread evenly across a given surface – a monochrome appears to involve no composition, no drawing, no subtlety; and it requires no skill, and certainly no craft skill, to make one. Anyone who can paint a door can paint a monochrome. Or, as El Lissitzky put it in 1925: 'Now the production of art has been simplified to such an extent that one can do no better than order one's paintings by telephone from a house painter while one is lying in bed.' This was painting as low comedy, the *reductio ad absurdum* of high abstraction. Having said that, a part of what attracted me to the monochrome was also the awareness that for many artists this form of painting had promised a great deal more – the freeing of colour from the tyranny of line, the liberation of painting from the register of representation and the possibility of a brush with some sublime void or other metaphysical nothingness. It's just that I didn't believe that anyone could still seriously maintain its claims to transcendence, be they formal, spiritual or otherwise.

So there was the monochrome: born in revolution (around 1920, say, in the tussles between Malevich, Rodchenko, Lissitzky and others); grown through tricky adolescence to some kind of ambiguous respectability in the 1950s and 1960s (think Yves Klein, Piero Manzoni, Lucio Fontana in Europe; Ad Reinhardt, Robert Rauschenberg, Ellsworth Kelly in the US; Hélio Oiticica in

Brazil, etc.); and now old, fat and bloated, come to die as corporate decoration in the boardrooms and marble foyers of every other steel and glass office block, hanging over the head of the CEO like a halo, only rectangular and usually grey. At least, that's what I thought, back then. In truth it was difficult to think of that many actual corporate monochromes, but I loved the image nonetheless, and that, for a while, was good enough for me.

The monochromes I started making began life as paintings, gradually turned into reliefs, and then, after a few years of flailing around, ended up on the floor as objects. The first ones were black. They turned white over time, became silver for a while and occasionally went red – out of embarrassment, I suspect. And all the while there was this nagging question: if the monochrome was so simple, why was this all taking so long? In retrospect, I realise one of my many difficulties was that I had an idea of what I wanted without any obvious sense of what these things might actually be made from – which is only a problem if you are working in a studio surrounded by materials of one kind or another, and with some space to fill in an as yet unspecified and perhaps entirely imaginary gallery. Which is another way of saying that in art ideas are often much tidier creatures than objects. And then, to cut a rather long and very dull story short, at some point in the early 1990s my monochromes tripped up on a couple of readymades and stumbled into some colour. And in the process they began, just possibly, to have a life of their own, rather than one I had dreamed up for them.

In 1997 I also began taking photographs of what I called 'found monochromes' in the streets around where I lived in London. My initial thought was that I would somehow refute a

thesis I had recently heard being made by Jeff Wall in a lecture on the work of On Kawara. Wall had presented a rather vivid account of the history of Modernism as the history of two opposed forces unable fully to escape each other and equally unable to be reconciled with one another. These forces were embodied in the painting of modern life, on the one hand, and high abstraction on the other, and they had found form in photojournalism and the monochrome, respectively. As I understood it, he appeared to be saying that, in its logic of exclusion and emptying out, the monochrome was in some structural way unable to engage with or embody the experience of modernity. That seemed a very plausible argument – except I just didn't buy it. So I went out into the street, literally, with the aim of finding evidence that the city is actually full of monochromes, that modernity is a precondition of the monochrome and that, in all its artificiality, the city is the monochrome's natural habitat, an unacknowledged museum of the inadvertent monochrome. None of which, I now realise, necessarily refuted Wall's thesis, but never mind.

On 17 November 1997, I photographed a monochrome I found on a street in King's Cross, near where I lived at the time. It was off-white and cracked, but I thought it would do the job if I could find another four or five to go with it. But then, slowly, or maybe not so slowly, something happened. I found there was something strange and rather compelling about these ready-made blanks. And from time to time I found new ones. So I photographed them, too. And in the process I learned a few things: a found monochrome has to be a blank surface in the street, but not just any blank surface. It has to be rectangular or square, vertical, white and in some sense

David Batchelor, *Quinta Normal,*
Santiago, Chile, 31.03.05

inadvertent, unplanned, or temporary. For it to work, the monochrome has somehow to detach itself from its surroundings. That's why white is better than black or other colours (I photographed some reds and blues and yellows too, early on). And in detaching itself from the surroundings, by being white and parallel to the picture plane, the monochrome plane can begin to form a small empty centre in an otherwise saturated visual field. A bit of nothing – but more nothing-much than nothing-ness; a presence that is more like an absence, at least for a moment or two. Or, to put it another way, the monochrome became more interesting – more ambiguous, more uncertain – than I had been prepared for it to be. Rather than just a dumb blank or just a bit of exotic emptiness, it appeared that it might occasionally be both, or it might somehow flicker between the two mutually exclusive alternatives. A plane and a void. But not a mysterious void-in-general, rather a contingent void, a void in a place, here, today, on this particular railing in this particular street; here today, and probably gone tomorrow. A void in a place, but not in every place: these incidents are not, I noticed, distributed evenly throughout the city; they have a tendency to cluster in more overlooked and transitional environments, and are scarce in more refined and elegant districts. For me, and perhaps only for me, these bits of peripheral vision are little heroic moments, small monuments to modernity – if modernity can still, in part, be defined in that great phrase of Baudelaire's as 'the ephemeral, the fugitive and the contingent'.

Since 1997 I have found versions of these occasional void-planes in areas of London and in just about every other city I have travelled to. There were around 400 at the last count. I have come to think of the series as an open-ended project that changes shape as it grows and can be exhibited in a number of forms – as a slide show, as individual prints, as an installation of images pasted on a wall in a grid. Together the series forms a map of sorts: a city map; an autobiographical map; a mildly psycho-geographical map; and a map that principally indicates the location of something that is no longer there.

David Batchelor, *The spectrum of Brick Lane*, 2003

David Batchelor, *Star Ferry,
Hong Kong, 10.11.08*

James Woudhuysen
Colour, brands and identity

In London, they brought the fluid neon colours back. For more than fifty years, the moving, illuminated electronic liquid of Lucozade, an energy drink, inspired motorists driving above down-at-heel Brentford as they reached the western approaches of Britain's capital at night. Then, in 2004, the local council demanded that the ageing red bottle endlessly pouring golden goodness into a glass be demolished, despite local protests. But in 2010 the product's makers, GlaxoSmith-Kline, built a new and exact replica of the original sign and mounted it just 200 metres away.[1]

How corporate and product colours will infiltrate public space even more

With Lucozade, the brand, the sign and its colours were a widely loved urban monument. And whatever the intensity problems with the new, dear, long-life but low-energy, light-emitting diodes (LEDs) that are coming into general interior use, we can be sure that over the next ten years the names of brands will brightly shine in gigantic colours, with moving lights and in amazing new ways, on the exteriors of the world's big buildings. One does not need to term these works *kinetic sculptures*, as some do. The point is simple: developments in architectural engineering, height and form, when melded with progress in displays, will conspire to make facades into cinemas for the colourful brand.

In Pudong, Shanghai's financial district, the vertical corners of buildings already boast blue lights that run up and down seventy storeys or more, making edifices fairly throb with energy at night. And one whole side of a skyscraper is already playing video clips over the Huangpu River. So it will not be long before such large-scale tricks make corporate colours into urban icons all over the world. In 1970, following a visit to Tokyo four years earlier, France's Roland Barthes published his personal interpretation of Japan: *Empire of Signs*. Forty years later, the electronic urban logo has become a large, dynamic spectacle, an emphatic corporate or product identifier that's coming to your city wherever you are. What's more, its colours are going to be more precise than ever.

How colours affect our recognition of and preference for certain brands

With Lucozade, the red and yellow in the sign directly copy the colours of the product's distinctive packaging. But there is something interesting about this mix of colours. Red and yellow were for decades the colours of two other, more universal urban landmarks – McDonald's and Shell.

As is suggested with Lucozade, red and yellow together effectively connote things that are essential to travel in and between cities: fuel and energy. Figuratively these are what McDonald's provides, and Shell provides them literally.

Some maintain that McDonald's may have benefited from the fact that red stimulates the adrenaline glands in the brain, or that red and yellow are the first two colours the eye processes and sends to the brain. Yet the similarity of the colours in Lucozade, McDonald's and Shell suggests that colour in branding is more about repeatedly and consistently being distinctive – about standing out, especially in poorer, grittier, greyer districts such as Brentford – than it is about differentiation against other brands. Indeed, distinguished Australian academics, studying soft drinks brands in the UK and banking brands in Australia, have come to the same conclusion.[2]

The financial and colour clout wielded by large corporate brands may create homogeneous cities, as environmentalists often charge.[3] But we may also conclude that in complex urban settings, and perhaps especially in the Third World, endlessly familiar corporate colours are reassuring, suggest modernity and relative safety, work as geographical landmarks, and invite brand loyalty.

How companies choose and claim their identifying colours

Interestingly enough, both McDonald's and Shell have recently changed what professionals sometimes term their Retail Visual Identity. In the case of McDonald's, there has been a shift in Europe towards a literal translation of 'green'. In the case of Shell in the US, pectens on canopies have been stripped of the word 'Shell'. Here the Australian academics are confirmed in an additional point they make – that colour alone 'can replace the brand in some circumstances, or extend the branding quality of any communications beyond simply mentioning or showing the brand name'.[4]

In Europe late in 2009, McDonald's replaced its traditional red for a 'deep hunter green' in hundreds of stores. The intention was to 'clarify', as McDonald's vice chairman for Germany, Hoger Beekof, put it, the company's 'responsibility for the preservation of natural resources. In the future we will put an even larger focus on that.'[5]

Clearly, corporate colours are the subject of much deliberation. At the Cold War's end, for example, both Exxon and Gulf, BP's US subsidiary, used the graphic design titan Saul Bass, no less, to overhaul their filling stations.[6] Now Shell in the US is prepared to let its colourful logo alone to do much of the work of branding, assisted only by some extra white and a nighttime halo.[7] Perhaps this attempt to be less

Glaxo Smithklein building in London
with Neon advertising for
Lucozade, 1950-2004

Interiors of McDonald's

obviously commercial marks a belated concession to Naomi Klein's critique of 'brand bullies'.[8] Cutting costs, however, seems a more important motivation.[9] What is really striking about the colours of brands, both in cityscapes and elsewhere, is how the firms responsible for them say little about how they were chosen, but frequently engage in very public legal controversies to claim them as their own.[10]

In signs, canopies and general outdoor advertising, colour appears to be mute, yet in fact it speaks volumes.

Notes

1. Ian Mason, 'Lucozade to unveil its new neon sign by the M4 after six-year absence', *This is local London*, 15 February 2010, on www.thisislocallondon.co.uk/whereilive/southwest/hounslow/5008320.Brentford_welcomes_back_giant_neon_sign/

2. Jenni Romaniuk, Byron Sharp and Andrew Ehrenberg, 'Evidence concerning the importance of perceived brand differentiation', *Australasian Marketing Journal*, 15 (2007), no. 2, on http://members.byronsharp.com/different.pdf.

3. See for example Molly Conisbee et al., *Clone town Britain: the loss of local identity on the nation's high streets*, New Economics Foundation (NEF), 28 August 2004, on www.neweconomics.org/gen/z_sys_PublicationDetail.aspx?PID=189. For an update, see Andrew Simms, Petra Kjell and Ruth Potts, *Clone town Britain: The survey results on the bland state of the nation*, 6 June 2005, NEF, on www.neweconomics.org/gen/z_sys_publicationdetail.aspx?pid=206.

4. Romaniuk et al., 'Evidence concerning the importance of perceived brand differentiation' (note 2), p. 51.

5. 'Color McDonald's Green', *NACSonline*, 25 November 2009, on www.nacsonline.com/NACS/News/Daily/Pages/ND1125093.aspx.

6. James Woudhuysen, 'Bass profundo', *Design Week*, 22 September 1989, on www.woudhuysen.com/index.php/main/article/272.

7. 'USA: Shell RVIe Identity Unveiled', *PetrolWorld*, 22 September 2009, on www.petrolworld.com/world-headlines/usa-shell-rvie-identity-unveiled.html.

8. Naomi Klein, *No logo: Taking aim at the brand bullies*, London: Flamingo/HarperCollins, 2000. For a critique, see Mick Hume, '"No Logo" – ten years on', *The Times*, 16 January 2010, on http://entertainment.timesonline.co.uk/tol/arts_and_entertainment/books/book_reviews/article6988405.ece.

9. 'USA: Shell RVIe Identity Unveiled' (note 7).

10. See for example IP Media Centre (Australia), 'Battle Royal over the Colour Purple', 24 October 2008, on www.ipaustralia.gov.au/media/pages/lead/cadbury_purple.htm.

Pudong, Shanghai, China

Caroline Bos
UNStudio studies colour

Colour is an important aspect of architecture. Buildings belong to the public realm, and as such their visual contributions to the city are socially relevant. Colour is an intrinsic part of that narrative and has the ability to enrich and transform the readings of both space and place.

UNStudio embraces all colours in architecture; we enjoy a diverse palette. In the Almere office of the project *La Défense* (2001), colour says something to us about time of day. The elevations of the internal courtyard change colour depending on the incidence of the light, naturally animating the office environment by producing an ever-changing atmosphere. For the laboratory in Groningen (2009), colour opens up the facade, functioning as a link between the communal zones of the campus and the research building.

Our enjoyment of colour leads us to ask: what is the role of colour in the urban environment? Why is colour important? And how can it be used in better ways?

This pre-study serves to articulate some questions and issues relating to the future of colour in the urban environment. UNStudio occupies a highly specific position within this field. We want to acknowledge this position (it would be disingenuous to pretend to be a neutral observer of a discipline in which we actively participate and compete), and this study is therefore largely of a personal nature, casting a reflective light on our own use of colour and questioning our own decisions in order to further the understanding of the use and the future of colour in the urban environment.

Cultural identity
For many societies, colour is a direct expression of their culture. Different cultures distinguish and identify themselves in part by the colours found in their environment. Colours can be seen as a reflection of location. Local climate and environmental factors coupled with regional building materials and technology all play a role in determining the visual environment of a city. There is a direct chromatic link between material and location seen in the traditional buildings of Dubai, where materials for coral and mud bricks are locally quarried. As these determinants vary from place to place, identity can be found in their uniqueness.

These 'hard' parameters of geography and technology have shared relationships with the associative attachments that a culture may place on a colour. Collective memory and cultural meanings can often be seen visualised through the distinct use of colour treatments. A strong example is the Korean 'Dancheong' traditional colour scheme. Here the facade colour application protects the wooden structure from the elements and also functions as a codification system, indicating the building's status. Function and significance of colours contribute to the experience of a location, infusing meaning and *genius loci*, adding to the identity of place.

Homogeneity
Colour has the potential to play a unique role in challenging the homogeneity experienced in the modern city. Cities are often shaped by very pragmatic decisions, with one of the ramifications being the prevalence of certain colours within the urban environment. Global access to building materials and construction methods has encouraged the uniformity of the ever-expanding modern city. The danger of the repetitious standardisation of building elements is that it can lead to monotony and in turn lack of place, with the result that nothing unique marks the environment, and there is nothing distinguishable upon which to orientate yourself.

It needs to be remembered that in our large metropolitan cities, culture is not only attached to cultural buildings. Here, large buildings transcend their roles as retail or office typologies due to their scale and the extensive room they occupy within the city. There is a need to see these buildings as playing a social role and to consider their impact on the public realm.

Architecture
Vernacular architecture is often far more colourful and expressive than that produced by the modern architect. The role of the architect has to be examined. Why is modern architecture more visionary in form than in colour?

Historically colour has been both valued and marginalised in Western theory and philosophy. During the Renaissance, the question of the value of colour as opposed to that of the drawn line sparked much debate. The privileging of line over colour continued to be an important point of discussion within Modernist discourse, where colour is thought of as emotional while line is promoted as being intellectual. Often colour is relegated to secondary status, the idea being that strong architectural form should stand alone, unadorned and devoid of chromatic considerations, which would only distract the viewer's attention.

As Le Corbusier wrote in 1925 in *The Decorative Art of Today*: *'What shimmering silks, what fancy, glittering marbles, what opulent bronzes and golds! [...] Let's have done with it [...] It is time to crusade for whitewash [...]'* (Quote: David Batchelor, *Chromophobia*)

UNStudio, Research laboratory,
Groningen, 2003–2008

Colour in the urban environment is a taboo

A taboo is a social and cultural construct. The general tendency to shy away from and marginalise colour has given rise to patterns of behaviour, some of which have become so second nature that they remain for the most part unchallenged or unnoticed.

Whether lack of chromatic consideration is based on pragmatic reasons, architectural trends, the universal access to building materials or construction methods and technology, cities and neighbourhoods run the risk of becoming disassociated from their inhabitants and losing their identity of place.

The inclusion of colour in the discussion of our urban environments can aid in addressing some of the contemporary societal demands placed on the modern city.

The future of colour use in the urban environment

Colour has been injected into the public environment in a number of venues. These examples not only lead to interesting thoughts on potential avenues of architectural pursuit, but they also demonstrate that the need for urban colour usage has already been identified. New typologies have emerged such as public art installations and exhibition pavilions which fill an important niche within the city fabric. They are prized and highly regarded landmarks and symbols of the city.

There are numerous scales by which one can experience the urban environment. Public art and temporary pavilions engage colour at the scale of the pedestrian. Whether permanent or transitory, often cropping up in unexpected locations, these are vehicles that promote social connection. New techniques, often associated with art and pavilion design, offer a territory rich with possibilities. One fruitful avenue is the application of technological possibilities. Among

other developments, a transformative use of colour has emerged, where LEDs and projections are able to completely alter the appearance of the environment.

Colour as an urban activator
The meaningful use of colour
The colour palette for UNStudio's Agora Theater in Lelystad was based on a chromatic spectrum distilled from photos taken of cloud formations over that city. The vivid colours are from the effect of light reflecting off water onto the low-lying clouds. Our experience of using a strong colour palette with the theatre project is akin to wearing your heart on your sleeve. Architects who use colour in a bold way tend to stir up a great deal of interest. The reward has been that the vivid colours are a great way to create identification; people have strong feelings towards the building, and it has become a symbol for the city. Unique to Lelystad, the building evokes a sense of pride and ownership.

The dynamic use of colour

The architectural use of colour must concern itself with the volumetric perception of chromatic change. Colour reacts in a three-dimensional manner in relation to changing variables, such as distance, scale and light conditions. The changes in hue or colour saturation can greatly influence the perception of an object and in turn the space around it. The varying daylight conditions in Rotterdam have a chameleon effect on the colour of our design of the Erasmus Bridge, with both sky and water influencing the visual perception of the light-blue colour, creating a dynamic effect.

Colour as an urban activator
From name-branding to place-branding
There is an innate importance in creating a positive living environment. Visual disorder is often the

result of clashing and competing agendas, which are frequently market driven.

This colour pollution can diminish urban quality and identity. With proper planning, colour can be taken away from branding and be given public significance. In this way colour becomes identified with place.

Way-finding
Colour has the potential to function as a way-finding tool, creating references or landmarks within the city, allowing for and acting as a point of orientation. It permits you to locate yourself, and it also has the capacity to guide and steer pedestrian flows.

Pre-study conclusion and future directions

Our investigation into the use of colour has taken us on an amazing journey, from historical theories to contemporary practice to insight into the future. Through all the variables, one constant remains and that is the important role that colour can play in the urban environment. The effect and influence that colour has are profound, and as architects we are privileged to be able to include colour within our design tools.

Within this pre-study phase of the research project we have identified strong and promising ways to activate colour in the urban environment: the meaningful, the dynamic, colour as place-branding, and as way-finding.

With these techniques as a base, we look to the future: how can they be used in order to encourage the use of colour in the modern urban landscape?

Cultural connector
The first avenue of pursuit is that of colour as a 'cultural connector', a means of bringing together, where colour says something about how a community identifies itself as a group within a location. Identity of place.

UNStudio, Star Place, Kaohsiung,
Taiwan, 2006–2008

Social activator

The second is the potential of colour to activate public life as a 'social activator'. This is where colour plays a role in stimulating social events and focusing civic energies.

Public attractor

The third theme we propose for future investigation is the ability of colour to create a sense of orientation, a method of navigating through the city, using colour as a 'public attractor'.

Literature

Aiping, Gou, and Wang Jiangbo, 'Research on the Location Characters of Urban Color Plan in China', in: *COLOR research and application*, 33 (2007), no. 1

Batchelor, David, *Chromophobia*, London: Reaktion Books Ltd, 2000

Caivano, José Luis, 'Research on Color in Architecture and Environmental Design. Brief History, Current Developments, and Possible Future', in: *COLOR research and application*, 31 (2006), no. 4

Caivano, José Luis, and Mabel Amanda Lopez, 'Chromatic Identity in Global and Local Markets. Analysis of Colours in Branding', in: *Colour: Design & Creativity* (2007), no. 1. <www.colour-journal.org/2007/1/3/ 07103 article.pdf>

'Chronological Bibliography on Color Theory', in: *Color Research Program School of Architecture, Design and Urbanism, Buenos Aires University.* <www.fadu.uba.ar/sitios/sicyt/color/bib.htm>

'City's color plan not as simple as black and white', in: *China Daily*, 22 March 2007 <http://news.jongo.com/articles/07/0322/9912/OTkxMg1Phy TxcN.html>

Kuehni, G. Rolf, 'Forgotten Pioneers of Color Order. Part I: Gaspard Gregoire (1751–1846)', in: *COLOR research and application*, 33 (2007), no. 1

Lenclos, Jean-Philippe, and Dominique Lenclos, *Colors of the World. A geography of Color*, New York: W.W. Norton & Co, 2004

Mahnke, H. Frank, *Colour, Environment, and Human Response*, New York: John Wiley & Sons, 1996

Minah, Galen, 'Colour as Idea. The Conceptual Basis for Using Colour in Architecture and Urban Design', in: *Colour: Design & Creativity* (2008), no. 2, p. 1–9. <www.colour-journal.org/2008/2/3/08103article.pdf>

Porter, Tom, *Colour for Architecture Today*, New York: Taylor & Francis, 2008

Shelton, Barrie, *Learning from the Japanese City. West meets East in urban design*, London: Spon Press, 1999

Solon, Leon V., 'Principles of Architectural Polychromy', in: *The Architectural Record* (1922). <http://archrecord.construction.com/inthecause/onTheState/0402solon-1.asp>

Suh, Jae-Sik, *Korean Patterns*, Elizabeth, NJ: Hollym International, 2007

Swirnoff, Lois, *The Color of Cities. An International Perspective*, New York: McGraw-Hill, 2000

Swirnoff, Lois, *Dimensional Color*, New York: W.W. Norton & Co, 2003

Yugo, Hatakey, Toshinobu, and Oku Suguru, 'The Changing Appearance of Color of Architecture in Northern City. A Comparison Study of Architecture's Appearance in Summer and in Winter, in Sapporo City', in: *Journal of Asian Architecture and Building Engineering*, 4 (2005), no. 1, p. 161–167

Zhang, Tingting, 'New Urban Garbage, Color Pollution'. China.org.cn. 25 May 2004. <www.china.org.cn/english/2004/May/96405.htm>

UNStudio, Erasmus Bridge, Rotterdam,
1990–1996

Luis Barragán
The colours of Mexico

*Colour is a complement to
the architecture. It serves to
enlarge or reduce a space.
It's also useful for adding that
touch of magic a place needs.*

1

In my activity as an architect,
colour and light have always
been a crucially important con-
stant. Both are basic elements in
the creation of an architectural
space, given that they can vary
the conception of the latter. For
example, in my project for the
chapel of the convent of the
Capuchin Sacramentarian Sisters
of the Purest Heart of Mary in
Tlalpan, I attentively studied light
and colour, because I wanted to
create an atmosphere of stillness
and spiritual meditation. The idea
of semi-darkness was very im-
portant in this project. I underline
the study of colour above all.
Before deciding on the exact
shade that I want to use I do
several tests to verify the effect,
applying the colours on large
and small panels to evaluate the
results.

2

It is the pleasure of seeing the
colours, of enjoying them. There
are fewer colours in nature. In
nature it is green shades that
predominate. I have never used
green, I would not know how to
do it. The green would compete
with nature, so that the one or
the other would perish…

3

Colour is a complement to the
architecture. It serves to enlarge
or reduce a space. It is also
useful for adding that touch of
magic a place needs. I use
colour, but when I draw I don't
think about it. I usually define it
when the space is constructed.
Then I constantly visit the loca-
tion at different times of the day
and begin to 'imagine the

colour', to imagine colours
ranging from the craziest to the
most incredible ones. Then I
return to my art books, the sur-
realistic works of De Chirico,
Balthus, Magritte, Delvaux and
Chucho Reyes.

I leaf through the pages, behold
the paintings and suddenly dis-
cover colours which fit in with
what I have imagined, and so
these are the ones that I decide
on.

Later, I ask the master painter
to paint these colours on large
pieces of cardboard and to
attach these to the uncoloured
walls. I leave these cardboard
walls hanging for several days,
move them around, change the
contrasts on the walls until I
finally come to a decision about
what I like best.

4

Walls are made to be painted on
over and over again. I believe
that a building should be repaint-
ed every two years. In the last
house that I built, that for Mr
Gilardi, the colours play a signif-
icant part: the patio is done in
vibrant purple. The hallway takes
one through the house to a signif-
icant place: the dining room with
its covered cistern. A pink wall
rises abruptly out of the water-
tank, cutting through the water
and reaching almost to the roof.

This wall makes the room
sensitive, gives it a magic quality
and radiates tension. A small
overhead light sprinkles light
over the wall, thus heightening
the effect.

Both the colours for the pink
wall and the blue of the surround-
ing area originate from a famous
painting by Chucho Reyes.

Luis Barragán, Ciudad Satélite,
Mexico City, 1957

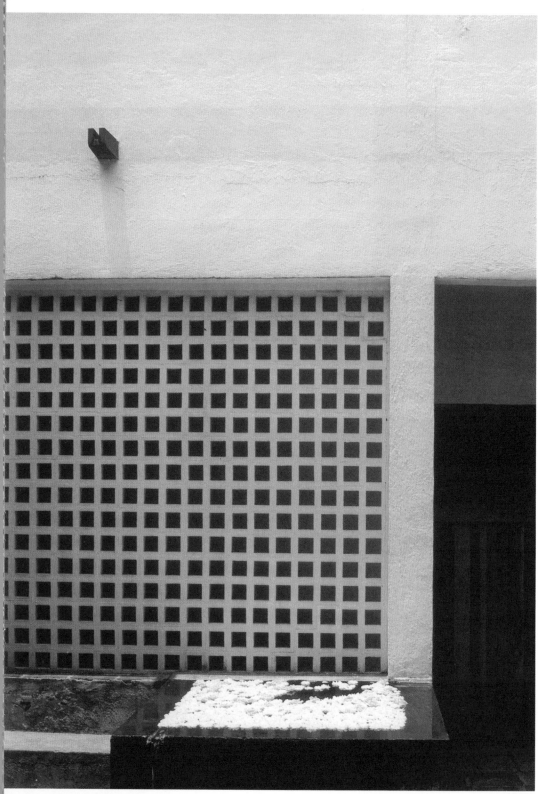

Luis Barragán, Capilla de las Madres
Capuchinas Sacramentarias del Purísmo
Corazón de María, Tlalpan, Mexico, 1953–1960

Luis Barragán, Gálvez House, Chimalistac,
Mexico City, 1955

Anne van der Zwaag
**Temporary architecture:
colour as tour de force**

Short-lived architecture crops
up wherever people gather.
Temporary pavilions give form
and identity to often amorphous,
anonymous places like squares
and parks, and as such they fulfil
an important role in the public
space. In that sense, architec-
tural interventions are still closely
connected to events, happenings
and other kinds of gatherings
inside and outside the urban
setting. While temporary archi-
tecture in the past was associa-
ted with follies, circuses, party
tents, camps and barracks, the
world's top architects today
excel in temporary pavilions in
the full knowledge that sooner or
later the structure will disappear.
In fact, awareness of this
inevitable demise seems to
inspire them and often results in
freer design language and a new
aesthetic.

Architects feel momentarily
liberated from the pressure to
erect something of eternal value,
and they use temporary pavilions
to interrupt or transform the
space, as a laboratory or as a
means of expression. An inciden-
tal advantage is that temporary
pavilions are usually flexible,
mobile, lightweight and relatively
cheap, which means they can be
constructed more easily than
conventional buildings. Often
experiments are undertaken with
light and transparent materials
such as paper and cardboard,
and in many cases the temporary
pavilion functions as a pilot
project, such as *A Piece of
Banyan*, the installation that
Mecanoo presented in 2008 at
the Salone del Mobile in Milan.
This involved making a scaled-
down fragment of their National
Performing Arts Center in
Taiwan. In the evening, the walls
and ceilings of the Mecanoo
pavilion underwent a constant
colour change.

Perhaps even more important
is the fact that there is only a brief
period of time to make an impres-
sion on the viewer, to intrigue
him, to tempt him or to otherwise
entertain him. For this reason,
these pavilions are often not only
works of technical ingenuity but
creative feats as well, comparable
with the expressive 'limited
editions' of industrial designers
or with the work of autonomous
artists. The temporary pavilions
that are created by architects
each year in the London Serpen-
tine Gallery already seem to have
been elevated to works of art.
Among the great masters
responsible for installations here
are names such as Hadid, Gehry,
Niemeyer and Koolhaas. Some
pavilions have scarcely any
practical function; just creating
admiration and excitement
seems to be the most important
goal of the Serpentine Pavilion.

In many cases, use is made of
things that guarantee a big visual
impact such as light and colour.
Not only do light and colour raise
the aesthetic value of a building,
but they can also emphasise its
ephemeral character. The tenth
Serpentine Pavilion, designed by
the French architect Jean Nouvel
and unveiled in the summer of
2010, consists of lightweight
materials and is coloured bright
red.

The Shanghai Expo in 2010
bathed visitors in colour. The
exterior of the Shanghai
Corporate Pavilion by Atelier
Feichang Jianzhu is built up of
multicoloured, computerised
LEDs that constantly change the
appearance of the facade. In the
Polish pavilion, designed by
WWA Architects, colour and light
also play an important role. The
building is constructed of
enormous ornaments with
coloured light shining through,
thereby forming a large
decorative object. In the Danish
pavilion and the Macau Pavilion
by Carlos Marreiros Architects
the colour red dominates, and
that colour also plays an

important role in the building
designed by John Körmeling for
the Netherlands, Happy Street.
This pavilion contains a street
lined with well-known Dutch
architecture. The colour red of
the paving is a reference to the
Chinese tradition, in which red
is (among other things) a symbol
of happiness. Several architects
in Shanghai have taken their
inspiration from their host coun-
try, and as a result the colour red
is widely used. The fact that red
has such a strong indicator func-
tion is no coincidence either.

South-Korean Pavilion,
Shanghai Expo, 2010

Jean Nouvel, *The Red Sun Pavilion*,
Serpentine Gallery, London, 2010

Susanne Komossa
Historic colour on public buildings: more than local identity

Palau de la Música Catalana and Mercat de Santa Caterina in Barcelona

Usually the relationship between the colours used for public and private buildings and local identity is based on models that have 'grown' over time. In such cases, colour is connected to notions like 'authenticity', to something that expresses the supposed real character of a city, a region or a country, or reflects its natural environment. We're all familiar with books and studies that describe the way colour is used on the island of Burano in Venice,[1] for example – studies that classify cities according to colour (Paris as the white city, for instance), that speak of national colours or develop historical colour schemes that are meant to restore a supposedly lost identity, as Canella and Cupillilo did in their work on Turin.[2]

What is less well known is that the exterior and interior colours of public and private buildings can also have a political significance, which is used to express the struggle for political recognition – sometimes independence – of a particular region, area or nation. When people are seeking to establish a new identity, special applications of colour and material are developed. These applications are 'constructed', as it were, in order to reinforce a political position. In such a process, colour communicates this new self-awareness within the public domain in a way that is clearly visible, as if it were a *fait accompli*. The deviating colour and material application, and its striking appearance, stand out immediately and emphasise the new political consciousness.

The most interesting European examples of such use of colour date from the end of the nineteenth and early twentieth century. This was a time of massive economic, cultural and political change and upheaval on the eve of the First World War. Some regions, such as Catalonia in Spain, underwent rapid economic and cultural development and sought to achieve a new status in the modern world.

A whole series of these attempts to exhibit a new national and political self-awareness is connected with particular style variants of the Jugendstil and Arts & Crafts movements. A good example of this in Slovenia, in Ljubljana, is the work of architect Josef Plečnik. In Brussels there are the projects of Victor Horta, and in Barcelona there's the work of the Modernista movement (1880–1915), in which the architects Antoni Gaudí and Lluís Domènech i Montaner played a part. In a certain sense, Amsterdam and the Beurs van Berlage also belong in this series.

Having roots and relationships in the Jugendstil movement made it difficult to place this agitprop architecture *avant la lettre* within the canon of modern architecture during the 1920s. The propagandists of the Modern Movement called it 'unmodern', an insignificant local phenomenon, and the standard twentieth-century works on architecture simply passed it over. It wasn't until 1970, when the Modern Movement came under revision, that architects and architectural students began to show renewed interest in the oeuvre of the supposed dissidents. In a quest to find the undamaged roots of modern architecture, projects and excursions were organised at various places to study this work once again and bring it to public attention. The Department of Architecture at Delft University of Technology also undertook such a project.[3] One of the most surprising but lesser known examples of architecture in which colour and a special use of materials were put to work in pursuing the cause of political and cultural autonomy is the Palau de la Música Catalana by Lluís Domènech, which was opened in 1908. Catalonia had undergone a period of turbulent industrial development during the second half of the nineteenth century, and its struggle for political and cultural independence went back even further.[4]

In its genesis and function as a concert hall as well as in its architecture, the Palau embodies the new self-awareness of the local bourgeoisie. Many of them were industrialists who jointly commissioned the building of the Palau and financed its construction. The use of new industrial products and rationalised construction methods is also striking. Not only were these products and methods aimed at driving the costs down, but the building materials were actually supplied by companies in the Barcelona area, often owned by the new elite.

The Palau itself is rather tightly squeezed into a corner of a city block on a side street of the Via Laietana in the center of Barcelona. Most of the exterior is red brick and is decorated with sandstone elements, majolica mosaics[5] and a few sandstone sculptures. The tile decorations on the exterior and interior of the building are a colourful mishmash of materials and production methods. Most of the tiles are painted with lavish flower motifs, some of them aflame, and they vary from tiles made especially for the Palau to leftovers and shards – that is, rubbish. There's a comparable freedom and virtuosity in the stained glass, which is used throughout the building: from ordinary clear service glass to magnificent cobalt blue, everything is effortlessly combined in decorations that always strike a balance between regularity and spontaneous variation.

It's almost impossible to take in the concert hall in its entirety

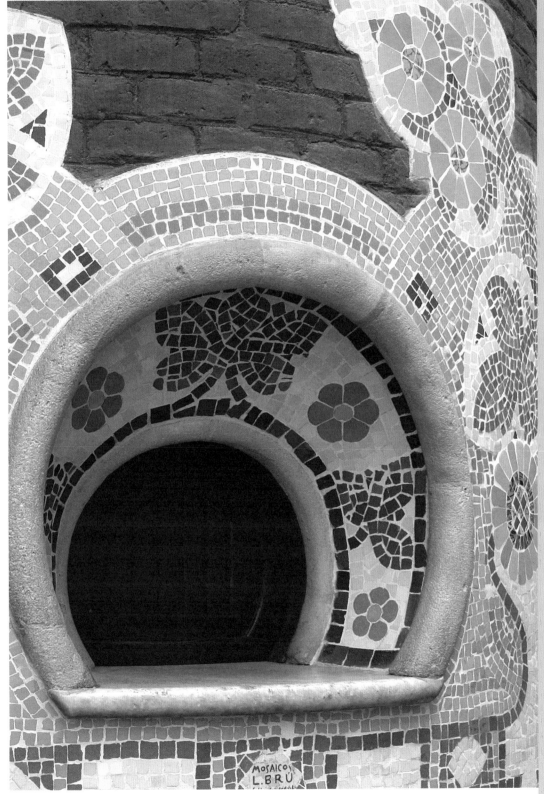

Palau de la Música Catalana,
Barcelona, detail

from the adjacent narrow lanes. So a great many of the decorations are located on the plinth and the underside of the balcony, and in the loggia on the first floor. The corner of the city block, which can be seen from a greater distance, is expressively accentuated. Construction and cladding, regularity and exception blend together seamlessly in both the exterior and the interior. In some places the lack of space is dealt with ingeniously. For example, the box office for ticket sales is housed in one of the heavy-brick entrance columns. Another space-saving idea was to move the concert hall, with its large volume, to the first floor, so the foyer could occupy the street floor. Every effort was made to compensate for the lack of space by letting in the daylight from the surrounding lanes and installing strategically placed skylights: the daylight, which enters the building from all sides, creates the illusion from within that the building is freestanding.

The level floor of the concert hall is constructed by means of vaults, giving the foyer below a somewhat crypt-like and *bodenständig*, down-to-earth character. This is reinforced by the 'natural' brown and beige tones of the tiles, the natural stone floor and the unpainted brown wooden door and window frames. The baroque-looking balusters on the balconies, the stairways and in the concert hall are made of prefabricated, cylindrical glass elements produced industrially *en masse*. They wouldn't be out of place in a technical installation.

The colour scheme of the interior unfolds vertically upward, from earth tones to a multitude of colours on the top floor. The motifs usually refer to elements in nature, which puts them in the nineteenth-century colour tradition such as the one developed by Semper (*Vorläufige Bemerkungen über bemalte Architektur bei den Alten*, 1834) and later by

Ruskin (*The Seven Lamps of Architecture*, 1849) and Owen Jones (*The Grammar of Ornament*, 1856).[6]

Despite the profuse decoration, the Palau building is extremely rational, modern and efficiently constructed. The floor above the concert hall, for example, which forms the roof, is a relatively light combination floor consisting of iron T-sections containing prestressed concrete elements about 60 cm in width.[7] The construction spans the entire width of the hall and looks quite light in the tectonic sense of the word. The concrete elements and the iron T-sections are faced with ceramics, but the construction as a whole has been left fully visible. Some of the prefabricated majolica roses were applied as ribbons, but others form a pattern in which they seem to have been freely scattered around the capitals of the columns. They form a cheerful addition that tones down the utilitarian character of the ceiling but doesn't negate it. Fitting the roof with a trimming joint made it possible to install a large skylight, which, along with the light from the two facades, bathes the hall in coloured light during the daylight hours. Along with the flower motifs, this reinforces the sense of 'being outside' even more.

For the restoration of the Santa Caterina market[8] in Barcelona's Barrio Gótico, completed in 2005, architects Enric Miralles and Bernadetta Tagliabue (EMBT) drew on the colour and materials of Catalan Modernism. Right up to today, the four Catalan provinces (including the Balearic Islands) emphasise their language and culture as important aspects of their autonomy within the Spanish system of government, an autonomy they were officially granted in 1932. One aspect of that culture is Catalan cuisine (culinary products are on sale everywhere in the covered markets of Barce-

lona), and the people of Catalonia are immensely proud of it.

The facade and wing of the old Santa Caterina market are still standing. The roof, however, with its undulating tiles and steel support structure, are new. The tiles are suggestive of the parabola-shaped constructions that Gaudí developed for optimal weight distribution based on his hanging chain models. The tile pattern on the roof reveals a collage of magnified fruit, with the undulating surface as the garden on which the inhabitants of the surrounding residences can gaze. Once again, nature, with her profusion of colours and forms, is the source of inspiration.

In conclusion, it can be argued that the use of colour and materials in the Palau de la Música Catalana brilliantly expresses the spirit of the age: it's a symbiosis of modern and classic, of traditional methods and industrial production, of local and international, of stylistic freedom and architectonic discipline. As architects, we can only look on it with admiration and envy: will we ever be capable of creating such a successful embodiment of society's ideals? There's one thing we know for certain: in such an enterprise, colour is one of the most powerful architectonic tools. For present-day proof, we need look no further than Miralles and Tagliabue.

Notes

1. Martina Düttmann, Friedrich Schmuck and Johannes Uhl, *Color in townscape*, London: The Architectural Press, 1981.
2. Nino Canella and Egidio Cupolillo, *Dipingere la città, il piano del colore: L'esperienza pilota di Torino*, Turin: Umberto Allemandi, 1996.
3. Vincent Ligtelijn and Rein Saariste, *Josep M. Jujol*, Rotterdam: 010 Publishers, 1996.
4. For a detailed description, see: Manfred Sack, *Lluís Domènech i Montaner, Palau de la Música Catalana, Barcelona*, Stuttgart: Axel Menges, 1995.
5. Majolica is the name of a robust, brittle kind of ceramic painted in bright colors. The name 'majolica' is a corruption of the Spanish Mallorca, an island in the Mediterranean Sea and the production center for that type of pottery during the Middle Ages. The technique comes from North Africa and the Middle East. Source: Dutch Wikipedia.
6. For more detailed documentation, a timeline and the original texts, see: Susanne Komossa, Kees Rouw and Joost Hillen (eds.), *Colour in contemporary architecture: projects / essays / calendar / manifestoes*, Amsterdam: SUN, 2009.
7. 'The early use of an iron support structure alone is important. Indeed, the Palau appears to have been the first European building of this type – one not strictly for industrial use – along with the Ritz Hotel in London, which dates from 1905.' Oriol Bohigas, *Resena y catalogo de la Arquitectura Modernista*, Barcelona: Lumen, 1973; from the Dutch translation by Karen Rombout and Rien Pico, Delft, typescript Architecture library, 1978, p. 38. When I visited the Palau for the first time, in 1975 – Barcelona was still groaning under the yoke of General Franco and many architects, including Oriol Bohigas, were under a professional ban – the Catalan national anthem was still being sung before every performance.
8. Also see: Komossa et al. (ed.), *Colour in comtemporary architecture*, 2009 (see note 6), p. 198–201.

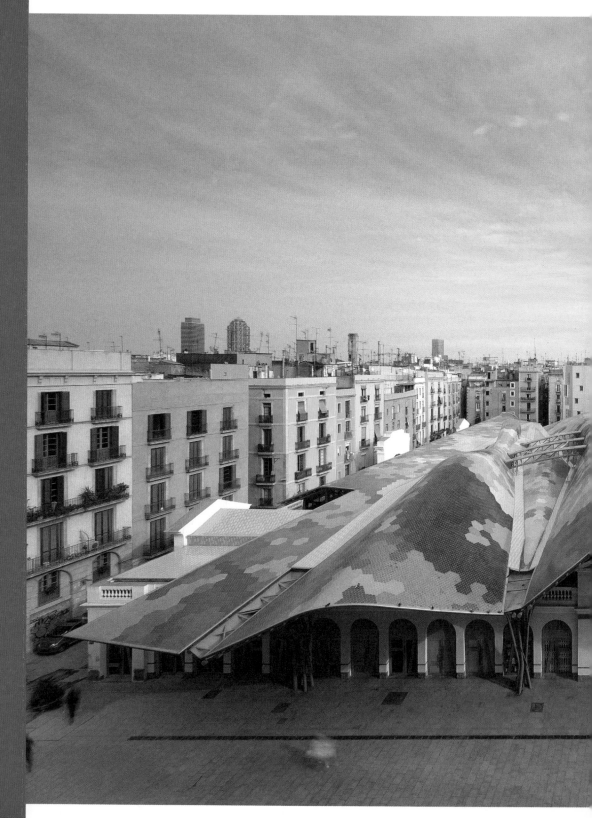

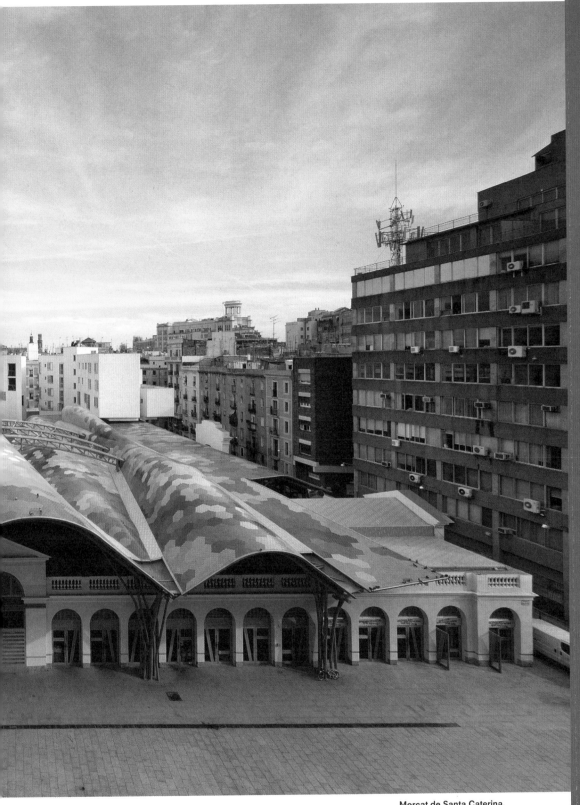

Mercat de Santa Caterina,
Barcelona, facade and roof

Anne van Grevenstein
'Moving on with Cuypers'

All through the twentieth century the exterior of the Rijksmuseum in Amsterdam remained virtually intact, as befits a national monument. The interior, however, was a different story: the original unity of form, colour and architecture that had been so characteristic of the nineteenth century had all but disappeared by the beginning of the twenty-first.

The renovation of the interior of the Rijksmuseum was preceded by a two-year period of research. This involved looking into the archives at the design sketches, the old black-and-white photographs and the building specifications, and carrying out a technical investigation of the materials in order to answer the question, 'How much of the original interior decoration has survived?'

The interior of the Rijksmuseum, which was completed in 1885, underwent a series of gradual changes – certainly after the death of architect Pierre Cuypers in 1921 – until it ended up as a white space with completely filled inner courtyards. The museum galleries were dominated by artificial light, while the building was originally intended to be a daylight museum. Numerous renovations were performed in the interior, layer by layer, and new colours were applied that reflected the taste of the successive museum directors and changes in the function and significance of the various rooms. This layer structure was still in evidence in many places and could be accurately documented by means of stratigrafic examination using scalpels, microscopes and pigment analysis. We can follow the first colour change in a letter that the second director, Schmidt Degener, wrote to his government minister, 'I have tempered the excessive decoration', and

we can still trace this intervention in the library as dots of grey paint that were applied to the original painted surface with a sponge. This produced a grey film that served to soften the colours and contours. What followed were a few more monochrome layers in grey, beige or green, and after the Second World War everything became white. The painted canvases by Georg Sturm in the Entrance Hall and the Hall of Honour were removed and stored away, piece by piece. Two organs were installed on the short sides of the Entrance Hall, and these, in combination with the bright white paint, gave one the impression of being in a Protestant church. A few decades later the plaster was entirely removed from the walls and the mozaic floor was removed.

The Entrance Hall, which Cuypers had envisioned as a 'Temple for the Arts', was originally an ensemble piece in which decorative and figurative painting, stained glass windows and the floor complemented each other iconographically and in terms of form and colour. The question was whether this original unity could be reconstructed, and if so, how? An examination had shown that the first layer of overpainting was a mixture of linseed oil and white lead, and this binding agent had been absorbed into the original distemper. The result was an indissoluble layer, mechanically and chemically irreversible, that could not be removed from the original without causing damage.

Because restoration of the authentic material was not possible, the option of reconstruction was looked into. A 'Cuypers palette' was developed with the valuable help of the Sikkens Laboratory. The restoration team from the Limburg Conservation Institute reproduced the colour values and provided a meticulous description of the mat surface and the saturations of

the decorations as they had naturally aged over time. Rare fragments of untouched parts of the original decoration provided information on the painting techniques common to the late nineteenth century, such as the use of cartoons and stencils. These methods were employed in order to approximate the authentic aesthetic effect of the decoration.

Of great importance to the reconstruction were the educational opportunities it afforded. Art students from the Sint Lucas vocational school in Boxtel were called in to assist in reconstructing the decorations, working under the supervision of the restoration team.

This inspiring synergy has restored the main parts of the Rijksmuseum to the original unity between architecture and colour. Today, colour in the museum can be experienced in its inseparable connection with late-nineteenth-century design language. It's a historical function whose rarity has made it all the more valuable.

Entrance Hall, Rijksmuseum, Amsterdam

Hall of Honour, Rijksmuseum, Amsterdam;
a museum worker creating a stipple effect
by tamponing

Tracy Metz
Interview with Jan Dibbets on his church windows

Choosing the right colour is just like finding the right word for a poem.

Precision

When his designs for stained glass windows are installed in France and the Netherlands, Jan Dibbets works closely with glaziers without having mastered the skill himself, or so he says. 'All I wanted to do was to make something that was simple to construct without too much embellishment or virtuosity on the part of the glazier. Actually there's much more virtuosity in my designs in a certain sense because they require such a high degree of accuracy. Like the lines having to be three centimetres apart and not two and a half. So it's extremely difficult from a technical point of view because it demands precision.'

He has also tried to eliminate any kind of playing around with the material. Unlike glaziers, he's not in love with glass: 'It becomes *l'art pour l'art* then, but you end up sacrificing the window as a work of art. Thicker, thinner, bubbles, running colours – that's crippling. All those pretty little bits interfere with the unity. As an artist you have to subjugate your material. It's like oils in a painting: it's no more than a tool that you have to restrain: you are blue, and blue you shall remain!'

Dibbets has chosen his colours because they fit: the colour of *Kyrie*, of *Gloria*, of palm branches, the long yellow stripe in *Puer natus est nobis*, unto us a child is born, that connects 'natus' with the earth. He walks to the other side of his work table, an oval wooden surface five meters long. Lying there, like an inviting jewellery case, is a cigar box full of strips of collared glass – only a fraction of the possible choices that he's examined, he assures me. He holds two strips of green against the light: 'That one's too artistic, too precious, too soft. It would weaken the image. But this one! So incredibly bold. That's the one I want. The boldness of the colour forces the image on you. Palms in this shade of green aren't palms, they're representations of palms that are there because they symbolize something else: martyrs.'

Choosing the right colour is just like finding the right word for a poem, says Dibbets: the process follows its own rules that have nothing to do with what's *beautiful*. The power of the window to persuade is not in the beauty of the colours but in the way the materials have been used. Not the 'what' but the 'how'. 'The least beautiful blue can be the best; a red line must be a red line, as if it's been drawn with a pencil. Actually, they're rather crude colours: as soon as the colour palette becomes refined and you have to start looking for variations, it's all over. You fall prey to good taste.'

'In the end, nothing is more beautiful than the neutral colour of the window with a single additional colour. A very simple blue, for example. Exquisite. In most cases there are no more than three colours per window, and even those colours are used very sparingly, such as the red on the tips of the crown of thorns. In choosing the basic colours, I did pay attention to the incoming northern and southern light. Between six and eight different shades of green are used on the sunny southern side in order to soften the light, to make it cooler. On the northern side there's a combination of red, brown, beige and pink to make the light warmer. But if you stand in the middle of the church you can't tell the difference. The colour has to accompany the light, and not vice versa. Otherwise you end up with a magic lantern. It's a Dutch specialty: first the light, then the colour.'

Has working in an applied art form like stained glass had a positive effect on Dibbets's other work? 'Every artist thinks about images, and about the imagination, and about light... But then you start talking about painterly light and two-dimensional space. Stained glass is such a specific medium: the light isn't noticeable but it shines right through, and it's three-dimensional to boot. This project has taken me through everything I've ever learned as an artist, but at an accelerated tempo. In a very short space of time I've learned to draw, to see space and to use colour all over again.'

Jan Dibbets, design for a stained
glass window for the Blois cathedral,
France, 1992

Kees Rouw and Lisette Kappers
An architecture of joy

In 1979 the book *An Architecture of Joy* was published, written by the extravagant American architect Morris Lapidus (1902–2001), who was known for his remark 'Too much is never enough.'[1] With his neo-Baroque, lavish architecture he may have won the praise of those who made use of his structures, but he was scorned by his American colleagues and architectural critics, who awarded him the dubious 'honour' of being the second worst architect of all time. Comparable scenes were played out in Dutch architecture in the early 1930s. At that time the central figure in the discussion was the civil engineer S. van Ravesteyn (1889–1983). Van Ravesteyn, initially a successful advocate of clean-cut architecture in the style of his friend Gerrit Rietveld, ended up promoting neo-Baroque gaiety in modern form, although a bit less glamorous than that of Morris Lapidus. The controversy he incited – in the press he was known as a 'convinced chameleon', 'talented pastry chef' and 'a star that rise and fall in the twinkling of an eye' – was borne of his conviction that modern architecture did not have enough to offer the beholder when it came to silhouette, movement, ornamentation and colour. 'Modern architecture is not square – it's alive,' was one of his contrary claims, made in 1935. The most individualistic architecture by Sybold van Ravesteyn was completed between 1935 and 1940 and is fascinating for its bizarre combination of influences from 'Nieuwe Bouwen' (Dutch functionalism), the Baroque and the Rococo.[2]

This hybrid marriage of the modern and the traditional, the flamboyant and the industrial, is also reflected in the way he applied colours and materials to his buildings. Tracking down all that luxuriance and bringing it back was one of the goals behind the restoration of the entrance to Diergaarde Blijdorp, the Rotterdam zoo, Van Ravesteyn's magnum opus in terms of both urban development and architecture.[3]

If there's one design in the Netherlands that embodies *the architecture of joy*, it's Diergaarde Blijdorp. Despite the fact that the building of this festive, thirteen-hectare complex took place only seventy years ago – interestingly enough, on the very brink of the Second World War – no one can remember the original colours. Van Ravesteyn's coloured architecture had far outstripped the capabilities of the black-and-white photography of the time, and even the archives of his work fail to provide a definite answer regarding colour: apparently any decisions about exact colour applications were held off until the work was actually being carried out.[4] The only hope was to undertake a meticulous study of materials and traces of paint.

Van Ravesteyn's colour palette, which was found on the admission desks, the fences, the office and the gift shop – all part of the entrance area – was just as optimistic as his architecture. The aluminium colour, very popular in *Nieuwe Bouwen* architecture, provided a sense of agility and transparency, while the natural stone plaster, a distinctive feature of his work, was coloured reddish brown.

The columns, covered with arabescato marble between which sunny yellow fencing was suspended, held seven stylised animal figures in gilded concrete. Van Ravesteyn deliberately chose a monochrome exterior for the office – bricks in a yellow ochre tint and wood and steel painted in the same colour – so that the visitor's gaze would automatically be directed towards the polychrome admission desks and gift shop. This small, circular shop was exuberantly light in colour, decoration and typography, which was pleasant for adults and festive for children. Here Sybold van Ravesteyn used aluminium paint in combination with concrete and natural stone plaster, as well as graceful mossy yellow combined with sky blue, reddish brown and light beige. The neon lighting on the entrance awning, consisting of frivolous lettering with the zoo's logo, greeted visitors in grassy green and golden yellow.

Notes
1. See Bernard Hulsman, 'Morris Lapidus (1902): Architectuur is strijd', in: *NRC Handelsblad*, 28 March 1997.
2. More about S. van Ravesteyn in: H. Blotkamp, E. de Jong, et al., *Sybold van Ravesteyn: Nederlandse architectuur*, Amsterdam/Utrecht: Stichting Architectuur Museum/Centraal Museum, 1977–1978. In 2005 the film *Sybold van Ravesteyn: Architect voor de eeuwigheid*, directed by Koert Davidse, was released.
3. The restoration of the entrance was carried out under the direction of Kees Rouw (Architectuur & Onderzoek), in cooperation with Vis Restauratie Architecten; the restoration of the Rivièrahal by Broekbakema was carried out in cooperation with Kees Rouw (Architectuur & Onderzoek); in both cases, colour research was conducted by Lisette Kappers (Onderzoek & Architectuur).
4. See: Kees Rouw, 'The archeology of colour', in: Susanne Komossa, Kees Rouw and Joost Hillen, *Colour in contemporary architecture*, Amsterdam: SUN architecture Publishers, 2009, p. 248–273.

Samples of the colours found during
the restoration of Diergaarde Blijdorp

The entrance area at Diergaarde Blijdorp
upon completion in 1940

Detail of the restored fencing
(arabescato marble, natural stone
plaster, aluminium paint and golden
yellow paint on steel)

Michael van Gessel
No colour, thank you

In my bailiwick, which is landscape, colour is not something I'm likely to promote. In fact, I'd argue for curbing the use of colour. When it comes to colour I'm very restrained, and I don't use the colour green at all. That's a colour that clashes with almost everything growing out of doors. No green can equal the richness and vitality of real green: chlorophyll.

In the landscape of northern Europe, the use of colour – in the sense of added colour – usually stands out like a sore thumb. Why is that?

It's the latitude, and in northwestern Europe it's the proximity to the sea and the high atmospheric humidity resulting from it, which makes the air milky. Everything is covered with a grey haze; everything has a subdued, pallid tone. Look at the paintings of Ruysdael and Turner, or the photographs of Ger Dekkers and Elgar Esscher. The beauty of our landscape lies in its muted, muffled quality. Everything blends together; there's little contrast.

This is quite different from southern Europe, northern Africa or Mexico, for example, where the intensity of the sun just begs for contrast. Bright colours fit right in, and so does the abundant use of the colour white. Look at the paintings of Van Gogh during his Arles period, or those of De Chirico, or the architecture of Luis Barragán. Here in northwestern Europe the most suitable colours are unobtrusive, earthy tints. Bright, outspoken colours don't conform to the fullness of the landscape. They remain outspoken and bright, which makes them outsiders. They'll never fit in.

Take a widespread phenomenon like the colour of swimming pools. In southern countries, water – the sea – is a magnificent azure blue. We often want the same

thing here. But the water we encounter here is dark and mysterious, of unfathomable depth: different, serene, perhaps less pretty for those who want everything to comply with their wishes all the time, but it does have its own quality and it's certainly better suited to our climate and our landscape. Azure blue swimming pools are jarring here.

Because white is a relatively neutral colour it *can* be used, but with as much restraint as possible. White farms in Scotland and Ireland, or white country houses along the Vecht, are often a charming contrast with the surrounding green landscape. But it is a contrast, and it always will be, and you've got to handle contrasts with restraint. The landscape is not a collection of contrasts but an entity that is experienced as pleasant and natural, as long as things blend together logically and don't try to set themselves apart. Contrasting things demand space. Driveways and landscaped parks surrounding country houses, vast areas of cultivated land surrounding farmhouses, or the white dwellings that cluster together into little white hamlets along the seashore and form a single contrasting object in the landscape.

But then there are all those white villas on the edge of towns and cities that are such a blot on the landscape. In a certain way they turn our landscape into something coarse and ordinary. Darkening the tone sometimes does wonders. You've really got to make beautiful architecture to merit the use of white, and not everyone is in a position to take on Richard Meijer, Oud or Gehry as their architect. If the architecture is already mediocre, then light colours that stand out in the landscape are not a good idea.

Rather than *applying* colour, one should *add* colour by using materials that have a pronounced colour and that age nicely at the same time. Brick, natural stone, wood, glass, steel, cane.

These materials acquire the patina of time all on their own, quietly conforming to the landscape. Isn't it true that landscapes in which native, locally found materials are used have so much identity, and therefore so much quality? Norwegian slate on the roofs of houses in Norway, golden sandstone in Beaujolais, Belgian hard stone in the Ardennes, loam in Yemen and bricks in the Netherlands, where the materials in this river landscape can be quarried in abundance.

When it comes to landscape, time and the process of change under the influence of rain, wind and the seasons play a far more important role than in, say, fashion, interiors and graphics. In this process, the materials and the colours seem to run into each other and appropriate something from each other, so they complement each other and fit into the landscape as a whole.

It is for these reasons that I myself very seldom use colour. I let the materials speak for themselves, and when the steel or wood has to be painted I use extremely unobtrusive colours like dark or light anthracite, elephant grey or off-white. If I did use colour in the past, I have mixed feelings about it now.

On the Keizersgracht in Amsterdam I once installed a fence around a garden that was thirty metres long and four metres wide. The fence was made of perforated steel, and I had it painted Chinese lacquer red because this long, narrow garden, which was otherwise quite austere, needed an accent that would give it a visual lift and emphasise its drawn-out length. You can get away with this in the seclusion of an enclosed space in the center of Amsterdam, but I'd never do it on the outskirts of the city.

Another example is Valkenberg Park in Breda. This, too, was a very urban setting where colour could be used more freely. The park contained a bridge of rather bulky proportions that was made

Michael van Gessel, garden of a building
on the Keizersgracht, Amsterdam

in the 1950s. I was able to bring the bridge more in line with this romantic, nineteenth-century park by installing equally bulky handrails of oversized concrete that were made to resemble logs, and I had them painted the same Chinese red that I had used in the garden in Amsterdam. In this way the bridge's rails were more in keeping with the broad, heavy concrete construction under the bridge. This was reinforced by the colour red, which turned the bridge into one of the park's attention-getters. Even now, almost twenty years later, it's still a pleasure to behold.

The fence around the park, painted the same colour, is a different story. The fence is still splendid. It encloses the park and at the same time invites people to enter. But if only I hadn't used red again. What is possible in the case of a bridge with red handrails – it turns the bridge into an accent within the park landscape – is impossible in the case of the fence because it produces a solid red wall within an ordinary Breda cityscape. Because of the colour, the fence is too pronounced, much too present, much too harsh in this urban setting.

One last example: the banks of the IJ in Amsterdam. Kees Rijnboutt and I spent the last twelve years supervising the development there. This transformation from a harbour to an urban area can be compared in scale to that of a landscape. And here, too, the same rules apply: pay special attention to the whole, and make sure that each individual development conforms to the adjoining developments as well as to the composition and colour of the existing Amsterdam cityscape. Once again, that cityscape consists of pallid colours with a fairly dark palette, in which the colours are mainly derived from used materials: Dutch bricks, Belgian hard stone, black roof tiles for the most part, and windows and casings in white and off-white. Each individual

building has its own identity while at the same time conforming to the whole. This was our constant motto in the development of the banks of the IJ: use materials that age beautifully and let the materials speaks for themselves. We're still deeply involved in the process of redevelopment of this former harbour area, but the initial results are clearly in evidence: the Westerdokseiland and the Oostelijke Handelskade. Each individual building stands out from the rest and is clearly contemporary, yet together they form a whole that fits perfectly in the Amsterdam cityscape, imparting a sense of timelessness to the new developments along the southern banks of the IJ.

The landscape has been growing all through the ages. It's constantly transforming itself, but always on the basis of local possibilities and of limitations in the use of the soil with regard to technological developments. We're increasingly losing sight of this because technological developments have now made everything possible, everywhere and all the time. We've become footloose and 'time-loose'. So it's all the more important that we learn to understand and respect the underlying laws of the landscape, whether urban or rural, and that any new developments we come up with are grafted onto those laws.

Restraint is something that fits right into this picture of the Dutch landscape. Restraint in design, in materialisation and therefore also in the application of colour. Highly pronounced things in general are quick to grow stale and become outdated – or they have to be brilliant. In fashion, graphics and design, this transience is actually a plus-point. It marks the time and makes way for a new era, one with its own identity. Landscape, however – if it's any good – is in for the long haul, and that calls for timelessness.

Michael van Gessel and Kees Rijnboutt,
banks of the IJ, Amsterdam

Mobile

'Contemporary civilisation differs in one particularly distinctive feature from those which preceded it: *speed*. The change has come about within a generation,' wrote the historian Marc Bloch in the 1930s. I found the quote in an exhibition catalogue by the French architect and philosopher Paul Virilio. Speed, as a particular attribute of movement, has been Virilio's theme for several decades now, and thinking about mobility unavoidably brings his work to mind – even when we are just writing about mobility and colour. In Virilio's thinking, mobility is automatically related to its opposite – immobility – in many, even paradoxical ways. In fact, radical increases in speed lead, in Virilio's eyes, inevitably to immobility. Speed is related to technology and thereby immediately related to accidents. Every invention or innovation automatically implies accidents, and the larger the scale and the speed are, the bigger these accidents become until they acquire catastrophic dimensions in what Virilio calls the 'integral accident'. In a metaphor that is immediately related to colour, Virilio writes,'Daily life is becoming a *kaleidoscope* of incidents and accidents, catastrophes and cataclysms, in which we are endlessly running against the unexpected, which occurs out of the blue, so to speak.'[1] Virilio's ideas may help us to structure this essay, which we can now organise around the concepts of Mobility, Immobility and Accident, each defined by its own colours.

Mobility

When it comes to moving objects, we tend to give them bold and saturated colours. The colours don't have to be and shouldn't be discreet for several reasons. First, we don't have to think about how the objects would fit in a specific place, surrounded by other objects in other colours in a tasteful way. Just because the objects are moving, they are always somewhere else, in a different context any split second. Second, because we associate speed with danger. The bright colours are there to draw our attention and warn us in time when they approach. 'Objects in the mirror may be closer than they appear', is the standard sentence on rear view mirrors in the United States. And third, because when objects move fast, the colours tend to blur or dissolve. In art history, the blurring and the disappearance of objects in movement became a theme in the work of the Futurists, for example. 'The Hand of the Violinist' in Giacomo Balla's painting disappears in a brownish haze, and similarly, the legs and ears of the dog in *Dynamism of a Dog on a Leash*, as well as the feet of his master, almost become invisible in greyish clouds. In the work of Marcel Duchamp, from his 1911 *Nude descending a staircase* on, this visual blurring becomes a theme in itself, leading to his scepticism in visual and early conceptual art. The impossibility of depicting movement in painting and thereby the impossibility of using painting as an explorative tool for thinking made Duchamp stop working in more traditional artistic frameworks. His desperate attempt to paint something as simple as a *Coffee Mill* by introducing an arrow to show the movement of the handle, as an engineer would do, had already posed the problem a bit earlier. The famous bicycle wheel from 1913, a stool with a bicycle wheel mounted on top of it, was only one of his last attempts to demonstrate the paradox of showing movement in art, fixating it in a sculpture. His *Rotary Glass Plates* (*Precision Optics*) from 1920 and his *Rotoreliefs*, spinning disks with different motives painted on them from 1935, followed. His main works, *The Bride Stripped Bare by her Bachelors, Even* and *Given: 1. The Waterfall; 2. The Illuminating Gas* (1946–1966) take up movement only implicitly as parts of the complex processes of nature and technology, Eros and Thanatos, that define our world. The more cerebral movement becomes in art, the more colours disappear, in the end leaving movement only as an invisible concept. The moving waterfall in *Given* only enhances the idea of the impossibility of depicting movement: it is unashamed kitsch as we find it in Chinese restaurants. Movement is essentially invisible. Therefore we have to enhance the visibility of the objects themselves.

Think about racing cars: they always appear in bright colours. From the beginning of organised motor sports events in the early 1900s until the late sixties, racing cars were painted in standardised racing colours, relating to the nationality of either the car or the driver. Italian cars were supposed to be red – and still often are, like Ferrari's – French cars blue, Dutch cars orange, German silver, British green and so on. Other countries tried it with a mix of a few contrasting colours: for the body and the bonnet, for example, or for stripes in the longitudinal direction of the car. Only when commercial sponsorship became dominant, from the sixties on, did this coding lose some of its meaning, although certain car manufacturers such as Ferrari and Mercedes still maintain the tradition. Even though racing cars today bear an overload of logos, and traditional colours have often lost their meaning, they remain as brightly coloured as ever.

It is different for regular cars for everyday use, however. They increasingly come in more shaded and darker colours. In 1989, Dutch author Rudy Kousbroek made a plea to paint

cars in bold colours, complaining about the vague colours cars were being given at the time. 'In those years that telephones still had handles, coach work was still painted fire engine red, canary yellow, aquamarine blue, bottle green or snow white. In comparison to the pastel colours of today, this is not without meaning. It is as if primary colours suggest a difference between the object and the colour, between the paint and the painted. Pastel colours, on the contrary, give the impression of being the colour of the matter itself, undistinguishable from it, like chocolate or toilet soap. Under the primary colours, the object remains autonomous. The cross-section of a car from 1925 shows a cover with a thin layer of paint, with a machine on the inside: cylinders of naked steel, camshafts, pistons and so on. There is no autonomous concept under the pastel colours of a modern car. A vague colour is the colour of the vague. The inside, the mechanism, has dissolved into the upholstery. When a modern car is cut through (a normal bread knife slides through it as if it were a pastry), a homogeneous sponge-like matter appears, in the same colour as the outside, doughy and undifferentiated. A machine is unrecognisable. The queen of Spain has no legs. Modern cars ride without the intervention of any mechanical parts. What does this sticky, spongy matter symbolise? The absence of *thinking*.' Kousbroek laments, 'Anything that hints at a machine, anything that appeals to intellectual capacities, has been eliminated in a modern car. [...] The modern car strives for seamlessness. It looks more and more like any household appliance: a vacuum cleaner, a boiler or a razor. [...] A car today has not been invented, it is part of a new physiology that, under the influence of the poetic vision of our society, has grown out of technology: *the*

physiology of the incomprehensible. Our technological society makes itself an image of technology that is similar to the natural men of nature.'[2]

In short: Kousbroek criticises cars today as being *blobs*. The architect Greg Lynn wrote just a few years later that the 'image, morphology, and behaviour of the blob present a sticky, viscous, mobile, mobile composite entity capable of incorporating disparate external elements into itself'.[3] The blob, like the one in the 1958 Hollywood science fiction B film of the same name starring Steve McQueen, is indeed incomprehensible. But for Lynn, it is not incomprehensible because thinking is absent but because blobs have a superior intelligence that can deal with higher levels of complexity than the Cartesian logic that dominated design before. What Lynn and Kousbroek agree on is that blobs have no internally regulated shape and depend entirely on contextual restraints or containment, like aerodynamics in the case of a car, and they have no outspoken colour, either. They may be intelligent but they are slow. The Blob in the Steve McQueen movie has a brownish liquorice colour, and even Lynn has to admit that the manner in which blobs 'slither, creep, and squirm, instigates disgust and queasiness in the movie audience'.[4]

Immobility

In Virilio's *Dromology*, the science of speed, colour is either present as ephemeral light or as the grey of the bunker. For Virilio, the bunker is the opposite of speed – yet it is also the very starting point, the materialisation in stone, of a potential ballistic line – and at the same time it is the only thing that remains in the explosions and the fire when attacked. The bunker is the exact opposite of the car, Virilio reminds us, as the predecessor of the automobile, the steam-

powered vehicle created by the French inventor Nicolas-Joseph Cugnot, pulled a cannon on its first ride from Paris to Vincennes. The bunker is one of the few – if not the only – monolithic building types in modern architecture. That it is probably more monolithic than any other building in history has to do with the fact that it is poured concrete, a liquid material that when hardened leaves no open spaces or seams. Therefore bunkers rest *in themselves* and not on a foundation. They can even move as a whole, but their shape and their centre of gravity remain the same.

In his book *Bunker Archeology*, Virilio is puzzled and fascinated by the correspondences between these bunkers and various cultic buildings from architectural history, like Egyptian and Etruscan graves and Aztec structures: 'as if the Organisation Todt had nothing else to think of than to organise a sacred space…'[5] Virilio and Claude Parent built a church in the shape and material of a bunker, the church of Sainte-Bernadette du Banlay in Nevers in France. What is very different from bunkers, however, is that the cleft from which one looks out of the building is not oriented towards the horizon but towards the sky and heaven, letting the light shine on the congregation. When Virilio found the bunkers on his trips along the Atlantic Wall, located amidst the complete normality of French coastal cities and villages, he saw they were uncared for, like ruins from a forgotten subterranean civilisation in a science fiction novel. This made their grey colour look even greyer.

Maybe it is in this bunker grey that we find a clue as to why the casings of computers and peripherals (apart from the screen of the monitor) – the only visible and stable moments in computer and communication networks – tend to be grey or beige. Contrast this with the rays

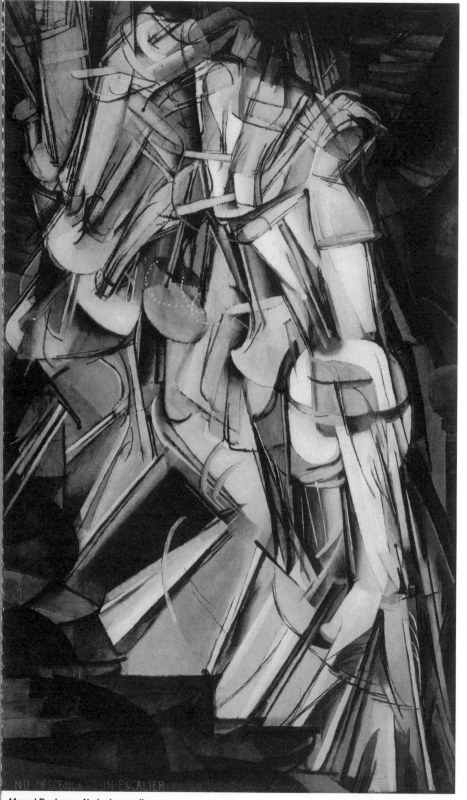

**Marcel Duchamp, *Nude descending
a staircase no. 2,* 1912**

Daniel Buren, *La montée de la couleur et la cascade de la couleur*, Leipzig, 1996

page 212
John Chamberlain,
Hit Height Lear, 1979

page 215
Jackson Pollock working
in his studio, 1950

of light in glass fibre cables or radio waves that, travelling at the speed of light, are invisible to us.

Black is another colour of the immobile. A black hole is a region of space, a compact mass, from which nothing can escape. It absorbs all light. Similarly, black objects are immobile or suggest being immobile. In contrast to bunkers, which in their dull greyness try not to draw attention, black objects are centres of attraction. The Kaaba, the black object per excellence, is a cube-shaped building made out of granite, covered with a black curtain, in Mecca. It is the most sacred site in Islam, attracting millions of Islamic pilgrims during the Hadj every year. On the inside of the eastern corner of the Kaaba is the *Ruknu l-Aswad*, the Black Corner, or *al-Hajaru l-Aswad*, the Black Stone, which is possibly a remnant of a meteorite that ended its travel through space there. It is about 30 centimetres in diameter and rests 1.5 metres above the ground in a silver frame that vaguely resembles an eyelid, placed in an opening in the black curtain veiling the Kaaba. Muslims believe the Black Stone dates back to the time of Adam and Eve and the origin of the world. The meteorite is supposed to have shown them where to build an altar and make a sacrifice to God. This altar became the first temple on earth. Pilgrims can kiss the black stone when they come to Mecca, as Mohammed once did. Because of the large number of pilgrims coming to Mecca every year, not everyone is able to kiss the stone, but every single member of the crowds that circle around the Kaaba at least points at it.

A black limousine is a larger luxury sedan, sometimes with a lengthened wheelbase, preferably driven by a chauffeur. Limousines transport VIPs, senior politicians and executives. Even if some of them can reach higher speeds in cases of emergency,

the idea is rather that they cruise at lower speeds – or give that impression, which guarantees that the VIPs sitting immobile in the back, who are smiling and at the most waving graciously, will command more respect. A Yugoslavian friend of mine, who went to a kindergarten near a restaurant where Field Marshall Tito used to dine, strongly believes that Tito's black Mercedes 600 Pullman and Rolls Royce were floating when they passed by, and that a bright light shone under them. In former years, the VIP could even stand up to receive the cheers of the audience that a black limousine would inevitably attract. This is mostly avoided today since President John F. Kennedy was shot in Dallas in the back of a Lincoln Continental while responding to the cheers of the crowd.

But basically, black is the colour of things that do not move at all and remain discretely in the background. Black *is* an immovable, unchangeable background colour. It is the ideal background for mobile objects. The static black asphalt of motorways and racing circuits is the ideal setting for the strong colours of the cars that pass by, as we can see in Andreas Gursky's photographs and photomontages of racing tracks and in his Formula 1 series, in which red Ferrari's appear against a black background. Black is also the default colour of the computer screen, as long as there are no signs or images being projected on it. As Mark Wigley has pointed out, this is a major revolution in drawing, because we suddenly have to learn how to draw with light, instead of with shadows.[6] Last but not least, a black sky at night is not only the ideal condition to see the stars, but also to see fireworks, the moving artificial stars and colourful explosions with which we collectively express our joy at special festive days.

Accidents

With fireworks, we come to the final part of this essay, because fireworks were a side effect of the invention of gunpowder in twelfth-century China. Fireworks were used to chase away evil spirits – and soon enough evil people. The rockets used in fireworks were first used in war and only later on for decorative purposes. But everybody is aware that apart from pure beauty consumed for beauty's sake, gunpowder can also cause catastrophes when it explodes. This is not necessarily intentional, as in times of war. Disasters caused by exploding fireworks factories and storage facilities have been known to erase whole sections of cities in all parts of the world.

The evolution of technology goes hand in hand with accidents. The invention of the railways implied the possibility of derailment, for example, and in fact the *fardier á vapeur* developed by the French inventor Nicolas-Joseph Cugnot was also the first automobile to be involved in an accident, knocking down à part of the Arsenal wall. The increase of movement and mobility over the course of history has most certainly increased the number of accidents and their impact. The scale of the disaster also increases. If an Airbus A380 crashes, at least 1,000 people will most probably be killed all at once. The only things that may survive are the Black Boxes. For the rest, the airplane, the passengers and their luggage will be blown to pieces, shattered and burned in a final unintended firework, or at least blown to pieces in a last colourful show of kaleidoscopic confetti. 'Progress and catastrophe are the opposite faces of the same coin,' as Hannah Arendt wrote.[7]

Paul Virilio's catalogue of the exhibition *La vitesse* in the Fondation Cartier in Paris in 1991 shows many examples of how people and objects are deform-

Bart Lootsma

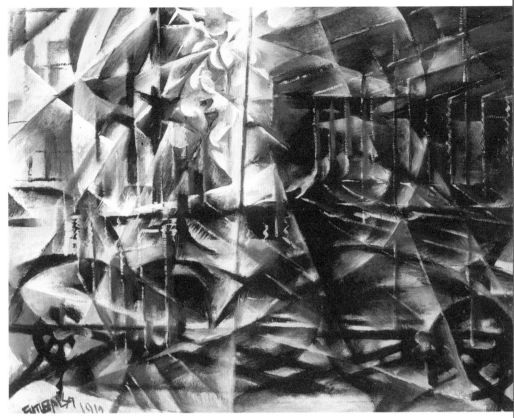

Giacomo Balla, *Speeding automobile*, 1912

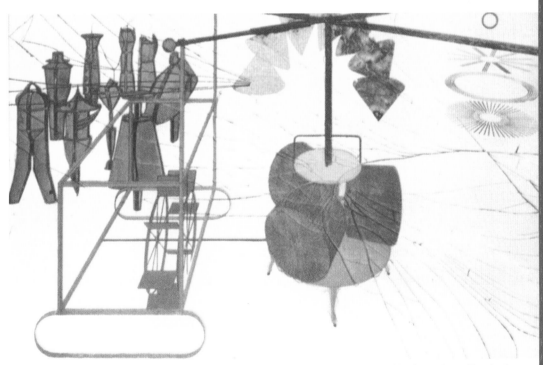

Marcel Duchamp, *La mariée mise à nu par ses célibataires, même*, 1915 – 1923

Jan Dibbets, *Colorstudy C1, 2, 3, 4,* 1976

Paul Virilio, *Bunker Archéologie*,
1958–1965, observation post

Paul Virilio, *Bunker Archéologie*,
1958–1965, command post
in the Bay of Biscay

Andreas Gursky, *F1 Boxenstopp I*, 2007

ed under the influence of speed, in our perception under the influence of speed and anticipating the influence of speed (such as streamlining, for example). The cover shows the traces of the coloured lights of a Ferris wheel on a photograph taken at night with a long shutter speed.[8] *Unknown Quantity*, the catalogue of an exhibition on accidents, also in the Fondation Cartier in 2002/2003, shows the fragmentation that is caused by all kinds of accidents.[9] Virilio's flap text starts with a quotation from Sigmund Freud from 1914–1915, when he said that 'Accumulation puts an end to the impression of chance.'[10] Indeed, we live in a *Risk Society*,[11] in which risks are constantly calculated. We accept certain risks, even if we try to eliminate them. We improve our technology, get insurance – or calculate that it makes no sense. We know for example that flying is safer than driving a car. Even politics, particularly the politics of the welfare state, calculates risks – and makes us pay for them. We elect the politicians who we believe will make the best calculations. But at the same time the nature and extent of certain risks we face exceed all rationality. Different events such as Chernobyl, the crash of the Concorde and the attack on the World Trade Center made that very clear. Chernobyl, because we learned that a meltdown can actually happen and has global consequences, the Concorde because we learned that one little piece of metal left by another airplane can actually cause a catastrophe, and 9–11 because we learned that just a few people can actually cause a catastrophe by intention. It is the accumulation in the scale of risks that escapes our rationality, however. Without really knowing how or when or why, we may reach a point in the speed of our mobilisation at which all the colours suddenly merge into the light of one white flash, as in an overexposed photograph.

Notes

1. Paul Virilio, *Unknown Quantity*, London/Paris: Thames & Hudson/Fondation Cartier pour l'art contemporain, 2002, p. 5.
2. Rudy Kousbroek, *De archeologie van de auto*, Amsterdam: Meulenhoff, 1989, p. 15–17.
3. Greg Lynn, *Folds, Bodies & Blobs*, Brussels: La Lettre Volée, 1998, p. 169–186.
4. Ibid.
5. Paul Virilio, *Bunker Archéologie*, Paris: Les Editions du Demi-Cercle, 1991, p. 37–45.
6. Mark Wigley, 'Back to Black', in: Marie-Ange Brayer and Frederic Migayrou, *Architectures Experimentales 1950–2000*, Paris: Collection du FRAC Centre, HYX, 2003, p. 27–32.
7. Hannah Arendt, as quoted by Paul Virilio in *Unknown Quantity*, see note 1, inside cover.
8. Paul Virilio, *La vitesse*, Paris: Flammarion/Fondation Cartier, 1991.
9. Virilio, *Unknown Quantity* (note 1).
10. Sigmund Freud, as quoted by Paul Virilio in *Unknown Quantity*.
11. Ulrich Beck, *Risikogesellschaft*, Frankfurt am Main: Suhrkamp, 1996.

Johan Grimonprez, *Dial H-I-S-T-O-R-Y*, 1997

Paul Overy
**Colour in the work of
Norman Foster**

Norman Foster made a series of colour sketches for a light aircraft, a Robin Regent. Initially he thought of painting the fuselage a rich deep blue – a colour he has used for exterior and interior accents in some of his recent buildings. He explored a combination of the blue with yellow trim to emphasise the lines of the wing and fuselage, and also considered unifying the form of the canopy by painting the struts and roof dark grey to blend in with the acrylic panels.[1] But in the end he decided to paint the entire plane white because he came to the conclusion that the form of this classic aircraft did not need the distraction of any cosmetic embellishment. For an aircraft which would be used mostly in the summer, Foster argues that white was also the best colour to reduce solar gain – hence the decision to reject the idea of dark grey for the canopy. Other colours were confined to details, such as the propeller spinner highlighted in red, because it marked a potential hazard on the ground and would be more conspicuous in the air. Colour was also used to denote the area at the wing root that was reinforced and could be walked upon – as opposed to the more fragile covering elsewhere. Finally he added the blue symbol of the EC flag to the fin.

The Robin is a very popular aircraft in France where it is immediately recognisable, partly because of its shape, but also because it is invariably painted in a standard factory colour scheme. Foster's treatment of the aircraft, however, transformed its appearance so completely that apparently even air traffic controllers did not recognise it. On seeing the plane from the control tower they would immediately ask, 'What type of air-

craft?' Foster explains that the greatest difference between the normal Robin and his own was that he used a single colour to unite the intrinsic form of the aircraft – to emphasise the purity of its aerodynamic shape; other colours were then employed as signals to convey information. (He talks at some length about how colour is used in nature either to attract attention or to camouflage.) Foster's thinking about colour in relation to his personal light aircraft is revealing and can be extended to explain the philosophy about the use of colour in his buildings. Although there are some exceptions, he tends to emphasise spaces, both inside and out, by the use of a single neutral or metallic colour, working with limited accents of other colours to create 'signals'.

Both Stansted and Hong Kong airports are typical examples of buildings in which white and light shades of grey are used to enhance the space and quality of light, creating what Foster describes as an 'artificial sky' by means of the vast white or pale-grey roof, while stronger colours are confined to information signs, thereby making the terminals more legible for passengers. Similarly in the Bilbao Metro a vocabulary of neutral concrete is employed for the surfaces of all the spaces. Orientation within the sequences of tunnels and stations is made easier and safer by the use of bright red for all direction signs and announcements. Foster talks about the stress of twentieth-century travel and the need to create social spaces which not only celebrate transportation by air or rail but also offer some calm, tranquillity and reassurance – colour is one of a number of ingredients employed in that quest. It is tempting to look back to earlier projects such as the Renault building in Swindon, where colour was used quite directly, and conclude that Foster is now committed to a more neutral approach. He

would argue against this, citing the way in which a blue with almost the intensity of an Yves Klein painting was used in the Électricité de France (EDF) Headquarters building in Bordeaux (1992), combined with the tones of mellowed wood and concrete to give a corporate identity to the building on the outside and to repeat the theme in the interiors. The exterior is fitted with a *brise-soleil* of untreated cedarwood to prevent the building from overheating in summer; this weathers to what Foster describes as a 'delicate silver' surface.

The bright-yellow Renault Centre overlapped with the design and construction of Stansted Airport in the 1980s, where colour is employed much more sparingly. According to Foster, the Renault building was conceived at the time as being more than just a commercial project – a 'socially minded' building as much as a warehouse or a showroom. The yellow used in the Centre was the Renault 'house-colour' and had a 'co-ordinating' function in bringing together the modular structure of the building, but it also had a symbolic value. It was, Foster says, meant to make people look at cars 'with new eyes' (cf. Le Corbusier's 'eyes that do not see'), and also act as a kind of 'social space' for the locality. While Foster and his clients wanted the Swindon centre to be more than just a commercial building, Stansted as London's third airport is a much more 'public' project with its own 'social space'. The choice of neutral colours here respects the forms of the spaces in a similar manner to Foster's decision to paint the Robin Regent all white. It is also an acknowledgement that the users of this building will bring their own colour with them as they set out or return from their package holidays wearing Hawaiian shirts or pink Bermuda shorts.

Norman Foster, *Robin Regent*, 1997

Note

1. Much of the material in this essay is based on a conversation between Foster, John Small, Cees de Jong, Hans Ultee and the author at the offices of Sir Norman Foster and Partners at Riverside Three, 22 Hester Road, London SW11, on 27 June 1997. Further material has been supplied by Foster himself.

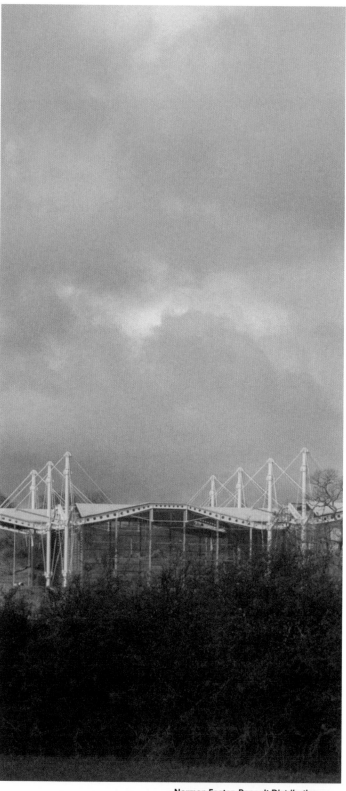

Norman Foster, Renault Distribution Centre, Swindon, England, 1980–1982

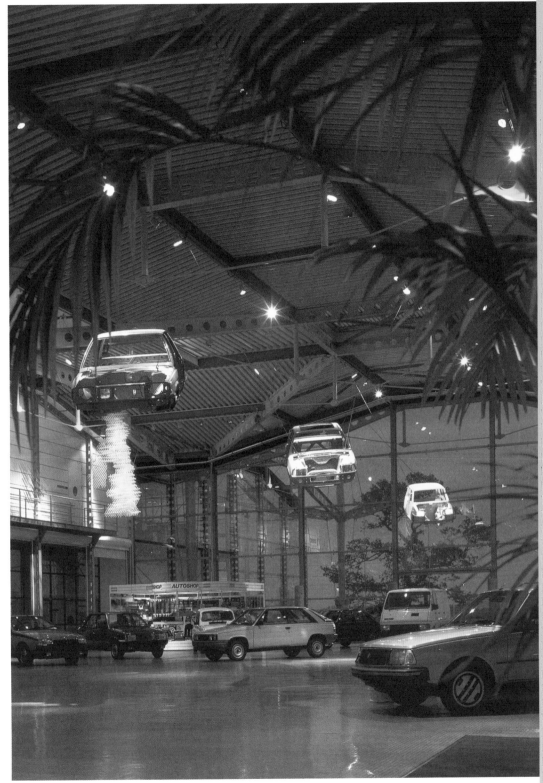

Norman Foster, Renault Distribution
Centre, Swindon, Engeland, 1980–1982,
showroom

Paul Mijksenaar
Colour in transit

In the hierarchy of ways to transmit visual information, colour is the most effective because colour combines functional conspicuousness with emotional value. For this reason, those who design interfaces must think very carefully about colour, and colour should only be applied when sufficient use has been made of simpler variables such as size, contrast and location. Once colour is brought in, nothing else can top it.

It's been confirmed by scientific research that colour coding – that is, using colour to create distinctions in different categories of information – not only makes it easier to find things, but is also intuitively understood without the need for a lengthy learning process; we learn by doing.

So colour coding is an ideal way to quickly divide people up into the most important basic groups, as in signposting at busy transportation hubs like train stations and airports: departing and arriving passengers, people who are waiting and people on their way to the exit (or the emergency exit).

This principle was introduced in simplified form back in 1967 at Schiphol airport by architect Kho Liang Ie and graphic designer Benno Wissing. The designers worked from the basic idea that airport signs would be most visible and noticeable if shown against a neutral colour scheme throughout the airport itself. The only colours present would be the conspicuous yellow and green signs... besides the often colourful clothing of the passengers.

In around the year 2000, it was decided for safety reasons to use the colour green only for emergency exits and red for fire safety signs. Directions to airport facilities such as toilets would not be indicated with the same kinds of black-on-yellow signs that were used for the gates but with the opposite combination – yellow-on-black – if only to limit the number of colours in use. In addition, blue signs were added to point out shops, cafés and restaurants.

Not only is colour used to codify different categories, but it also serves to make signs as conspicuous as possible within their particular context, with maximum contrast between the background and the information for the sake of readability. The combinations of black text on a yellow background (and vice versa) and white text on a blue background score the highest in this regard. While white signs with black text may have the highest colour contrast, the problem with white signs is that they don't show up very well in any given environment, neither indoors nor outdoors. There are many possible colour combinations, as long as care is taken to make sure they stand out against the background. The text and/or symbols also have to be sufficiently large.

Because codes naturally become more recognisable the more widely they're used, it's important that the same principles be made to apply at other airports, the most well-known examples being the airports of New York (JFK, La Guardia and Newark). But the same principles are now being introduced in Aruba, Eindhoven, Abu Dhabi, Frankfurt (in development) and Washington Dulles.

That about covers the functional aspects of conspicuousness, readability and recognition. But as we said earlier, colour also plays a major role in emotional perception. We know from experience that a user-unfriendly map printed entirely in colour will always be preferred to a much better map in black-and-white because people always follow their first impression. When I asked the famous 'information architect' Richard Saul Wurman whether the colour systems he used in all his famous Access travel guides weren't too much of a good thing, he replied, 'But it sells like hell...'

This airport has a color coded signing system

Follow yellow signs when flying
- Ticketing
- Arrivals
- Gates
- Check-in

Follow black signs for airport services
- Restrooms
- Phones
- Escalators

Follow green signs when leaving the airport
- Ground Transportation
- Parking

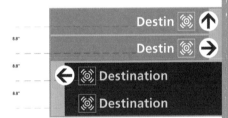

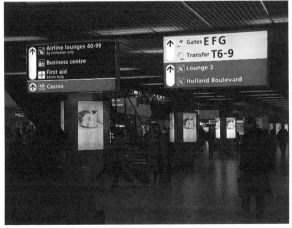

John F. Kennedy International Airport,
New York

This sign hangs in all the entrances to New York airports to explain the colour coding principle. Yellow stands for flights, black for airport facilities and green for arterial roads.

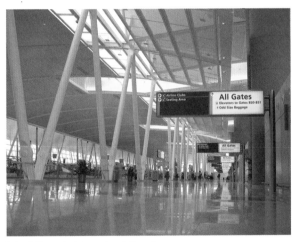

Schiphol, Amsterdam Airport

	beige	wit	grijs	zwart	bruin	roze	paars	groen	oranje	blauw	geel	rood
rood	78	84	32	38	7	57	28	24	62	13	82	
geel	34	16	73	89	80	58	75	76	52	79		82
blauw	75	82	21	47	7	50	17	12	56		79	13
oranje	44	60	44	76	59	12	47	50		56	52	62
groen	72	80	11	53	18	43	6		50	12	76	24
paars	70	79	5	56	22	40		6	47	17	75	28
roze	51	65	37	73	53		40	43	12	50	58	57
bruin	77	84	26	43		53	22	18	59	7	80	7
zwart	89	91	58		43	73	56	53	76	47	89	38
grijs	69	78		58	26	37	5	11	44	21	73	32
wit	28		78	91	84	65	79	80	60	82	16	84
beige		28	69	89	77	51	70	72	44	75	14	78

Figure 2.2.4.2 **Contrast between colored text and backgrounds (adapted by Arthur and Passini,**

Top-16 color combinations for 'outdoor displays'

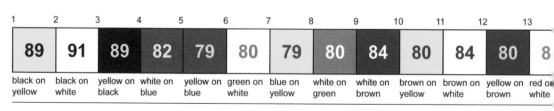

1	2	3	4	5	6	7	8	9	10	11	12	13
89	91	89	82	79	80	79	80	84	80	84	80	8
black on yellow	black on white	yellow on black	white on blue	yellow on blue	green on white	blue on yellow	white on green	white on brown	brown on yellow	brown on white	yellow on brown	red on white

	beige	wit	grijs	zwart	bruin	roze	paars	groen	oranje	blauw	geel	rood
rood	78	84	32	38	7	57	28	24	62	13	82	0
geel	14	16	73	89	80	58	75	76	52	79	0	82
blauw	75	82	21	47	7	50	17	12	56	0	79	13
oranje	44	60	44	76	59	12	47	50	0	56	52	62
groen	72	80	11	53	18	43	6	0	50	12	76	24
paars	70	79	5	56	22	40	0	6	47	17	75	28
roze	51	65	37	73	53	0	40	43	12	50	58	57
bruin	77	84	26	43	0	53	22	18	59	7	80	7
zwart	89	91	58	0	43	73	56	53	76	47	89	38
grijs	69	78	0	58	26	37	5	11	44	21	73	32
wit	28	0	78	91	84	65	79	80	60	82	16	84
beige	0	28	69	89	77	51	70	72	44	75	14	78

aus and Claus)

	15	16
32	82	84

w on red on
yellow
white on
red

Diagram adapted by Arthur and Passini that shows the contrast between coloured text and various backgrounds. The left-hand side shows all the possible combinations of coloured text and coloured background. The contrast should be at least 70 on a scale of 1 to 100. On the right-hand side, all unacceptable colour combinations are shown in grey.

The lower diagram by Claus and Claus shows the sixteen most frequently used combinations of text and background. All the colours used for new colour-coding systems, such as those at Schiphol Airport, Amsterdam, and John F. Kennedy International Airport, New York, have a value of approximately 80, which is a good contrast level.

Jonathan Bell
Colour and cars

A car is a cultural statement, an industrially designed and mass-produced object that carries within it a strong narrative under-current, built up over decades, carefully transmitted, dutifully imbibed and subsequently decoded by the many different strata of society. Colour is one of the most significant components in this jigsaw of meaning. While the early history of car colour is marked by the economic necessity of a strictly limited palette ('any colour you like as long as it's black'), the close synergy between automobiles and marketing in the decades that followed placed colour at the heart of consumer perception of the car. It is no coincidence that General Motors' first styling division was called 'Art and Color', established by Alfred P. Sloan in the 1930s and overseen by Harley Earl, one of the most charismatic visual designers of the industrial age.

Earl realised that modernity could be expressed through bold but ultimately superficial design changes, combined with a striking palette and extensive marketing activity, setting a pattern that is still in place, over eighty years later. Such polychromatic optimism was also applied to the roads of the future, at least in America, where the freshly laid two-lane blacktop was literally poured on virgin ground, seeding its environs with a veritable utopia of architectural possibility; motels, parking garages, gas stations, off-ramps, theme parks, big box stores, supermalls, and drive-throughs. Everything was signposted in a riot of colour, form and shape, 'carchitecture' for the senses, designed to be absorbed and digested through a windshield at 55 mph.

The European experience was very different, as it was an extant landscape that was scoured and re-shaped by the newcomer machine. The car's impact on the landscape was initially stealthy and low-key; road signs were a folksy evolution of traditional signposts, with little thought given to legibility and ease of use. It wasn't until the pioneering work of British designers Jock Kinneir and Margaret Calvert in the late 1950s that the grey asphalt road was finally and comprehensively furnished with its true complimentary colours, blue, white, yellow, green, red and brown.

The clash between the Day-Glo and pastel pop dreams of post-war America and the austere earth tones of Europe has largely dissipated. Today, colour serves as a trigger, the key means by which car companies can conjure up the spirit of an imaginary past, its gasoline-fuelled glamour scrubbed away by catalytic converters, crash test regulations, pedestrian impact laws and multiple airbags. Now that the paint shop has at last been emptied of the molybdate lead chromates and lead sulphochromates that fortified metal against the sun and kept bodywork lustrously shiny and desirable, bold colour is a guilt-free aspect of an ever more conscience-riling decision – what kind of car to buy, or even whether to buy a car at all.

Yet while colour still symbolises the dreams of tomorrow, be they past or present, our real lives are still remarkably unadventurous. Statistically speaking, we know a great deal about global tastes, thanks to the careful aggregation of vast amounts of sales data, distilled down into simple graphs. The most popular car colours create a surprisingly monochromatic chart, more akin to the restrained palette of Dieter Rams than the myriad possibilities promised in brochures and swatches. Published every year since 1952, the 2009 DuPont Global Automotive Color Popularity Report shows that 25 percent of cars were silver, with 77 percent of cars issued in shades of silver, black, grey and white.

This paints a bland picture of the car showroom and highway, a reality that is at odds with the rough, romantic poetry of the contemporary colour chart, where the collection of names, locations, materials and objects is designed to evoke time and place. Manufacturers reach out to tap our collective memories, deliberately referencing key moments in automotive history to give their current products historical resonance. For example, the multi-colour jingoism of the international auto racing colours, a list that enabled certain colours to become utterly infiltrated into cultural history; the Rosso Corsa of Italy, British Racing Green, Bleu de France in particular, but also a host of combinations of colour and forms that have faded quickly from memory (the pale violet of Egypt, Malaysian yellow, Jordanian brown). Consider this list, a poetic trawl through the catalogues of high-end car manufactures.

Cornish white and diamond black
Woodland green, Madeira red
Blue velvet
New sable (black)[1]
Giallo Granturismo

Bianco Fuji, Grigio Alfieri
Bordeaux Pontevecchio
Blu Oceano[2]
Blu Abu Dhabi

Rosso Corsa
Celeste
Grigio Ingrid, Blu Mirabeau[3]
Sea Grey, Thunder, Panther Black

Frozen White
Hypnotic Silver
Avalon Metallic[4]
Crystal Green and Aqua Blue
Cognac and Ruby Red

Topaz Brown and Yachting Blue
Amethyst, Ruby Red[5]

Terry Richardson, *Los Angeles*,
from 'World's End' for *Purple Fashion*,
autumn/winter 2008–2009

'Blu Abu Dhabi' and its ilk clearly exist at the intersection of colour, place and perception, as far above humble blue as the beaten-up white rental car in Florida is to the fleet of all-white supercars in a Dubai garage. Everything is in the name. And at the rarefied end of the market, perverse colour choice is a genuine statement, not just one of individual choice but of economic independence; it matters not if a car's value is adversely affected by a peculiar shade. 'We've been asked to match a paint finish to a cherished nail polish, a 50-year old classic Bentley and on one occasion a shade of turquoise on a food mixer for our Arnage, Brooklands and Azure customers.'[6]

If colour is equated with memory, desire and ingrained cultural prejudices, what of the architecture that accompanies cars, the structures that exist to serve the car and its driver? Architectural colour rarely has the benefit of good PR, or the savvy wit of a seasoned copywriter. Alongside French auto routes, paint manufacturers leave little installations of coloured panels, each bearing paint samples that are subjected to ageing tests, accelerated by the constant smog. These small flashes of colour are imperceptible to the speeding driver, as invisible as the strange hybrid that is contemporary 'carchitecture', the architecture that no-one really wants or wants to acknowledge. Even the new temples to car manufacturer, the brand palaces erected by BMW, Citroen, Volkswagen, Mercedes, Maserati, and others, in the first decade of the twenty-first century, are largely absent of colour, preferring the predicable metallic greys of high-technology as a neutral backdrop.

Colour will continue to impress its mystique upon the automobile, at odds with the prosaic reality. Perhaps the most strikingly quotidian pieces of auto-motive-related architecture of recent years is the Road Transport Hall at the Swiss Transport Museum in Lucerne, designed by the architects Gigon and Guyer. A foursquare shed overclad by a mosaic of road signs, the Hall is a giant homage to Venturi and Scott Brown's popularisation of the 'building as sign', as well as a backhanded celebration of the deep blue ubiquity of the motorway environment. From a distance, the building is a solid colour and little else. Romance and memory are pervasive components of the mythology of the road. Colour remains a critical part of this new mythology.

Notes
1. Rolls Royce colours
2. Maserati colours
3. Ferrari colours
4. Ford colours
5. Porsche colours
6. Bentley Motors press release, 8 March 2010

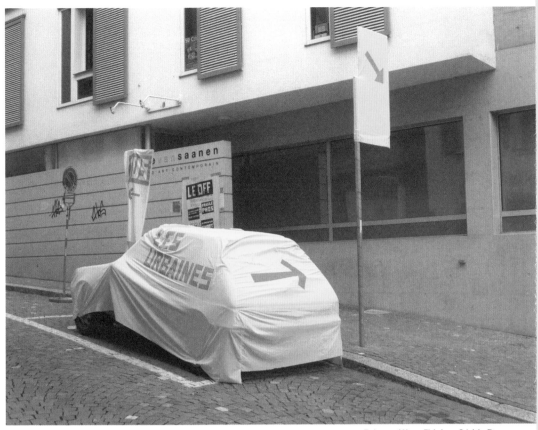

Fulguro / Yves Fidalgo, Cédric Decroux,
Axel Jaccard, *Les urbaines*, 2004

BLESS, *Car Cover*, 2008, from the
BLESS Nr. 35 Automatica collection

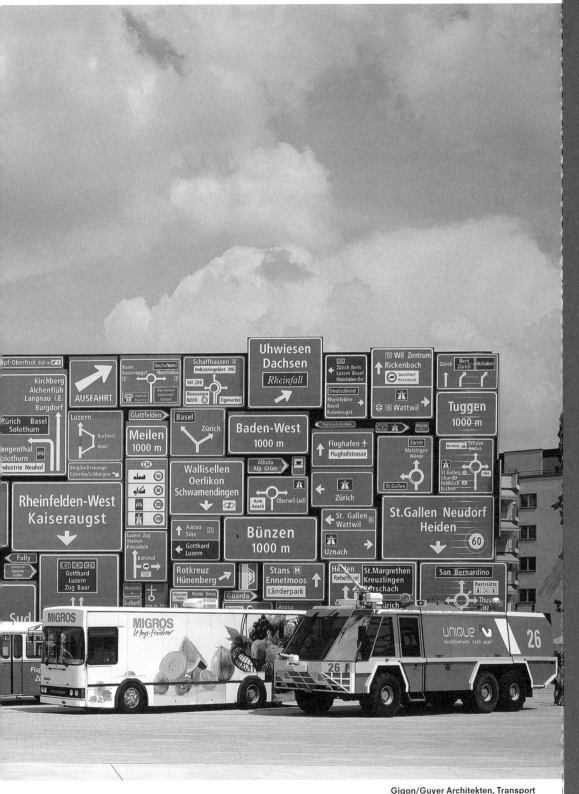

Gigon/Guyer Architekten, Transport
Museum, Luzern, Switzerland, 2005–2009

Ann Temkin
Alighiero Boetti

Some of the best moments in Arte Povera were hardware shop moments.
Alighiero Boetti, 1972[1]

Alighiero Boetti's first exhibition was presented in January 1967 at the Galleria Christian Stein, in the artist's hometown of Turin. The invitation itself is a small wonder of what would soon be termed Arte Povera: a sampler of the materials used in the works on view, including hardware-store staples such as electrical cable, PVC tubing and wire mesh, as well as a letter of the alphabet made of cork. Another item available at a hardware store was automobile paint; Turin, blessed with a rich cultural heritage, was also the site of the Fiat automobile company's head-quarters. The city was filled with Fiat employees, and the general population was highly car-conscious. In the 1960s, when auto-mobile bodywork was often a do-it-yourself affair, car paints were arranged at the local hardware store according to the model and year of the vehicles.

Boetti's exhibition at Christian Stein featured, among other things, a few small panel paint-ings made with automobile paint and featuring quirky phrases spelled out in standard cork letters painted the same colour as the background, as in *Stiff Upper Lip* (1987).[2] In the months following the exhibition Boetti found his definitive approach to these monochromes: the cork letters would cite the colour name and code number of the paint being used. The paintings saluted the poetry of the colour names invented by companies such as Max Meyer and Lechler, which supplied the paint for Fiat, Maserati, Alfa Romeo and others. Certain themes emerge in the nomenclature, such as race-tracks (Oro Longchamp, Argento Auteuil, Verde Ascot, Bianco Saratoga) and names that invoke the allure of faraway places (Beige Sahara, Bleu Cannes). Boetti chose a 70-by-70-centi-metre format for these mono-chromes, with the colour name and code placed on two lines in the centre of the square. Initially he made the panels from Maso-nite and spray-painted them him-self, but for later works in the series he had metal panels fabri-cated at a friend's auto-body shop, where they also were painted.[3]

Rosso Gilera 60 1232, Rosso Guzzi 60 1305 (1972) is one of several versions of the only diptych composition in this family of work.[4] It is a succinct demon-stration of colour as a manu-factured and branded commod-ity: the two similar but not identical reds represent the warring houses of Guzzi and Gilera, rival motorcycle manu-facturers since the 1930s, when Mussolini had declared 'better yet the motorcycle' one of the slogans of his regime.[5] Boetti's pair of matter-of-fact red panels (colours manufactured for Gilera and Guzzi by Lechler) cunningly embody the fierce loyalties and passions of the Italian 'guzzisti' and 'gileristi'.

Colour would be a lifelong obsession for Boetti; his three-decade career celebrated colour as joyously as that of any artist of his generation. Although by the early 1970s he had left the context of Arte Povera, he did not abandon his roots in the movement. He retained the notion of colour as something always to be employed in ready-made fashion, directly, with the most ordinary means available. Choices were not to be weighed – the principles of selection were limited to 'any' or 'all'. For the most part, composition and execution of the work was dele-gated to others so as to avoid any recognition of a single hand, even if this hand were that of an anonymous surrogate for the artist. (The artist's opposition to the myth of the individually complete and coherent genius also underlay his decision, in 1973, to split his name in two and call himself Alighiero e Boetti.) This philosophy is evi-dent in the large body of ball-point-pen drawings from the 1970s and 1980s, such as *Uno Nove Otto Otto* (One Nine Eight Eight, 1988) made using Biro pens in one or more colours – blue, black, red, and green. Boetti's studio assistants enlisted people from all walks of life to make them, assigning separate individuals to make each panel of these multipart works and follow-ing Boetti's dictate that adjacent panels be drawn by a man and a woman. In the embroidered works entitled *Tutto* (Everything), made since 1971, Boetti similarly enlisted hundreds of crafts-women in Afghanistan (and later Pakistan, where they had fled due to warfare in their country) to fabricate his and his assis-tants' designs, using their own judgement in the handling of colour. Boetti supplied them with high-quality Italian em-broidery thread, in the brand that produced the greatest variety of colours. Supplying his collabo-rators with the necessary chro-matic resources, Boetti trusted a plurality of voices to make the colours sing with a more aston-ishing beauty than a single man's taste or habits could have ever produced.

Alighiero Boetti, *Stiff Upper Lip*, 1966

Notes

1. Alighiero Boetti, in an interview with Mirella Bandini, 1972, in: Richard Flood and Frances Morris, *Zero to Infinity: Arte Povera 1962–1972*, Minneapolis: Walker Art Center, 2001, p. 188. First published in *NAC* 3, March 1973, p. 2–18.
2. The phrases, such as 'stiff upper lip', were ones that he was amused to learn from his wife, Annemarie Sauzeau, an English teacher; Sauzeau, conversation with Ann Temkin, Rome, June 26, 2006.
3. The Archivio Alighiero Boetti has undertaken extensive research to find the manufacturer, the respective car model, and the year for each paint colour Boetti used. The Archivio has so far identified about eighteen works in the series. Boetti also made several sets of multiples, each 25 by 20 centimetres.
4. *Rosso Gilera, Rosso Guzzi* was the only version made in a one-metre-square format as well as his usual 70-centimetre square, and in an edition of ten smaller multiples.
5. 'Meglio ancora la moto', Giorgio Franchetti recalled, 'we dreamt of [the motorcycle] more than we dreamt of girls', in: Giorgio Franchetti, 'Rosso Guzzi (60 1305) Rosso Gilera (60 1232)', in: *Alighiero e Boetti*, Stuttgart: Wiese, 1992, p. 28–29.

Alighiero Boetti, *Millenovecentosettanta*,
1970

Alighiero Boetti, *Mappa*, 1971–1973

Ann Temkin

Alighiero Boetti, *Rosso Gilera 60 1232,
Rosso Guzzi 60 1305*, 1971

Theo Hauben
Slow colours

Our current network society is dominated by physical, social and virtual networks. A typical feature of these networks is the capsule: the unit in which we live, work and travel. The road and railway network, the air traffic network, the telephone or cable network and the World Wide Web all function on the basis of cars, trains, airplanes, computers, office units and housing units. In the network society, we live and move in safe spaces that keep out the rain, wind, cold and heat.

The physical network is populated by commuters who travel from their homes to their work environments by train or car. Commuting has caused the border between private and public to become blurred. Train commuters see the space they occupy in public transportation as an extension of their work. On the way to work they read papers for meetings, and on the way back they do e-mail or make phone calls. For car commuters it's just the opposite. They're happy if their car breathes a home-like atmosphere. With a mobile space as his only pleasure, the car commuter carries his home to work as long as he can, and when office hours are over and he gets back in his car, he already feels immediately at home. The living environment of the commuter is dominated by interiors that are continually changing meaning, and here colour plays a crucial role.

For train commuting, however, it's difficult to understand why the capsule has become increasingly important. In every new model of train, bus, tram and subway, economies have been made in seat and leg room, while everyone knows that the average human being is only getting taller, and that obesity has become a universal problem. Among public transportation

organisations, countercyclical investment has taken on an entirely different meaning. What haven't changed in a very long time are the basic colours of the train interiors. The colours of the floor, the walls and the ceiling are white, beige or grey, or a colour that might be any one of these, or a colour that might be all three together. This connects with the beige trench coat (commuter model) and the anthracite-grey Samsonite suitcase (inspector model) with which the train commuter is long familiar. The fact that the train commuter's work begins in the train is interesting, since the colours we use at home have a great deal in common with the colours in the train. According to the DIY stores, the colours we are most likely to use in our homes are white, beige and grey, with the occasional accent colour on a single wall. In trains the seats are usually of a different colour, often the colour that the transport company uses in its logo. Other commonly used colour options are green, blue or red, often featuring a nondescript design. Transport companies that have yellow in their logo usually don't have yellow seats, oddly enough. Perhaps that colour is too light.

How different it is among the car commuters. As a private capsule the car is already highly developed, and every attempt is made to provide each person with as much room as possible. The car commuter can choose from a wide selection of cars, either to purchase or lease. The car commuter can also choose the colour of the exterior and can furnish the interior to his own taste. The car is very much like a home – at least it seems that way at first. What quickly becomes apparent is the alarming uniformity of models and colours. The decent, respectable car commuter will select a nice mid-size car that doesn't depart too much from the others in terms of

brand or model. The best-selling leased cars in Europe are the Volkswagen Golf and Polo, the Ford Fiesta and the Opel Corsa. The colour of a car is an important consideration, unlike the colour of the train, which is usually simply based on the company colour. But the freedom of choice enjoyed by the motorist never results in anything exciting. Black is far and away the best-selling car colour in Europe, followed by silver, grey, blue and white. Red, brown, green, purple and yellow cars are sold only in very small numbers. The interior is even more extreme. The average European leased car has a black interior. Details in the dashboard and seats may sometimes feature a non-standard colour, but, as with the exterior, non-standard colours cost extra. That's why most commuters go for black. The fact that a car evokes a sense of home is strange, to say the least. Black is only rarely used as a colour for a home interior, and never for an exterior. About a hundred years ago, Henry Ford said you could have a Model-T Ford in any colour as long as it was black. Now that we can choose a colour ourselves, it's black that we prefer nine times out of ten.

In the automotive branch, the colour palette is set a number of years before the vehicle is put on the market, an impossible undertaking if you remember that colours change with every fashion season. On the other hand, you can keep a black suit, a white shirt and a beige raincoat in your closet for a long time, irrespective of the fashion season. For the time being, at least, there won't be any quick changes in the colours of motor vehicles either.

Commuters at Utrecht Central Station

Train interior

Anne van der Zwaag
**Colour and screen:
the rise of the mobile
internet**

It may be rather difficult for the youngest generation of mobile telephone users to imagine, but what used to be a big, black unwieldy appliance fifteen years ago is the tiny and usually colourful mobile of today. Colour had already proved itself in the fashion world as an important and personal means of expression, and companies like Nokia, Samsung and Sony Ericsson wasted no time using this to their advantage. With the introduction of various colours and coatings such as mother-of-pearl, glossy and mat, the little device became an accessory that was an object of desire. Mobile phones became available in white, shades of grey and brown, blue, purple and red, and within a few years they were a fashion item that shaped the street scene, like a striking pair of sunglasses or a scooter. Even the efficient, ever-black Blackberry is available in pink.

Once upon a time, the use of the mobile telephone was limited to making calls and sending text messages. Then a clock and a calculator were added, and now it's impossible to imagine the mobile without an MP3 player and a digital photo and video camera. The mobile telephone is the most important means of communication for both private and professional use, and it's been the object of countless innovations. When it comes to applications, personalisation is the magic word, and that includes phone design. With an agenda and a phone book, ringtones and wallpaper, covers and colours, the device has become an extension of ourselves.

The most important innovation has been access to the internet, so you can be online everywhere and all the time. Not only is the internet essential for the growth

of the mobile industry, but innovations in screen size and the number of available colours have also been responsible for changed and more intensified use. The screen resolution of a mobile telephone has doubled 23 times since 2005, and the colour spectrum has increased from two colours in 2002 to sixteen million today, which allows for many more applications. After all, what's a photograph, a film, television on demand, an on-line commercial (even lifestyle brands have pounced on this medium), a video clip on YouTube or a game… without colour?

The introduction of so-called *smart phones* like the iPhone and the Blackberry has amounted to a breakthrough in mobile telephony. With their quick internet connections, big screens and vast quantity of colours, smart phones even threaten the existence of the PC and the laptop. After all, in a globalised society, nobody wants to be tied down to a particular time or place. So it's not surprising to learn that the number of smart phones in Germany increased by 47 percent in 2010 to 8.2 million devices. Google has already introduced the Android, a mobile telephone system, and software giant Microsoft has made its claim for a piece of the pie with Windows Phone 7, launched in 2010. The high point, at least for now, is the iPad, by which Apple once again has opened up a world of wireless possibilities. The prices of the smart phones are dropping while the number of high-tech functions and innovative applications is growing. For example, work is even being done on a chip that will enable the viewer to watch HD video and play 3D games, and not only in the more expensive models. New screen technologies like LED and *pico projectors* will soon find their way to the market. Mobile images and colours will be even richer as a result, and the medium will become all the

more interesting for the user, the provider *and* the advertiser.

People all over the world are taking advantage of the availability of entertainment 'on the move', and the mobile internet is becoming more and more engaged in daily life. Naturally this has to do with the ever-broadening access to the web, but there's no doubt that a major contribution has been made with the introduction of the colour screen.

Viewing screen technology

iPhone, Apple

Ghislain Kieft
Living grey

Colour is like time. If you don't think about it, it makes sense; but once you start pondering it, you find you don't understand it at all. Even the most common classification of colour soon raises difficulties.

We're used to classifying the visible colours according to hue, saturation and brightness. The problems start with the notion of 'hue': hue is what we call normal colour (red, green, blue). We understand 'saturation' as the extent to which a hue is a 'real' colour (and not a mixture of other colours; some reds are 'redder' than other reds); this leads to confusion and gets our minds going.

Then there's 'brightness', which is sometimes called 'luminance': the amount of light that is radiated by a light source or reflected from a (coloured) surface. It follows that two very different colours ('hues') can still have the same brightness. To give the simplest of examples: red and green are colours that we perceive to be quite separate from each other (it's impossible for something to be reddish green). If both colours have the same luminance, the red will be indistinguishable from the green in a black-and-white photo. If we look at the painting *The Poppy Field, near Argenteuil* by Monet, the title makes perfect sense.

But because the red poppies are 'isoluminant' (identical in brightness) with the green field, they disappear without a trace in a black-and-white reproduction (try it out or look it up: it's a well-known example of isoluminance).

This is an accident of Monet's palette – and a printer's nightmare. In reality isoluminance does not occur very often, certainly not when we're moving through space. If we were to walk through the field near Argenteuil, we would move our position with respect to the sun and experience a changing colour pattern, actually a pattern of shadow and light, or a difference in luminance. Even a colour-blind person can trust his surroundings because he observes the different 'grey values' (that is, 'luminances').

We can thus conclude that Monet's lively spring colours are not what determine our interaction with space, but rather the autumnal greys. Quite unconsciously, and whether we like it or not, these greys guide our groping hands or help us aim for a bull's-eye.

In the case of isoluminance and very diffuse light, the moving brain is faced with a puzzle: because of the uniform brightness, you can no longer tell where things are. Where are the letters? What is the foreground, and what is the background?

The above paragraph, for example, could not be read very easily; isoluminance quickly causes irritation.

In some specially designed isoluminant images, it even seems as if the colours *themselves* are moving. Such images pose problems for the brain, and after a while the brain resolutely opts for the wrong solution.

Imagine an isoluminant supermarket. Normally, a supermarket – with its vast array of colours – is approximately what a field near Argenteuil is to industrious bees. But if the colours were all of uniform brightness, what is usually so simple for our powers of coordination would become a hallucinatory experience requiring nerves of steel: despite the clear differences in hue, it would be impossible to determine where any article was located, and this is due to the lack of grey contrast.

If Monet's field were a green football field and the poppies were isoluminant opponents, then our players would have a very difficult time of it: they wouldn't be able to find the other team. And the supporters wouldn't be able to find them, either.

Fortunately, this is only a thought experiment.

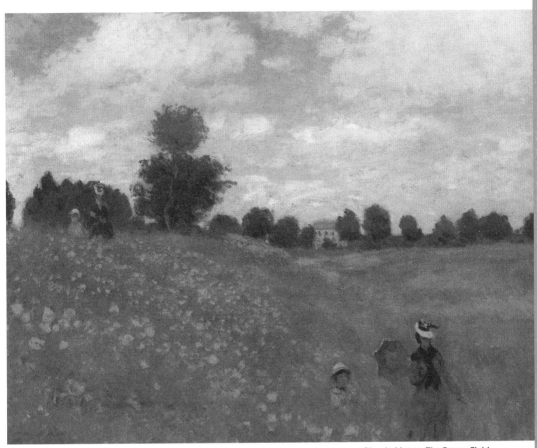

Claude Monet, *The Poppy Field,
near Argenteuil, 1873*

Job Koelewijn, *Nursery Piece*, 2009

Virtual

Pipilotti Rist, *Tyngdkraft var min vän*, 2007, audio/video installation, video still.
Work commissioned by Magasin 3 Stockholm Konsthall

**24-hour colour:
all colour is virtual**

I have long resisted buying a colour printer. Didn't need it. All this fuss about coloured lines and words in text, which is much more legible in plain black and white... Maybe this aversion was motivated by the same sentiment that inspires my dress code – and that of many of my peers in the cultural field – of black and shades of grey. Colour is distraction, black and white is essence. And we're about essence.

Meanwhile, of course, I do own a colour printer, if only because there is no other kind on the market these days. But I use this printer sparingly. For years now, my main medium for reading has not been the printed page but the computer screen. And in this medium, colour plays an important role that far exceeds frivolous aesthetics. Coloured words mean that you can use them for more than just reading. Colour says: click here. On the screen, therefore, colour is a functional element, an essential part of the graphic user interface. Just which colour is used for a certain inter-action seems of less importance. Going by optical and typographical criteria, the purple or blue that has indicated links since the early days of the web browser is a remarkably bad colour for this functionality, as most experts in the field acknowledge. Nonetheless, one of the most respected among them, usability guru Jacob Nielsen, once remarked that although it was the wrong choice, this colour should not be changed because everybody had become used to it. For a medium that was hardly a decade old at the time Nielsen made his remark, it seemed a bit premature to use habituation as decisive argument, but actually it is more interesting to note that the anonymous software developer who decided on blue/purple was psycholo-

gically colour blind. I for one would bet that most people, when asked which colour they find best suited to accentuate a word in a sentence, would answer: red. Since the dawn of human communication, that is the colour that says: attention!

Each colour has a sensory charge, an emotional meaning that can also be experienced as touch or taste or sound. The abstract painter Wassily Kandinsky said, 'Yellow sounds like a shrill trumpet.' In his time, around the turn of the previous century, this was a phenomenon that stirred the imagination of many: synesthesia. For some, synesthesia is an actual experience of mixed sensory perceptions; these people literally undergo a sensation of taste whenever they see certain colours, or they see colours when hearing certain sounds. For most of us, however, synesthesia is a mental association between what we perceive with various senses and how we experience these perceptions. In around 1900, artists were fascinated by this association. Kandinsky titled his abstract paintings in musical terms like 'improvisations' and 'compositions'. The composer Hector Berlioz described a friend's music as *chiaroscuro* of sounds with a 'melancholy colour'. His colleague Alexander Scriabin combined sound and colour in his own music by adding an organ to his orchestra that projected colours instead of producing tones. And the futurist Carlo Carà wrote a manifesto about 'painting colours, sounds and smells'.

Such 'synesthetic' virtuality also plays a role in the functional use of colour. Red sounds loud, smells strong, tastes sharp, feels heavy. Yellow sounds clear and far, smells sweet and feels warm. Green feels safe and sounds friendly. Blue smells fresh. Graphic designers know the power of these colours and their virtual associations with sound

and taste, and therefore often use them as signal colours. But they also know that one should use them wisely and moderately. Too many colours, just like too much taste or sound, lead to saturation and a loss of discerning capability. The more garish a designer's pallet, the greater the risk of visual chaos. And that can sometimes be life-threatening. When analyzing the causes of a fatal fire at Düsseldorf airport that killed sixteen people, design bureau MetaDesign concluded that the signs indicating the emergency exits had been badly placed, badly designed and badly coloured. This insight was the leading factor in Meta's design of a new set of signs for the airport in which a light green was used very selectively for pictograms associated with safety: emergency exits, first aid, alarm buttons. And it convinced sign designer Paul Mijksenaar to use green exclusively for the indication of escape routes.

Next to typography, colour is a decisive factor in the legibility and recognisability of information design. With the aim of creating visual order in the tangle of thin black lines that represent the movements of stock market quotations in traditional charts, designer Frédérik Ruys translated these graphical lines into bands of colour, blue for rising, red for falling quotes. The degree of rising or falling was indicated by varying the colour intensity of the bands. His graph of the effects of the credit crisis on stocks quoted on the Dutch AEX, made for *Het Financieele Dagblad* of December 20, 2008, is a textbook example of the effectiveness of colour in representing complex collections of data. It also is a typical example of good virtual use of colour. Red and blue are not material qualities of the numbers or the reality behind them, but colours are traditionally used to visualise concepts associated with that reality. 'Red num-

bers' and 'in the red' are syno-
nymous for loss and debt. If Ruys
had wanted to consistently stick
to this kind of metaphor he could
have used green for positive
results, but luckily he chose blue,
which from the vantage point
of optical recognisability is the
better colour because the human
eye can recognise its hues
more easily that those of green.

Colour gives a voice to words,
numbers and signs: shouting,
talking or whispering. The
'loudness' of a colour depends
not only on the colour itself
but also on the colours and hues
that surround it. This was an
essential insight after the fire at
Düsseldorf airport – the signage
for the escape routes did not
stand out enough from the sur-
rounding visual clutter. In a snow-
white winter landscape, even
the most tender green of a
butting leaf or the palest yellow
of the first daffodil catches the
eye immediately. In a carnival
parade, it's hard to discern any
colour separately. So many loud
voices merge into a cacophony –
or, if arranged and directed well,
into a many-voiced choir. That
is what the colourists among
the painters do: arrange many
colours into harmonic compo-
sitions, perhaps with the odd
dissonant to wake up the viewer.
This is how Kandinsky described
his paintings: as musical com-
positions in which colours re-
present sounds. Conversely,
Louis Andriessen wrote a
composition for the Christmas
issue of the Dutch *Drukkers-
weekblad* in 1967 in which colour
was a central aspect of the
notation. He used the colours
black, red and blue to indicate
three separate voices in this
visual score. Andriessen used
colours as notation, limiting
himself to three very distinctive
hues. Thus, in his visualisation
of the music, he acted like a
graphic designer who wants to
render information in a clear
and legible way. Kandinsky's
work does not have to be 'read'

or 'heard' literally but is meant
to be experienced as a whole.
Therefore, the painter/colourist
can use a far broader range of
colours and mix them to a much
greater extent than the designer.
His concern is the chord, the
harmony. The designer aims at
contrast, at keeping each colour
recognisable as a single tone.

In this context, Umberto Eco
remarked in his Mondriaan
Lecture of May 1981 that in order
to warrant universal distinctive-
ness, a culture can probably use
no more than seven colours in
a meaningful way. Everyone can
agree on those seven. As soon
as smaller nuances are used,
disagreement and differences
of interpretation arise: is this
azure or ultramarine? Old rose
or gold red? If you want to keep
the difference between colours
generally discernable, you must
submit to the common denomi-
nator. This is the case with
the colour range of traffic signs.
Under the influence of weath-
ering, the use of nondurable
paint or the surrounding street
lights, the red used for prohibi-
tion signs may fade a bit into
orange or purple, but it will still
be classifiable as red. Which
is as it should be; an orange-
red traffic sign does not mean
'slightly prohibited' and a purple-
red sign does not mean 'extreme-
ly prohibited'. Red is red, prohib-
ited is prohibited. Eco remarked
that something similar can be
seen in national flags: there are
seven basic colours with which
one can make just about any flag
in the world.

There are two projects that
have taken this fact, albeit unwit-
tingly, as the point of departure
for the design of a new flag for
the European Union. Rem Koolhaas
and his graphic research team
AMO combined all the colours of
all the European Union members'
flags by order of nation. This
resulted in a kind of barcode in
which every member country
is represented but also dissolves
into a colourful whole – the

borders between the national
colours fade. On the other hand,
the number of colour bands is
so large that it hardly matters in
which order they are displayed.
AMO's flag, therefore, is sym-
bolic, but not iconic in the sense
of resulting in an immediately
recognisable and unambiguous
form. The students of graphic
designer Annelys de Vet did
something similar, but differently.
They, too, collected all the
colours of all the EU flags and
arranged them based on 'popu-
larity' – the frequency with
which each colour was used
in the flags. This produced an
image quite like AMO's, a kind
of barcode. But they went on
to reduce all the colour hues to
their respective basic colours,
resulting in a flag with six colours
in six bands of varying widths
– red being most frequent,
and black the least. This flag
follows Eco's insight and has the
potential of becoming iconic:
generally recognisable and
unmistakable.

The national flags also show
that 'virtual colour', meaning
colour that is not a physical
characteristic of a material or
object, can become 'real'. Red,
white and blue, horizontally
arranged *is* the Netherlands.
Blue, white and red, vertically
arranged, *is* France. A yellow
prohibition sign will not be
recognised as such. A turquoise
emergency exit sign will be
overlooked. The colours and the
objects – flags, traffic signs – are
entangled to such an extent in
these cases that we have come
to experience the combinations
to be as natural as the blue of
the sky, the red of fire, the green
of grass and the yellow of sand.
Habituation plays a large part
here. The same goes for the
use of colour in packaging for
various products. Anyone who
has ever entered a supermarket
abroad will have noticed it: that
they weren't able to find certain
basic products because they
were packaged differently than

AMO/Rem Koolhaas, *EU Barcode*, 2001

Irma Boom, cover *Experiencing Europe*,
including all European Flags, 2000

the same products back home. In the Netherlands, milk comes in blue packs, whatever the brand. If he sees a yellow milk pack on the dairy shelf abroad, a Dutchman thinks: vanilla custard. When the Dutch supermarket Albert Heijn introduced a new packaging design for its sugar, I wasn't able to find that product for quite a while. The dominant red colour of that design means 'salt' in my head. For as long as I can remember, sugar has come in packaging with blue print.

Another good example of virtual use of colour in packaging is the blue of sanitary napkins. Not a single brand of sanitary napkins will ever show a spot of red. And in TV ads for this product its effectiveness is not demonstrated with tomato juice – without doubt the best stand-in colour for blood – but with a clear blue fluid. The use of blue in this case is a textbook example of a colour euphemism. The ad shows hygienic blue but means blood-red. Blue is clean, clear, clinical, anorganic, light, without smell. Blue is not just optically the opposite of red, but also psychologically. All products that are associated with shame in our culture – sanitary napkins, toilet paper, air fresheners – will feature clear, light colours instead of dark, heavy hues. The clean colour tones down the blush of shame.

Feelings have colour. Being in a brown study. Seeing red. A grey mood. Films can use this correlation in sophisticated ways. Since all colour that fades turns to shades of brown, we associate such colours with age. Therefore, historical films often use sepia colours, which evoke the sensation of seeing an old picture album. For economical reasons early comic books were printed in unmixed primary colours – the halftones that would facilitate colour mixing were too expensive for the few dimes such booklets were sold for. This re-

sulted in a habituation that director Warren Beatty later made use of in his movie based on the comic book hero Dick Tracy: the rigorously limited and harsh colour pallet in which he shot the film makes us experience it as a cartoon, despite the live action.

It is remarkable that we stop being conscious of such colour biases after a while, regardless of whether it concerns soft sepia tones or hard primary colours. Our eyes seem to adjust and gradually accept the virtual colours of the movie we are watching as real. This is not just a psychological effect. It's also a neurological property of the eye, as anyone knows who has ever stepped from a predominantly coloured environment back into the world. It happened to me when I entered a ski lift years ago, a bluish plexiglas bubble. It didn't surprise me to see the world in a blue hue, but what I didn't realise was that on our way up the world gradually reassumed its normal colours. The shock came when I stepped out of the ski lift: the snow-clad slopes had suddenly become rosy, the blue sky had turned deep red and my brother's yellow ski suit was hard green. The ski lift's blue filter had installed itself in my brain!

This leads me to conclude that in essence all colour is virtual. Colour is not a material but an immaterial property of physical objects. Colour is how objects and materials reflect light. But just as much, the colours we perceive are dependent on how our brain interprets this light. Are we looking through rosy glasses or a blue bubble? The virtual world is in essence everything we think before we see it, or everything we think while seeing it. It is the realm of the imagination, which can literally colour our real-life sensations and perceptions. However 'unreal', the virtual is closely connected to cultural standards and assumptions, as may be clear

from the examples above. These cultural notions form a reality in and of itself and they shape reality as we experience it. In that sense, the 'virtual' codes that govern our view of the world are as real as reality can get. Even the colour-blind know what 'red' means and that the grass is green, even if they can't see it. Artists and designers use colour in this way, to trigger thoughts, feelings and moods that may be as virtual as an on-line avatar, but which represent a mental reality nonetheless. They show us not how the world is, but how we can or should experience it. Although one can analyse this virtuality and describe the way it works with sounds, smells, colours and their synesthetic intermingling, it's still very hard to define it. The virtual is there and not there. It is within our minds, and just like colour, it's not a physical property of the world outside us. For the virtual, we could therefore use the words of Dutch painter and graphic designer Dick Elffers when he attempted to describe the essence of colour: 'The eyes listen to colour, and with the eyes it is answered. For colour, there are no words.'

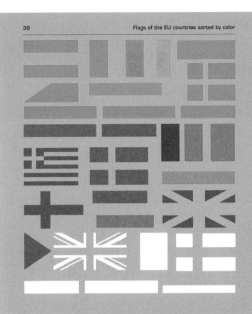

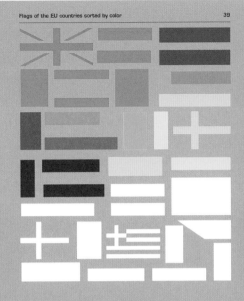

Parts of the national flags of the EU countries sorted by color*

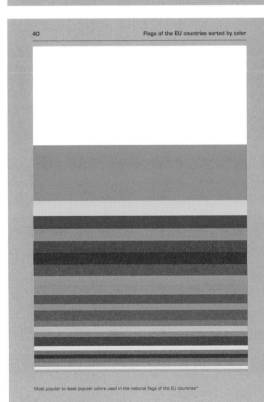

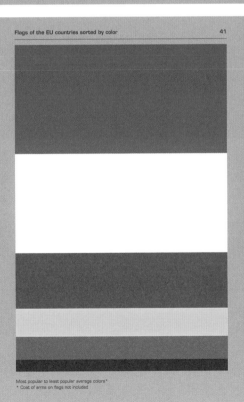

Most popular to least popular colors used in the national flags of the EU countries*

Most popular to least popular average colors*
* Coat of arms on flags not included

Koït Randmaë, 'Flags of the EU sorted by colour', from: Annelys de Vet,
Subjective atlas of the EU, from an Estonian point of view, 2004

Louis Andriessen, *The garden of Ryoan-gi*, 1967

Hoe de kredietcrisis de beurs besmette

De kredietcrisis heeft alle fondsen in de AEX, Midcap (•) en Smallcap (○) zonder uitzondering getroffen. Ten opzichte van 2 januari 2007 scoren vandaag alle fondsen lager.

Frédérik Ruys, 'Hoe de kredietcrisis
de beurs besmette' (How the credit
crisis infected the stock market),
Het Financieele Dagblad, Saturday,
20 December 2008

Ewan Lentjes
More than black and white!
Graphic design and colour

Graphic designers are the experts when it comes to line, surface, colour and typography. All these tools are mobilised in the various forms of visual communication by which the designer, on behalf of his client, tries to reach a particular segment of the intended audience. Typography would seem essential here, as would working with line, composition and proportion. But what about the application of colour? In the tradition of graphic design, firmly-held notions about colour seem to alternate with a more casual application in practice.

Graphic design is a discipline that is difficult to define. On the one hand it is regarded as a continuation of 450 years of book typography. On the other hand it only began to flourish in the wake of the industrial development of the nineteenth century. So the notion of 'graphic design' is of relatively recent origin: it wasn't until after the Second World War that it really came into fashion. The specific function and significance of the discipline are largely dependent on the socio-economic developments occurring at the time – and to a certain extent that is also true of the use of colour.

Book typography marks an important change in the way knowledge and information were stored and circulated in the Western world. The introduction of the typographical system meant that the propagation of knowledge was more and more a public affair, which represented a real break with the past. Knowledge was no longer reserved for a closed circle of adepts (from the university or the craft guilds). The distribution of information (about the 'New World', among other things) proceeded via the 'market' and

stimulated the growth of printing shops and publishing houses. In other words, information became merchandise, and with the introduction of the vernacular it flourished by leaps and bounds. According to Elizabeth Eisenstein, the really revolutionary thing about printing was that *authentic* texts became available for the first time – without omissions or the undesired addition of material from other sources – so that each printed copy contained identical, verifiable information.[1] Ever since then, printing has been the basis of reliable information, expressed simply in the saying: *it says here in black and white!*

Over the course of modern history, this metaphor has become normative – simply because of limitations inherent in the printing process. Until the nineteenth century, printing was done in two colours of ink at the most: black and red. The illustrations (woodcuts or engravings) were also printed in the same print run. With the development of lithography, the proportion of more colourful illustrations increased. Socio-economic developments played a crucial role in this: production increase and a corresponding growth in the market gave an extra impulse to visual expression. Advertising brochures and posters extolled the blessings of the industrial age. And the information landscape widened considerably, with pamphlets and newspapers as extensions of the debating culture of the bourgeoisie and an increased production of literary works for purposes of delight.

The poster, with its fields of solid colour, took possession of the street – as an explicit form of extolling the qualities of various products, but more as a way to announce events within the cultural domain. A wave of renewal in arts and crafts swept across Europe, bringing forms of cultural expression of every kind and description (revue, dance, theatre) before the public

eye. This 'New Art' was expressive and optimistically coloured (despite a widely perceived mood of decadence), as attested by the images of designers such as Henri de Toulouse-Lautrec, Jules Chéret, Alfons Mucha, Aubrey Beardsley and Lucian Bernhard.

Yet it was Art Nouveau that ushered in the radical break at the beginning of the twentieth century. The political crisis at the time marked the end of an era. In the face of the stale values of the bourgeoisie, Modernist pioneers propagated the *radically* new. The visual language of the modern avant-gardes (Constructivism, De Stijl, Bauhaus and New Typography) was indicative of a whole new canon in design. The use of colour, like the application of other visual elements, was reduced to an elementary minimum. The attitude 'less is more' set the tone in an age that was literally about to explode.

The design language of New Typography dictated a functional arrangement of visual elements that met the demands of modern times. This required uniform, objective typography, an asymmetrical layout, a photographic image and the use of only primary colours, set within a basic composition that employed the white of the page as a high-contrast element referring to a boundless context beyond the image.[2]

The New Objectivity of the twenties can still be interpreted as a revolt against the dead weight of an overloaded bourgeois Expressionism. Post-war Functionalism was more like a protest turned inward: an aesthetic aversion to the unavoidable, one-sided perspective that was part of Cold War ideology. Given this kind of black-and-white thinking, you would expect a wildly patterned offensive. But unlike the work of the Cobra artists, post-war Functionalism was anything but spectacular. Swiss design was held up as the dominant model. With its efficient typography and restrained organ-

L'Esprit Nouveau, all covers,
October 1920 – January 1925

een kleine keuze uit onze lettercollectie

Cover Reclameboek Drukkerij Trio
(Trio Printing Company), The Hague 1931

delaunay

stedelijk museum amsterdam 18 oct - 1 dec

Willem Sandberg, poster for
the *Delaunay* exhibition, 1957

Tomás Maldonado, *Inexact through* *Exact or Inexactness through* *Exactness I,* 1956–1957, Tomás Maldonado's assignment for the Hochschule für Gestaltung Ulm, carried out by William S. Huff

Grapus, *Parc de la Vilette* magazine
cover, 1986

R.D.E. Oxenaar and Hans Kruit,
**250-guilder bank note, Printing
office Enschedé, Haarlem, 1986**

Karel Martens, Telephone cards, 1994

isation of visual elements within the context of a vigorous, functional white, the aim of Functionalism was to contribute to maximum transparency in public forms of communication, decision-making and argumentation. Unwelcome power claims were met with reasonable arguments. It was a noble ambition that was given additional emphasis by means of a consistently applied rational organisation of the grid. Organisation and transparency, the basis of the belief that society can be shaped to meet human needs, acquired the tone of the three-piece pin-striped suit in endless variations of grey.

This did not survive. The ideal of a society based on power-free communication came to an end during the sixties and seventies with the resistance of the counter-culture. In the eighties, the revolt against the establishment led to a heartfelt aversion to the standard values of high culture. Popular culture constituted the end of a strict hierarchy of values; it was an extension of the post-modern practice of seeing everything in relative terms, and was easily influenced by fleeting turmoil or success. Visually, it led to an unrestrained spectacle of styles, genres and forms of expression that merged into a directionless 'anything goes'.[3]

Now we live in a context in which other values and debates predominate. Under the influence of a radical broadening of perspective (globalisation, digital technology and the internet), reality is increasingly being described as chaotic and complex. Everyday reality is a melting pot of visions, forms of expression, styles, scents and colours. We see this reflected in design and communication. But what are today's designers drawing on? Their visual attitudes seem to be based on social opinions and political preferences.[4]

In my opinion, visual argumentation benefits mainly from structural research *within* the particular professional discipline. Interestingly enough, the tradition of graphic design itself contains assorted stimulating examples of ongoing research on the application of visual tools, particularly colour.

In the twenties and thirties in Europe we saw a lively context for everyday Modernism, which was mainly concentrated on advertising design.[5] These designs form an eye-opening counterbalance to the strict rules of New Typography. It is work that finds its inspiration in the creations of leading designers such as Dick Elffers, Stefan Schlesinger, Jan Bons, Otto Treumann and Willem Sandberg, who happily went on applying the riches of colour as their organising principle. There are still designers today who are working along those lines, such as Pierre Bernard, Paula Scher, Pierre di Sciullo, Anthon Beeke, Joost Swarte and René Knip.

Richard Paul Lohse[6] and his systematic colour studies went one step further, as did Tomás Maldonado's methodical exercises on the effects of colour in the foundation course at the Hochschule für Gestaltung Ulm[7] in the sixties and seventies.

In both cases, the focus is on seriality (as in the music and art of that period). The effect of connection, proximity or contrast in a series of colours is part of the study of observation. Rhythm and flexibility in the visual arrangement of colour is seen in the light of control (over the visual tools) and freedom (of expression).

For Lohse and Maldonado, everything was aimed at facilitating more effective communication. And although in our own time the focus has shifted considerably, the motivating principle – a systematic approach to colour research in visual communication – is still essential. That insight might be taken more for granted within the field itself, certainly at this time. To that end, the studies of Lohse and Maldonado are being supplemented by more recent examples, including the Studio Dumbar colour study for the manual of the KPN house style, the Bureau Mijksenaar study for the signposting of Schiphol Airport, and the study conducted by Ruedi Baur for the Centre Pompidou in Paris. And last but not least to be mentioned are the form studies of Karel Martens, such as the series of telephone cards for PTT Telecom, undeniably preceded by an exhaustive study of the application of colour combinations.

Notes
1. Elizabeth L. Eisenstein, *The Printing Revolution in Early Modern Europe*, Cambridge: Cambridge University Press, 1983.
2. Jan Tschichold, 'Was ist und will die neue Typografie?', in: Idem, *Eine Stunde Druckgestaltung*, Stuttgart, 1930. The German text (literally: 'The New Typography: What is it and what does it want?') was originally published as 'New Life in Print' in the British journal *Commercial Art*, London, July 1930.
3. Ineke Schwartz, 'Eindelijk op de plek waar het gebeurt' / 'Where it's happening at last', in: Gert Staal et al. (eds.), *Apples & Oranges*, Amsterdam: BIS Publishers, 2001.
4. An analysis of fifty posters made over the past five years for the Ontwerp Platform Arnhem (Arnhem Design Platform; OPA) reveals that little graphic or visual research is being used in today's visual language. See Ewan Lentjes, 'OPA Affiches: De vele gezichten van het creatieve klimaat' / 'OPA Posters: The many faces of the creative climate', in: *Made to measure: 60 Posters for Design Platform Arnhem*, Amsterdam: De Buitenkant, 2010.
5. Steven Heller and Louise Fili, *Dutch Moderne: Graphic design from De Stijl to Deco*, San Francisco, CA: Chronicle Books, 1994. So-called applied design provides for a wide application of colour. Obviously this is reflected in many examples of printed advertising and house styles, but it is most certainly revealed in the expressive power of the cover in book design.
6. *Lohse lesen. Texte von Richard Paul Lohse* ('Reading Lohse: Texts by Richard Paul Lohse'), Hans Heinz Holz et al. (eds.), Zürich: Offizin Verlag, 2002.
7. *Ulm: Method and Design: Ulm School of Design 1953–1968*, Ostfildern: Hatje Cantz Verlag, 2003.

28·5-2·6·1996

KUNST RAI

dinsdag 28 mei 18-22 uur
woensdag 29 mei tot en met
zaterdag 1 juni 11-20 uur

zondag 2 juni 11-18 uur
toegangsprijs ƒ 20,-
Pas 65, CJP ƒ 17,50

Amsterdam rai

Anthon Beeke, poster for the
Amsterdam KunstRai, 1996

Arjen Mulder
The perception of analogue and digital colour

Photography can get along without colour. For more than a hundred years, black, grey and white – the non-colours – were all that was needed to produce the most surprising and familiar photographs. These works constitute the corpus of what we have gradually come to regard as the photographic canon, as well as the immense mountains of happy-memory photographs: the portraits and snapshots that fill old family albums, shoe boxes at jumble sales and storehouses of the historians of daily life. In 1839, photography eliminated colour from what until then had been highly colourful painted images, demonstrating that silhouettes, shadow effects and composition were sufficient for a convincing portrayal. Alberti had already predicted this in *De pictura* (1435) when he pointed out that in building up the image in a painting the colour isn't applied until the very end, when the picture in fact is already finished and is only in needs of a few additional details.

With the arrival of photography, colour became an independent domain with its own laws and forces. Once it had escaped confinement in realistic or fantastic forms, it turned out that colour had its own tale to tell – a tale that was unfailingly picked up by painters from the Impressionists to Kandinsky, Itten and Klee in their abstractions. In the first half of the twentieth century, colours were heard synaesthetically like sounds. Colour was the element in the picture that provided dynamics and movement, while black, white and grey evoked motionlessness; they were static. For more than a hundred years, photography glorified motionlessness and silence, that which

remained timeless in the self-propelling, high-pressure modern world.

In a photograph you recognise something that you can't see in reality because there everything is always in a constant flux. A hundredth of a second is beyond our comprehension, but that's the scale at which photography works. The black-and-white photo shows how much of the Renaissance remains in our world view: the way the world can be rendered to provide us with knowledge. The abstract painting, on the other hand, shows what is modern in our world view: how the world generates experience and how that can be evoked. Kandinsky called that the 'Geistige', the spiritual or the abstract in art, an experience that only emanates from colour. Cartier-Bresson called the other, Renaissance side of the picture 'the decisive moment': a moment of perfect harmony in an otherwise chaotic world. Colour is modern, up-to-date; black-and-white is forever, timeless. I suspect this is why so many photographers, with their inherent sense of nostalgia, have had (and continue to have) such a dislike of colour, even though colour has been affordable for decades and has become quite ordinary. Many photographers have a deep love of black-and-white, judging from the stacks of photo books that are constantly being published. Black-and-white is a statement about authenticity and artistry, not only of the depicted subject but even more of photography itself. It requires precision. A little too dull or too dazzling and it's kitsch.

Colour photography has undergone two phases. These can be broken down into the points in time when new technological possibilities were tapped, but the principal division is analogue versus digital. The three analogue primary colours are blue, red and yellow. The three digital

primary colours are blue, red and green. In the analogue process, blue and yellow make green; in the digital process, green and red make yellow. That difference has to do with the fact that analogue images are made visible by reflective light and digital images by transmitted light. A pigment reflects light and a pixel radiates it. In light-sensitive chips there are two times as many receptors for green as for red and yellow, because the electrical reaction to green is much weaker. Each pixel is calculated on the basis of colour development or change with regard to adjacent pixels and converted into the most prob-able colour value. A digital camera is a portable computer which, on the basis of a few megabytes of information, executes a giga-number of calculations in order to produce the most probable patterns, making the image sharp and clear or blurred, if desired.

Colour in a digital camera is always colour correction. This was seldom done in analogue photography. Yet analogue colour reproductions of classical masterpieces come much closer to the original than any digital photograph. Analogue photography requires more skill and the colours are deeper, more nuanced, more lively. Digital photography depends on colour combinations and in particular on ranges of colour that flow into each other, on visual complexity and on surprising connections. Everything is possible in the digital colour spectrum in terms of breadth, almost nothing in terms of depth. Fate, God or intuition play no role in the digital image, so there's little left to admire or to excite astonishment. But perhaps this is because digital photography is still young, and any intuitive interplay is only in the infant stage.

An analogue image comes from the outside, from outside the camera and from outside

Gerald van der Kaap, *Hover Hover
(Room 18)*, circa 1991

the 'I', the body, subjectivity, the
personal imagination. A digital
image comes from inside: it
shows the effects of hardware
and software; it is not a copy of
the world in chemicals, in matter,
but a conversion into streams
of electrons, zeroes and ones.
In digital images, sharp or blur-
red, hard or soft, are not ethical
statements about how the
world ought to be but aesthetic
statements about how it *can*
be. Digital photography is emo-
tionally lighter than analogue.
Digital colours appear faster
than analogue and are better at
causing a shock effect. There are
only a few digital photographers
who can manage to hold our
attention beyond the first dumb-
founded glance.

Gerald van der Kaap is such
a photographer. He began as one
of the first in the Netherlands
to do photography digitally (with
a scanner in the beginning) and
to manipulate the photos almost
as a matter of course. The blue
of the wave that rolls through a
museum gallery in *Hover Hover*
(1991) is something you'll never
forget. The colour is so vivid,
so wet, so invigorating that you
think you're on Aloha Beach,
right there in the middle of the
Stedelijk Museum in Amsterdam.
Yet the metaphorical or symbolic
meaning of that blue is rather
thin, and also unnecessary.
Digital colours are not bearers of
meaning; they convey intensities.
That's how you recognise them.
The analogue photographic
experience, laden with meaning,
is becoming increasingly rare
because it can only be repro-
duced materially, not digitally.
The digital photographic experi-
ence has to do with how you
can be sure that something has
the right colour, since everything
can be any colour. Analogue
photographs did not copy visible
things, they made things visible.
Digital photographs do not make
things visible, they make the
visible. And that's enough to
put a smile on your face.

Gerald van der Kaap, *Moi Non (I)*, 2008

Jan van den Brink
**Colour in film,
a compendium**

A

Abstract animation. As early as the 1920s, avant-garde filmmakers were carrying out colour experiments to their hearts' content. The focus of their research was cinematic language, with 'visual music' as the ideal image. In Germany in particular, avant-gardists such as Walter Ruttmann (*Opus II, III & IV*), Oskar Fischinger, Hans Richter and Lotte Reiniger were quite advanced in their experiments with rhythm, harmony, colour and interaction with live music – unhindered by the problem of having to underscore the film with synchronous sound. Oskar Fischinger fled Germany in 1940 and began working in Hollywood for Disney, among others, where he became the driving force behind the now-classic animated film *Fantasia*. In the Netherlands, Willem Bon made his mark with his attempts to produce pure, autonomous films. His most important achievement was entitled *Is er overeenkomst tusschen klank, rhythme en kleurafwisseling? (Do sound, rhythm and alternating colours have anything in common?*, 1932), and for good reason: it consisted of a repetitious succession of abstract blue, red and yellow flashes of colour, recorded on film to the rhythm of Ravel's *Boléro*.

B

Berlin, the setting for *Wings of Desire (Der Himmel über Berlin;* Wim Wenders, 1987). This is the high point in Wenders's oeuvre, with two angels (Damiel and Cassiel) as leading characters. The angels can hear the thoughts of ordinary Berlin mortals. One of the angels wants to become a human being and longs for the small, 'normal' pleasures of life: taking a walk through the city, smoking a cigarette, falling in love. As angels, they can't touch things; they don't know the physical world, so they don't know colours, either. This is how director Wenders plays with colour: all the scenes with the angels in their 'dream world' are in black-and-white. As soon as they become 'human', the film immediately switches to colour. According to Wenders, black-and-white is perfect for rendering the extremes of a city like Berlin, and as in almost all his films, he links the documentary (in this case, colour) with the artificial (black-and-white). Wenders takes his place in a long tradition of filmmakers who use the combination of colour and black-and-white narratively in the same film: Christopher Nolan in *Memento* (2000, the memories of the main character, who has amnesia, are in black-and-white), Francis Ford Coppola in *Tetro* (2009, here it's the flashbacks that are in colour) and Gary Ross in *Pleasantville* (1998): two teenagers find themselves in the TV series *Pleasantville* – in black-and-white, of course. They play the main characters in the series, thereby turning the easygoing, traditional life of this fifties community inside out: sex, rock-'n-roll, painting and modern slang all make an appearance. Gradually the series acquires colour as more and more characters embrace modern life, with a conflict between the 'black-and-whites' and the 'coloureds' as a result. Today, using tools such as Final Cut Pro to produce the same effect in the editing of home movies is known as the 'Pleasantville effect'. Also see Q and R.

C

Colour. It is still mistakenly believed that in the first few decades of its existence, film was exclusively black-and-white. But colour has always been added to original black-and-white material, right from the very beginning. Three important colouring processes were used: colouring in, tinting and toning. The first process involved hand-painting film images one by one. In a number of studios, special workshops were set up where the painting was done by large numbers of women, often using brushes consisting of only a single hair. Sometimes it took years before a film coloured in this way was really finished. Over time, such processes were improved and optimised by such means as stencilling. In tinting, a film was laid in a colour bath so that all the film material, including the perforations, acquired a single colour. Sometimes a strip of film was coloured beforehand and was only printed afterwards. When the films were edited, the most important colours – the ones that were symbolic of feelings like love (red) and fear (blue, because of the threat of night) – were worked in. Toning is a chemical process in which the silver in the film emulsion changes colour; as a result, the grey and black parts of the image (which contain silver) become coloured, and the white parts (which do not contain silver) remain white.

The 'colourless' idea we have of the first few decades is due to the fact that the first generation of film museums and archives (established in the 1940s) preserved cinematic material (which had been recorded on flammable and perishable nitrate) on black-and-white film, which was popular at the time. This preserved, sometimes restored black-and-white material was often the only reference material to survive. It wasn't until the eighties that notions about this period began to change, influenced by renewed research on rediscovered nitrate film, the original source material. Today we're amazed at the strange and magnificent display of colour produced by early nitrate; but even with the most up-to-date

Jan van den Brink

Walter Ruttmann, *Opus II, III & IV*,
1920–1923

Stanley Donen, *Funny Face*, 1957,
publicity photo featuring overexposed
close-up of Audrey Hepburn's face

digital restoration techniques, a good imitation of those colours is all we can achieve.

D

Dick Tracy (Warren Beatty, 1990) is a 'live action' film version of the popular comic strip of the same name drawn by Chester Gould in the 1940s, which attracted a lot of publicity because of the relationship between the leading actors, Beatty and Madonna. But the film's real lead was its colour scheme: from beginning to end, the spectrum was limited to primary red and blue, bright green, pink, orange and 'banana yellow' – colour enough to make your mouth water despite the limitations. Much of the action in the film was bathed in velvety shadows, revealing how well these colours match and how much colour and light the darkness of night can contain. It was a whole new take on Expressionism, and the production design of *Dick Tracy* looked as if the makers had asked Andy Warhol to colour in an old-fashioned *film noir*. Pop Surrealism at its very best.

E

Encyclopaedia. Cameraman Vittorio Storaro (*Il conformista, Last Tango in Paris, Novecento, Reds, One from the Heart, Dick Tracy, The Sheltering Sky, Dune, Apocalypse Now*, among others) is not only a gifted director of photography and winner of three Oscars but he's also a photographic theoretician. This is reflected in the encyclopaedic book *Writing with Light* (2002) in which he devotes three volumes (*The Light, Chromatic Emotion* and *The Equilibrium of Elements*, more than twelve hundred pages all told) to philosophising over the use of light and colour, and revealing the sources that inspire him – from the Italian Renaissance to Francis Bacon, and from primitive art to Tarzan comics – with the help of more

than four hundred stills from his private archive.

F

Funny Face (Stanley Donen, 1957) is a colourful musical starring Audrey Hepburn and Fred Astaire. Astaire's character is loosely based on the photographer Richard Avedon, who also produced a number of stills for the film, including the opening credits. The film's most famous image is the consciously overlit close-up of Hepburn's face in which only the essential elements remain. It makes a brief appearance (in black-and-white) during a musical number in the darkroom, but it has become famous as a publicity photo in the colour variant. The opening number of the film is the song 'Think Pink' – sung in the office of a fashion magazine à la *Vogue* – and ushering in a new campaign for more colour.

G

Grading is the process of changing the colour of a film in post-production or during restoration, either electronically, photochemically or digitally, and is done in a laboratory.

H

Hitchcock. Seldom was black-and-white more beautiful than in Hitchcock's *Suspicion* (1941), in which suspicion mounts against Cary Grant, a newly married husband who seems about to murder his rich young wife (Joan Fontaine). Hitchcock makes subtle use of Expressionist influences in his staging (sinister shadows, harsh black-and-white contrasts), and at the climax of the threat he shows us the whitest glass of milk ever seen in film history: when Grant walks up the stairs to the bedroom with a glass of milk, his wife assumes he's going to use it to poison her – and so do all the viewers. Our gaze is drawn to the glass like a magnet. Hitchcock's unerring sense of suspense works, and

later he explained that he had built up the scene around that crucial glass of milk and had put a burning light bulb in it to heighten the effect.

I

Il deserto rosso (Michelangelo Antonioni, 1964). Antonioni approached his first colour film like a painting, and none of the colours available in reality were able to satisfy him. To create 'the red desert', Antonioni collaborated with his cameraman Carlo di Palma and had the streets and a forest literally painted red. For the oppressive industrial landscape that has such an impact on the main character, Giuliana, he designed a special palette of subdued green and red, interwoven with many shades of grey: the haze and the smoke were grey, and parts of the trees and fruit were painted grey. By contrast, the fantasy world that emerges in a fairy tale told by Giuliana to her little son is shown in bright sky blue and green. Antonioni's intention was to reveal the 'colours of feelings'. Later, he would use this approach (painterly in both the figurative and the literal sense of the word) for the landscape in the psychological thriller *Blowup* (1966).

J

Jenny (Willy van Hemert, 1958). The 'colour' phenomenon entered the world of Dutch cinema as a visual joke: in the opening credits of *Jenny*, a film about an enthusiastic competitive rower (Van Hemert's daughter Ellen), the eight-member women's rowing team go under a bridge in black-and-white, only to appear a minute later on the other side in full colour (Agfacolor). A memorable detail in an otherwise utterly unmemorable film in which it should be noted that the colour red is everywhere present, but in a subtle way: in clothing and furniture but also as the rear light of a parked car or the corner of a painting.

Jan van den Brink

STANDÁARDFILMS
Amsterdam

ELLEN VAN HEMERT

MAXIM HAMEL

Jenny

De eerste nederlandse speelfilm in kleuren

SF

Bittins Films
Berlyn

40

Willy van Hemert, *Jenny*, 1958

K

Krzysztof Kieslowski (1941–1996). *Trois Couleurs: Bleu, Blanc, Rouge* from 1993–1994 is Kieslowski's ambitious attempt to represent the French values of liberty, equality and fraternity in a trilogy that constitutes his interpretation of the French tricolour. Colour proves to be more decisive in setting the tone than one might expect, and in his swan song Kieslowski manages to evoke a number of arresting connotations that break free of reality. In the first part, *Bleu*, Kieslowski explores the notion 'freedom' through the glance of a woman who has lost her husband and child in a car accident. Here the colour blue is associated with grief, but for Kieslowski suffering stands for catharsis, and with that, liberation. Freedom is also to be found in having nothing, losing everything. Part 2, *Blanc*, is an ironic comedy about a Polish man who undertakes an act of revenge against his former wife. In the flashback structure of the film, his wedding day plays a major role, so that during the divorce proceedings, innocence, symbolised by the white wedding dress, acquires a double meaning. In part 3, *Rouge*, a Swiss model enters into a friendship with a retired judge who eavesdrops on his neighbours. Gradually she turns out to be the catalyst who can heal his empty soul, a kind of lifeline for the old man. Here, red is the colour of love and of blood, the colour that, in all its variations, spreads across the film like a blood stain and reaches an overwhelming intensity.

L

Le Hollandais. Restaurant in Peter Greenaway's *The Cook, the Thief, his Wife and her Lover* (1989) and main location for a film based on five principal ideas: colour, Jacobean theatre, table groupings, use of human figures as sculpture and eating. The film is tightly constructed around a number of colours that belong to specific places: car park, kitchen, restaurant, toilets and library. The most striking thing is that the clothing, designed by Jean Paul Gaultier, changes colour as each character moves from one room to another.

M

Meet Me in St. Louis (Vicente Minelli, 1944). Musical made in lavish Technicolor by the master himself, a gifted 'colourist' and one of the first Hollywood directors to make full use of Technicolor's possibilities. Also see *An American in Paris* (1951), *The Band Wagon* (1953) and *Gigi* (1958). The scene with leading lady Judy Garland in the middle of a circle of female singers, all wearing brightly coloured hats and dresses, has become a kind of emblem for the Hollywood musical: full of bright, varied accents in purple, green, yellow, pink and blue, this chromatic whirlwind directs all attention to the star – who is dressed in black and white. During the heyday of this genre, colour created a spectacular setting for the star, guaranteeing her 'poll position' within the composition of the scene and emphasising the explosions of song and dance in the story line.

N

Paul and Menno de Nooijer. For decades, the De Nooijers, father (1943) and son (1967), have been working on an extensive and varied oeuvre of photographs, experimental films, video clips, animated films and installations. Alienation and eroticism, absurdism and surrealistic observation play an important role in their work, and this manifests itself in a corresponding and unconventional treatment of colour. Take *Exit* (1997), their first and only feature film, which centres on a blue room with a great many doors and latches through which the main character, a photographer, looks back on his past. This surrealistic room can be seen as the head of the photographer himself (both the main character and De Nooijer?). The most impressive thing behind these doors is the design. With the necessary symbolism, metaphors, dream images, wide-angle lenses, and especially with the theatrical lighting that virtually bathes the viewer in colour, the makers have created a completely unique universe. Each staged segment in itself is a small work of art. Often, the treatment of the colours – the intervention of the artist – is the subject of their films, both in Paul's painting (*Window Painting*, 1982) and in his photography, and then with the particular characteristics of Polaroid photography (*Transformation by holding time*, 1976).

O

Ben van Os (1944). The Netherlands' most famous art director, who, with his partner Jan Roelfs, made quite a name for himself with his striking production design for a number of films by Peter Greenaway: *ZOO* (1985), *Drowning by Numbers* (1986), *The Cook, the Thief, his Wife and her Lover* (1989) and *Prospero's Books* (1991). Exuberance, intense use of colour, baroque sets, radical stylisation and the deliberate creation of pastiches from historical sources have given the field of production design a whole new dimension. Van Os was twice nominated for an Oscar: for Sally Potter's *Orlando* (1994) and for the 'Vermeer adaptation' *Girl with a Pearl Earring* (Peter Webber, 2004).

P

Pierrot le fou (Jean-Luc Godard, 1965). The first colour film by the most important exponent of the *Nouvelle Vague* is both innovative and intuitive in its explosion of colour. In this 'film noir in colour', Godard employs his own colour scheme, with the primary colours

Alfred Machin, *Molens die juichen en weenen
(Windmills that cheer and weep)*, 1912

Vicente Minelli, *Meet Me in St. Louis,*
1944

referring to the colours of the French flag as well as to the leading characters in his film, Jean-Paul Belmondo (Pierrot/Ferdinand) and Anna Karina (Marianne Renoir – how symbolic can a name be?). But the most innovative aspect of the film is the way Godard uses colour as an autonomous principle: as a painter who paints a composition and is completely free in his aesthetic choices, but is fully aware of the art historical context, in this case Mondriaan and Matisse. As usual, Godard deconstructs the conventions of the medium, and with his newly created grammar he generates new meanings – in this film, for example, it's colour as a narrative principle. Watch this film while squinting and you see the play of rejection, attraction, mixing, exploding, drenching and saturating, like the deepening layer of a simple novella. Godard has become famous for his quote, 'It's not blood, but red.'

Q

Quote: 'No! No! Don't turn the projector off! No! No! It gets black and we disappear!' A theatre-goer in the film *The Purple Rose of Cairo* (US, 1985) perfectly expresses the illusion that Woody Allen has constructed. Cameraman Gordon Willis (*The Godfather* trilogy) beautifully evokes two divided worlds: the bleached-out New Jersey at the time of the Great Depression, home of the unhappy housewife Cecilia (Mia Farrow), and the glamorous, black-and-white world that is her only escape from the drab daily life she lives. The film is both a poetic treatment of the role of the viewer and an ode to the love for the medium of film. Cecilia falls in love with Tom, a character in one of the movies she sees. He escapes from the screen in order to be with her. As soon as he steps off the screen, he changes from black-and-white to colour. *The Purple Rose of Cairo*

emphasises the universal desire to unite reality and dream world, which under normal circumstances are separated by an unbridge-able distance. It also shows that it's not colour (symbol of the everyday) but black-and-white (specifically, the 'film black-and-white' that no longer exists today) that is the actual ideal. Comedy meets philosophy.

R

Rumble Fish (Francis Ford Coppola, 1983) is a portrait of a gang and a former gang leader who is admired by his younger brother and is colour-blind. Almost the entire film is appropriately in black-and-white, with a few fragments in colour. The most important things we see in colour are the blue and red 'rumble fish' in an aquarium, Siamese fighting fish that are capable of attacking their own mirror image and killing themselves if they are 'caged'. When the Motorcycle Boy (Mickey Rourke) dies, we see Rusty James, the brother, attack his own mirror image in colour (in the window of a police car) and destroy it. At the request of his deceased brother, Rusty James releases into a river a rumble fish that his brother stole from a pet shop. In this way, both brothers complete their quest – life and death are subtly connected by a few seconds of red and blue…

S

Spellbound (1945) is the film with which Alfred Hitchcock demonstrated his virtuoso film technique once and for all. The film, the first thriller about psychoanalysis, became famous for its dream sequence designed by the Surrealist Salvador Dalí, and the final scene, in which one of the main characters, Dr. Murchison, an evil genius, kills himself: the viewer sees only his hand with a pistol making a 180-degree turn. Since this is physically impossible, Hitchcock designed

an artificial hand that he then 'animated'. He emphasised this key moment in the film by colouring the fragment after the pistol shot completely red – the only colour moment in an otherwise totally black-and-white film.

T

Technicolor. It was only in the 1930s, after years of experimentation, that effective systems for photographic colour reproduction were developed. One of the most famous from those years was Technicolor, a system that made use of a fairly complicated matrix technique in which the density of the negatives indicated the colour combination to be recreated. This was known as three-strip Technicolor. In the old two-strip variant, the colour blue could not be reproduced, whereas the three-strip process covered the entire spectrum. In an age that was just beginning to outgrow black-and-white, colour still had the ring of the unconventional: exaggerated, with too much emphasis on feelings, and certainly not realistic. Only in the sixties and seventies, when mainstream film and television also began to use colour, did the significance of colour change and come to be identified more and more with realism. Fascinating examples of Technicolor are *Gone with the Wind* (1939), *The Wizard of Oz* (1939) and *An American in Paris* (1951).

U

Una giornata particolare (Ettore Scola, 1977), a film about the day Hitler visited Mussolini in Rome and Antonietta (Sophia Loren) and her neighbour across the hall, Gabriele (Marcello Mastroianni), have an accidental encounter, is striking for its highly subdued use of colour. Scola wanted to use colour to express the drabness of bourgeois existence and the restrained emotional lives of the two leading characters, and deliberately

 Jan van den Brink

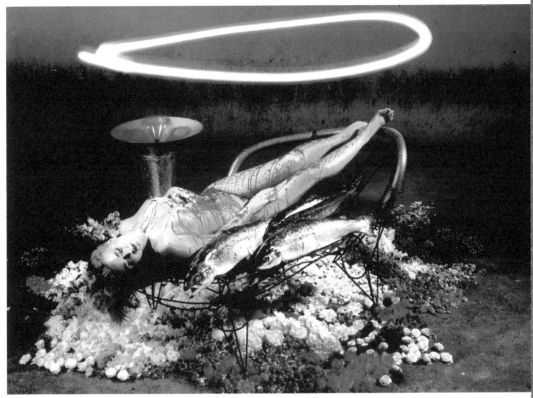

Paul and Menno de Nooijer, *Exit*, 1997

Jean-Luc Godard, *Pierrot le fou*, 1965, scene with Jean-Paul Belmondo and Sam Fuller

Jean-Luc Godard, *Pierrot le fou*, 1965,
scene with Jimmy Karoubi and Anna Karina

chose not to record the film in black-and-white, apart from the archival material. On May 8, 1939, Scola himself was eight years old. He can still recall the colour of the uniform of the 'wolf boys' (the fascist youth movement) that he wore that day, and the floral pattern of his mother's dress. Cameraman Pasqualino de Santis worked with Technicolor to develop a new method for stripping most of the colour out of the film. With this austere colour treatment, the film evokes the atmosphere of a scrapbook full of memories (not only from that one day) in which a patina lies over everything like a thin, tragic veneer.

V

Vinegar syndrome. Later sound films, which are recorded on acetate, often suffer from acidification. This is a chemical reaction which eats into the image and can lead to serious discolouration. The vinegar syndrome is a major problem for the preservation, screening and restoration of films. Anyone who has been lucky enough to visit a projection booth will immediately smell the penetrating odour of vinegar from an affected copy. Vinegar can also attack any film prints that happen to be nearby.

W

Wong Kar Wei (1958, China, but grew up in Hong Kong) may have made his magnum opus with *In the Mood for Love* (2005). With breathtaking colours, gorgeous costumes, striking and richly detailed wallpaper and eye-catching decorations, and in the hands of Wong's regular and inimitable cameraman Christopher Doyle, the film follows the impossible love between Ms. Chan (Maggie Cheung) and Mr. Chow Mo-wan (Tony Leung). Despite the film's opulence the colour is not glaring, but it expresses desire in every scene. All the passion that cannot be shown (unless they're committing

adultery) is demonstrated in the explosive tints that fill in the foreground and background. For Wong Kar Wei, colour expresses the delicate twists and turns of love and fate which his characters cannot bring under control – nor even name, at times. His intoxicating colours give voice to an occasionally complex emotional state that is beyond the power of language to convey.

X

X-men (Bryan Singer, 2000) is the filming of the famous series from Marvel Comics and one of the most popular science fiction movies ever made, with two sequels so far (*X-men 2* and *The Last Stand*) and the so-called prequel *The Origins: Wolverine* – and of course lots and lots of games. A group of mutants under the direction of the peace-loving Professor Xavier become entangled in a universal struggle between good and evil: not only are they striving to be accepted by a xenophobic America, but they're also fighting an evil genius, Magneto, who has gathered another group of mutants around him in an attempt to seize world domination. Part 1 not only shows the superheroes in all their glory, but it also has a strong political undertone – how 'different' can one be in a modern society? What are the consequences of racial hatred? All the parts contain astonishing examples of computer-generated imagery: live-action and 3D-animation that seamlessly flow into each other, dominated by special effects. The art direction department approaches the environment of the X-men as an underground hiding place, with many dark spaces and richly contrasting shadow effects that show the light and colour of the action of the main mutants to good advantage. There are the eyes of Cyclops, which can eliminate a person with their energy rays (bright white light), and the white hair of Storm,

who can manipulate the weather (when that happens, the pupils of her eyes disappear and all that remain are two equally white eyeballs). But the most imaginative character is one of the bad guys, Mystique (Rebecca Romijn), a mutant who can assume the form of another, which makes her a strategically important machinator. In her 'normal state' she's a young, naked woman covered in blue scales (with red hair and yellow eyes) who prowls the streets of New York with athletic ease, despite her 84 years.

The filming of *X-men* signified an upgrading of the literal and figurative black-and-white world of the original comics. In this case, the medium of film doesn't just add colour but it also incorporates a stratification and nuance: not a single character (especially in part 1 of the trilogy) is a one-dimensional cardboard cut-out.

In addition, colour functions here like a catalyst from the old-fashioned, nostalgic science fiction fantasies from the fifties. Director Bryan Singer manages to employ colour and special effects convincingly in order to reanimate those fantasies, thereby making a reasonable case for a fable about mutants and their arduous relationship with the 'ordinary' world and with racism (a theme that refers to black-and-white thinking).

Y

Yves Klein blue. *Blue* (Derek Jarman, 1993) is the ultimate colour film. A film that is difficult to access and at the same time enchanting, it fills the screen with a monochromatic blue – almost an Yves Klein blue – which continues unchanged for 75 minutes. Beneath this image, Jarman (who was suffering from AIDS) spreads a hypnotising layer of poetry, sound effects, diary fragments and music: 'Blue is the blood of feeling. The viewer feels along with Jarman.' Jarman was fight-

Jan van den Brink

HOUSE OF FLYING DAGGERS

Zhang Yimou, *House of Flying Daggers,*
2004

Georges Méliès, *Les quatre cents
farces du diable,* 1906

ing the approaching loss of his eyesight, which naturally for an artist is the symbol of the end of life. 'Blue flashes in my eyes. Blue bottle buzzing. Lazy days. The sky-blue butterfly sways on a cornflower. Lost in the warmth of the blue heat haze. Singing the blues, quiet and slowly. Blue my heart, blue of my dreams. Slow blue love of delphinium days. Blue is the universal love in which man bathes – it is the terrestrial paradise.'

Z

Zhang Yimou. Chinese director of the so-called Fifth Generation who became famous for films such as *Red Sorghum* (1987), *Ju Dou* (1990) and *Raise the Red Lantern* (1991). Zhang actually made a number of genuine martial arts films as well with his typical colour signature: *Hero* (2002), *House of Flying Daggers* (2004) and *Curse of the Golden Flower* (2006). As *Hero* goes deeper and deeper into the historical story of the unification of China, the colour of the main character's clothing changes. Each of the parallel universes in which the story takes place – fantasy, dream world, truth and enlightenment – has its own colour palette. The power and intensity with which the Australian cameraman Christopher Doyle (see also Wong Kar Wei) weaves the colours together are of unprecedented beauty. *Hero* is not only an epic spectacle film (the most expensive production in Chinese film history), but it's also an ode to age-old Chinese symbols, traditions and natural violence. For example, Zhang uses a red forest as the natural background for a fight scene. In *Curse of the Golden Flower*, he directs all his attention to portraying the decadence of the imperial family: gold, gold and more gold, and very bright colours, from the inner courtyards of the Forbidden City, which are completely covered with thousands of rows of

chrysanthemums (the 'golden flowers'), to the lavishly detailed golden costumes of the imperial family. 'I really love this period of Chinese history,' says Zhang. 'It was a very enlightened and luxurious era. I've done lots of research in the historical archives, and I've studied a great many paintings to see what the costumes were like, the colours. My intention was to bring that era to life in terms of sound and atmosphere, especially atmosphere.' The colours that are splashed all over the screen have no symbolic value, according to the director. 'It's a very detailed colour palette,' Zhang explains, 'but it has no special significance. What I really love is the combination of beauty, as expressed in colours, with tragedy. You see that preference in earlier films, such as *Ju Dou*, where I tell a very sad story against a magnificent, colourful background.'

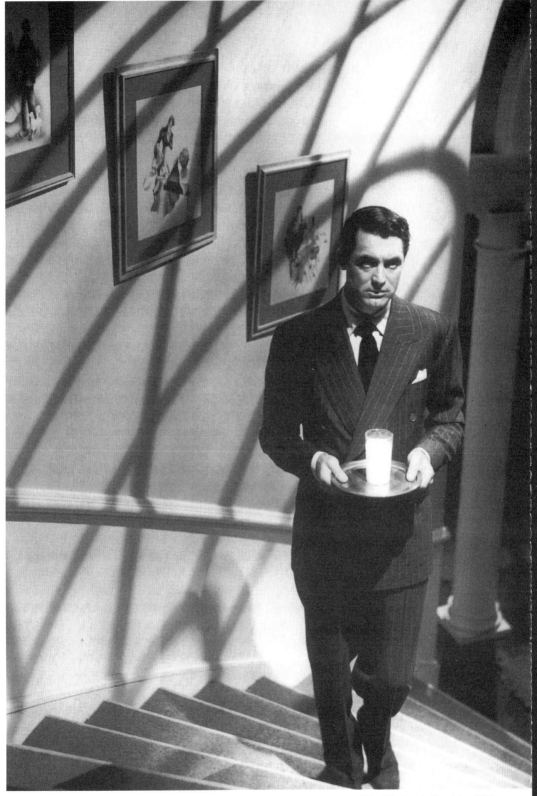

Alfred Hitchcock, *Suspicion*, 1941,
scene with Cary Grant

Jenny He
The colourful Tim Burton

There is often an environmental disconnect that exists in Tim Burton's films in that his characters inhabit two distinctly different worlds that exist simultaneously – whether in mind only or in an alternate reality such as the netherworld. As the story unfolds, the 'normal' world is exposed as claustrophobic and suffocating, and the colourful and imaginative 'topsy-turvy' world is revealed to be more logical than 'normalcy'. Colour is one of Burton's cinematic tools used to achieve this effect.

The study of colour has long attracted the interest of both scientists and artists alike. Although their approaches and purposes may be dissimilar, physicists and aesthetic theorists have both examined the interplay between different colours, and their cumulative work has furthered our understanding and appreciation of colour in art. In the late seventeenth century, Sir Isaac Newton – whose optics studies treated colour as a function of refracted visible light – was the first to attempt to illustrate visual relationships among hues by joining the ends of the visible spectrum (red, orange, yellow, green, blue, indigo, violet) into a colour wheel.[1] The analysis of points within the circle determined the hues' relation to each other. Later, in *Die Farbenkugel (The Colour Sphere*, 1810), German painter Philipp Otto Runge proposed the first three-dimensional model of colour in an effort to examine gradations of colour by adding a grey value scale to the hues.[2] This model laid the foundation for art instructor and scholar Johannes Itten's twelve-pointed colour sphere, constructed in 1921, which serves as a reference for his seven colour contrast theories: hue, warm/cold, light/dark, complementary, simultaneous, saturation, and extension.

Itten, in an effort to simplify the deconstruction of artistic impulses, proposed a systematic and functional way of looking at colour. Taking into account that our sense organs operate by means of comparison, the basis of Itten's theories maintains that a colour's overall effect can be weakened or intensified via contrast.[3] The closer two given colours are to being diametrically opposite, the more intense the contrast between them. In addition, Itten's theories proposed an objective view of colour harmony. Since the physiological phenomenon of afterimage suggests that the brain requires any given colour to be balanced by its complementary colour (red/green, blue/orange, yellow/violet)[4] in order to achieve equilibrium and negate discord, contrast can lead to pleasing effects.

Applying Itten's approach to colour aesthetics in the examination of Burton's films, and specifically concentrating on his theory of complementary contrast, the narrative effects of Burton's colour choices become evident. Burton uses colour to delineate the contrast between the separate worlds that occur in his films – one foreboding and one inviting. The 'real' world is depicted with a monochromatic and desaturated colour palette, while the 'other' world (whether imagined, fantastic, or supernatural) is saturated with colour. In *Big Fish* (2003), the dreary present is in monochromatic contrast to the colourful flashbacks that detail Edward Bloom's fantastic past. In *Charlie and the Chocolate Factory* (2005), the drudgery of London life is depicted in hues of grey and sepia while the inside of the delectable chocolate factory is filled with an array of multiple colours. Similarly, in *Corpse Bride* (2005), the living trudges along in muted tones while the underworld is alive with a palette of vibrant purples, greens and blues. When Mrs. Lovett sings

'By the Sea' in *Sweeney Todd* (2007) and fantasises about a happy union with the titular anti-hero, she is accompanied by a dream sequence rendered in unrealistic and exaggerated colour. The pleasing effect of the 'other' world is achieved not only by the mere presence of colour, but also through the pairing of colours that appear opposite each other in Itten's colour sphere. The contrast between specific hue choices leads to dramatic impact as complementary colours incite each other to maximum vividness when adjacent.[5] Edward Bloom stands in a blue suit in a field of yellow daffodils. He wanders the town of Spectre, awash in green, in a deep-red shirt. The circus where he works is punctuated by a panoply of red-hued costumes and decorations. In Willy Wonka's chocolate factory, red-clad Oompa Loompas dance on a stage of green grass, and subsequent costume changes contrast dramatically within their environment. Through impression – the registration of colour visually – and expression – the emotional response to colour – Burton's colour techniques direct subjective reactions to his visuals. 'Colourful' is not merely a descriptive, but a directive to identify with characters and settings, as colour had long been a tool used by artists to communicate with their audience.

Notes
1. Paul Zelanski and Mary Pat Fisher, *Color*, Upper Saddle River, New Jersey: Prentice Hall, 1999, p. 15.
2. Ibid., p. 60.
3. Johannes Itten, *The Art of Color: The subjective experience and objective rationale of color*, New York: Reinhold Publishing Corporation, 1961, p. 35.
4. Physiologist Ewald Hering determined that the eye and brain require medium grey to generate equilibrium. Medium grey can be produced by a mixture of black and white, or from several colours as long as they contain the primary colours in suitable proportions.
5. Itten, *The Art of Color* (note 3), p. 78.

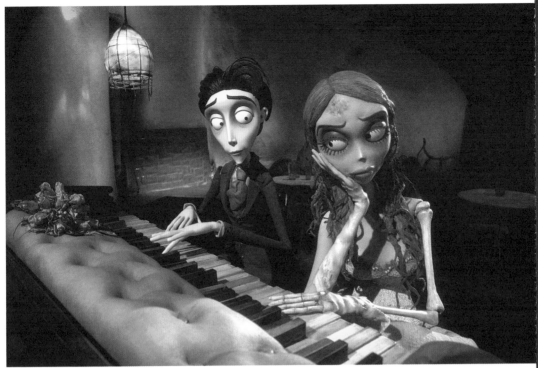

Tim Burton, *Corpse Bride*, 2005

Tim Burton, *Charlie and the Chocolate Factory*, 2005

Anne van der Zwaag
Robert Wilson: light is to the set as paint is to a canvas

In 2007 the American director Robert Wilson mounted a travelling exhibition of his VOOM Portraits. The project consists of 153 unique works of art: portraits of artists, actors, musicians and other well-known personalities, but also of dogs, panthers and other animals. The portraits are shown on HD flat screens provided by VOOM HD Networks, which commissioned and produced the project. They form a hybrid of motion pictures and still photography, made possible by innovations in HD technology. At first glance it's as if Johnny Depp, Winona Ryder, Isabella Rosselini and other models were simply being photographed. But all of them are making a small, directed gesture that brings them to life. The rhythmic sound track is also a reference to the medium of film. The costumes of the people being portrayed, their make-up, the lighting and the setting are all theatrical and draw on art history or popular culture. The VOOM Portraits fit in perfectly with Wilson's extensive oeuvre, and each one demonstrates his interest in art, architecture, film, performance, music and theatre, as well as his special relationship with colour and light.

Since the 1960s, Robert Wilson has been responsible for more than sixty theatrical works in Europe and the United States. These are true tableaux vivants that are revolutionary in both scope and design because they are constantly seeking out the borders between theatre, dance, opera and art. Wilson's international breakthrough came in 1976 when he collaborated with composer Philip Glass on the opera *Einstein on the Beach*, a four-and-a-half-hour production in which text, sound, movement, light and image are woven into a spectacular whole. To create a similar Gesamtkunstwerk he sought the cooperation of various writers, artists and musicians as well as of the Dutch fashion designers Viktor & Rolf. Wilson commissioned them to design the colourful costumes for the theatre production of the opera *Der Freischütz* (2009) by Carl Maria von Weber, among other works. Wilson's interdisciplinary approach to theatrical direction is closely connected to his activities as choreographer, performer, painter, sculptor, lighting designer and video artist. His theatrical productions do not follow the customary practice of focusing on the text; rather, Wilson concentrates primarily on the sensory experience of his work. Special attention is paid to the musical composition, the choreography, the architectural setting and the treatment of light. 'Theatre doesn't live in words,' he says, 'it lives in space. And space starts with light.'

The set for Wagner's *Lohengrin* (1998) is entirely cloaked in tints of blue, grey and green, which makes for a mystical atmosphere. Slowly moving beams of white light direct the viewer's eye to the players. Wilson often gives extra emphasis to the contrast between the player and the scenery by using white make-up, resulting in the so-called 'porcelain look'. For Wilson, however, light is more than a poetic means of establishing a production's atmosphere or rhythm. It's a technical instrument that he uses to suggest space and depth: 'Light is the most important part of theatre. I paint, I build, I compose with light.' Wilson achieves this by means of an ingenious play of light and shadow, but also by using special projection screens and applying horizontal colour zones on the stage. Warm, yellow colours alternate with cold, blue tones, creating a kind of stratification. It's a tried and tested method that had already been used in paintings by Cézanne. By using different light sources and experimenting with saturation and clarity, Robert Wilson is able to create an extremely rich and intense play of light with a limited number of colours. Very occasionally he makes use of the whole colour spectrum, as in *Quartett* (1987), a homage to the colourful Andy Warhol who had passed away that year.

Robert Wilson, *Madame Butterfly*,
Los Angeles Opera, 2005

Rainer Crone and
Alexandra von Stosch
**Anish Kapoor:
the use of colour
as a metaphor**

Anish Kapoor's oeuvre, dedicated since its beginning in around 1975 to the abstract and non-objective, is particularly successful because it speaks loudly and directly to its viewers. Kapoor started his artistic evolution by envisioning and crafting a new language in sculpture, exemplified in the vast group of his pigment pieces entitled *1000 Names* (1979–1981), all shaped in a very basic vocabulary of geometric forms and primary colours. Kapoor took forms and colours as well as mediums and turned them in on themselves by multiplying and combining shapes, carving into the surfaces to create voids and solids, incorporating non-colours (white and black), and turning powder into an impossibly unyielding substance, all demonstrating great complexity in simplicity.

Why paint something when it can be made out of colour?[1] Colour has been a central issue in much of Kapoor's oeuvre, particularly up until 1988, as it seems to function on many different levels. The two major roles of colour, which can be further subdivided, provoke the initial reaction of 'seeing' in conjunction with 'seeing' the symbolic, whether historically speaking or in a more visceral, primitive sense.

Colours have been described as having a quality of Modernist significance, in the sense that primary colours have the power to 'manipulate' or channel our perception. Thomas McEvilley, among other scholars, makes reference to this aspect in his essay 'The Darkness Inside a Stone': 'Goethe in his *Theory of Colours* associated blue with infinity. The most central and

intimate cult of Modernist abstraction, that of the monochrome icon, was an acknowledgement of and homage to the mystical power of colour, its ability to create a sense of metaphysical transformation. The emphasis on pure saturated primary colours in Kapoor's work reinforces the message of spirit, borne also by the primal simplicity of shape and the levitational powders.'[2]

It's always from colour to light. I'm interested in the other way around. From colour to darkness. That's why I use red a lot. Because red gives you a particular kind of darkness. The tonal range of red goes from red to black, not from red to orange.[3]

Red, yellow, blue, white and black seem to have this so-called 'mystical power', a metaphysical role as pure pigment. However, in applying such an interpretation, one must break down the Modernist colour theory even further to understand the origins of their universal nature. While McEvilley cites a part of Goethe's colour theory in his essay, he does not give a substantial context for understanding the implications of Goethe's argument, which was published in 1810. At that time, the early Romantics published their first groundbreaking essays about the theory of mimesis (*ars imitator naturam*).

Nearly a century before Goethe's *Theory of Colours*, Isaac Newton was performing experiments of his own in which he created a new way of understanding colour – the spectrum, which connects all visible colours (red, orange, yellow, green, blue, violet) in a continuum. Shortly thereafter, artists such as the Romantic Philipp Otto Runge began using this spectrum as a 'colour wheel' in order to explain the phenomenon of mixing colours in their very own studios.

By using red, blue and yellow, the three primary colours from

which all other hues in the colour wheel derive, Kapoor's *Part of the Red* (1981) addresses the idea of roots and origins. Unlike colours such as orange, green and violet, which are proportional mixtures of the primary colours, the hues in red, blue, and yellow cannot be defined in terms of other colours. Therefore, in pigment, the colours red, blue and yellow exist by themselves, apart from any other colour, claiming a separate and pure existence. As building blocks of art, these colours, in conjunction with geometric shapes, generate in us as viewers ideas of simplification and organisation of human thought that are an attempt to understand the world around us. In our efforts to find answers to our questions concerning the metaphysical, while eliminating what we believe to be extraneous information, we find ourselves returning to the question of existence.

In contrast to later works, *1000 Names* is concerned with evoking and emphasising a sense of disunity caused by the formidable red, cubic structure, which stands apart, its great, flat surfaces dwarfing the four surrounding conical forms. The smaller cube that emerges from the top of the rectangular form endows it with such a density and austerity that it acquires a threatening presence, surveying the field below it as if commanding an absolute notion of power towards the other entities. Like the red object in *Part of the Red*, the specific location of the cube is less relevant than its size. In this case it is sheer size rather than colour that is its defining presence. Regardless of scale, the cube remains the most daunting sculpture within the work, simply because the five-leafed cones contextualise its existence.

Anish Kapoor, *Part of the Red*, 1981

Notes

1. Anish Kapoor interviewed by Richard
 Cork in *Viewpoint: L'Art contemporain
 et Grande Bretagne*, Brussels: Musée
 d'Art Moderne, 1987, p. 6.
2. Thomas McEvilley, 'The Darkness
 Inside a Stone', in: Thomas McEvilley
 and Marjorie Allthorpe-Guyton (eds.),
 *Anish Kapoor. British Pavillion. XLIV
 Biennale di Venezia 1990*, exhibtion
 catalogue, London: The British
 Council, 1990, p. 19–20.
3. Kapoor in a conversation with Rainer
 Crone in the artist's studio in London,
 January 2007.

Ursula Sinnreich
**James Turrell:
the encounter of
inner and outer**

Turrell's artistic goal of giving viewers access to their own perception – not simply as an abstract, retina-controlled, consciousness-forming act, but as something connected to the sensory impressions of the entire body, and the emotions – enables them to have subjective visual experiences that link them in unique ways to the outside world, to their inner world, and to art.[1] The Skyspace concept in general is conceived in such a way that changes in the light from the sky are experienced most impressively during the transition from day to night. Lights are temporarily switched on at dusk, setting in motion an encounter of natural and artificial light during which the sky mutates into a coloured plane that seems to close off the space from the sky, but is actually the sky itself. The artist arranged the temporal horizon of the switching on of the lights according to precise calculations of the terrestrial perception of sunset. This point in time – which in Unna,[2] for example, is followed nearly an hour and a half later by nautical sunset and astronomical dusk – refers to twilight when it reaches its most dynamic form, when the sun approaches the horizon and falls below it. For every Skyspace site, there are notations calculated down to the second that, for the play of colours, take into account the changes in the time of sundown over the course of a year that result from the paths of the heavenly bodies.

The switching on of the colours lasts a good hour, beginning about twenty-five minutes before sunset and ending about forty-five minutes after it. The colour saturation and intensity of the lights are based on differences in the sun's radiation, which vary according to the geographical location of the object on the earth's surface. In Unna, the choice of colours moves within a rather cool spectrum – with lots of white – between pale blue and magenta, while the Californian Skyspaces become almost glowing objects of highly saturated warm reds and yellows. *Above Horizon,* a Skyspace in Los Angeles, is one such intense site. Rarely in James Turrell's oeuvre is the dovetailing of the interior and exterior space as densely and sensuously formulated as it is here. The inner part of the space, whose walls emanate the glowing play of colours, has mats on the floor and is primarily perceived while lying down. When a visitor is standing up, however, a clearly cut-out, window-like opening in one of the side walls offers a breathtaking view of the flickering light landscape of Los Angeles. This frame-like setting transforms the lighting scenario outside into a light painting that is implanted in the interior like a classic painting.

Turrell introduces the correspondence between interior and exterior into his work in ever new variations. For the campus of his alma mater, Pomona College in Claremont, California, he built a Skyspace in 2007 that functions like a transparent passage and transition. *Dividing the Light* is a supporting structure that can be accessed from all sides; on the floor opposite its opening to the sky is an expanse of water. Consequently, the Skyspace looks like a sort of metal frame for the sky, the light of which is intensified into an iridescent effect when reflected in the water. Other Skyspace installations create an impression of homogeneous coherence, such as *Revised Outlook* in Santa Monica, a round room in which both the sky opening and its entrance are round cut-outs. In *Boullée's Eye,* this principle of rounding has become an almost self-contained spatial system whose architecture evokes the utopia of the French revolutionary architect Étienne-Louis Boullée.[3] Boullée based his architectural visions of the future on archetypes of spatial forms, especially the ideal forms of the circle and the sphere. Turrell's Skyspace for the Quaker meetinghouse in Houston, by contrast, includes a kind of sky roof in the community's assembly room: an opening that transforms the presence of the sky into a seemingly cosmic vault.

Notes
1. 'My work is more about your seeing than it is about my seeing, although it is a product of my seeing. I'm also interested in the sense of presence of space; that is, space where you feel a presence, almost an entity – that physical feeling and power that space can give.' James Turrell, quoted in Craig Adcock, 'Light, Space, Time: The Visual Parameters of Roden Crater', in: Julia Brown (ed.), *Occluded Front: James Turrell*, exh. cat., Museum of Contemporary Art, Los Angeles, 1981, p. 102.
2. Translator's note: the city of Unna lies in the eastern part of the Ruhr Area. A 'Zentrum für internationale Lichtkunst' has been set up there which also contains a work by Turrell.
3. See also the essay by Julian Heynen in: Ursula Sinnreich (ed.), *James Turrell: Geometrie des Lichts/ Geometry of Light*, exhibition catalogue, Zentrum für Internationale Lichtkunst, Unna 2009, p. 102.

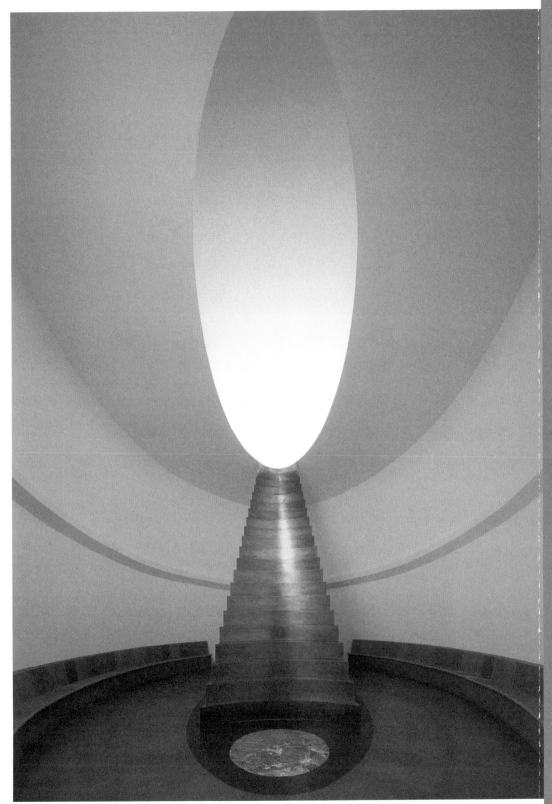

James Turrell, *Roden Crater*, 2007,
Skyspace East Portal, Flagstaff, Arizona,
interior daytime view

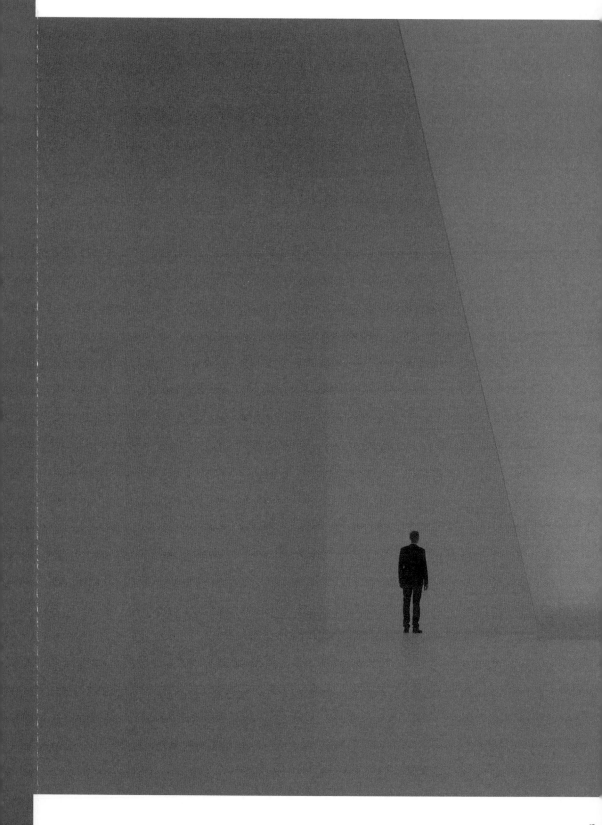

James Turrell, *Bridget's Bardo, Ganzfield Piece*, 2009, installation in the Kunstmuseum Wolfsburg, Germany

Lilian Tone
**Transient Rainbow.
Explosions and
implosions of time**

There is a fiery explosion of
colours, shapes and patterns,
fleetingly iterated against the
darkened sky. An effusion of
smoke lingering in the night air,
the atmosphere thick with the
smell of gunpowder. It is the
unfolding of a project, an event,
an artwork articulated through
the language of fireworks. These
orchestrations trigger aural,
visual and olfactory sensations,
eliciting a dynamic response
from the entire corporeal entity.
There are immediate and lin-
gering traces, at once ephemeral
and subtly material: bodily shock,
optical afterimages, perhaps
a ringing in the ears, degrees of
cognitive and spatial overload
and confusion. Dynamically
present only for a few moments,
then dispersing into the air,
creating a rich, smoky absence:
this is, in a sense, the intrinsic
aesthetic of temporal transience
that underlies Cai Guo-Qiang's
gunpowder and firework projects.
　Fireworks are a paradoxical
ritual: at once violent and beauti-
ful, populist and mysterious,
mundane yet magical, they can
be considered, historically, one
of the first truly public, spectacle-
oriented forms of cultural ex-
pression and social symbolism.
Traditional yet continuously
reinvented, fireworks have been
employed for purposes ranging
from militaristic symbolism to
nationalistic celebration, to just
plain consumerism; or, in their
most basic form, a kid firing
a bottle rocket in his or her
backyard.
　Cai has traversed many miles
to establish himself as one of
the most innovative and risk-
taking artists of the past decade.
Born in 1957 in Quanzhou City
(located within the Fujian Pro-
vince of China, where firecracker
manufacture is pervasive), he

moved to Japan in 1986, then
re-located to New York in 1995,
where he currently lives. He
developed a fascination with,
and critical understanding of,
historical manifestations of
process-oriented and event-
based art, and has internalised
the conceptual implications
of de-materialisation and site-
specificity (in terms of exploring
cultural and geographic topo-
graphies and territorial para-
meters). These concerns have
been fused with Cai's relation-
ship with notions of spirituality,
as well as an interest in spectacle
and entertainment, to engender
an art method and language
that is as premeditated as it is
unpredictable.
　This brings us to the evening
of 29 June 2002, wherein a
spectacular firework display,
choreographed to unfold in
a swift, staccato sequence,
crossed the East River in New
York City. *Transient Rainbow*,
true to its title, instantaneously
appeared and disappeared in
less than 15 seconds. The pro-
ject comprised 1,000 firework
shells launched sequentially
from Roosevelt Island. Starting
from the Manhattan side, the
fireworks progressively cascaded
towards the opposite side in
Queens. The dazzling visual effect
resembled a rapidly moving
rainbow momentarily spanning
– and symbolically linking – the
East River's two banks. Utilising
seven colours (red, orange,
yellow, green, blue, pale blue and
purple), Cai decided to visually
maintain the rainbow trail until the
end, with the shells continually
detonating until the entire
rainbow was illuminated. Each
shell would contain a computer
chip that instructed it to break in
the air three seconds after being
launched, thus making possible
the precise choreographing of
its explosion at a specific height
and the image-construction of
the rainbow shape. For the artist,
the rainbow is a sign of hope and
promise, something that comes

after a storm, and therefore the
choice of this iconography was
meant as a symbolically appro-
priate way to address a post-
September 11 New York City.

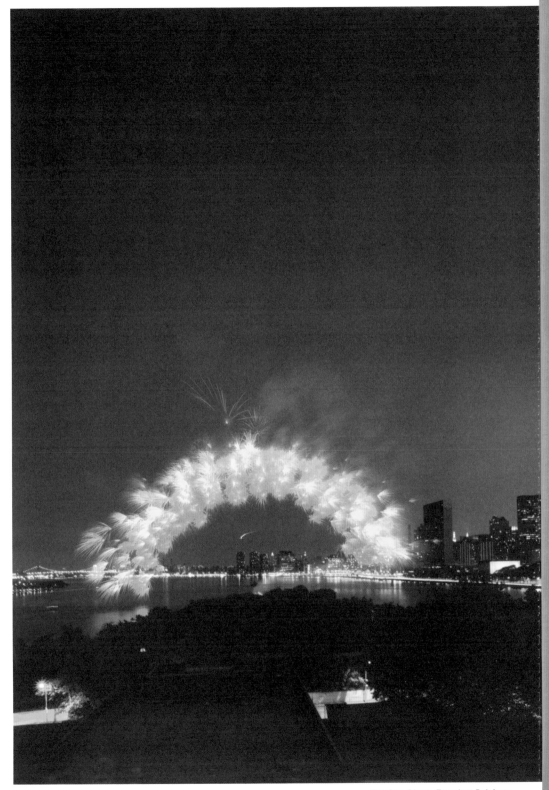

Cai Guo-Qiang, *Transient Rainbow*,
East River, New York, 29 June 2002,
9:30 p.m., 15 seconds

Rem Koolhaas
**The future of colours
is looking bright**

*In a world where nothing
is stable, the permanence
of colour is slightly naive.*

Somehow, for me, colour went
out of colour somewhere in the
late eighties.

There are two kinds of colours.
The ones that are integral to a
material, or a substance – they
cannot be changed – and the ones
that are artificial, that can be
applied and that transform the
appearance of things. The diffe-
rence between colour and paint.

After an initial outburst of the
use of paint at the beginning of
the century – was it the easiest way
to transform, to get rid of history?
– we are at the end of the twen-
tieth century, committed to the
authenticity of materials, or even
more, to materials that announce
their own dematerialisation.

The idea of a 'range' has be-
come tiresome and uninteresting.
Paint now seems brutal as colour
is given by glass, plastics,
artificial light, translucencies and
transparencies, a kind of
universe of quietness and
disappearance.

In the sixties, colour was crucial
for the unfolding of daily life –
cheerful at home, discrete for the
corporation. Around 1968, colour
started to become ideological
again: all colours at the same
time, a permanent fireworks
display, but no colour more
prominent than all the others.

Then in the eighties, under the
rise of Post-Modernism, colour
suddenly became suspect. Post-
Modernism wanted to dignify
the world with real materials
– granite, travertine, marble –
only beige or a purplish colour
like brick were considered 'classy'
and sufficiently mature. Entire
cities changed their colour pal-
ette overnight. Miami's violent
blues and pinks became white
and yellowish, all in the name
of good taste.

At the same time, we have
increasingly been exposed to
luminous colour, as the virtual
rapidly invaded our conscious
experience – colour on TV, video,
computers, movies – all poten-
tially 'enhanced' and therefore
more intense, more fantastic,
more glamorous than any real
colour on real surfaces. Colour,
paint, coatings, in comparison
somehow became matt and dull.

With Minimalism in the nineties
it was at most, the inherent colour
of materials themselves that was
allowed to register – a kind of
colourless colour of subtle hints
and refined contrasts. As if any-
thing more intense was too much
for our nervous systems.

But maybe colour could make
a comeback – not the exuberant
intensity of the sixties or seven-
ties, but with more impact than
the sedated nineties – simply
through the impact of new tech-
nologies and new effects. In a
world where nothing is stable,
the permanence of colour is
slightly naive; maybe it could
change. In a world where nothing
is what it seems, the directness of
colour seems simplistic – maybe
it can create more complex effects.

When all OMA people were
asked to propose 'their' colours,
to imagine a paint or a coating,
only ten people actually chose
a simple single colour. Most
imagined their colours as a treat-
ment, a way to affect reality in a
more subtle way than mere paint:
not simply a layer of colour but
a more subtle conditioning, a
layer that alters the state of the
painted wall or object, a colour
that would interfere with the
status of the painted object.

It is only logical that, with the
incredible sensorial onslaught
that bombards us every day and
the artificial intensities that we
encounter in the virtual world, the
nature of colour should change,
no longer just a thin layer of
change, but something that
genuinely alters perception.

In this sense, the future of
colours is looking bright.

OMA (Office for Metropolitan Architecture), presentation
of the design for Parc de la Villette, Paris, 1984, silk screen

Rogier van der Heide
Coloured light: a world of illusion

From hour to hour, from day to day and from season to season, colour sets the tone for public spaces and with it the quality of urban life. With the arrival of multi-coloured LED lighting, small enough for architectural applications that until recently were only being dreamt of, a new, hyper-realistic world of colour has emerged in the big city.

The city is a lively, dynamic environment created by time, place and the people themselves. In Asian cities in particular, light – certainly coloured light – has always played a major role. In the street scene, light is the big communicator. Coloured light at night suggests and creates a world of illusion and hyper-realism: both the media and illuminated advertising sketch out a world for us that doesn't exist in reality, but that we are quite willing to believe in – at least for now.

Seoul, the capital of South Korea, is a good example of such a place. It's a progressive, trendy, young Asian city. In terms of music, fashion, art and nightlife, Hong Kong is all too happy to emulate Seoul, which offers its residents an inspiring, fluctuating environment with a colour palette that changes from hour to hour.

In 2005, the Dutch firm UNStudio, in collaboration with lighting designer Rogier van der Heide and his team at Arup Lighting, created a new skin for the Galleria West fashion emporium in Seoul, clearly demonstrating once and for all how much impact the use of colour has on the average city-dweller. UNStudio and Arup covered the store's almost 3,000-square metre facade with thousands of glass discs which at night are transformed into

millions of tints of coloured light. The discs are 'intelligent' and can act like pixels in a viewing screen, with the clouds of colour moving across the facade as if it were a continuous surface. The red, green and blue light sources behind each glass disc are directed by software programs to create a single piece of visual choreography. These programs provide an interface for artists and designers so the images and colours on the facade can be changed, replaced or influenced.

While the facade of Galleria West may be a technical miracle and universally regarded as the world's first 'media facade', the aspect of the design that's *really* fascinating is the way the use of colour influences the behaviour of city-dwellers. The dynamic colours, which have been carefully selected to situate the building within a specific place and time context, draw the public like a magnet. The design has turned Galleria West into a main attraction.

In the evening, just before sunset, as the glass discs begin to outdo the sunlight in brilliance and the building slowly but surely sheds its softly glittering but somewhat professional daytime outfit, the colours take over and create a lively, organic, emotional expression that reveals the building's inner 'self', resulting in thousands of visitors a day.

And that's just what architecture needs to turn the city into an attractive place for consumers and passers-by: an unambiguous identity, an authentic look and the ability not only to provide people with the practical necessities but also to inspire them and to give them direction. The use of colour and light as an integral, dynamic architectural element imparts meaning to the places that architects create and gives voice to the identity of buildings, squares and streets.

Galleria West shows this in a way that is literally brilliant, with

a dynamically coloured facade that arranges itself around the angular building like a well-cut gown. The choreography of colours causes Galleria West to unveil its true character: the colours stream across the facade, around the corners and along the edge of the roof and create a new reality, contrasting sharply with the blind, concrete box that the building used to be.

Galleria West, Seoul, South Korea (2004)
Commissioning authority: Hanwha, Seoul, South Korea
Architect: UNStudio, Amsterdam
Lighting designer: Rogier van der Heide (Arup), Amsterdam
Lighting/colour technology: 4,330 glass discs, backlit with red, green and blue LEDs, each one of which can change 20 times a second into 256 levels of light intensity

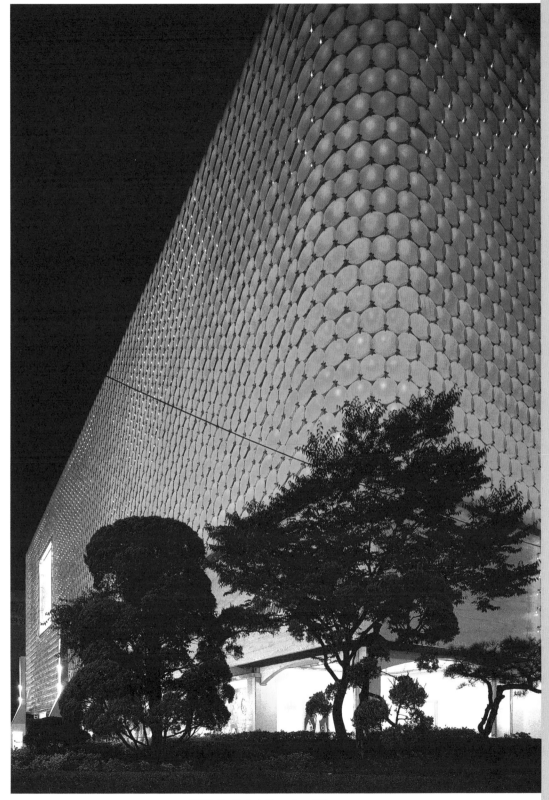

UNStudio, Galleria Department Store,
Hall West, Seoul, South Korea, 2003–2004

Minke Vos
**Interactive colour:
Angela Bulloch's *Pixel
Boxes* and *Pedestrian
Pixel System***

For artist Angela Bulloch (1966, Rainy River, Canada), the point of her work is to expose existing social structures. To this end, Bulloch makes works that are aimed at interaction with her public. As she says, '[…] you are already within a system which is much bigger than you. From an individual perspective you can't see it all at once. My system is an attempt to make these complex structures more visible, to indicate the individual responses to the larger structure, and therefore highlight the fact that you can cause an effect to the system you're within.'[1] Many of her works, whether in a museum or in a public space, are installations that respond to the viewer or passer-by by means of light, sound or movement. Because the viewer causes the interaction between the work and the public, he becomes part of the work and influences the form that it assumes.

At the end of the nineties, Bulloch, who lives and works in London and Berlin, was regarded as one of the Young British Artists. The nature of her work differs, however, from that of the other artists in this group, for whom controversial themes are central. Bulloch's work has several layers of meaning whose visibility depends on the moment in which the viewer comes in contact with it. She forms her installations from photographs, videos, written texts, sound and light. Much of her work refers to the conceptual art of the sixties and seventies. But the *Pixel Boxes* that she began making at the turn of the new century clearly refer to the Minimal Art school, and to the work of Dan Flavin and Donald Judd in particular.

Bulloch develops the *Pixel Boxes* with multimedia artist and graphic designer Holger Friese (1968, Zweibrücken, Germany). These are aluminium and wooden cubes made in a variety of sizes, each with a viewing screen on one of the sides displaying a monochrome coloured surface. Bulloch uses the boxes in different quantities and combinations as sculptural units in her installations and exhibitions. The installation *Z Point* (2001), for instance, consists of rows of stacked *Pixel Boxes* of the same size, which Bulloch uses to create a wall sculpture of different coloured surfaces, just as Minimal artist Donald Judd did with coloured geometric forms. The *Pixel Boxes* are sculpture and film, light and colour, all at the same time.

In each cube there's a red, a green and a blue fluorescent tube connected to a computer program by which more than sixteen million RGB colours can be generated. The colour made by the computer forms the monochrome coloured surface of the *Pixel Box*. This colour corresponds to an existing pixel, the smallest digital visual unit. Bulloch takes these pixels from old films, video material and television programmes. She reworks the source material until it's so abstracted that the original material is barely recognisable.[2] In the case of *Z Point*, the source material was from the film *Zabriskie Point* (1970) by Michelangelo Antonioni. Bulloch isolates the pixels from the material and converts them into the coloured surfaces of the *Pixel Boxes*. Because they're controlled by the computer, the coloured surfaces can change at any moment. Bulloch devises a colour sequence in advance that refers to the source material on which the work is based, so the composition of her work keeps changing over time.

In *Pedestrian Pixel System* (2000), Bulloch works in a public space, combining the colour sequences of the *Pixel Boxes* with the interaction that plays such a major role in her whole oeuvre. This work consists of 56 *Pixel Boxes*, each 50 x 50 cm, installed at four different places in the city of Linz, Austria. The coloured surfaces respond to bypassing pedestrians. Using sensors, the computer registers the number of people passing by as well as the speed and the frequency with which this happens. This information about the passers-by is then converted into corresponding colours chosen beforehand, producing a colour sequence. Because new information on the social environment is constantly being added, Bulloch's work undergoes continuous change.

Notes
1. Stefan Kalmar and Angela Bulloch (eds.), *Satellite: Angela Bulloch*, exhibition catalogue, Museum für Gegenwartskunst, Zürich / Le Consortium, Dijon, Cologne 1998, p. 25.
2. Helmut Draxler et al., *Prime numbers: Angela Bulloch*, exhibition catalogue Secession, Vienna / Modern Art, Oxford / De Pont, Tilburg / The Power Plant, Toronto, Cologne 2006, p. 119.

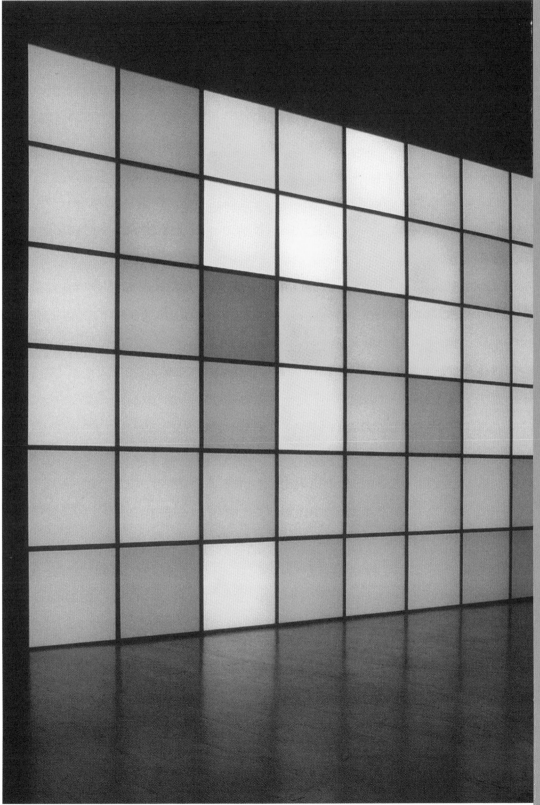

Angela Bulloch, *Z Point*, 2001

Anne van der Zwaag
Gaming: the battle of colour

In computer games, colour is just as important as it is in other highly visual disciplines. The first games were like film and photography in that they were only issued in black-and-white. For some games, a cellophane sheet was developed that you could place over your computer monitor, but this still didn't result in a colour game. It was during the 1970s that the first real colour games appeared. One of them was Super Pong from Atari, an American producer of arcade games, game computers and home computers. Super Pong was a game computer for home use; its coloured graphic applications were groundbreaking at the time. A couple of years later, in 1979, Namco put the arcade game Galaxian on the market, not one of the first colour games but certainly one of the most well-known. The multicoloured animations and graphic elements in Galaxian set a new international standard.

Atari promoted itself as one of the leading players in the computer industry and continued to come out with innovative colour applications. The company placed so much emphasis on the marketing of colour that its programmers were instructed to restrict themselves to colour and to make minimal use of the prevailing black. In 1982, Atari launched the world-famous game Pac-Man for the home console. In this game, the gamer is beset by little red, yellow and green ghosts, which turn to blue when the roles are reversed. Nintendo, a Japanese manufacturer of video games, overtook Atari in the eighties and assumed the top position. Many still remember the bright colours of Nintendo's Super Mario, the best-selling game ever. With the successful introduction of the Wii in 2006, Nintendo proved that it

was still a major innovator.

In today's games, colour is taken for granted when it comes to user interface, menus and fonts. The colour green gives the start signal, just as it does in traffic lights, and red functions as both alarm and brake. Colour also turns the gamer's attention to important objects or warns of impending danger. In addition, designers use our colour associations to enhance a game's reality content and to draw the gamer into another, simulated world.

This application of colour has been even further expanded with the emergence of hyper-realistic or *emersive* games. Colour is not only a reflection of reality, but it also provides atmosphere and appeals to the emotions in order to highlight the story line or the game element. Here the film industry serves as a shining example. In the box-office hit *The Matrix*, colour is used to impart meaning as well; all the scenes in virtual reality take on a greenish glow.
In the television series *Twin Peaks*, David Lynch skilfully combines the colour red with the underworld. And in the popular *World of Warcraft* games, the colour yellow, which alludes to the betrayal of Judas, points to areas of danger. Most war games, however, consist of darker colours and subdued tones, since a festival of colour is not what we associate with war. The popularity of the more grisly games has resulted in the increasing use of purple, blue, grey, brown and mainly black as an indicator of evil.

In *De Blob*, made for the Wii, colour serves not only as a *wayfinder* or a means of conferring meaning but has also taken on the role of subject. The game takes place in a colourless world where colour has been outlawed and banished from society. It's up to the rolling and bouncing Blob to restore colour to the world again. In the meantime,

however, the gamer is menaced by the malicious INKT company. If evil hits you, you have to spend the rest of your life colourless, just like the black Blob.

Super Mario, screen shots

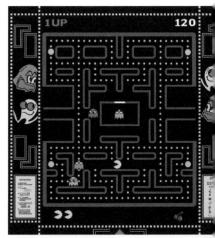

Pac-Man, screen shot

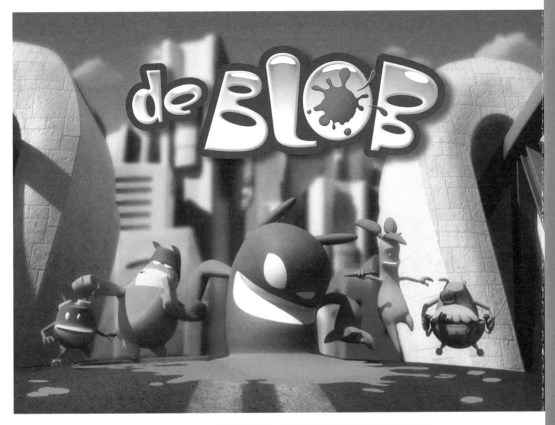

De Blob, screen shot

Nalden
<title>#FFFFFF</title>[1]

1

Colour in websites is just as important as colour in food. It imparts added value and makes the product more attractive for the person consuming it. That makes colour the more important feature ever added to the internet! Without the internet colour revolution, we'd still have white pages, black text and blue links that turn purple after you click on them. Or even worse: black-and-white bits and bytes in a DOS environment. Colour is one of the most important factors for innovation, first in television and later on the internet. Although not everyone has mastered the use of colour online, there have been fantastic developments that have turned today's web into a riot of colour. I'm glad for all the brilliant people who developed software to take colour to the next level because they recognised its relevance.

2

Thanks to the compression technology that brought us .GIF .JPEG and .PNG, it became possible to optimise the web by adding images that could be rapidly uploaded onto a web page. That may sound old-fashioned, but it was highly relevant for online colour use at the time. After that, web pages could be enhanced with photos, and later with actual Photoshop layouts. Finally we could talk about web design in which the animated GIFs were replaced by fine colour palettes that created a particular feel for the person visiting the site. It took lots of experiments, of course, before the fine balance for online colour application was reached. And it took even longer than expected before all the animated GIFs disappeared from most of the websites. Fortunately, we're now very conscious of the fact that online design provides added value, and that good use of colour must be the norm.

3

Almost synonymous with colour is Pantone, the brand that's known for the Pantone Matching System (PMS), with its universal numerical values that make it possible to apply the same colour codes the world over. Pantone recently underwent a revival, thanks to the internet. The brand entered into a number of joint ventures that have resulted in Pantone Eyewear (by which you can create your favourite colour combinations online), Pantone notebooks, Pantone USB sticks, Pantone toys, Pantone coffee cups, Pantone cashmere sweaters in collaboration with the innovative Japanese brand UNIQLO, Pantone iPhone cases, Pantone handbags, Pantone art and even Pantone colour astrology, a site that dishes up a serving of Eastern wisdom based on your favourite colour and your birthday. Thanks to all these joint ventures the blogs and websites of the world are awash with colour!

4

The DIY (Do It Yourself) trend provides countless online applications that make it possible to design products yourself. Actually the front runner here is still Nike, with the NikeID. By using the site (and soon your iPhone) you can make different models of shoes that are a celebration of colour. You start with a plain white sneaker to which you can apply at least ten layers of colour from the sole to the laces, giving your shoes their own colour identity. This opportunity to participate in the colour process has proven to be a gigantic success; thousands of shoes are coloured every month and home delivered four weeks later. It's great fun making a colourful shoe. You can see immediately which colours work on a shoe – and which ones don't. Thanks to the simple interface your design pops up right before your eyes, so you get a good idea of what works best.

5

Adobe has played a major role when it comes to colour (think of Photoshop, Illustrator and Flash). Certain colour palettes are big favourites, even when it comes to online colour. Adobe has skilfully taken advantage of this fact by creating a platform in which you can upload their colour palette and vote on it. By presenting an overview of existing colours that work well together, this platform – which is called Kuler (http://kuler.adobe. com/) – makes available all kinds of colour combinations that are tested by the 'community'. 'Black Cherry Mocha' and 'Skittles' are very popular right now, and my personal favourite, of course, is 'Happiness', which goes from mint green to soft red. Perfect for poring over if you're working on a visual identity for your new start-up. But even if you're just interested in a recent overview of popular colours, Kuler is the way to go!

6

More and more use is being made of 3D as well. And I'm not just talking about the old-fashioned red-and-green glasses. No, today Augmented Reality is the latest thing, where colour plays a very important role – not only in software design but also because of recognition. With today's smart phones and the cameras they contain, everything can be scanned. A group called TAT makes it possible to use AR to link a 'calling card' to you as a person, including the social networks you're active in such as YouTube, Twitter, Flickr and so forth. You then can use your mobile phone to scan people, and via the Augmented Reality browser Recognizr (www.

youtube.com/watch?v=5GqJHa NRlas) you can call up the elements that are part of this person's 'calling card'. Undoubtedly the norm of the future!

7

By building their interface and the menu of their website – http://www.organicgrid.com/ – mostly of colour, design consultants Organic Grid have produced a visual journey of discovery. This isn't something you see very often, but every now and then websites are constructed of various colour layers with associations that evoke a particular emotion. This is a good example of how colour is put to work as interface, clearly showing what a difference can be made. The Spectra Visual News Reader – http://msnbcmedia.msn.com/i/ msnbc/components/spectra/ index.html – is another example of the same thing. Each category has its own colour, which you can then add to a channel. This is then visualised in an extremely attractive way, and all the elements are clearly differentiated, thanks to the colours. A clever example of good programming!

8

It is claimed that social networks are the goldmines of our age. Facebook has become the biggest 'country' in the world and is forever linked to the colour blue, a colour that stands for authority and safety. Whether your privacy is really guaranteed or not is another question, but what is certain is that no other social network will ever associate itself with blue from now on. Even if Myspace was there first, Facebook has the colour blue in its back pocket for years to come. Soundcloud is linked to orange, and our own Dutch Hyves does it in yellow. Colour is immensely important for these networks, since this is where people spend most of their online time. Interestingly enough, one specific colour is always chosen, which sets the

tone right from the start. I was immediately struck by the fact that the networks with a clear colour identity are the most successful. So my tip is: claim your colour right away and stick with it!

9

Thanks to digitisation, we've got a growing quantity of data on our hands that people are managing to visualise in marvellous ways. Once again, the use of colour is essential here. The website Visual Complexity (http://www.visualcomplexity. com/vc/) shows many different examples of gorgeous data visualisation projects. Whether it's the New York subway system or airplane traffic across the globe, it doesn't matter. With the help of 'real time data' everything is visualised into beautiful maps and graphics that are also extremely impressive from a graphic standpoint. Here, too, colour is absolutely indispensable in dealing with all those different factors. You'd almost think there aren't enough colours to keep track of it all. A lovely, wellorganised example is 9 Elements, which reproduces various 'tweets' on HTML5 on a canvas in a highly visual way, a fullscreen website: http://9elements. com/ io/projects/html5/canvas/.

10

And last but not least, Nalden. net – my own website. It was designed by my friends from Momkai whose aim was to create a dynamic, stylish platform that could show every form of colour by means of the wallpapers that are intentionally part of the website. Inspired by a desktop model à la Apple's OS X, the site is built up of black-and-grey tints with just one colour: turquoise. It used to be magenta, but at a certain point I thought turquoise was more mature. That's the way it goes. The wallpapers contain different colours, and it's incredibly clever how they always go

together so well. It means the colour of the site is always fresh and new when visitors come to browse. It's a real online experience that would really be impossible without colour. And with that we hit the nail on the head. We simply can't live without colour. Not even on the internet!

Notes
1. <title>#FFFFFF</title> is the HTML colour code for white.

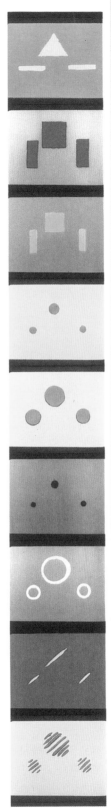

page 311
Mike Perry,
wallpaper for Nalden for
<http://www.nalden.net>,
2010

Oskar Fischinger, *Radio Dynamics*, 1943

Andreas Gursky, *99 Cent*, 1999 and Damien Hirst, *Opium*, 2000,
both from Irma Boom, 'Kleur', *Grafisch Nederland*, 2004

Aalders, Steven 119
Adobe 310
Aguilon, Franciscus 102, 104, 115
Albers, Josef 153
Albert Heijn 258
Alberti, Leon Battista 272
Alfa Romeo 240
Allen, Woody
Alma-Tadema, Lawrence 157
AMO 256, 257
Andriessen, Louis 256, 260
Angelo, Frank 58
Annunzio, Gabriele d' 125
Antonioni, Michelangelo 278, 306
Apple 151, 152, 249, 312
Arendt, Hannah 224
Aristoteles 150
Arora, Manish 58
Arthur, Paul 232–233
Arup Lighting 304–305
Astaire, Fred 278
Atari 308
Atelier Feichang Jianzhu 194
Avedon, Richard 278
Aznavour, Charles 41

Baca, Ernesto 12
Bacon, Francis 278
Balenciaga, Cristobal 72, 73
Balla, Giacomo 213
Balthus [Balthasar Kłossowski
 de Rola] 190
Banks, Tyra 56
Bardot, Brigitte 6, 8, 56
Barragán, Luis 160, 190–193, 208
Barthes, Roland 180
Bass, Saul 180
Batchelor, David 174–179, 188
Baudelaire, Charles 176
Baur, Ruedi 270
Bayer, Herbert 111
Beardsley, Aubrey 262
Beatty, Warren 258, 276
Beeke, Anthon 270, 271
Beekof, Hoger 180
Bell, Jonathan 234–237
Belmondo, Jean-Paul 282, 283
Benetton 46, 68, 69
Benetton, Luciano and Giuliana 68
Benjamin, Walter 48, 154–155
Bentley 236
Berlage, Hendrik Petrus 158, 196
Berlioz, Hector 255
Bernard, Pierre 270
Bernhard, Lucian 262
Bernini, Gian Lorenzo 157
Betsky, Aaron 156–171
Beumer, Guus 118, 121
Birnbaum, Daniel 172–173
Blanc, Charles 72
BLESS 237
Blige, Mary J. 56
Bloch, Marc 213
Bloemink, Barbara 150–153
BMW 152, 236
Boetti, Alighiero [Alighiero e Boetti]
 240–245
Bohigas, Oriol 199
Bon, Willem 276
Bons, Jan 270
Boom, Irma 5, 257
Bos, Caroline 184–189
Boullée, Étienne-Louis 296
Bouroullec, Ronan and Erwan 123

BP 180
Brassaï 162
Brengman, Malaika 142–147
Brink, Jan van den 276–289
Broekbakema 206
Brown, Capability [Lancelot Brown] 160
Bruinsma, Max 254–261
Bulloch, Angela 306–307
Bureau Mijksenaar 230–233, 270
Buren, Daniel 217
Burnham, Daniel 157, 158, 161
Burton, Tim 290–291
Bush, George W. 15

Cai, Guo-Qiang 300–301
Calvert, Margaret 234
Campana, Fernando and Humberto 122
Campbell, Naomi 56, 57, 71
Cannella, Nino 196
Carà, Carlo 255
Carey, Mariah 56
Carlos Marreiros Architects 194
Cartier-Bresson, Henri 272
Celmins, Vija 62
Cézanne, Paul 132, 292
Chamberlain, John 212, 217
Chanel 41, 58, 112
Chanel, Gabrielle 'Coco' 72, 74, 150
Chéret, Jules 262
Cheung, Maggie 286
Chevreul, Michel-Eugène 104, 153
Chirico, Giorgio de 190, 208
Citroën 236
Claus, K.E. and J.R. 233
Comme des Garçons 50
Concrete Architectural Associates 143
Coppola, Francis Ford 276, 282
Correggio, Antonio da 122
Crone, Rainer 294–295
Cugnot, Nicolas-Joseph 214, 218
Cupolillo, Egidio 196
Cuypers, Pierre 202

Dalai Lama 96
Dalí, Salvador 282
Davidse, Koert 206
Decroux, Cédric 237
Dekkers, Ger 208
Delvaux, Paul 190
Depp, Johnny 292
Diaghilev, Serge 112
Dibbets, Jan 204–205, 220–221
Diesel 60
Dijksterhuis, Edo 60–61
Dijkstra, Rineke 8
Disney 276
Doesburg, Theo van 120
Domènech i Montaner, Lluís 196
Donen, Stanley 277, 278
Doyle, Christopher 286, 288
Dresser, Christopher 150
Duchamp, Marcel 213, 216, 219

Eames, Charles and Ray 120, 122,
 126, 132
Earl, Harley 234
Eco, Umberto 256
Edelkoort, Lidewij 5, 14–39, 106
Eisenstein, Elizabeth 262
Eklund, Paula 148–149
El Lissitzky [Lazar Markovitsj Lisitski]
 174
Elffers, Dick 258, 270
Eliasson, Olafur 6, 7, 50, 156, 161,
 172, 173
EMBT 198

Estée Lauder 58
Eugénie, empress 46
Exxon 180

Farrow, Mia 282
Ferrari 213, 218, 236
Ferris, Hugh 157
Fiat 240
Fidalgo, Yves 237
Finlay, Victoria 94–99
Fischinger, Oskar 276, 313
Flaubert, Gustave 44
Flavin, Dan 50, 51, 306
Förg, Günther 11
Fontaine, Joan 278
Fontana, Lucio, 73, 117, 174
Forbo Flooring Systems 140, 141
Ford Company 152, 236, 246·
Ford, Henry 246
Ford, Tom 6, 9
Foster, Norman 226–229
Foucault, Michel 168
Freud, Sigmund 224
Friedrich, Caspar David 104
Friese, Holger 306
Fujiwara, Dai 84
Fulguro 237
Fuller, Sam 283

Gage, John 94
Galliano, John 56
Gamma 148
Garland, Judy 280
Garnier, Charles 157
Gates jr., Henry Louis 64
Gaudí, Antoni 196, 198
Gaultier, Jean Paul 280
Gehry, Frank 194, 208
General Motors 234
Gerhardt, Paul 41, 50
Gessel, Michael van 208–211
Gigon / Guyer Architekten
 236, 238–239
Gilera 240, 242, 245
Gillick, Liam 122
Glass, Philip 292
GlaxoSmithKlein 180, 181
Godard, Jean-Luc 6, 280, 282,
 283, 285
Goethe, Johann Wolfgang von
 76, 104, 105, 108, 294
Gogh, Vincent van 208
Google 248
Gould, Chester 276
Grant, Cary 278, 289
Grapus 267
Greenaway, Peter 280
Grevenstein, Anne van 202–203
Grimonprez, Johan 225
Gropius, Walter 108
Gulf 180
Gursky, Andreas 218, 223, 314 (l)
Guzzi 240, 242, 245

Hadid, Zaha 194
Hagen, Nina 46
Hauben, Theo 246–247
Haynes, Todd 8
He, Jenny 290–291
Heide, Rogier van der 304–305
Hema 114
Hemert, Ellen van 278, 279
Hemert, Willy van 278, 279
Hepburn, Audrey 277, 278
Hering, Ewald 291
Hirst, Damien 314 (r)

Hitchcock, Alfred 278, 282, 289
Hitler, Adolf 282
Ho, Melissa 62–63
Horsting, Viktor 112 (see also
 Viktor & Rolf)
Horta, Victor 196
Huff, William S. 266
Huygens, Christiaan 102, 106
Huysmans, J.-K. 117, 118, 120

Ideal (rock band) 41
IKEA 148–149
Itten, Johannes 106–108, 110, 272, 290

Jaccard, Axel 237
Janiak, Seb 57, 71
Janssens, Ann Veronica 13
Jarman, Derek 10, 286, 288
John, Elton 41
Jones, Owen 117, 198
Jong, Cees de 228
Jong, Folkert de 8
Jongerius, Hella 120, 122, 124,
 130, 132–135
Judd, Donald 306

Kaap, Gerald van der 273–275
Kandinsky, Wassily 108–110, 255,
 256, 272
Kant, Immanuel 150
Kapoor, Anish 12, 96, 294–295
Kappers, Lisette 206–207
Karina, Anna 282, 285
Karoubi, Jimmy 285
Kawara, On 62, 174
Kelly, Ellsworth 11, 159, 161, 174
Kennedy, John F. 218
Kester, Peter van 140–141
Kho, Liang Ie 230
Kieft, Ghislain 250–253
Kieslowski, Krzysztof 280
Kim, Byron 62–63
Kinneir, John 234
Klee, Paul 272
Klein, Naomi 182
Klein, Yves 10, 12, 148, 174, 226, 286
Knip, René 270
Knowles, Beyoncé 56
Körmeling, John 194
Komossa, Susanne 196–201
Koning, Krijn de 40, 45
Koolhaas, Rem 158, 194, 256,
 257, 302–303
Kousbroek, Rudy 214
KPN 270
Kroes, Doutzen 56
Kruit, Hans 268
Kubrick, Stanley 12
Kyoto Costume Institute 78–83,
 112, 153

Lacan, Jacques 172
Lampe, Katinka 45
Lamsweerde, Inez van 74
Lancôme 58
Lapidus, Morris 206
Larsson, Carl 148
Le Corbusier 157, 184, 226
Lechler 240
Ledoux, Claude Nicolas 157
Legorreta, Ricardo 160
Lentjes, Ewan 262–271
Leung, Tony 286
Lévi-Strauss, Claude 76–77
Leyland, Frederick R. 121
Lichtenberg, Georg Christoph 172

Lohse, Richard Paul 270
Lootsma, Bart 212–225
Loos, Adolf 158
Loren, Sophia 282
Louis, Morris 8, 9
Louis XV 150
Lovibond, Joseph 106
Luther, Maarten 72
Lynch, David 308
Lynn, Greg 214

M&M'S 152
M·A·C 58–59
Machin, Alfred 281
Madonna 56, 276
Magritte, René 190
Maison Martin Margiela 71
Maldonado, Tomás 266, 270
Malevitsj, Kazimir 174
Manzoni, Piero 174
Marden, Brice 62
Margiela, Martin 10, 71
Maria, Nicola de 13
Marin, John 157
Maroni, Gian Carlo 125
Martens, Karel 269, 270
Marzano, Stefano 136–139
Maserati 238, 240
Mastroianni, Marcello 282
Matadin, Vinoodh 74
Matisse, Henri 282
Mayer H., Jürgen 127
Max Meyer 240
Máxima, princess 56
McDonald's 144, 180, 182
McElvoy, Anne 98
McEvilley, Thomas 294
McQueen, Alexander 56, 58
McQueen, Steve 214
Mecanoo 194
Meijer, Richard 208
Méliès, Georges 287
Mercedes 41, 213, 218, 236
MetaDesign 255
Metz, Tracy 204–205
Michelangelo [di Lodovico
 Buonarroti Simoni] 157
Microsoft 248
Mijksenaar, Paul 230–233, 255, 270
Minelli, Vicente 280, 281
Miralles, Enric 198–201
Miu Miu 60
Miyake, Issey 84–87
Mondrian, Piet 10, 12, 282
Monet, Claude 250, 251
Monroe, Marilyn 42, 56
Moroni, Gian Carlo 125
Morris, William 150
Mucha, Alfons 262
Mugler, Thierry 53
Muijnck, Catelijne de 84–87
Mulder, Arjen 272–275
Mussolini, Benito 240, 282

Nalden 310–313
Namco 308
Nauman, Bruce 77
Newman, Barnett 62, 132
Newton, Isaac 70, 104–106, 115,
 290, 294
Nielsen, Jacob 255
Niemeyer, Oscar 84, 194
Nieuwelaar, Aldo van den 120
Nike 152, 310
Nintendo 308
Nokia 248

Nolan, Christopher 276
Nooijer, Paul and Menno de 280, 283
Normand, Alfred Nicolas 122
Nouvel, Jean 194, 195
O'Doherty, Brian 172
Oiticica, Hélio 174
OMA 302–303
Oman 56
Opel 246
Opera Amsterdam 124, 128–130
Organic Grid 312
Os, Ben van 280
Ostwald, Wilhelm 254
Oud, J.J.P. 208
Overy, Paul 226–229
Oxenaar, R.D.E. 268

Paine, Roxy 12
Palma, Carlo di 278
Panton, Marianne 151
Panton, Verner 151, 152
Pantone 106, 310
Pardo, Jorge 147
Parent, Claude 214
Passini, Romedi 232–233
Pastoureau, Michel 70, 72
Pauw, Josée de 140
Paxton, Joseph 117
Perkin, William Henry 46, 74, 112
Perry, Mike 311
Petrarca, Francesco 41
Perry Mike 311
Philips 136–139
Pierre et Gilles 45
Piët, Susanne 148–149
Pimlott, Mark 120
Piper, Adrian 66
Plato 41, 150
Platteel, André 6–13
Plečnik, Josef 196
PMS (Pantone Matching System)
 106, 310
Poele, Louise te 53–55
Poiret, Paul 74
Pollock, Jackson 215, 217
Porsche 236
Potter, Sally 280
Proust, Marcel 48
Pseudo-Dionysius the Areopagite 42
PTT Telecom 270

Rai, Aishwarya 56
Randmäl, Koït 259
Rams, Dieter 234
Rauschenberg, Robert 174
Ravel, Maurice 276
Ravesteyn, Sybold van 206, 207
Rehberger, Tobias 122, 124, 130, 131
Reinhardt, Ad 62, 174
Reininger, Lotte 276
Renault 226, 228, 229
Reyes, Chucho [Jesús Reyes Ferreira]
 190
Reygadas, Carlos 6
Richardson, Terry 235
Richter, Gerhard 43, 45, 62
Richter, Hans 276
Riefenstahl, Leni 60
Rietveld, Gerrit 118, 206
Rijke, Jeroen de 9
Rijnboutt, Kees 210, 211
Rist, Pipilotti 254
Rodchenko, Alexander 174
Roelfs, Jan 280
Rolls Royce 218, 236
Romijn, Rebecca 286

Rooij, Willem de 10

Ross, Gary 276
Rosselini, Isabella 292
Rothko, Mark 10, 12, 132
Rourke, Mickey 282
Rouw, Kees 206–207
Runge, Philipp Otto 103, 104, 290, 294
Ruskin, John 198
Ruttmann, Walter 276, 277
Ruys, Frédérik 255, 256, 261
Ruysdael, Salomon van 208
Ryder, Winona 292

Saenredam, Pieter 116, 119
Saint Laurent, Yves 114
Saint Phalle, Niki de 48
Samsung 248
Sandberg, Willem 265, 270
Santis, Pasqualino de 286
Sapper, Richard 120
Sassen, Viviane 60–61
Sauzeau, Annemarie 242
Schama, Simon 130
Scheltens, Maurice 9
Scher, Paula 270
Schiaparelli, Elsa 74
Schiffer, Claudia 56
Schlesinger, Stefan 270
Schmidt Degener, Frederik 202
Schouwenberg, Louise 132–135
Sciullo, Pierre di 270
Scola, Ettore 282, 286
Scott Brown, Denise 236
Scriabin, Alexander 255
Semper, Gottfried 117, 198
Shell 180, 182
Shiseido 41
Sibande, Mary 49
Sikkens 5, 114, 202
Singer, Bryan 286
Singh, Gobind 96
Singh, Raghubir 95
Sinnreich, Ursula 296–299
Sloan, Alfred P. 234
Small, John 228
Smelik, Anneke 52–57
Smith, Paul 114
Snoeren, Rolf 112
 (see also Viktor & Rolf)
So 60
Sony Ericsson 248
Staal, Gert 116–131
Steele, Valerie 70–75
Stewart, Martha 152
Storaro, Vittorio 278
Stosch, Alexandra von 294–295
Strehlow, Theodor 94
Struycken, Peter 140, 141
Studio Dumbar [Gert Dumbar] 270
Studio Makkink & Bey 155
Sturm, Georg 202
Swarte, Joost 270

Tagliabue, Bernadetta 98–201
Tarantino, Quentin 72
Temkin, Ann 64–67, 240–245
Thurston, William 84
Tillmans, Wolfgang 4
Tito, Josip Broz 218
Tone, Lilian 300–301
Toscani, Oliviero 68
Toskan, Frank 58
Toulouse-Lautrec, Henri de 262
Treumann, Otto 270
Turner, Tina 56
Turner, William 208

Turrell, James 12, 50, 296–299

Ultee, Hans 228
Ungaro, Emanuel 58
Unger, Marjan 102–115
UNStudio 184–189, 304–305

Valentina 72
Veluw, Levi van 47
Venturi, Robert 236
Verkerk, Herman 118, 121
Vermeer, Johannes 132, 280
Vet, Annelys de 256, 259
Victoria, queen 46
Viktor & Rolf 78–83, 112, 153, 292
Vinken, Barbara 40–51
Virilio, Paul 213–214, 218, 222, 224
Vis Restauratie Architecten 206
Vogelzang, Marije 92–93
Volkswagen 236, 246
Vos, Minke 68–69, 306–307

Wagner, Richard 292
Wall, Jeff 174
Warhol, Andy 50, 276, 292
Watanabe, Junya 75, 114
Webber, Peter 280
Weber, Anne 11
Weber, Carl Maria von 292
Weems, Carrie Mae 64–67
Wenders, Wim 276
West, Franz 170–171
Whistler, James Abbott McNeill
 121, 122
Wienerschnitzel 144
Wigley, Mark 120, 172, 218
Wilde, Oscar 122
Willis, Gordon 282
Wilson, Robert 292–293
Winckelmann, Johann Joachim 42
Wissing, Benno 230
Wittgenstein, Ludwig 104, 172
Wojcik, James 59
Wolinsky, Cary 99
Wong, Kar-Wai 286, 288
Woudhuysen, James 180–183
Wurman, Richard Saul 230
WWA Architects 194

Yamamoto, Yohji 50
Yoon, JeongMee 88–91
Young British Artists 306

Zhang, Yimou 287, 288
Zola, Émile 42
Zwaag, Anne van der 58–59,194–195,
 248–249, 292–293, 308–309
Zwart, Piet 264

Colophon

Editors
Jan Brand, Anne van der Zwaag

Picture editor and editorial coordination
Minke Vos

Design and selection first images chapters
Irma Boom, Amsterdam

Authors
Luis Barragán, David Batchelor, Jonathan Bell, Walter Benjamin, Aaron Betsky, Daniel Birnbaum, Barbara Bloemink, Caroline Bos, Malaika Brengman, Jan van den Brink, Max Bruinsma, Rainer Crone, Edo Dijksterhuis, Lidewij Edelkoort, Paula Eklund, Victoria Finlay, Michael van Gessel, Anne van Grevenstein, Theo Hauben, Jenny He, Rogier van der Heide, Melissa Ho, Lisette Kappers, Peter van Kester, Ghislain Kieft, Susanne Komossa, Rem Koolhaas, Kyoto Costume Institute, Ewan Lentjes, Claude Lévi-Strauss, Bart Lootsma, Stefano Marzano, Tracy Metz, Paul Mijksenaar, Catelijne de Muijnck, Arjen Mulder, Nalden, Paul Overy, Susanne Piët, André Platteel, Kees Rouw, Louise Schouwenberg, Ursula Sinnrich, Anneke Smelik, Gert Staal, Valerie Steele, Alexandra von Stosch, Ann Temkin, Lilian Tone, Marjan Unger, Barbara Vinken, Marije Vogelzang, Minke Vos, James Woudhuysen, JeongMee Yoon, Anne van der Zwaag

Copy-editing
Nancy Forest-Flier

Translations
NL– Eng: Nancy Forest-Flier:
Jan Brand and Anne van der Zwaag: Preface, Malaika Brengman, Jan van den Brink, Michael van Gessel, Anne van Grevenstein, Theo Hauben, Rogier van der Heide, Peter van Kester, Ghislain Kieft, Susanne Komossa, Ewan Lentjes, Tracy Metz, Paul Mijksenaar, Catelijne de Muijnck, Arjen Mulder, Nalden, André Platteel, Kees Rouw and Lisette Kappers, Louise Schouwenberg, Anneke Smelik, Gert Staal, Marjan Unger, Barbara Vinken, Marije Vogelzang, Minke Vos, Anne van der Zwaag
NL – Eng: Max Bruinsma:
Max Bruinsma

Lithography
Pixel-it, Zutphen

Printing and binding
Printer Trento, Trento, Italy

With thanks to
Jan-Hein Bal, Piet Dirkx, Laura Jackson and Julia Tilley for additional research on the article 'Religions and colour' by Victoria Finlay, Jaap van Nes, Stichting Kleurenvisie – Nederlands Platform voor Kleur en Kleurgebruik (originally the Nederlandse Vereniging voor Kleurenstudie)

Acknowledgements for reprinted essays

Luis Barragán: 'The colours of Mexico'
From: Susanne Komossa, Kees Rouw and Joost Hillen (eds.), Kleur in de hedendaagse architectuur: projecten / essays / tijdlijn / manifesten / Colour in contemporary architecture: projects / essays / calendar / manifestoes, Amsterdam: SUN, 2009, p. 396–397. This article is compiled by Kees Rouw from a series of interviews held in 1981, published in: Antonio Riggen Martinez (ed.), Luis Barragán. Escritos y conversaciones. Special edition of El Croquis, Madrid, 2000.

David Batchelor: 'A bit of nothing. On monochromes'
From TATE etc., issue 16, summer 2009.

Walter Benjamin: 'Colours'
Walter Benjamin, Berlin Childhood around 1900, Cambridge, MA: The Belknap Press of Harvard University Press, 2006, p. 110–111. Translation: Howard Eiland.

Daniel Birnbaum: 'Prologue'
From: Olafur Eliasson, Your Engagement has Consequences. On the Relativity of Your Reality, Baden: Lars Müller Publishers, 2006, p. 238.

Barbara Bloemink: 'The New Century of Colour '
From: Akiko Fukai, Chul R. Kim and Esther Kremer (eds.), Fashion in Colors, exhibition catalogue, Cooper-Hewitt, National Design Museum, Smithsonian Institution, New York: Assouline Publishing, 2004, p. 9–11.

Caroline Bos: 'UNStudio studies colour'
This article appeared earlier as a commissioned publication of AkzoNobel. Ben van Berkel, Caroline Bos with Machteld Kors and Colette Parras, UNStudio studies colour, 2009.

Rainer Crone and Alexandra von Stosch: 'The Use of Colour as a Metaphor'
From: Rainer Crone and Alexandra von Stosch, Anish Kapoor. Svayambh, Münich: Prestel Verlag, 2008, p. 23–25.

Edo Dijksterhuis: 'Viviane Sassen'
This article was taken from the website of Viviane Sassen and was first published in the catalogue of the Prix de Rome, 2007.

Melissa Ho: 'Byron Kim'
From: Ann Temkin (ed.), Color Chart. Reinventing Color, 1950 to Today, exhibition catalogue, The Museum of Modern Art, New York 2008, p. 188–189.

Rem Koolhaas: 'The future of colours is looking bright'
From: Susanne Komossa, Kees Rouw and Joost Hillen (eds.), Kleur in de hedendaagse architectuur: projecten / essays / tijdlijn / manifesten / Colour in contemporary architecture: projects / essays / calendar / manifestoes, Amsterdam: SUN, 2009, p. 411–412. This article originally appeared in: Rem Koolhaas / OMA / Norman Foster and Alessandro Mendini, Colours, Basel: Birkhäuser, 2001, p. 10–12. Original Dutch edition: Blaricum: V+K Publishing, 2001.

Kyoto Costume Institute:
'Viktor & Rolf: Self-portrait'
From: Akiko Fukai, Shinji Kohmoto / Kyoto Costume Institute (eds.), Fashion in Colors. Viktor & Rolf & KCI, Kyoto: Kyoto Costume Institute, 2004, p. 279–280.

Claude Lévi-Strauss:
'The Two Faces of Red'
From: Akiko Fukai, Shinji Kohmoto / Kyoto Costume Institute (eds.), Fashion in Colors. Viktor & Rolf & KCI, Kyoto: Kyoto Costume Institute 2004, p. 286. Copyright: Monique Lévi-Strauss, Parijs.

Tracy Metz: 'Choosing the right colour is just like finding the right word for a poem'
From: 'Choosing the right colour is just like finding the right word for a poem'. An interview with Jan Dibbets on his church windows, by Tracy Metz, Maastricht, Sassenheim 1995, p. 12–14.

Paul Overy: 'Colour in the Work of Norman Foster'
From: Norman Foster 30 Colours, Blaricum / Sassenheim: V+K Publishing / AkzoNobel Coatings, 1998, p. 8–11.

Louise Schouwenberg: 'One colour is no colour'
This article concerns the publication of part of a fictional conversation between Hella Jongerius and Louise Schouwenberg. The full text appeared in the monograph on Jongerius published in November 2010 by Phaidon Press.

Ursula Sinnrich: 'James Turrell: The Encounter of Inner and Outer'
From: Ursula Sinnrich, James Turrell. Geometrie des Lichts / Geometry of Light, Ostfildern 2009, p. 41 and p. 46.

Valerie Steele: 'She's Like a Rainbow: Colours in Fashion'
This article appeared earlier as a brochure issued in conjunction with the exhibition She's Like a Rainbow. Colors in Fashion in the Fashion and Textile History Gallery of The Museum at FIT, New York City, 11 November 2006 – 12 May 2007.

Ann Temkin: 'Carrie Mae Weems'
From: Ann Temkin (ed.), *Color Chart.*
Reinventing Color, 1950 to Today,
exhibition catalogue, The Museum of
Modern Art, New York 2008, p. 184–185.

Ann Temkin: 'Alighiero Boetti'
From: Ann Temkin (ed.), *Color Chart.*
Reinventing Color, 1950 to Today,
exhibition catalogue, The Museum of
Modern Art, New York 2008,
p. 108–109.

Lilian Tone: '*Transient Rainbow.*
Explosions and Implosions of Time'
This article is an excerpt of the essay
originally published in: Cai Guo-Qiang,
On Black Fireworks, Valencia: IVAM, 2005,
p. 86–103.

Marjan Unger: 'Colour in design '
From: *Morf*. Tijdschrift voor vormgeving,
no. 3, November 2005, p. 27–48.

JeongMee Yoon: 'The Pink & Blue
Project'
This article was taken from the website
of JeongMee Yoon, Seoul, South Korea.

Anne van der Zwaag: 'Gaming: the
battle of colour'
Part of this article on *de Blob* is based
on: Jaap van Nes, de Blob (Wii),
Gamer.nl, 16 July 2007.

ArtEZ Press
Jan Brand, Minke Vos
PO Box 49
6800 AA Arnhem
The Netherlands
www.artez.nl/artezpress
ArtEZ Press is part of ArtEZ
Institute of the Arts

Uitgeverij Terra Lannoo BV
PO Box 614, 6800 AP Arnhem
The Netherlands
info@terralannoo.nl
www.terralannoo.nl
Uitgeverij Terra is part of the
Lannoo-group, Belgium

This publication has been financially
supported by Mondrian Foundation,
SNS REAAL Fonds and Sikkens
Foundation.

Mondriaan Stichting
(Mondriaan Foundation)

SNS REAAL Fonds

SikkensFoundation

The Sikkens Foundation is an
independent institute whose purpose is
to stimulate those social, cultural and
scientific developments in society in
which colour plays a specific role. It
does this by means of the Sikkens Prize
and the Piet Mondriaan Lecture and by
initiating and/or supporting projects
having to do with colour application and
colour study. Over the past fifty years,
the Sikkens Foundation has grown into
a leading institute that today also
expresses the social responsibility of
AkzoNobel. The Sikkens Foundation
and AkzoNobel share a passion and
curiosity to investigate the role of
colour in society.

ISBN ISBN 978-90-8989-110-5
NUR 640

This book is also available in Dutch
ISBN 978-90-8989-094-8